THE EMBODIED EYE

The publisher gratefully acknowledges the generous support of the Art Endowment Fund of the University of California Press Foundation.

THE EMBODIED EYE

RELIGIOUS VISUAL CULTURE
AND THE SOCIAL LIFE OF FEELING

David Morgan

UNIVERSITY OF CALIFORNIA PRESS

Berkeley Los Angeles London

University of California Press, one of the most distinguished
university presses in the United States, enriches lives around the
world by advancing scholarship in the humanities, social sciences,
and natural sciences. Its activities are supported by the UC Press
Foundation and by philanthropic contributions from individuals
and institutions. For more information, visit www.ucpress.edu.

University of California Press
Berkeley and Los Angeles, California

University of California Press, Ltd.
London, England

© 2012 by The Regents of the University of California

Library of Congress Cataloging-in-Publication Data

Morgan, David, 1957–.
 The embodied eye : religious visual culture and the social
life of feeling / David Morgan.
 p. cm.
 Includes bibliographical references and index.
 ISBN 978-0-520-27222-4 (cloth : alk. paper)
 ISBN 978-0-520-27223-1 (pbk. : alk. paper)
 1. Vision—Religious aspects. 2. Senses and sensation—
Religious aspects. 3. Experience (Religion). 4. Psychology,
Religious. 5. Art and religion. I. Title.
 BL53.M66 2012
 204.2019—dc23
 2011022765

Manufactured in the United States of America

21 20 19 18 17 16 15 14 13 12
10 9 8 7 6 5 4 3 2 1

In keeping with a commitment to support environmentally
responsible and sustainable printing practices, UC Press has
printed this book on Rolland Enviro100, a 100% post-consumer
fiber paper that is FSC certified, deinked, processed chlorine-
free, and manufactured with renewable biogas energy. It is
acid-free and EcoLogo certified.

To my father, who taught me not to rest where contentment bids,
and to my mother, who would have preferred it, but never complained.

CONTENTS

ILLUSTRATIONS

PREFACE

This book is an extended argument for materializing the study of religions. It seeks to establish its claim by focusing on seeing as embodied practices of engaging what it refers to as "the sacred." Sacred moments, sacred things, sacred relations, sacred bodies, sacred persons. But what is the meaning of this word and how shall we understand its relationship to things and feelings and bodies and seeing? I spend most of the time exploring how seeing performs religious action, or one might say how seeing constructs or enacts a situation called sacred. But can we agree on a single definition of *sacred* or *religion*, one that will reasonably apply to the considerable diversity of religions in human history? The problem with a universal definition of religion is that, as Talal Asad contended, it tends inexorably to lift any religion out of its historical situation: actor X performed this ritual because it is human nature to do so and humans everywhere will evince this activity.[1] But deterministic historicism is no better: actor X performed this ritual only because of the circumstances that led to that moment such that he or she could not have done otherwise.

The fact that human beings exhibit a remarkable genetic and biological uniformity means that it should not be surprising to find societies over great stretches of time and distance manifesting behavior that might be reasonably said to represent a recurrent set of concerns designated by the term *religion*. The designation is not based on content, but on a description of behavior. Ritual practice, priesthood, communities organized about cultic celebration and commemoration, individuals and communities deploying objects in commerce with nonphysical or superphysical powers to achieve desirable effects,

the communal designation of certain persons, places, things, or times as special, or sacred. We may justifiably call such behavior "religious" as we encounter it not because the term prescribes any consistent content or meaning, but because it warrants the expectation to find patterns of related behavior shaped by the currents of time and place in that discrete culture and society. Doing so is analogous to an English speaker using the word *village* to name a small communal settlement in the ancient world no less than in the modern. What kind of village, how old it is, its location, purpose, constituents, ethos, and so forth remain entirely unnamed by the designation, and can only be adduced on the basis of careful historical examination. Daniel Dubuisson is probably right about "the propensity of the Western conscience and Western science to conceive simultaneously the Other and the universal in terms of their own indigenous categories," but surely calling a configuration of homes in ancient Persia a "village" and one in latter-day Montana by the same name is not necessarily an act of ahistorical Orientalism.[2]

A number of recent studies have criticized religion scholars for their discipline's tradition of defining the word *religion* in a number of ways that project all manner of cultural hierarchies, ideological prejudices, and suppressed theology.[3] I take the point as an important and relevant one to make. Clearly, scholars must be vigilant in avoiding subtle importations in the terminology and methods they use. But I also hear the response from thoughtful critics of Daniel Dubuisson's critique of *religion* pointing out that many scholars of religion are already "self-reflexive, aware of the ontological baggage that 'religion' travels with, and attuned to our use of language."[4] And in a characteristically incisive essay on the definition of *religion* as a "second-order, generic concept," Jonathan Z. Smith has made the case quite compellingly that the term has been "created by scholars for their intellectual purposes and therefore is theirs to define." Indeed, without doing so, he concludes, there "can be no disciplined study of religion."[5]

But the problem with nomenclature persists. Smith once pointed out that "the Sacred" did not exist in the study of religion until Durkheim.[6] A few years after Durkheim's influential book, *The Elementary Forms of Religious Life* (1912), Rudolf Otto (and after him, Mircea Eliade) pressed the term to signify, in the summary description of Peter Berger, "a quality of mysterious and awesome power, other than man and yet related to him, which is believed to reside in certain objects of experience."[7] The word has become a synonym for the Transcendent, the Holy, the Numinous, the Real, the Divine, God. Once

a term like that gets deployed on the shelves of popular bookstores, there's no putting the genie back in the bottle. But perhaps we can agree here, in the context of an academic book that will never sit on those shelves, that *sacred* means something more circumscribed.

While later writers transposed his coinage to a substantive definition of religion, Durkheim was less apt to do so. He wrote in *The Elementary Forms of Religious Life* that "Religious forces are in fact only transfigured collective forces, that is, moral forces; they are made of ideas and feelings that the spectacle of society awakens in us, not of sensations that come to us from the physical world."[8] This means that things are not themselves sacred. "The sacred beings," he went on to assert, "are sacred only because they are imagined as sacred." Humans must work to make the sacred. If they stop behaving as if something were sacred, it ceases to be so. The sacred character of things depends "on the thought of the faithful who venerate them. The sacredness that defines them as objects of the cult is not given in their natural makeup; it is superadded to them by belief."[9] The sacred is not really any thing; instead, it is the differentiation of sacred from profane as collectively maintained by a group. And that difference, according to Durkheim, is ultimately social phenomena that have been "hypostatized and transfigured."[10] Marx would say "reified." Feuerbach or Freud would say "projected." But Durkheim did not presume religion was a form of false consciousness. The sacred was straightforwardly the natural result of social processes of contagious feeling generated by and invested in ritual and myth.

Although he was not concerned with material culture, and conveyed little interest in scrutinizing the particular place of objects in ritual, Durkheim did not allow symbols to evaporate. In discussing the power of totems, he recognized the important role of the totemic emblem: "By expressing the social unit tangibly, it makes the unit itself more tangible to all."[11] Collective representations congeal with the assistance of "tangible intermediaries" such as movement, which take a definite form and are "stereotyped" and acquire the status of a recognized symbol. Symbols, he argued, are crucial because they stabilize evanescent "social feelings." When the movements that express the shared feelings "become inscribed on things that are durable, then they too become durable. These things keep bringing the feelings to individual minds and keep them perpetually aroused."[12] For this reason Durkheim urged against regarding symbols as "mere artifices—a variety of labels placed on ready-made representations to make them easier to handle. They are integral to those

representations."[13] The relation between "collective feelings" and "things" is not "purely conventional," he insisted, because the connection was not the result of an arbitrary invention of an "individual consciousness," but of the group. This was key for Durkheim because it meant that people encountered the symbol as originating *from beyond*—not in heaven or in time immemorial, but in the collective domain of social life. For that reason symbols commanded authority among people. The "transcendence" that mattered to Durkheim was the arch distinction between individual and collectivity. Individuals did not make symbols; society did. "Thus, when we imagine them [social feelings] as emanating from a material object, we are not entirely wrong about their nature. Although they certainly do not come from the specific thing to which we attribute them, still it is true that they originate outside us. And although the moral force that sustains the worshipper does not come from the idol he worships or the emblem he venerates, still it is external to him; and he feels this. The objectivity of the symbol is but an expression of that externality."[14] The totemic figure is sacred because it is the body of the power sustaining the person and his society. But this power did not actually exist as a god in his heaven. Mythology has no reality but a pragmatic one as a socially useful fiction. It is the mask through which a society peers back at its members. One wishes Durkheim might have said more about this masking because it would have increased attention to its material form, the images and objects that perform so powerful a function as disguising the group's manipulation of itself.

The transfiguration, hypostatization, or masking of social forces in the figures of religious myth, ritual, and material culture does well to avoid the reductionism of deterministic explanations precisely because the mechanics of sacrality are very elusive. Why an image seems powerful to a person or group of people is something we may never fully explain. But that should not deter the scholar from proposing accounts that trace the history of power over time as it shapes and takes shape in historical events. For me, this task has taken the form of focusing on the visual fields that form relations among social actors. The visual field shifts focus from the symbol, as Asad urged, to a configuration of relations. Certainly Durkheim can be read to have been in sympathy with this way of framing the totemic symbol. Unfortunately, Clifford Geertz obscured the issue with a confusing treatment of *symbol* in his famous definition of religion, aptly criticized by Asad. In his critique, Asad nicely conveys what I take to be the aim of visual fields, as I treat them in chapter 3: "a symbol is not an object or event that serves to carry a meaning but a set of relationships

between objects or events uniquely brought together as complexes or as concepts, but having at once an intellectual, instrumental, and emotional significance."[15] A visual field in any given situation is, at least in part, the instantiation of a history of power relations. The sacred is the experience of seeing or being seen as configured in a particular gaze, which may be understood as a current of feeling that flows among the components of a visual field. The one returning the gaze, the source of the gaze one avoids, the gaze one shares with others, the look one devotes to the saint, a look that expects so much in return—all these visual practices construe relations that are sacred because they embody relations that matter. They are forged in the circumstances of history and deployed in the social theatre where gods find visibility. The result is the sacred.

Robert Orsi has recently stressed that religion is not about meaning but about relationships, materialization, and "making the invisible visible."[16] This comports closely with what I have in mind by the visual construction of the sacred, which articulates an embodied relation with the saint or ancestor or nation or god. The medium of this relation is seeing, but not in most cases a pristine and distant form of contemplation. The forms of seeing that I have explored here enfold the senses, feeling, and flesh into a visual medium to embody the sacred in a variety of ways. To study seeing is to study embodiment as the mediation of the visible and invisible.

The premise of this book is that seeing is not disembodied or immaterial and that vision should not be isolated from other forms of sensation and the social life of feeling. Images and the practices of viewing them belong to discrete ways of seeing that perform the social construction of the sacred. How does that happen? Gazes or visual fields, of which there are many, engage the human body as an interface with other bodies—bodies of other people, things, and images, and through them interface with social bodies, or the groups that individuals inhabit as an integral aspect of their identities. Human beings are bodies of flesh and of social fabric bound in intricate conversation with one another. These are culture's two bodies, which is the name of the book's first set of chapters. Bodies of flesh are cultural constructions no less than the social bodies to which people adhere and against which they struggle. As with a fleshly corpus, belonging to a social body means sensuously experiencing the world through it. Vision is one medium whereby people engage in embodiment, the process of imagining oneself as an individual as well as belonging to

a corporate body. Embodiment is not a condition, but a process, and it contributes powerfully to religious life by joining people in communities of feeling. Shared practices of hearing and tasting, collective memory conveyed in bodily practices such as kneeling, bowing, and enduring pain, and gazing upon images exercise the flesh and bone of the social bodies that structure religious life.

The visceral connections among bodies that seeing enables will occupy my attention from beginning to end. Chapter 1 considers the many ways in which vision has been abstracted from the somatic or fleshly body and how the study of seeing has been dominated by a singular conception of "the gaze" keyed to shame. It is important to acknowledge what is useful in this tradition of thought, but also to move far beyond it in order to open up the much larger range of gazes. Chapter 2 examines the relationship of images and bodies at the important juncture of the Renaissance, where older modes of devotional vision and imaging operated in the work of Albrecht Dürer along side new ways of making pictures and training artists to see. Chapter 3 considers how the sacred happens visually in the mediation of several components that comprise what I call gazes or visual fields. I outline a number of these, arguing that it is these that form the interface of culture's two bodies, somatic and social. Chapter 4 brings the first half of the book to a close by scrutinizing the relationship between images and the face in the evolving and powerful category of the *icon*, a historical legacy of Christianity that has survived in the modern, secular domain of advertising and commerce.

In the second part of the book, "The Senses of Belief," I explore how seeing is a social medium that draws on the relationship of seeing with other forms of sensation. *Belief* is a term that long dominated the Protestant Christian academic study of religion with a strong set of ideas that dwelled on the priority of dogmas, doctrines, confessional statements, and official texts. An important range of studies by anthropologists and religion scholars over the last few decades has thoroughly critiqued this approach and even invoked a taboo on the word *belief*. I endorse the critique, but not the taboo. I have argued elsewhere for materializing belief as a sedimentation of practice.[17] That approach underlies the case studies comprising the second half of this book. My argument is that belief is as close to sensation as it is to intellection, and I seek to show how deeply patterns of belief are planted in sensory, intuitive, and felt-life.

The chapters in part 2 seek to correct in their own way the long-standing tendency to isolate vision from the other senses. Each chapter focuses on seeing and another domain of the sensorium—touching, feeling, hearing, and the

precarious nature of apparitions, visions, and dreams. Chapter 5 traces the history of the Sacred Heart of Jesus as an image of an object in which touch and seeing are intimately intertwined. Chapter 6 follows the modern history of sympathy as a powerful, visually active medium in the formation of communities of feeling. Chapter 7 seeks to recover the place of the body in Protestant worship by looking at the ways in which hearing is enhanced by body gesture. And the final chapter attempts to expand the remit of visual culture studies by considering how images are a fundamental part of the integration of visions, dreams, and apparitions into religious life. As immaterial as such phenomena may be, they are hosted, accessed, remembered, confessed, and adored visually and somatically in images, practices, and places that engage human bodies with one another and with anything else that touches them in the register of the social life of feeling.

ACKNOWLEDGMENTS

A book, like a religion, is the product of relationships. The connections and ongoing relations that shaped this book stretch over many years and stand out in the many people I have to thank. Reed Malcolm enthusiastically supported this project from our first conversation about it, and it has been, as always, a pleasure to work with him. Larissa Grau read every word of the manuscript at least three times and offered critical suggestions and most welcome encouragement. I also wish to thank her for help of so many kinds in Brazil. My sincere thanks to the following colleagues and friends who read portions of the manuscript or commented on versions presented at conferences: William Christian, Jr., Erika Doss, Cynthia Hahn, Kajri Jain, Kathryn Lofton, Keith McNeal, Robert Maniura, Peter-Jan Margry, Birgit Meyer, Allen Roberts, Leigh Schmidt, and Angela Zito; and to others who helpfully recommended literature or pointed me in fruitful directions: Mona Hassan, Hwansoo Kim, Susan Kwilecki, David Need, Peter Névraument, Peter Nickerson, Leela Prasad, and Lucas van Rompay. For their permission to use two images in this book (figs. 17 and 50), my thanks to Stewart Hoover and Jolyon Mitchell. Connie King and Erika Piola at Library Company provided continual help with the collections there. Karen Glynn at Duke Special Collections helped with the collection of photographs, and my thanks to Susan Kwilecki and her family for permission to reproduce three photographs by their father, Paul Kwilecki.

I have benefited over the years from the opportunity to present work in progress at a variety of far-flung venues, where I have received excellent

criticisms from colleagues from around the world. The earliest version of chapter 3 was first presented to a working group at the Arcada Institute in Finland several years ago at the invitation of Johanna Sumiala and Matteo Stocchetti. Their comments encouraged me to continue to develop the paper. I presented short versions of chapters 3 and 8 at Princeton as a Stewart Fellow, for which I thank my colleagues there at the time, especially Leigh Schmidt and Marie Griffith. Chapter 8 was also presented at a conference organized by the Index of Christian Art, Princeton University, where I benefited from many useful suggestions and heard an impressive array of papers, which were published in a volume edited by Colum Hourihane, *Looking Beyond: Visions, Dreams, and Insights in Medieval Art and History* (Index of Christian Art, Department of Art and Archaeology, Princeton University, and Penn State University Press). A different version of chapter 8 appeared in that volume, and I wish to express my thanks to Colum Hourihane and the publishers for permission to use portions of that essay here. I also wish to acknowledge the journal *Material Religion*, which first published chapter 6. A version of chapter 6 received very helpful suggestions from seminar participants organized by Monique Scheer on the theme of emotions in religious practice, held at the Max Plank Institute for Human Development, Berlin, Germany. Part of chapter 3 was presented at the University of Southern California, for which my thanks to Lisa Bitel and to several other friends there, including Jon Miller, Don Miller, Roberto Lint Sagarena, and Diane Winston; and at Jacobs University, Bremen, Germany, in a summer institute on religion and virtual reality, for which my thanks to Kerstin Radde-Antweiler and participants for illuminating sessions and fellowship.

All translations from French and German are my own unless otherwise indicated.

Culture's Two Bodies

Vision and Embodiment

Seeing is powerful among humans and many higher mammals in part because it is a primary medium of social life. Communal relations are established and sustained in different kinds of looks—shy glances, bold stares, rapt gazes, or averted eyes interpret an encounter, confirm a relationship, or signal an intention with visceral force. Vision reveals authority and weakness, charisma and stigma, compassion and aggression, and a host of other dispositions. Seeing collaborates with gesture, movement, touch, sound, and facial expression to form the sensory basis of human communication. Vision also helps maintain social relations by linking individuals to the groups or social bodies that comprise their society—class, kin, tribe, ethos, folk, nation, monastic order, elect, redeemed, and damned.

Because seeing is such a powerful social sense, there is sometimes a tendency to characterize one of its most brutal features, shame, as the dominant tone of vision. That is because shame and shaming are very effective ways in which human beings deal with one another. Shame easily establishes pecking order and etches primary distinctions such as good and evil, powerful and weak, pure and impure, right and wrong. Shaming is a visual procedure, a way of looking; and being ashamed is a way of being seen, a way of appearing. This dual aspect of shame is clear in a nineteenth-century illustration (fig. 1), which appeared in a very popular schoolbook and captures every child's horror at being singled out for reprobation by teacher and peers.[1] The dunce must wear the large conical hat, derived from the headgear once worn by subjects

3

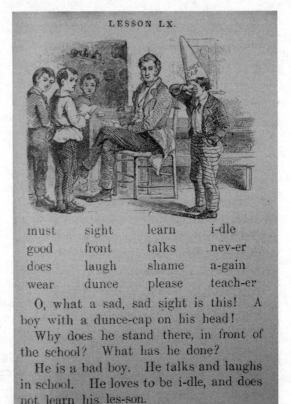

LESSON LX.

must	sight	learn	i-dle
good	front	talks	nev-er
does	laugh	shame	a-gain
wear	dunce	please	teach-er

O, what a sad, sad sight is this! A boy with a dunce-cap on his head!

Why does he stand there, in front of the school? What has he done?

He is a bad boy. He talks and laughs in school. He loves to be i-dle, and does not learn his les-son.

FIGURE 1. Dunce, *McGuffey's New First Eclectic Reader*, by Wm. H. McGuffey. New York: American Book Company, 1885. Photo: author.

of the Inquisition. The hat invites the shaming gaze of the group, whose concerted look sets off the boy for special odium. He is stricken by the look and desperately avoids the gaze by covering his eyes. The boy is reduced to the object of their collective stare. He is "the dunce," a role prescribed by a social script enacted in the stare. The gaze defines him; all he can do is to refuse to be seen. He is "a sad, sad sight," as the lesson describes him, trapped in front of the class. And there is no escape—unless he repents and seeks the approval of the others, whereby he may be reincorporated into the group. Only the appropriate *penance* will secure his freedom from the *penitentiary* gaze of the others. When that happens, he will cease to be the object of the look of shame, remove the damning hat, and take up another way of seeing and being seen, which will redefine him as a member of the social body of his community in the classroom.

There is no doubting the power of the gaze of shame. Anyone who has experienced it knows its force. We shall examine other examples of it in this chapter, but my intention is to show how unsatisfactory it will be as the singular model for the study of vision as culturally constructed. Unfortunately, the monolithic study of vision as "the gaze" has reduced seeing to shaming or being shamed. The aim in this chapter is to open the book with an argument for expanding the range of study to look for a broader basis on which to study seeing.

———

To see is to see from the circumstance of a body. Not just one's own, biological or somatic body, but also any encompassing corpus such as a gathering of worshippers. This suggests that to look for a point of view is to look for a body from which, or in which to see. Seeing is the act of embodiment, taking a position in a body—one's own or the shared boundaries of a social corpus. In either case, people make or maintain a body by affirming its composition and lineaments. In the case of the social body, they stand in relation to others, sharing some aspect of common features and maintaining the perimeter of the group. The body is the medium of vision. Placement within a corpus is also individual in the case of the body one inhabits. Collective or individual, a body is a bounded set of members that work together to endure, a system of interdependencies, an enclosure with a homeostatic force of coherence, a structure that displays itself as a public surface concealing an interior, a body with a face that has the ability to reveal the unseen depth. The face of the somatic body is a richly communicative zone. Likewise, the face of the social body is a densely semantic stereotype or symbol—think of familiar faces of social bodies such as the stereotypes of an immigrant group or Uncle Sam as the totemic representation of the American people.[2]

Human societies consist of many bodies, groups such as families, neighborhoods, cities, regions. Also clubs, associations, institutions, classes, religious denominations, professions, ethnicities, races. Each is a kind of community, demarcated by a social boundary. To belong to the community means to *look* a certain way. There are two different but related senses to this. In the first instance, one bears certain characteristics in appearance—style of dress, accoutrements, behavior, gesture, color of skin. In the second instance, one regards others and the world about one with a characteristic look. In the first

sense one is seen; in the second one does the looking. Sometimes the medium of vision is visible; sometimes it is the means of doing the seeing and becomes as invisible as a lens one looks through. This dual meaning suggests that one belongs to a social body by virtue of what one looks like *and* how one sees the world. One bears on one's body the signs of participation in the social body and one inhabits this body by seeing with its eyes, smelling with its olfaction, feeling with its fingers and flesh. The fact that human beings are always seer and seen, agent and the object of vision, means that the individual human body is not only a discrete biological unit, but also a medium, an interface, the way we participate in bodies larger than our own. But separating the two aspects of seeing, ignoring their intimate connection, is what a fuller account of visuality should seek to correct.

In the case of social bodies, individuals do the seeing, but they are looking with eyes not entirely their own when they gaze upon the world with visual practices they share with other members of the group. The idea of a social body is compelling because I am strongly inclined to understand religions as communities of feeling or sentiment that are held together by shared forms of intuition, imagination, and body practices. But this does not mean that members of most groups walk in locked step. Those who belong to the same club or family, for example, don't feel or see identically. But they do share an ethos drawn from common formation in such things as speaking, eating, throwing, dressing, sitting, running, waving or looking. Members of a group also share history, ideology, and economic interests. My intention is to understand how they also share ways of seeing. Doing so is important for this study, which argues that visual practice is a powerful form of social embodiment. Seeing is vital precisely because it situates viewers within social configurations of power. I do not mean this in a deterministic sense, though indeed the effect of seeing in certain ways can be overwhelming, subjecting the viewer to a commanding set of circumstances, as we shall see. But adopting other points of view can also empower the viewer with sympathy for others, move one to moral intervention, provoke the will to resistance, inspire protection for the weak, compassion for the poor, admiration for some, scorn for others. Understanding how an act of seeing mobilizes people by situating them within the compelling social body of a community that is animated by a common ethos has everything to do with understanding how seeing constructs the sacred in visual practices and images.

THE DISCIPLINED EYE:
DISTANCE AND THE EYES OF OTHERS

It is not difficult to observe that human beings commonly change what and how they see by modifying the state of their bodies. They do so by relying on visual practices that discipline or restrain the eye-brain network in order to idealize or conceptualize what or how they see, which may mean purifying, rationalizing, or spiritualizing the object. Vision is made to defer to measurement or technical calculation or the use of special instruments; or it is guided by the rhetoric or technique or style of diagrams, drawings, x-rays, magnetic resonance imaging, or other special imaging devices. Or vision may be conditioned by ascetic disciplining of the body such as meditation, fasting, yogic exercise, sweat lodges, or narcotics. In every case, the body is modified in order to enhance, deepen, restrain, or purge how the eye-brain system works. As one philosopher has noted, "no matter how sophisticated our abstractions become, if they are to be meaningful to us, they must retain their intimate ties to our embodied modes of conceptualization and reasoning. We can only experience what our embodiment allows us to experience."[3]

The history of philosophy offers one of the oldest practices of disciplining vision. In a telling etymology, William Barrett once pointed out "the Greek ideal of *detachment* as the path of wisdom" was expressed in the fact that the word *theory* derived from the verb *theatai*, "which means to behold, to see, and is the root of the word theater." Barrett contended that in a theater "we are spectators of an action in which we ourselves are not involved."[4] Theater and theory consist of contemplation, or seeing at a distance. He wished to make the point that Greek philosophers advocated detachment or dispassionate distance from the senses for the exercise of reason. In *The Symposium*, Socrates portrayed the quest of the lover of wisdom as a graduated removal from the senses, climbing up a ladder of love that began with sexual desire for beautiful boys but ended in the desire to gaze upon the pure Idea of Beauty.[5] Socrates' guru, the priestess Diotima of Mantinea, drew a strong distinction between mortal body and divine idea when she celebrated "the felicity of the man who sees absolute beauty in its essence, pure and unalloyed, who, instead of a beauty tainted by human flesh and colour and a mass of perishable rubbish, is able to apprehend divine beauty where it exists apart and alone."[6]

The desire to idealize seeing is evident in the modern era.[7] The ascent to divine goodness was visualized by Americans early in their nation's history in a very different image—the emblem on the verso of the Great Seal (fig. 2), which is today found on the backside of the American dollar bill. The pyramid, Masonic device and symbol of stepped ascent to wisdom and moral perfection, culminates in the disincarnate eye of the deity, whose effulgence shows benevolently on the new nation's enterprise. The motto, *annuit coeptis*, announces the providential blessing of the unseen but all-seeing deity. Its act of seeing issued favor, promising Americans that an abundant and felicitous future awaited. The looming eye preserved God's invisibility or supreme otherness, suggesting that virtue was the only proper approach to the godhead just as Socrates insisted that dialectic was the singular means of beholding the ideas of divine thought.

If we are to believe Plato's account of him, Socrates disparaged the bodily senses and the representations that appealed to them with the single-mindedness that also characterizes Jewish, Islamic, and Calvinist anxieties about images and idolatry. Judging from *The Republic*, Socrates did not associate "theory" with "theater." Indeed, he rued the power of the Greek theater's embodied nature of seeing. The experience of the body and the sway of its aesthetic knowing was never far from the audience of a Greek tragedy, especially if we bear in mind Aristotle's claim that tragedy purges an audience of its pent up fears and anxieties. Think of the gory scene of the blind and bloodied King Oedipus appearing center stage through the ocular gates of the palace:

> . . . The doors are opening.
> Yes, you shall see a sorry spectacle
> That loathing cannot choose but pity.[8]

Sophocles arranged the scene to mimic the structure of an opening eye: the audience is cued by a cast member to behold the sightless, mutilated man, who appears through the aperture of the stage setting. Oedipus is blind, but the audience is not, and is drawn inexorably to gaze upon the horror of his fate. The viewer was not meant to regard the humiliated king dispassionately, but with pathos. It goes without saying that Sophocles orchestrated a moment of high drama that was anything but dispassionate. Yet Barrett was correct in recognizing the detachment of much Greek philosophy. Reason was powerful for Socrates precisely because he deployed it to curb the darker elements of the soul that Homer and Sophocles stirred turbulently.

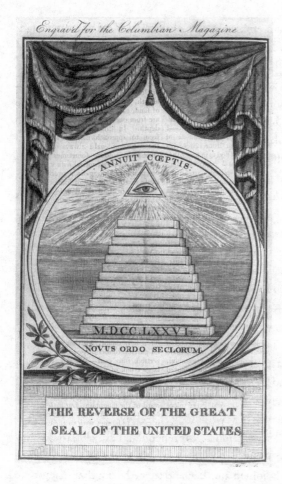

Engrav'd for the Columbian Magazine

FIGURE 2. James Trenchard, "The Reverse of the Great Seal of the United States," engraved for *The Columbian Magazine*, September 1786. Courtesy of the Library of Congress.

Although seeing is sometimes detached, it is also often deeply passionate. If we contemplate some events with lofty disinterest, on other occasions we experience an intense empathy for someone's struggle; or a violent revulsion at someone's deed. The power of seeing resides in the compelling connection it forges between ourselves and whatever we behold. But no matter how detached we wish to be, the very repression of feeling is itself an embodied act. The stiffened gesture, the passive demeanor—dispassion is couched in the body. Seeing construes all manner of relations but on every occasion the act of looking is a bodily one.

Take, for example, those instances in which seeing is unbearable, moments when we bury our eyes or turn sharply away in order to avoid the sight of

something disturbing. If I am embarrassed or humiliated, if I've been caught committing an error, even if I merely stumble while strolling on the sidewalk, I am likely to avoid the gaze of an onlooker. Why? Perhaps because in that moment of loss of self-control I see myself with another's eyes. By avoiding the look of the other I presume to vanish, to sink into invisibility, and thereby to remove the stigma of the gaze of judgment and to regain a sense of self-possession. To see myself being seen, to look into the shaming eyes of the other is to suffer the loss of esteem. To see myself being seen under these circumstances can be excruciating because I become painfully aware that in some sense I am inferior to the one looking at me. Yet I am not condemned to this fate if the other excuses my faux pas. In that case, I recover myself and return the gaze with an affirming one of my own. Seeing is able to reestablish my countenance with a look of esteem. But if that does not happen, I may choose to rush off into the oblivion of being unseen and there recover some form of self-presence.

The active and passive coupling of seeing and being seen captures two interrelated bodies of vision—the somatic and the social. Culture's two bodies, as I have called them. Human vision is eminently, perhaps always social, given the expressive nature of the face. *Look* is what I do and what others do toward me. We see with the same aspect of the body on which we rely for communicating with others. I see and I am seen by others. In the case of being seen, I feel others seeing me—it may be a look of admiration, of contempt, of shame or a petition for assistance. Whatever the look, I feel my objecthood, in the touch of their look on my flesh. Variously apprehended, I am able to imagine myself from the outside, to intuit or envision myself from beyond, as if my eyes separated from my body, joined another, and turned from that distance to behold me. This is a kind of reembodiment, where my objectification results in an altered sense of embodiment.

In fact, there are several different visually activated ways in which reembodiment occurs and it is important to enumerate them for the sake of clarifying how vision works. We have already noted the first, *moral judgment* or *discernment,* as a visual apprehension represented in extremis in the Oedipal act of extinguishing the eyes that condemn him by removing his own. On a more practical level, Adam Smith brilliantly explained moral self-government in ocular terms. In *The Theory of Moral Sentiments* (1759) Smith claimed that "our first ideas of personal beauty and deformity are drawn from the shape and appearance of others, not from our own." But we quickly learn, he added, "that others exercise the same criticism upon us. We are pleased when they approve

of our figure, and are disobliged when they seem to be disgusted."⁹ Beauty and ugliness, according to Smith, the capacity for attraction and repulsion, are not personally generated, but originally interactive or social constructions. We learn of our social deployment from our interaction with others. We then turn to examine ourselves, Smith reasoned, in order to test what others have impressed upon us: "We examine our persons limb by limb, and by placing ourselves before a looking-glass, or by some such expedient, endeavour, as much as possible, *to view ourselves at the distance and with the eyes of other people.*"[10]

On this quest for self-knowledge based on the response of others, Smith built his conception of the operation of human sympathy, or fellow feeling. The origin of moral awareness or conscience parallels our sense of beauty and deformity in Smith's account: we reflect on how much we deserve the "censure or applause" of others and so proceed to examine "our own passions and conduct." It works like this: "We suppose ourselves the spectators of our own behaviour, and endeavour to imagine what effect it would, in this light, produce upon us. This is the only looking-glass by which we can, in some measure, with the eyes of other people, scrutinize the propriety of our own conduct."[11] The image in this moral mirror looks at us with the eyes of others. It is a self-examination conducted from the position of the other. One might say that the mirror image is "us" looking at me. It is the chorus of the Greek tragedy conversing with the Oedipal self. For Smith the look of the other became integrated into the self as the basis of conscience and the human capacity to feel the pain and travail of others. The look of the other is the basis of sympathy or human sociality:

> When I endeavour to examine my own conduct, when I endeavour to pass sentence upon it, and either to approve or condemn it, it is evident that, in all such cases, I divide myself, as it were, into two persons; and that I, the examiner and judge, represent a character from that other I, the person whose conduct is examined into and judged of. The first is the spectator, whose sentiments with regard to my own conduct I endeavour to enter into, by placing myself in his situation, and by considering how it would appear to me, when seen from that particular point of view. The second is the agent, the person whom I properly call myself, and of whose conduct, under the character of a spectator, I was endeavouring to form some opinion.[12]

Moral discernment was a way of seeing with "the eyes of other people," suggesting that the self was enlarged by an imaginative act of disembodied vision, transcending its own interests and integrating itself into a social fabric of duties and expectations by virtue of seeing itself as others see it.

Abstraction is a second way in which seeing undergoes a kind of trans-embodiment. Plato conveyed this in describing Socrates' subordination of the sensory faculty of vision to intellectual vision that grasps the Ideas, the truly real substance of divine thought. Abstraction is the epistemological procedure of separating essences from accidents, differentiating general and particular. If I wish to discuss the nature of horses, I talk about the horse and do not mean this or that horse, but the entire class of horses, what Socrates meant by the "idea" of horse, or horseness. As a form of contemplation, abstraction separates idea from body in what it sees, but in so doing also distances the seer from what she contemplates, suggesting the remote consciousness of the cogito, that disembodied thinking thing that René Descartes classically described as something distinct from the body in which it resides. Here the etymological derivation of *theory* from *theater* that Barrett noted comes fully into play. Theoretical thought is contemplative, speculative reflection: vision that gazes from afar.

Akin in some respects to abstraction is a third category, *mystical* and *aesthetic contemplation*. Both of these lift the viewer ecstatically beyond immediate corporeal circumstances to inhabit a self-transcending form of vision. In art and nature aesthetic experience is able to elevate observers above themselves. At least, this is one way of defining "aesthetic" experience that has commanded considerable attention since the eighteenth century. It hinges on disinterested-ness, that is, the disengagement of certain aspects of embodiment. One does not focus on the satisfaction of bodily desires as the end, but on the pleasure of contemplative absorption in the object of disinterested contemplation. By virtue of this denial of self-interest, one is alienated from an aspect of oneself and made free to regard an object otherwise. Ralph Waldo Emerson provides a powerful example of contemplation that is both mystical and aesthetic in the opening pages of *Nature* (1836). Walking in the woods, he says, allows him to escape the distractions of social life:

> Standing on the bare ground—my head bathed by the blithe air and uplifted into infinite space—all mean egotism vanishes. I become a transparent eyeball; I am nothing; I see all; the currents of the Universal Being circulate through me; I am part or parcel of God. The name of the nearest friend sounds then foreign and accidental: to be brothers, to be acquaintances, master or servant, is then a trifle and a disturbance. I am the lover of uncontained and immortal beauty. In the wilderness, I find something more dear and connate than in streets or villages. In the tranquil landscape, and especially in the distant line of the horizon, man beholds somewhat as beautiful as his own nature.[13]

Here mystical and aesthetic experience intermingle. Beauty, God, and Self appear as versions of one another. A contemporary reader created a delightful caricature of Emerson's passage (fig. 3), in which we see the writer's grotesque form as a giant eyeball, floating over the rural landscape on long, stilt-like legs, supported by a body shriveled to a ghostly whisper, the merest accession to materiality by the looming orb of pure consciousness. This version of the disembodied eye captures the human longing to transcend sociality, but also a kind of self-transcendence that reduces the body to an ethereal apparatus. Emerson aimed at a liberation of the mind for a loftier form of self-communion, one purged of social obligations, distilled of egotism and self-interest, a state of being in which soul and Soul merge.

Another form of visual reembodiment that should be outlined here may be called *extension* because it consists of projecting the body beyond its organic limits in acts of observation that rely on a mediating apparatus or technology. The device for tracing objects illustrated by Albrecht Dürer, discussed in the next chapter (see fig. 9) is a good example of technique or technology intervening between the seer and seen to transpose both to a mechanical or cybernetic body of seeing. In some sense, the eye is augmented by a lens or protocol that arrests the body, separating it from the thing seen in a process of objectification. Scientific observation is perhaps the most immediate example. Ocular devices such as telescopes, microscopes, cameras, or magnetic resonance imaging machines make visible something distant or tiny or hidden.

A final and related mode of seeing, *objectivization*, relies on protocols of observation that restrict the observer's interaction with the *object* of study as if the observer were present only at the remote distance of seeing. The medical scientist studies human "subjects" who are coded with numbers. Their personal identities are masked. Journalists cover stories exercising reportorial objectivity. And the effect of ideology is no less objectifying. The "body count" of enemies is morbidly objective. Enemy dead are nameless and faceless, referred to only as foes, enemy combatants (only "our dead" have faces, which appear as official portraits in media reports). Propaganda operates in the same way, reducing opponents to stereotypes and racial clichés. Ideological ways of seeing act as cultural lenses that distance us from what we see by subjugating our eyes to the manipulative views of ideology.

These forms of visual scrutiny variously induce self-alienation, self-transcendence, or the cancellation of vision in one register in order to see in another. Or we might say, they cancel seeing for oneself in order to replace it

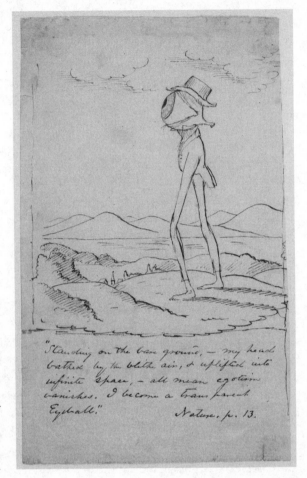

FIGURE 3. Christopher
Pearse Cranch, Caricature
of Ralph Waldo Emerson
as "transparent eyeball,"
1838, drawing on paper.
Christopher Pearse
Cranch Illustrations of
the New Philosophy
(MS Am 1506—4).
Houghton Library,
Harvard University.

with being seen by another. In discernment, abstraction, contemplation, extension, and objectivization, one strives to see objectively, not subjectively, that is, to subordinate one's bodily and personal or otherwise idiomatic interests in order to regard an object—one's own self, another person, a work of art, a microorganism—with a look one does not control. It is almost certainly true that this ideal of objectivity is deeply interested. Behind it may be concealed a variety of desires and aims that are anything but dispassionate.

The larger matter to recognize is that even in subjugating one's interests, *seeing in one form or another is a practice that integrates two corporeal registers: the body of the individual and the body of the group.* An example will make the point. In his youthful compilation, *Rules of Civility*, the teenage Virginian aristocrat

George Washington assembled a code of conduct, drawn from French sources, befitting a gentleman. Rule 37 reads: "In speaking to men of quality do not lean *nor look them full in the face*, nor approach too near them. At least keep a full pace from them."[14] Social station was registered in the look one gave the other. Mode of address was not only ocular, but thoroughly corporeal, as the code demonstrates: the informality of leaning and the familiarity of proximity were the bodily analogues of looking the superior other "full in the face." For Washington, social order and harmony depended on the observance of a code encouraging self-inspection. Civility was the medium and foundation of a republic, a kind of self-applied discipline. Republican gentility meant submitting oneself to the templates of social imaging. Self-indulgence was rigorously subordinated to the strictures of gentlemanly conduct. "Good form" trumped individual interest because it meant one belonged to the social body of the genteel class.

Seeing, I have wished to suggest, happens in tandem with the entire body of the seer. But if emending the state of the body changes vision, the importance given the sense of sight among human beings also enables the reverse: changing patterns of seeing not only affects the body of the seer, but also, I shall argue in chapter 3, shifts consciousness from the somatic body to the register of the social body, the corpus of the group. But there remains much to say about the bodily context of vision and how seeing has been studied. Many at work in visual studies have presupposed a model of vision in which shame is the arch orientation of seeing. This is implicit in the sharp distinction between *look* as forceful act and *look* as the passive object of being seen. To be sure, shame is a powerful motive in human relations, and is used by parents, teachers, priests, and other authorities to shape behavior and attitudes among children as well as adults. It is important, therefore, to examine this orientation of the visual encounter of people in order both to understand it and to be able to move beyond its singular fix on the study of visual culture. Shame, as we shall note, marks the end of seeing, which is a circumstance that suits those averse to vision as untrustworthy, dangerous, or misleading. Shame is the state of seeking invisibility, the longing to avoid being the object of vision. But if we want to know how seeing operates in other respects in religious practice, a more capacious view of visual encounters will prove indispensable.

The various modes of visual reembodiment that we have quickly surveyed chasten or discipline the self, even resulting in self-erasure, and are propelled by shame of one sort or another, or a sense that the body must be repressed

or controlled in order to see properly. This is a prevalent way of analyzing vision among scholars of art, film, and popular imagery. Shame undeniably commands a powerful social utility, but it is inadequate as a broad basis for understanding visuality. The remainder of this chapter and the next two will seek to demonstrate this and to establish a more encompassing scheme for studying visual culture.

SHAME: PUBLIC SPECTACLE AND THE END OF VISION

The power of the eye is dramatically demonstrated by extreme instances that turn on destroying it: putting out the eyes when seeing is said to be unbearable or unacceptable. The end of vision arises in shame, an emotion that commands enormous social effect. The Gospel of Matthew transmits a grimly puritanical but ironically spectacular teaching of Jesus: "And if your eye causes you to stumble, tear it out and throw it away; it is better for you to enter life [after death] with one eye than to have two eyes and to be thrown in to the hell of fire" (18:9). I remember feeling relieved as a boy when a biblical commentary assured me that this was an instance of "oriental hyperbole." Jesus didn't *really* mean what he said. He was simply exaggerating in order to signal the solemnity with which his followers were expected to comport themselves. But since Origen had been able to wrangle the passage into justifying the surgical removal of another, no less precious part of his body, lest he be tempted to sin with it, my relief was not complete. Jesus relies on a repulsive spectacle to underscore the urgency of membership in the social body of the kingdom of heaven. Seeing with only one eye meant seeing with the transformed vision of the blessed.

An even more gruesome and sensational example offers more text to work with than the gnomic utterance ascribed to Jesus. Was it similarly hyperbolic for Oedipus to puncture his eyes with the golden brooches plucked from the breast of his dead mother and wife? If Jesus could settle for one, Oedipus demanded both eyes, then accounted for the grisly deed:

> How could I meet my father beyond the grave
> With seeing eyes; or my unhappy mother,
> Against whom I have committed such heinous sin
> As no mere death could pay for? Could I still love
> To look at my children, begotten as they were begotten?
> Could I want to see that pretty sight?
> To see the towers of Thebes, her holy images,

Which I, her noblest, most unhappy son
Have forbidden myself to see—having commanded
All men to cast away the offence, the unclean,
Whom the gods have declared accursed, the son of Laius,
And, having proved myself that branded man,
Could I want sight to face this people's stare?[15]

The chorus had opined that death was preferable to blindness, suggesting that death might have offered an end to dishonor, while blindness only prolonged his humiliation. But Oedipus insisted the punishment was just, for death was no escape from his shame, and blindness at least removed from him the agony of seeing the shame reflected in the beauty of his incestuous children and the damning gaze of his fellow Thebans. Yet Oedipus's self-mutilation bears conflicting motives. Death would have compelled him to face his dead parents without the ability to satisfy the debt he owed them. Shame was the coin of his compensation. And blindness also relieved him of the unbearable, shaming look of the living.

Both Jesus and Sophocles acknowledge in their extreme examples of self-mutilation the power of the shaming look and the way in which social order relies on seeing and not seeing. Although I assume that neither moralist advocated the actual deed as the best way to deal with temptation or guilt, they each produced a striking sense of the terrible burden of shame and the powerful way in which shame was and remains a visual medium of sociality. Jesus's utterance seems to suggest that blindness removes the stimulus to sin. One eye is expendable because it could be easily made into the instrument of weakness. It is better to deny the self the pleasure, to practice mortification and thereby to preclude the exploitation of the senses that would prevent entrance into the kingdom of heaven. In a gospel that pivots on the trope of economy as Matthew does, an eye is worth the cost. The view presumes that the corporeal senses are inferior to the inward moral compass, the power of conscience, the inner sense of duty that properly subordinates the flesh to the higher calling of God's commandment to be holy.

Sophocles offered a different lesson. His account of Oedipus may teach with tragic pathos that removing the eyes from the body is a metaphor for the agonizing gaze of those who judge us. The idea assures that the guilty may not hide. They will be found out, they will fall under the penitential gaze of the good—those to whom all are beholden. Removing the eyes from the body deprives us of returning the gaze, that is, of *looking back*. As a result, we become

the hideous object of derision, dishonor, abjection, pity. There is nothing we can do to reclaim the countenance of those who see us because we have no means of reengaging and therefore changing their gaze. In a terrible sense, others do not see *us* any longer, but gaze instead upon a transgressor. We cease to be who we were and become another whom we ourselves would despise. In Oedipus's blindness, we are fixed forever in the visual aspect of disapprobation. To be seen in one way alone is to be rendered blind, unable to be a seer. It is a state of hopeless condemnation, judgment without reprieve. The self is reduced to one thing, and therefore becomes an object that cannot return sight. We might even say that Oedipus had to blind himself rather than take his own life because in doing so he placed himself in a perpetual state of self-contempt. He will never again see himself or images of himself (his children), but will remain singularly what others see. He is beyond redemption, forever unequal to his debt, incapable of compensating those he has injured and the public good he has violated.

The intricate economy of shame and vision was explored with considerable philosophical introspection in Jean-Paul Sartre's famous account of "the look" (*le regard*). Sartre analyzed the look as a way of understanding "the problem of the Other," that is, the ego or self of the other person who held him in his gaze and alienated him from freedom by regarding him as an object. Sartre characterized the encounter with the "other" as consisting of shame. He described shame in the memorable example of being caught seated on a chair before a door in a hallway, peering through a keyhole. Realizing that he is being observed, he is ashamed, which "is the *recognition* of the fact that I *am* indeed that object which the Other is looking at and judging."[16] Sartre had much more in mind than being caught in a single instance of spying. Shame is the nature of self-awareness that others afford us. "For the Other *I am seated* as this inkwell *is on* the table; for the Other, *I am leaning over* the keyhole as this tree is bent by the wind. Thus for the Other I have stripped myself of transcendence."[17] He was nothing other than what the viewer has found; someone exhibiting pettiness or jealousy by committing an impropriety. In the gaze of the other he becomes the vice he commits, an object of derision, and is nothing else. All that he might otherwise be—a distinguished academic, a lover, a humanitarian, a war hero—suddenly vanishes.

Sartre saw the other as the reality that robbed his ego of its transcendence. "The Other . . . is presented in a certain sense as the radical negation of my experience, since he is the one for whom I am not subject but object."[18] The loss was so fundamental for Sartre's account of self-awareness that he portrayed it

as the fall of humanity from an Edenic state, resulting in a shameful ejection from the blissful garden of complete self-presence: "If there is an Other, whatever or whoever he may be, whatever may be his relations with me, and without his acting upon me in any way except by the pure upsurge of his being—then I have an outside. I have a *nature*. My original fall is the existence of the Other. Shame—like pride—is the apprehension of myself as a nature."[19] To experience shame, he reasoned, was to watch himself losing his freedom in becoming the object of another's apprehension. One is reminded of Freud, for whom the pure state of the unfettered libido produced "the universal original condition" of narcissism that is objectified as the ego forms and the instincts undergo the chastising gauntlet of civilization.[20] The narcissism of the infant paralleled the transcendent reality of the thinking substance. The abrupt transition into consciousness was like the agony of leaving primordial bliss.

It becomes clear from Sartre's discussion that seeing is powerful because it configures human relations. To be seen by others estranges me from the experience of my ego as transcending the world of objects and subordinates me as being-for-the-other. Sartre likened this to a state of enslavement.[21] An image in which the Sartrean relation of subjection is horrifyingly performed is René Magritte's portrayal of a rape, *Les jours gigantesques* (1928; fig. 4). Enclosed within the contour of an assaulted woman's naked body is the form of her attacker. He is clothed and we see him from the back. The way in which the artist has merged the two figures conveys the repugnant nature of the forced union—the rapist's invasion of her being could not be more insidiously visualized. She looks away from him as he devours her body, gazing intently on her bare flesh. His hands do what his eyes see. The woman is alienated from herself by the attack; he invades the very being of her body. The invisibility of his gaze is felt in the objectification of her body. She is reduced to the objecthood of her flesh, the object of his humiliating manipulation. As Sartre said of the other, he is the one who refuses to be seen, refuses to be an object of her consciousness. Instead, she belongs to him. To be seen means to be powerless to regard the other close up or far away: "It is never when eyes are looking at you that you can find them beautiful or ugly, that you can remark on their color. The Other's look hides his eyes; he seems to go *in front of them*. . . . the look is upon me without distance while at the same time it holds me at a distance— that is, its immediate presence to me unfolds a distance which removes me from it."[22] Because the object of this gaze is unable to return it, unable to grasp the source of oppressive vision, the ego is fixed and enslaved.

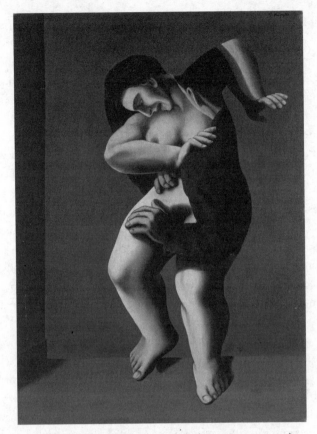

FIGURE 4. René Magritte, *Gigantic Days* (*Les jours gigantesques*). 1928. Oil on canvas. 116 × 81 cm. Kunstsammlung Nordrhein-Westfalen, Duesseldorf, Germany. Banque d'Images, ADAGP / Art Resource, NY. Artists' Rights Society.

One is tempted to say that the eye of the Sartrean other is the sinister sibling of the looming eye of God seen in the Great Seal (see fig. 2). Yet conferring appellations of sinister and benevolent will depend on one's location in the visual field. To those who fall in the providential path of the eye of God, rather than gaze from behind its searching light, it is not a smiling deity who beholds them, but a merciless force, what white Americans were fond of calling "manifest destiny." Native American possessions, British territory before the Revolutionary War, Mexican continental holdings before the war of 1846–48—all were transformed by the unilateral gaze of the divine eye, which shone in favor of the new nation, not its rivals. The gaze corresponds to the interests of those

directing vision on anyone forced to forfeit freedom when they find themselves under its auspices.

In every instance, seeing is a social medium, the means by which relations of power are arrayed and maintained among human beings. Seeing and being seen (or not) constitute frameworks of self-consciousness, consciousness of others, and consciousness of one's social body, which entails the feeling of one's relation to a group and to oneself. What is striking in Sartre, even if one objects to his unnecessarily reductionist scheme of ego set against ego in a zero-sum game, is that seeing articulates a world's focus and structure. Moreover, this articulation is, in spite of the hundreds of pages of Sartre's intricate philosophical analysis, conducted by feeling and intuition, and manifested as disposition and mood. Seeing, as he treats it, is infused with feeling, grounded in the body, linked directly to the felt-awareness of one's relation to others. Sartre was interested in the ego, the cogito, the human as thinking substance, but his data were the sensation of being seen and the physiological response one has to the look of the other. This urges us to correct the strong tendency to think singularly of the gaze as posing distance between viewer and viewed. Sartre may have thought he was a disembodied eye spying on a lover or neighbor from a silent distance, but he was also a crouched body gripped in the gaze of someone standing behind him. Shame made him visible as a body. Like the schoolboy in figure 1, he might have wished to become invisible, just as Oepidus destroyed his eyes in order to escape the penitentiary gaze of *others*. And yet, in doing so, Oedipus condemned himself to a debased visibility for public display. Oedipus's act is a grotesque hyperbole about shame. In matters of actual conscience, people don't puncture their eyes, but they do something that is figuratively equivalent when they avoid the gaze of others. They do not wish to see themselves being seen. Sartre considered fleeing in order to escape the terrible visibility that had trapped him.[23]

Sartre, Oedipus, and the dunce wished to make themselves invisible. As their accounts show, invisibility and visibility are inextricable. To see and not-see are complementary acts, both individually and publicly embodied. While he wished to escape the vision of the other, which made him visible, Sartre also longed to reduce the other to an object. He wanted to contrast his own (in)-visibility with the other's. And Oedipus concealed the world from himself at the expense of making a pathetic spectacle of his self-inflicted blindness. Invisibility and visibility are not just material conditions, the result of hiding or display, but are culturally fabricated forms of social association. You can only

be invisible, after all, if someone is looking but does not see you. And to be visible is to be capable of being seen, encountered, addressed, engaged. What we see and do not see is a project, a task driven by shame or hatred, but also, as we shall see, by such feelings as desire, devotion, and sorrow.

BEYOND SHAME

Seeing is robustly embodied, and so we do well to recapture the aesthetic element of vision, the felt-life of seeing, the manifold and subtle relations of seeing to other forms of sensation. Exploring the intricate psychosocial anatomy of vision is the task of the critical study of visual culture. The study of religion as visual practice has something important to offer this broader enterprise by helping to restore the vivacity of sensation and emotion—seeing as interface, intimacy, or intercourse with people, places, and things. To this end, we might scrutinize several other modes of consciousness in addition to shame for their capacity to reveal the structure and focus of worlds as characteristic forms of human relation, situations that stage the human self and its communities. For example, what about powerfully orientating states like desire, sorrow, or praise? Surely such forms of awareness reveal different situations in which a human self might be grasped in no less prevalent forms of consciousness. By entering visual fields of others, we discover and cultivate modes of the human self. A self, it follows, is not a timeless essence or disembodied cogito, but a particular orchestration of roles in which that self engages with other selves to create the world to which they belong. Visual fields parse or disclose the structure of relations prevailing among a variety of actors. By entering these fields, people practice and cultivate modes of individual and shared identity as well as produce and encounter what may be called the sacred, as I shall explore in greater detail in chapter 3.

There is no reason to make shame the master trope of vision. Sartre was persuasive in arguing that human freedom consists of the construction of human existence. Only his restriction to the look of shame was unnecessary. Looking takes a number of other forms with existential and social consequences. Shame is just one, very powerful, visual orientation. There are many others. This is not to deny the importance of shame, but to seek to reestablish the embodiment and sociality of vision. There are probably many archetypal visual dispositions, but to make the point that shame is only one among several others, we might enumerate a few that, along with shame, characterize

the felt-life and emotional temperaments that religions generate and manage. We have already mentioned such common human feelings as desire, sorrow, and devotion, or praise. These are not deduced from an a priori scheme, but belong to a longer list, and one that will inevitably be parsed differently from one culture and historical moment to the next. But that there are fundamental emotional dispositions in any given society that help organize human experience seems a reasonable hypothesis. The point is *not* to determine a universally representative set of moods, but to identify compelling orientations to add to shame as examples of the dispositions that conduct the visual construction of reality. Each disposition represents a fundamental orientation characterizing relations among humans, between humans and animals and other animate beings, divine or mortal, and between humans and their worlds. This is not to flatten cultural differences into a general human nature. I have in mind by these moods or dispositions the broadly shared, culturally varied, and historically transmitted matrices in which human worlds tend to take shape.

Shame, as we have seen, occurs as an objectification in the gaze of others, and in some sense a loss or end of vision: one is seen, but no longer sees, as grimly illustrated by the case of Oedipus. But more commonly with shame, one looks away from the sight of others as if to cancel vision and become unseen. *Desire* operates quite differently, seeking out or hunting another. Meeting the gaze or even the glance of the beloved repays the long suffering of the lover. The gaze of those in love, who dwell in long silence and rapt attention, intermingles their egos by canceling contrary inclinations in themselves or discovering undeveloped impulses. They grow together and experience a powerful symbiosis that measures time in a narrative marked by anniversaries, the purpose of which is to renew the recognition of the original look. For this reason, a record, photographic or otherwise, of the journey together is cherished and curated with care. To desire is to want to see.

In contrast to love, capturing the flesh of the desired is the aim of pornography, another version of desire, which may be said to consist of two aspects: the sexual violation of boundaries of the body (abjection); and sexual enforcement of hierarchy in domination and submission (subjection), both of which are perversely envisioned by Magritte's painting examined earlier (see fig. 4). Abjection assaults the definition of the self in the body's configuration of inside and outside, transgressing borders and blurring distinctions. Subjection enslaves the subject to the other by compelling its visibility as object and concealing the other from view. In both cases, and in all forms of desire, the

appetite is voracious. It always wants more and is never content with the previ-
ous conquest, or with what the beloved last allowed as a favor.

Limits are the agony and stimulus of desire, which is a driving force that
would violently burst all bonds restricting its satiation. This is why the lover
worships the item which the beloved has given as a gift—a lover letter, a pho-
tograph, an article of clothing, any trifle, the more minor or casual the better as
a gesture to be overinterpreted and cherished as the promise of more and more
to come. Likewise, pornography and erotica operate most powerfully when
desire is teased. The slightest bit of clothing that adorns the body generates
intense desire because it incites the longing to remove it. In desire we see what
we can become or consume (and thereby make into ourselves).

While love seeks a sustaining relation to the other who restructures one's
relationship to oneself and the world, *sorrow* is the violence of losing someone
or something whose familiarity and agency are so important that we depend
on them to orient and anchor daily life. Sorrow is a sharp punctuation, a hor-
rific end to the ordinary. If desire is a hopeful hunting, sorrow is a desper-
ate pining. I am reminded of the splendid elegy of Roland Barthes' *Camera
Lucida*, where readers become aware that the author mourns the loss of his
mother, whose photograph he happens upon one day following her death.
Barthes discusses her image and her presence in the image, but never shows
readers her picture. She remains unseen, haunting the book. We see instead
many other photographs of dead people and distant places.

Photographs for Barthes are about loss, loss but not destitute absence.
They give something to the viewer. Barthes characterizes the power of photo-
graphs as their ability to prick or wound the viewer. They bear a *punctum* that
impresses the viewer with pain. One is reminded of the Franciscan tradition
of the stigmata, the wounds of the crucified Jesus that pierce the bodies of the
saintly few whose suffering he graces with this supreme favor of imitating him
in their very bodies. And so it is that Barthes speaks of "the gift, the grace of
the *punctum*."[24] A gift, but the gift of the dead. The *point* of any photograph is
its impact on the body of its viewer. Photographs touch us, Barthes contends,
in a way that light once touched them. We encounter in the photograph the
trace of a presence that is gone. The way to see a photograph well, he says, is "to
look away or close your eyes."[25] Then its poignancy emerges. In not seeing the
image, it becomes more visible to us than before. One remembers it in a second
act of loss that is also a recovery. Memory is a sort of resurrection: "to say noth-
ing, to shut my eyes, to allow the detail to rise of its own accord into affective

consciousness."[26] In the look of sorrow we see what is absent in ourselves, we see the end of ourselves, a border caused by sudden violence. In mourning we learn to be someone else, a new thing created by loss.

Missing the lost one leads inexorably to *praise*, or the expression of devotion. Loss and gratitude are either side of the same coin. In fact, they are features of every moral economy. Loss is the depletion of resources, and gratitude is what one offers as an expenditure to acquire a social good. Gratitude signals the nature of praise as part of a relationship that is described in the social dynamics of the gift, a form of economy that organizes relations between two parties. One pays tribute in order to buy obligation, license, liberty, or privilege. There are at least two distinct forms that praise takes: deference or public tribute to those whose stature is pivotal as constituting and sustaining the community (god, leader, or hero); and devotion, which is personal or private dedication of oneself to the other. In either case, praise posits a difference discernible in the submission of oneself to the other. But in most instances the submission is not absolute or purely unilateral. The king must honor the rights of subjects or suffer rebellion. The other is also amenable to supplication and covenant. The devotee of a saint offers thanks, pilgrimage, prayer, or pledge before the saint's image precisely because the saint can be flattered, moved, or cajoled into helping the petitioner. Praise is the coin one pays to entreat attention and favor.

Deference is the prevalent form of praise that suits public commemoration of the deeds of a hero or national patron. Memory is key to the communal tribute of deferential praise. Presidents, senators, emperors, and kings offer their tribute to gods and founders to invoke blessing on their reign and renew national dedication to a cause. Public rites of piety remember the founding narratives that confer identity on the community by tracing its story from origin to the present. The monument or memorial statue erected in the public square visually and spatially triangulates the viewer's relation to the hero and the people for whom the hero dedicated himself in some sacrificial form. Heroes are important to a social body because their presence allows a form of visibility otherwise unarticulated. By seeing the hero, people see themselves as a people belonging to and embodied in the hero. The totem is us.

In every case, desire, sorrow, and praise configure a field of visual relations, a network of linkages between the viewer and another, or others, transforming personal identity in the process. Seeing and being seen is not a singular prospect, as Sartre's characterization of the look holds with respect to shame. We might say the same of Jacques Lacan's celebrated treatment of the mirror stage.

This moment in early psychological development occurs when the child, aged between six and eighteen months, according to Lacan, "assumes an image" presented by a mirror.[27] The image perceived by the infant becomes a new version of himself, his double, his own ego looking back at him. The development is of singular importance, according to Lacan, because it marks the move from an inwardly felt sense of self to a "specular I," a fictive, imaginary, and ideal self that looks back and constitutes the paradigm that the lived I forever and imperfectly seeks to emulate. Self-consciousness is born in a moment of misrecognition: the infant's acceptance of the specular other as its true self, imposing itself on the gazing baby as the superior reality of its inarticulate, embodied self.

Fascinating as this conception of self-development is, it easily ignores the already rich interactive, social life of the child by this age. From birth the child has been sensuously engaged in relations with its parents, and perhaps with siblings. And the mirror is hardly necessary to conceive of the encounter of an ideal self, since parents and others address the baby in terms of what she ought to do. The superego, in other words, is an internal ideal self that the child is constantly urged to instantiate. Indeed, Lacanian psychoanalysis does not insist on actual mirrors to achieve the decisive step in consciousness (if Lacanians did so, they would need to account for the absence of mirrors in cultures and societies that did not include polished metal or silvered glass devices). Instead, Lacan might suggest that mirrors are only symbolic of the self-imaging that does constitute the significant stage in human awareness. The mirror stage does not require them. The social interactions of the child account for this moral formation.

In fact, this idea was developed by Adam Smith in his idea of the looking-glass. But unlike the shame of the look of the other analyzed by Sartre, Smith found the look able to affirm no less than to scold. Moreover, the look of the other did not undermine the ego, as it did in Sartre's phenomenology of consciousness, but enabled its moral operation in the world of fellows. The motif of judgment, passing sentence, bears comparison with the moral severity of the Freudian superego. But the motif of self-judging also recalls Foucault's discussion of Jeremy Bentham's panopticon.[28] An architectural configuration for prisons, factories, poor houses, hospitals, asylums, and schools, the panopticon or "inspection-house" organized cells around a central tower in which attendants conducted surveillance. The form of the construction was not only to make surveillance efficient, but served, according to Bentham, as "a new mode of obtaining power of mind over mind."[29] Foucault argued that the

structure's design configured a gaze, an entire visual field, in which occupants themselves were structured. To see within this regime was to participate in a gaze that organized the very act of vision. The panopticon made occupants the subjects of perpetual inspection, serving as a physical framework that impressed on them a subjectivity of being seen. As such, the design is a visual template in which authority and subject reside in the enduring formation of one another. The panopticon is a material enactment of a mode of visibility, an active shaping of the conditions of seeing. The architecture was "to induce in the inmate a state of conscious and permanent visibility that assures the automatic functioning of power."[30] Or even more tersely, echoing Lacan, Foucault wrote: "Visibility is a trap."[31] At the same time, the panopticon manufactured invisibility by concealing freedom in the barren glare of visibility. Bentham's inspection house was to operate so perfectly that "inmates should be caught up in a power situation of which they themselves are the bearers."[32] And so it was that Adam Smith may be understood to have expressed the ideal of Foucault's "disciplinary gaze":[33] by internalizing the juridical gaze of others, the self is its own judge and jury.

For Sartre, Lacan, Smith, and Foucault, seeing and being-seen is a formative experience in which the ego is tempered by encounter with others who return its gaze. So powerful is the look of the other that it can imprison the ego. What I have proposed, however, is that this scenario does not exhaust visuality nor serve as an adequate foundation for its understanding. Smith's (and Lacan's) discussion contends that the alienating gaze of the other is internalized and used by the ego for self-scrutiny. This suggests that we need to understand the alienation of the other's gaze as part of a dialectic of reembodiment, in which we forsake or discipline our bodies in order to assume the look of others directed at us. The result is a useful self-transcendence. By seeing with another's eyes we acquire the ability to sympathize, to feel what the other feels under scrutiny because we ourselves have endured such scrutiny. The consequence is the capacity to participate in communities of feeling. This means an alternative to viewing others antagonistically or regarding the world from the unsympathetic distance of the isolated or secluded cogito. The visual construction of reality is more complex and pluralistic, and it is not the work of individual psyches, but of networks of individuals and communities forming a massive variety of social bodies.

What we learn from Smith as well as from Foucault, in contrast to Cartesianism, is that human beings are not principally or fundamentally indivisible

egos, but social beings visually constructed by their engagement with others and the material worlds in which they live. It was Descartes who posited a metaphysically foundational distinction between the mind as a thinking thing that was impartible and the human body, which admitted of partition.[34] But there is never a moment in human existence when we are not comprised of the looks of others. Smith, Foucault, and Lacan argue for selves constructed from engagement with others, encounters in which the other's gaze is incorporated into our identities. But in contrast to Sartre and Lacan, those looks are not limited to shame or deception or misunderstanding, but also include desire, love, sorrow, praise, and a host of other primary emotions that organize social life. Demonstrating how this is the case in a variety of different historical settings will occupy a number of the chapters to follow.

The Body in Question

In the modern world it is quite common to see pictures and assume that they convey a past event to viewers. In effect, the image takes the viewer's place as a missing witness—as if looking at an image, one sees what happened by virtue of a delay. The image is a relay, sending viewers what occurred when they were not there to see it. It is tempting to look at a picture depicting a historical event and think, "Hmm, so that's how it happened." And even if we do not believe it, we are tempted to do so, finding ourselves to believe in spite of knowing otherwise.

We are inclined to think that photography produces this credulity, that it teaches us to expect that an image offers the world itself. Roland Barthes pondered this in his marvelous little book, *Camera Lucida*, where he observed that it was "as if the Photograph always carries its referent in itself." What does that mean? Very simply, strangely, every photograph, he mused, is "the return of the dead."[1] Christianity haunts the pages of his book about photography. But it does not have to be that religion. André Bazin traced photography to the ancient Egyptian practice of mummification: photographs, and images generally, are powerful precisely because they preserve the dead.[2] Bazin's provocative essay urges us to look before the camera for the power of photographs and cinema. Any image is an image by virtue of its ability to enact something called *presence*, which Hans Belting has argued is occasioned by the body's absence.[3] Any image may act as a trace of its original, sharing with it some aspect of its being, even if only enough to *promise* the power of overcoming the absence. That is because what we are really talking about is the magical intermingling

of consciousness, the body, and the object of sensation. This interstice is where images happen, where the world takes shape and stands within, before, and after us. Rather than assuming the emptiness of the sign, the image as occasioned by death inaugurates a quest to find its missing origin. Martin Jay included Barthes' association of death and photography in the long list of French anti-ocularcentrism that he expertly scrutinized.[4] But this misses the longing generated by the snapshot of the missing mother, or the desire ignited by the photograph of the erotic nude. Images move us toward the body because body and image promise one another and therefore lend themselves as a bonded pair to the work of mourning.

Both Barthes and Bazin understand the presence of the photograph in terms of the body of the viewer. For Barthes, as I noted in the last chapter, the photograph punctured the body that gazes upon it, wounding it with the imprint of loss, which is a kind of presence—the presence of *was*. Bazin compared the photograph to the ancient Egyptian procedure of embalming corpses, which is itself a kind of image-making that is still widely practiced. "To preserve, artificially," he wrote, the deceased man's "bodily appearance is to snatch it from the flow of time, to stow it neatly away, so to speak, in the hold of life."[5] Bazin went on to suggest an entire history of images from mummies to painting to modern photography and film driven by this need to deal with loss. Painting is no more than vanity "if underneath our fond admiration for its works we do not discern man's primitive need to have the last word in the argument with death by means of the form that endures."[6] Images are about the bodies that are lost and the bodies that seek reconstruction.

Presence is a category that merits careful scrutiny in the study of images and the visual cultures they serve because embodiment is the domain of experience and feeling that fine art and aesthetics seek to discipline or control in the quest for beauty, refinement, and the judgment of taste. A brilliant project dedicated to investigating the submerged realm of response to images as more or other than art was David Freedberg's *The Power of Images*, in which he asked why art historians shied away from, even completely avoided certain kinds of images—magical images, obscenity, pornography, violent and terrifying images, images that perform miracles, simulacra such as wax replicas. In a word, he examined images that evoked responses that were ignored or repressed because "they are too embarrassing, too blatant, too rude, and too uncultured."[7] Since its establishment as the pictorial equivalent of the belles lettres in the tradition of royal academies of art in the seventeenth century,

painting as fine art was compelled to distinguish itself from its crude family relations. Most art historians ever since have been very happy to comply because they subscribe, wittingly or not, to Matthew Arnold's definition of culture as "a pursuit of our total perfection by means of getting to know, on all the matters which most concern us, the best which has been thought and said in the world."[8] Art historians and others today may no longer share Arnold's zeal for attaining "total perfection," but they are often deeply driven by admiration of the perfection of artistic achievement. Examine any art history textbook used in an introductory survey course and this will be evident. Such textbooks, the "coffee table" art book trade, the brisk commerce of museum gift shops, and many art exhibitions evince a passionate celebration of *great art.*

This book is no brief against fine art, but the interest in understanding the ancient and undiminished power of presence charts a larger scope for the study of images than the appreciation of fine art customarily entails. This broader domain of study is designated by the term *visual culture,* which denotes something larger than "art" defined as the best that humankind has ever produced. In addition to art, it includes the images traditionally overlooked and despised by art history, images that tell us so much about religious life. Yet visual culture is also more than images. It is the *cultural* function of visuality. Rather than this or that visual artifact, as many scholars are inclined to use the term, visual culture is a place people inhabit with others, a conceptual, aesthetic, sensory world that disposes them to think, feel, and see *communicatively.* Not in locked step, but with a view to imagining interactively. Visual culture refers to all the means of constructing life-worlds—attitudes, conceptual schemata, emotion, social dynamics, institutions. In addition to images, it is ways of seeing as well as the practices that deploy images. The study of visual culture is not just about pictures, but also powerful forms of embodiment, that is, the gendered, sexual, racial, ethnic, sensuous characteristics of perception and feeling that constitute primary forms of organizing human values. The study of visual culture seeks to understand how people put their worlds together by practices of seeing and how they keep them in working order.[9] At the heart of that enterprise lies the complex and layered relationship between seeing and the body.

This chapter is about the bodies in and before images and their coordination in the creation of presence. *Body* in this book always resounds in two registers—the body of flesh and the body of social fabric. In this chapter focus rests on the somatic body's relation to the image: the fleshly body that the image portrays and the body of the viewer standing before the image. In order

to get at this I will examine two groups of works by the Renaissance artist Albrecht Dürer: the first group is of religious prints that fashioned the flesh of Jesus for the visual engagement of devout viewers; the second group consists of illustrations of devices that Dürer believed could assist artists by properly orienting their bodies and eyes to what they wanted to portray. Both categories will help us understand what images are with respect to bodies—those they depict, those they address, and those that craft the images themselves.

BEHOLDING FLESH

A photograph is able to document the world in meticulous detail, as a flawless trace of the way things are, or were. So when I look at a woodcut of Jesus on the cross (fig. 5), surrounded by a starched swarm of angels, I am put in mind of a man who, the story goes, hung from a cross until he died, bleeding and nobly expiring in an event that must have had some drama. The look I undertake is propelled by a desire to see. But what? If I am Christian, I want to see the Jesus of my faith. If I am not Christian, I may want to see how this celebrated figure died. For both viewers, seeing is motivated by a force to see a certain event, though only topographically the same event. Yet for both, Jesus could not simply have perished. He had to die as heroes die—with effect. He had to die a death worthy of everything that happened *thereafter*. Paradoxically, the image is about what came after the event pictured in the image. The image is a shadow of what followed, not what actually occurred before what his death was later thought to mean.

Jesus is captive to his story, even or especially in dying. That is because there is no grasping him outside of the resilient fabric of his story. And his story happens in the retelling and visual restaging. What touches the pious viewer is the pinprick of loss. To see him is to be reminded that he is gone. But because he is gone, an image may stand in his place. It has been that way since the moment Jesus died. As soon as he was gone, he was accessible only by means of representation. Indeed, even before he left, "he" was part of a representation taking shape, preceding him as he traveled to preach. After his death, he became a new story. Storytelling, first verbal, later also visual, was the primary sense for apprehending him. The images that emerged over the course of many centuries were part of the archive of stories, or representations that maintained his presence among believers. Those images, like the stories about Jesus, are ways of encountering him. They are traces, likenesses.

FIGURE 5. After Albrecht Dürer, *The Crucifixion*, ca. 1509, woodcut. Photo: author.

Sometimes seeing is not really witnessing at all. It is seeing *with a purpose*. In such instances, seeing means looking for something. This kind of seeing is well described as *hunting* or *looking for* what matters through the lens of a story or an image or a community or an institution or a set of loyalties. When we think of seeing this way, it becomes clear that images themselves are a kind of device, a technology, part of a way of seeing, a means of establishing contact with what happened, or was supposed to have happened, or what tradition says happened. Even though we may want to think of images as the *result* of looking, they are the *means*; they are like a telescope that projects the seeing power of the human eye. The power of images, therefore, consists in their ability as extended forms of embodiment to provide the touch and hold of what they (re)present. That is why we feel so sure about what we see. We code it with the feelings that are important to us and we (be)hold what appears in the image as if it were a kind of footing or touchstone or way marker. This

holding is intensified in religious visuality because what believers see is what truly *matters* to them. It is important to note the double meaning in English of *matter* here: what matters is what is real and charged with purpose. For human sensation, *real* is what has purpose or significance for the perceiver. We easily ignore what does not matter. It has no point, no *punctum*. What is real is what gets our attention and holds it—by bothering, scaring, shaming, or seducing us. As Freedberg indicated, the connections between humans and their images are motivated by much more than reason, fine taste, or beauty.

An example of a complex and condensed event presented in an image is the large woodcut of Christ's Crucifixion (see fig. 5). Once thought to have been produced by Albrecht Dürer about 1500, the scene is more likely to have been based on a design by him.[10] Teeming with details, *The Crucifixion* displays dozens of discrete moments from the biblical accounts of the crucifixion of Jesus, and others ascribed to the event over the course of centuries of retelling and interpretation. How shall we understand the relation of these diverse sources informing the image? The New Testament makes no mention of angels flitting about the cross to gather a stream of blood gushing from the dead man, a feature peculiar to the late medieval, especially German, preoccupation with the blood of Jesus, collected for adoration and the wonders its contemplation could produce.[11] Nor is there mention of bones at the base of the cross, though the Gospel of John reports that *Golgotha* means "place of a skull" (John 19:17). Two elements of the picture operate allegorically: the sun and moon in the upper corners render the darkness mentioned in Luke 24:44–45, which may have been remembered as fulfilling a prophecy in the Hebrew Bible, what Christians call The Old Testament (Amos 8:9). But many of the features enumerated in the print are mentioned in some way in the Bible: the three Marys, the sister of Jesus's mother, and John were present at the cross. Although Joseph of Arimathea is not mentioned as having been present, he did take charge of the burial of Jesus (John 19:38) and so makes an appearance in the print on the left.

In the print's middle ground we see on a smaller scale the company of soldiers casting lots for the tunic of Jesus, which John linked to a prophetic verse in Psalm 22 (John 19:23–4), and a horseman carrying a lance, which was presumably used to pierce Jesus's side and cause the issue of blood collected by the angel. John cites the piercing and once again ties it to passages in the Hebrew Bible in order to present the details of Christ's death as fulfillment of ancient writ (John 19:33–37). Behind the central cross we glimpse a small

figure walking back to the city, carrying a pail and a staff. He must be the fellow who quenched Jesus's thirst with a sponge soaked in sour wine (John 19:29). Such minutiae encourage us to suspect that John even imagined Jesus himself actively completing scriptural prophecy in the finer details of his death: "knowing that all things were now accomplished, that the Scripture might be fulfilled, [Jesus] said, 'I thirst!'" (19:28). The scripture in question, according to exegetical tradition, is Psalm 22:15: "My tongue clings to my jaws." Such attention to detail on the edge of death is less likely than making the connection later, when memory gathers up and compresses into a single layer a matrix of points stretching from the Hebrew Bible to the life of Jesus to the author of the Gospel.

What *moment* do we see in the print that carefully musters so many details? Jesus's eyes appear to remain open as blood pours from his side, suggesting that he is not yet dead. Moreover, the "good" thief on his right also appears to be alive. Perhaps the print shows us the final moments of his life, before the instant conveyed in John 19:30, when Jesus utters, "It is finished," and expires. And yet that cannot be, for John indicates that in order to avoid violation of the Sabbath, Jewish authorities had asked the Roman authority, Pilate, to expedite the execution by having the legs of the convicts broken, hastening their demise by suffocation. Soldiers did so to the criminals on either side of Jesus, but when they came to Jesus they found him already dead, and contented themselves with a simpler means of confirmation—piercing his side with a spear (John 19:34). Either the print deviates from the biblical account, which it has taken care to observe very closely in other ways, or the two men are indeed dead, their eyes only appearing to be open, or, if they are open, they see nothing, exhibiting the blank gape of corpses. That would comport with the biblical account, and it would explain the moment of high pathos beneath, in which the group seems to respond collectively to the loss of their friend. And it would satisfy the viewer's desire to see an event, a single, uniform, consistent moment, one that actually happened. This would place the print on the road to the future, which is where we are, looking back, wanting to find something we recognize, something intrinsic to the medium of the image. That is certainly the desire pressing the modern visual sensibility that images record traces. There is something there, in them, caught up in their fixture of realities, their snapshot of truth, their statement: "Look at this—here *is* how it *was*." But the modern desire to see is not so terribly different than the late medieval desire. Perhaps moderns are so fond of the snapshot because it delivers what

premoderns wanted no less than their twenty-first-century counterparts: the moment when something gone happened because in that moment power and magic are made available. The mystery of images lies in the subtle slippage from *was* to *is*. But it takes a disposition for this to happen. Visual piety happens either as the credulity of faith—"I want to see Jesus"—or as the credulity of visual apprehension: "I want to see what happened."

Any form of representation is gloriously presumptuous and deeply engaged in contention about truth. What makes Dürer interesting is his manifest tendency to celebrate the capacity of images to make visible what happened. Consider his small depiction of the "Incredulity of St. Thomas" (fig. 6), from the *Small Passion*, a suite of thirty-six woodcuts issued in 1511. A heavy cloak thrown back over his shoulders, a muscular Jesus displays his flesh to the crowded assembly of disciples, among whom Jesus has suddenly appeared as the burst of his halo illuminates the small interior. In the fourth gospel, the only one to mention the event, Jesus had appeared earlier to his hiding followers, and Thomas had been absent. When told that the others had seen Jesus, Thomas responded skeptically, "Unless I see the mark of the nails in his hands, and put my finger in the mark of the nails and my hand in his side, I will not believe" (John 20:25). The remark reveals that, at least for Thomas, seeing and touching were dual features of a single operation of sensation. They were equal and corroborative. And believing was no more than a reasonable conclusion to sensory proof. The text continues with Christ's return and reproof of Thomas. Jesus came back a week later, once again entering the hiding place miraculously, appearing in the disciples' midst, behind locked doors. When he saw Thomas among them, Jesus immediately addressed him: "Put your finger here and see my hands. Reach out your hand and put it in my side. Do not doubt but believe" (John 20:27). When Thomas did as instructed, and affirmed Jesus's identity, only making good on his promise to do so, Jesus replied: "Have you believed because you have seen me? Blessed are those who have not seen me and yet have come to believe."

John's account assured its contemporary readers that seeing was touching, an assertion that was important to the author and community since some contemporaries doubted the bodily resurrection of Jesus, such as "the Jews," whom the fourth gospel forcefully vilified as opponents of the new religion and its (Jewish) founder. It was the fourth gospel that unprecedentedly made the affirmation of consuming Christ's body and blood a point of contention with his Jewish detractors and a breaking point between the leader's *true* followers and

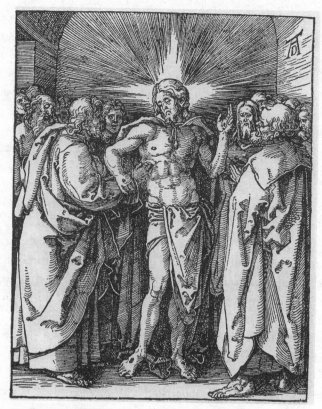

FIGURE 6. Albrecht Dürer, Incredulity of St. Thomas, from *Small Passion*, 1511, woodcut. Photo: author.

those disciples who fell away when he proclaimed the necessity of eating his flesh and drinking his blood (John 6:52–68). John's story about Thomas also underscored the superiority of those who believed from the distance of not seeing. And so his narrative has it both ways: Jesus really did rise in the flesh, but those who believe without seeing or touching him evince a stronger version of faith than the vulgar empiricists who insist on foundational sense-data. Clearly, there are two versions of belief at work, and the author of the Gospel of John prefers the one that replaces vision and touch with a new ideal of beholding. Written just after the end of the era of eye-witnesses, this gospel valorizes a new conception of belief even as it rigorously asserts the truth of the resurrected Jesus: he bodily rose from the dead, but belief without having seen him makes followers more faithful than those who actually did behold him.

Dürer, the artist with a livelihood and a talent to defend, and buoyed in a long tradition of Christian imagery keyed to the Passion, saw things otherwise. Look at his picture of Thomas and Jesus and try to argue it is only an illustration of the biblical text. In fact, look at the other images in his *Small Passion* and you will notice something remarkable: they are often about Jesus the trickster god, who is fond of fooling people who ought to have recognized him. Dürer has portrayed standard scenes, dictated by the genre as well as by the verses written by a Benedictine contemporary named Chelidonius, Latin texts that accompanied each image in his *Small Passion*. Yet he has treated the themes in his own way, as a skilled artist fascinated with the idea of visibility. On the way to Calvary we see Jesus's face appear mysteriously on the veil of Veronica. After Jesus dies on the cross, the next image shows him in hell rescuing Adam and Eve, John the Baptist, and other precursors. Meanwhile, his body is taken from the cross and he is interred. Easter morning he stands upright and effulgent beside the grave. In the following images he appears to his mother, then under the guise of the gardener to Mary Magdalene, then in a flash of light as he breaks bread with the disciples at Emmaus. And then, with halo ablaze, to Thomas.[12] All of these scenes turn on the pictorial magic of Jesus's bodily presence before and especially after his death, celebrating the power of images to speak directly to the desire of belief.

Dürer's portrayal of Christ appearing to his mother (fig. 7) is remarkable because he conceived it as an echo of Gabriel's annunciation earlier in the series: the resurrected figure, with triumphal staff and incandescent trinimbus, approaches his young mother and pauses to greet her with a gesture of benediction. She kneels before a lectern just as she does in the image of the Annunciation. In the New Testament Gospels Jesus first appeared at his grave, not to his mother. Accordingly, figure 7 is an image of something that did not happen. But the way of seeing crafted by Catholic tradition in the later Middle Ages posited the image as a faithful representation. Failing to mention his appearance before Mary must have been an oversight of the Gospel writers, or so later devotees of Our Lady thought. After all, another major theme in late medieval piety, the Pieta, in which the Virgin cradles her dead son's body, is also missing from the Gospels. Both instances are strong visual conveyances of Marian devotion. The absence of the filial appearance to Our Lady following the Resurrection noticeably bothered the thirteenth-century commentator Jacobus de Voragine, who strained to justify the omission as a willful decision of the gospel writers, who no doubt "judged it better not to write about this

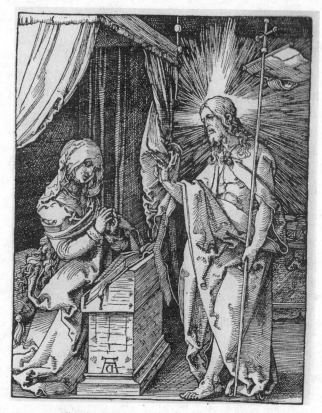

FIGURE 7. Albrecht Dürer, Resurrected Jesus appearing to his mother, from *Small Passion*, 1511. Photo: author.

apparition, and left it to be taken for granted. Christ must first of all have made his mother happy over his resurrection, since she certainly grieved over his death more than the others. He would not have neglected his mother while he hastened to console others."[13] Of course not, the very idea of the dutiful son precludes it. It was necessary to see what medieval believers felt to be true: Jesus honored Our Lady because *they* honored her. How could it be otherwise? Accordingly, Dürer and every artist who portrayed the subject before him corrected the omission, allowing the faithful to see what was not there, at least what was not there *in the Bible*. Dürer placed this image at the beginning of Jesus's post-Resurrection appearances, and in this followed the tradition of Passion cycles, including the cycle of verse by Chelidonius. As in so many early Renaissance depictions of the Annunciation, Dürer shows Mary at the instant

of moving her eyes from her prayerful reading to the guest: vision is caught in the very act of happening.

When he came to the image of Thomas (see fig. 6), Dürer was not about to disparage sight. To the contrary, inserting his fingers into the wound, his hand guided by Christ himself, Thomas *beholds* the truth. The body of Jesus is aglow and viewers are invited to gaze upon his flesh. In stark contrast to the disciples, who bear heavy cloaks and tunics, Jesus is clad in only a waistcloth. He has thrown back his cloak over his shoulders in order to reveal his bare body. This unveiling serves to reveal, and the revelation is ignited by the touch of Thomas and the guiding hand of Jesus. A long tradition of interpretation endorsed Dürer's treatment of the touching as affirmative rather than as a reproof. De Voragine transmits the tradition when he argues that allowing himself to be touched was one way that Jesus conveyed the truth of his bodily resurrection: "so it had to be his real body," he reasoned.[14] With his other hand Jesus extends blessing while displaying to Thomas (and us) the wound of the nail that the doubting man had insisted on seeing. The Gospel of John does not mention Jesus taking Thomas by the wrist to place the fingers in his wound. Why does Dürer show it? That was the iconographical tradition he inherited, but it also helped him focus on touching and seeing as revelation, a clear message of his *Small Passion*. Moreover, seeing and speaking are paralleled in Dürer's images. Each time Jesus appears, at his tomb and to his disciples, he holds up his hand in benediction. The Gospel of John relates that he said "peace be with you" on each occasion of appearing to Mary and the disciples. The hands in Dürer's prints speak in place of the gospel's dialogue. And so Jesus grasps Thomas's hand in lieu of his command in John 20:27, "put your finger here and see my hands."

Dürer champions the idea that seeing is tantamount to touching, and that both are a firm basis for believing. As if to punctuate the claim he followed the contemporary practice of portraying the Ascension of Jesus (fig. 8) by picturing only the feet of the ascending Jesus at the top of the print, rising in mid-air above the mound. Imprinted on the earth beneath him is further evidence of his earthly embodiment: his footprints, left there as tangible proof, a kind of photographic imprint or ontological trace of the now absent savior. We see his feet in the air and their tangible effect below, linking once again the sensory registers of touch and sight. Doing so left no doubt in minds of the devout regarding Jesus's bodily resurrection, and it adduced the image itself as a special medium of documentation. Dürer showed the miracle happening—the

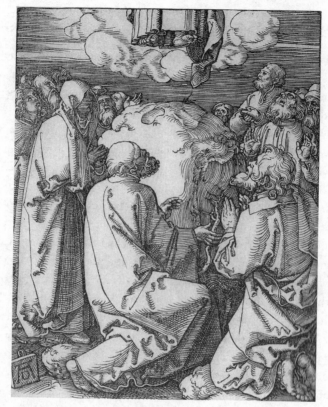

FIGURE 8. Albrecht Dürer, Ascension of Christ, from *Small Passion*, 1511. Photo: author.

process of Jesus's gradual invisibility. Gathered about the site are eyewitnesses: Mary, Peter, and John, adding further testimony.

A significant part of Dürer's cycle is dedicated to the visibility of Jesus. Most of the images capture a discrete moment, the instant of revelation or divine action. In every case, Dürer's images endorse seeing as the believer's access to Jesus. Accordingly, his image of Thomas refuses to issue Christ's rebuke, maintaining instead that touching is seeing is believing. This visual credo vindicates Thomas's empiricism in the interest of image-makers and believers whose visual piety contended that seeing with the longing to touch was itself a powerful form of belief. And the inclusion of a scene like the appearance of Jesus to Mary confirms that images document belief before they record the past, since the past is what it is because of the believer's subsequent need to grasp it.

THE BODY *IN EXTENSO*

In the *Small Passion* and *The Crucifixion* we see a late medieval piety of embodiment redeployed in the visual idiom of the Northern Renaissance: the enfleshment of the Son of God hailed in manifestly visual terms, occupying the world, expiring in it, resurrecting in it, ascending from it, and returning a final time in order to end it. The body of Jesus shares the world's matter, lives and moves within it, touches and is touched by others. In these images we encounter presence as a bridging of two worlds—the past and the present. *The Crucifixion* shows the ancient event in a latter-day landscape. And Jesus's appearance to his mother sews a latter-day belief into the narrative fabric of the New Testament. The images were true for Dürer's viewers for precisely the reason they seem naïve to us. But images, as I have said, are shadows of what comes *after*, far more than *before* them. The presence they trigger is the recognition in another guise of what one already knew.[15]

Another kind of imagery produced by Dürer seems different than the older conception of truth at work in his religious woodcuts. Compare the religious visuality or embodiment of the *Small Passion* imagery with a picture that the artist produced several years later, near the end of his life (fig. 9). In the text accompanying this image, Dürer referred to the device as a "method of copying an object."[16] A draughtsman sits before a largely undressed woman who is scrunched upon the table before him. Scanning her form, the artist aligns individual points on the surface of her body with coordinates on the intervening grid by means of the pointer before his eye. The resulting alignment creates coordinates in the lattice whose mesh of black thread corresponds to the squared paper before the artist. He then successively transfers points registered on the surface of the body in the grid to the paper, creating a matrix of dots that will comprise the transcribed image. The apparatus transforms her three-dimensional body into a configuration of dots as a system of two-dimensional information. In effect, the image is composed from a set of geometrical data taken from the model.[17]

Dürer's woodcuts discussed so far exhibit two conceptions of the image and the body, which need further attention in tandem. The religious pictures treat the physical body of Jesus and the space in which it performed the work of sacred flesh, the incarnate deity effecting salvation in the flesh and blood of divine sacrifice, seeking to make present what is absent. The Passion imagery was experienced as envisioning the relationship between pious viewers and the

FIGURE 9. Albrecht Dürer, Tracing device, 1525, from *Treatise on Measurements*, 1538. Photo: author.

body of Jesus. In the verse by Chelidonius that appeared with Dürer's woodcut of "Christ Crowned with Thorns" in the *Small Passion* we read a typical instance of the piety of empathy and contrition that characterized contemplations of the Passion among religious and lay alike during the late Middle Ages:

> Look you wretched man, you cause of so much pain.
> The holy body is opened all over with wounds.
> Christ, you have been made man so as to make us gods, and
> You have been chained so as to release us from our chains. God
> Tortured with floggings and thorns under an unjust judge,
> You teach us to bear our sorrows with calm resignation.[18]

Likewise, a homily of 1519 by Martin Luther, "Contemplation of the Passion of Christ," directed the attention of listeners to the ubiquitous imagery of the Passion and instructed them to regard the nails in his hands and the thorns in his head as something for which they were directly responsible.[19] Likeness in these images meant a direct mapping of the suffering of Christ's body over the penitent body of the viewer. This process of imaging was powered by an affective engine of shame.

The illustration of the man drawing a recumbent woman, a secular image that demonstrates a method of copying images, marks a fascinating step away from the late medieval conception of the body and the relationship of the image to the body of the viewer. Rather than viewing the image from the guilt of having caused the suffering of Jesus, viewers of images produced by the tracing machinery that Dürer illustrated would behold the familiar world of objects authoritatively rendered. Whereas Jesus was absent and is made present

to faith in the image, the model in figure 9 lies fully present before the artist and is replaced by the mechanically assisted means of pictorial transcription. Dürer promised his readers that they might "render anything within reach in correct perspective."[20] The transposition was authenticated by the apparatus, which operated by reproducing not only objects, but the artist's embodied relationship to them. In addition to translating the woman's body into a dematerialized code, the procedure transforms the draughtsman himself. Submitting to the structure of the apparatus, he becomes a mechanical eye and his body a medium of transcription. The pointer metamorphoses his eye, suppressing its action as glancing and scanning movements by focusing the eye in a precise linear projection. Like a laser, the device configures his vision as the emission of a single stream of sight, a contained ray that passes steadily through the grid and marks the surface of the woman. As a result, she comprises a cluster of loci that are translated to the paper. The pencil in the draughtsman's hand records the point before his eye. Seeing and touching are precisely analogous, even contiguous.

Distance is necessary for this operation. The testimony of the illustration is that to see means to see at a certain distance, one that will allow for the intervention of the device. The mechanical apparatus requires distance because it proposes that seeing is a process of abstraction that holds the two bodies, the woman's and the man's, in a methodically disciplined relation. The distillation of the infinite density of points that compose the surface of the woman to a discrete collection of nodes constitutes a form of remote touching. It is a mechanical contact, a mathematical conversion, a geometry that dematerializes the body by virtue of abstracting it. Seeing, as Dürer's illustration presents it, dissolves a body into a pattern of information, and then reassembles it on the page in the form of an image. As such, an image is a systematic operation that turns the eye of the artist into the component of a larger mechanism and a body into the methodically disciplined operation of the eye.

The practice shown in Dürer's illustration might seem at first glance a prototype of what Jonathan Crary described as modernity's "relentless abstraction of the visual," in which "functions of the human eye are being supplanted by practices in which visual images no longer have any reference to the position of an observer in a 'real', optically perceived world."[21] But that would be pushing the comparison too far. The apparatus in Dürer's illustration was not a form of mass-production that reduced the maker to a machine's attendant. To the contrary. The task remained the creation of art. The device was designed to

secure the privilege of the artist as image-maker. Dürer conveyed in letters his longing for a book that would establish the lost methods of the art of painting. Because the manuals authored in antiquity were lost, Dürer hoped to learn the "secret art of perspective" from living artists in Italy when he went there.[22]

Not learning everything he wanted during his visits, Dürer also looked to nature itself as the source, stating in his *Four Books on Human Proportion* that one could extract art from nature: "Once captured, it will save you from many errors in your work. And a great deal of your work can be given certainty by geometry. But whatever cannot be proven we must leave to public opinion and to society's judgment."[23] This suggests that Dürer's manual and diagrams were intended to secure the artist's social stature. It was, in effect, the artist he was crafting by compiling a digest of the artist's techniques. The operator of his tracing mechanism is what mattered to Dürer, for he repeatedly mentions that the artist using the device will use it "as you like," "according to one's wish," "so as to please you."[24] The result was not a factory manufacture, an item rendered in a serial issuing of identical pieces, but the judgment of the discerning artist. Stressing stark rupture and historical discontinuity, Crary distinguished the newness of early-nineteenth-century scientific thought and visual technologies from foregoing conceptions of vision. By contrast, Dürer remains part of the early modern age in which the old and the new were not severed from one another. The apparatus was meant for shaping the artist to the machine that made him different from nonartists by facilitating the reproduction of objects. The machine, as Dürer understood it, did not destroy the artist's will and desire, but enabled them.

Dürer's images did two different things: one demonstrated how artists might draw objects before them by engaging a device with their bodies, in effect, reembodying themselves for the sake of seeing more truly; the other offered images that were intended to engage the bodies of devout viewers in emotional reflection on the sacred flesh of Jesus and sank them viscerally into their own flesh as the medium of both their complicity in Christ's suffering and their own participation in his passion. Different as these are, they are not so very different in that they both addressed viewers with the concern to secure a *faithful* representation of an original. Figure 9 remembered the model's body that the artist's eyes had touched; Figures 5 to 8 sought to restore the body of Jesus that believers longed to touch. Sacred and secular do not admit of absolute differentiation. The "tracing" of the apparatus is no less concerned with transcribing reality as the Crucifixion image or the illustration

of Thomas. True, different orders of "reality" are clearly involved, but late medieval Christianity's concern to affirm the three-dimensional flesh of the resurrected Jesus and the Renaissance desire to provide artists with a mechanical means of reproducing objects for the sake of believable art or convincing images occupied the same cultural space and flourished in the single mind of an important artist.

Their similarity does not end there. Both reason and faith rely on deception. If *The Crucifixion* fudges on details, and the image of Jesus appearing to his mother presumes to correct its omission from the Bible, Dürer's studious draughtsman does some "correcting" of his own. That is because morality has a way of forcing rationality and scientific method to suit its demands. This is evident in a subtle, but telling feature of Dürer's recumbent model. In order to show the methodical procedure of visual abstraction, he actually distorts the image we see, breaking the very laws of perspective, measurement, and proportion that were his passion to explicate. It is an amusing irony that is apparent in the awkward appearance of the woman. She lies on a table abundantly present, though not as a person so much as a cumbersome, nude still life. Compressed to fit into the field of the draughtsman's vision, her legs are tucked uncomfortably beneath her. In fact, her feet vanish, as if into the table's very surface. For all the "truth" the illustration is meant to demonstrate, Dürer's draughtsman lies resolutely. Or shall we not say that Dürer himself deceives us? The artist has pulled the female figure out of the perspective system he used to render the table and the interior. Rather than drawing her in her proper place atop the table, in which case we would view her almost entirely from the side, Dürer has tipped her upward and forward in order to display the body in a nearly frontal aspect. She does not recede as she ought, which would mean conforming to the plane of the table and the orthogonals defined by the screen before her. Note the plentiful pillows, which do not lie flatly on the tabletop, but prop her up, making her breasts and left arm fully visible, though at the expense of lopping off her right foot at the ankle. Abstraction comes at the expense of the lady's body. As a result, she does not belong to the fictive world of the interior, but to the viewer's realm. She reclines uncomfortably on the cusp of two worlds.

Why the attempt at deception? Is it an awkward stab at sado-voyeurism, another example of grisly vivisection conducted by the "male gaze"? If so, cultural analysts inclined to that sort of interpretation should thank the artist for serving them up such an obvious instance of their theoretical obsession. But

there are other ways to account for Dürer's duplicity. If you examine a large number of Dürer's prints and paintings, and the even larger field of Renaissance art in Europe, it is not difficult to conclude that artists of that age were energetically engaged in producing a certain kind of visibility. They wanted to know how seeing was the product of a method. Objects were not drawn from templates or formulae, as they had been during the Middle Ages, but were the result of generative rules organizing visual fields. An object, in other words, was the expression of a system of transposition. The artist no longer memorized how to draw horses or boots or human heads, but rather practiced the technique of perspective to produce space as a set of relations among objects. The organizing principle was the vanishing point—the stationary, singular, radial point marked in Dürer's woodcut by the pointer. It is both the vanishing point organizing the picture's overall composition and the vantage point from which the draughtsman plots the model's position in space. That point is the intersection of the pictorial world we see and the world the draughtsman observes before him. For him, the pointer is absolute: he subordinates himself to it, letting this point define him in the varying position of his surveying eye. This point instrumentalizes his body so that he can transform hers into a constellation of points on the page before him.

So the question once again: why did Dürer place the figure out of kilter? Shouldn't he have wanted to insert her seamlessly, homogenously into the fabric of space he otherwise wove so nicely? After all, what could better corroborate the value of the method or technique that he advocates? Setting aside the unlikely prospect that he simply made a mistake, Dürer may have done so in order to show what we imagine the man is drawing. The artist cheats so that vision can appear to happen as it *ought* to. One might note the phallic point of the optical device that morphs the draughtsman's vision into a penetrating line of sight. This suggests a reason for the artist's deception. If he had drawn the woman "correctly," we would see something inappropriate. Not her intimate parts, which would be hidden from our view. Instead, we would be watching the draughtsman doing so, peering between the woman's legs like a sixteenth-century gynecologist. As it is, the woman's violation of the logic of the visual field preserves something of her *and his* virtue. The artist gazes on her knees and thighs, as viewers of the image do. Taken in this manner, the image does not show us what the artist would see, but what he ought to see given the tempering effect of propriety. As if to underscore the point of decorum in what is clearly an awkward image, Dürer covered the lady's genitals with drapery,

which she demurely appears to adjust as our stolid draughtsman goes about his scientific business. Because the measure of modesty would not have been necessary if she'd been consistently drawn according to the rules of perspective, the gesture only accents the absurdity of her situation. Yet the absurdity makes a subtle point: even method bows to modesty. Dürer may have wished to avoid the predicament of Sartre's protagonist caught in flagrante peeping through a keyhole. As it were, he sought to avoid the shame that drove the viewer of his image of the scourged Christ in the *Small Passion*. So Dürer's persona turned his model toward the viewer, proving thereby that he was not gazing inappropriately. He was a painter, not a peeper.

In both religious and nonreligious imagery, Dürer evinces the way in which seeing is shaped by conviction and social mores, but more importantly how seeing is an interface of the body and the world. Seeing is a form of touching or tracing, a beholding, and a collaboration of the entire body with its environment. Seeing is not, even in the case of the optical machination of reproducing appearances, a disembodiment. It is rather a reembodiment, an extension of sensation. We see with the body, with the embodied eye. Demonstrating how this occurs, especially in the visual culture of religion, is the aim of this study.

BODY, MIND, IMAGE

What do Dürer's woodcuts suggest about seeing? Arguably several things. First, that images cheat, willfully distorting for the sake of demonstration. Even the most mechanical procedure is not what it seems because seeing is fundamentally engaged in what one *ought* to see. That is because seeing is not merely biological, but constructed of multiple sources. The world as it appears to viewers arrives bearing a certain order consisting of moral, social, historical, artistic, and religious features that appear quite natural unless we discern the joints that betray the manufacture. Presence, as I pointed out, is a compelling sense of recognizing what one already knew—by virtue of faith or technique. Second, seeing is closely related to touching. Relying on faith or belief, seeing promises that touching will follow. Seeing is believable precisely because it is akin to touching. Finally, Dürer's imagery suggests that seeing is part of the body, even if it contrives all manner of devices for trying to convince us otherwise. The means by which we see is a process of embodiment, a formation of the body. We become the medium of vision, taking it into ourselves, identifying it with our bodies, projecting our senses outward through it. We do so

in order to stabilize sensation, to encode what we behold with the feeling of objectivity, and to encounter ourselves and one another in a form and rhetoric that organize the world around us into a meaningful social order.

But more directly, we might ask about the significance of Dürer's method of reproducing objects for the history of European visual culture. The tracing device he illustrates undertook a mechanical extension of the body engaged in the act of vision. The print marks the beginning of a long historical development in which the body becomes an instrument, or is subordinated to an instrument that extends vision from beyond the organic body. The visual piety that informed the images of the *Small Passion* understood thinking as inherently imagistic. The medium of thought was images. As Luther put it in an essay defending the use of images against the destructive marauding of the Bilderstürmers in 1525: "it is impossible for me to hear and bear in mind [the Passion of Christ] without forming mental images of it in my heart."[25] The *Small Passion* provided a visual lexicon of pious meditations, a mobile set of archetypal devotional images for installation in the heart and mind.

Comparison of the two conceptions of images informing the *Small Passion* and the illustration of the tracing device reveals a pivotal turn in visual culture. Both conceptions of imagery were about credible imitation, but they ultimately served different ideas of likeness. The late medieval ideal of *imitatio Christi* meant conforming the self to the example of Jesus. The images of the Passion were visual formulae of pathos designed to elicit an empathetic response. The tracing machine imitated appearances by converting three-dimensional objects into points of information or geometrical signs on a flat surface. Where the *Small Passion* imagery observed the iconographical tradition of an important genre of late medieval devotional piety, the tracing machine, by contrast, made seeing a method, something humans rationalized, controlled, and relied upon to introduce a critical distance between the self and the world-object that it contemplated. Dürer instructed his readers who used the device to "place the object to be drawn a good distance away" so that the grid might be stationed between the draughtsman and the object.[26] In this space Dürer sought to erect the sovereign realm of the artist. He located there the techniques or "secret art" of method. The object was translated into the special code of points, lines, and planes—signs from which appearances were constructed. Likeness was a geometrical effect.

Dürer's apparatus may anticipate at least one important aspect of the study of vision produced by Descartes a century later in his treatise, *The Dioptrics*

(1637). There Descartes set out to topple the imagist model of cognition by arguing for the discontinuity of external appearances and the operation of thought. Do not assume, he warned his readers, "as philosophers ordinarily do, that it is necessary for sensation that the soul should contemplate certain images transmitted by objects to the brain."[27] Descartes noted that isomorphism was not necessary, since even the most minimal features and "imperfect resemblance" can suggest a particular body: "engravings, which consist merely of a little ink spread over paper, represent to us forests, towns, men and even battles and tempests."[28] And he made his point in a telling way by reverting frequently to a blind man's use of two sticks to "see." Descartes considered the blind man's reliance only on sticks that sweep and tap to be irrefutable evidence against the ancient theory of the emanation of images from objects and their reception in the mind. The blind man's ability to see without seeing meant that vision needed to be understood in a nonvisual register. Cognition did not rely on images. "When our blind man touches bodies with his stick, they certainly transmit nothing to him; they merely set his stick in motion in different ways, according to their different qualities, and thus likewise set in motion the nerves of his hand, and the points of origin of these nerves in his brain; and this is what occasions the soul's perception of various qualities in the bodies, corresponding to the various sorts of disturbance that they produce in the brain."[29] The optic nerve registers movement, disturbance, agitation—not images. It is the sense of touch, Merleau-Ponty rightly observed, on which "the Cartesian concept of vision is modeled."[30] The blind man's sticks are a device comparable to Dürer's tracing apparatus inasmuch as each generates signs that constitute the means of representation, though one is cognitive and the other pictorial. Each point registered in the grid of Dürer's machine corresponds to one tap of the blind man's stick.

The difference that Descartes posited between the neural registration of sensory disturbances and the objects stimulating sensation corresponded to the difference between mind and body, his philosophy's all-important distinction. In his struggle to establish an enduring foundation for philosophical reasoning, Descartes detached the mind from the senses, marking a sharp distinction between the mind or soul, "pure substance" and therefore immortal, and the body, an aggregation of material things, and therefore perishable.[31] Dürer's apparatus, the argument proceeds, separates the ego from body by pulling the eyes out of the body and subordinating them to the apparatus of which they and the rest of the body are a part. And so Dürer and

Descartes belong to a new, early modern metaphysical ideology or "scopic regime," one that is resolutely dualist and constructed as a distant, disembodied gaze.

Dualism is useful for securing a certain notion of the human self, the deity, and a very mechanical account of the body as machine, as Descartes' work suggests. But dualism is weak when it comes to working out the precise interactions of mind (or soul) and body. But even in dualist constructions, the fact remains that human beings universally exhibit the practice of integrating tools and other devices into the repertoire of their bodies. Human beings embody almost anything. The body is not static, but incessantly appropriating the world about it in order to extend itself by architecture, costume, weapon, or other implement, by dreams, ecstasy, and apparition, by any manner of modifying sensation, by any means that will bring the world closer, transform it into an ideal version, imbue it with feeling, or secure or stabilize it for the sake of endowing human society with a greater purchase on survival. In the instance of Dürer's print, the use of the apparatus abstracts vision by mechanizing the body of the image-maker. By virtue of the interface between his eye and the apparatus, the draughtsman's body is extended and made part of a mechanism. This suggests that his alienation of ego and body, the *excorporation* of the eye, should be understood as part of the larger history of human embodiment. He participated in the historical development of a new way of touching and seeing. Beholding becomes a method of visual touching or registration. Dürer's illustration begins to reembody vision, even if the body in question is not purely organic. But then, it never is "purely" anything with humans. Tool makers by definition, human beings have used telescopes, spectacles, headware such as masks or brimmed hats, helmets with visors, cosmetics, theatrical lighting, gauze, smoke, darkness, stained glass, and any number of other devices to extend or otherwise modify vision. It is not an exaggeration to say that *homo faber* is the species characterized by its deft transformation of an organic body into inorganic mechanisms or techniques. *Homo faber* is never content with the body as such because the unfinished body is the very basis of human culture. Stretching, shrinking, trimming, bulking, thinning, painting, perfuming, scarring, impaling, dressing, and tattooing the body: these are only some of the things that human beings do to extend individual bodies into collective or social bodies, to make one body part of something larger to join it to a shared way of seeing. The power of the reembodied eye is seeing in an expanded regime of embodiment.

The human body is constantly reaching beyond itself, transforming objects into extensions of itself. Forever unfinished, the body experiences an organic relation with the ambient world in all forms of sensation. Merleau-Ponty conveyed this powerfully in his *Phenomenology of Perception*: "My body is the fabric into which all objects are woven, and it is, at least in relation to the perceived world, the general instrument of my 'comprehension.'"[32] He returned to this intimacy of objects and the body later in his book when he discussed the perception of things: "The thing is inseparable from a person perceiving it, and can never be actually *in itself* because its articulations are those of our very existence, and because it stands at the other end of our gaze or at the terminus of a sensory exploration which invests it with humanity. To this extent, every perception is a communication or a communion, the taking up or completion by us of some extraneous intention or, on the other hand, the completed expression outside ourselves of our perceptual powers and a coition, so to speak, of our body with things."[33] In contrast to Descartes' segregation of mind or soul as "thinking thing" from the body and senses, this book, in sympathy with Merleau-Ponty, argues that objects are part of the self, that we do not merely use them, that they complete us.[34] The sexual feature that some may denounce in Dürer's illustrated apparatus might alternatively be seen as the "coition" that Merleau-Ponty observed as the intimate fit between the human body and the world of things that constitutes perception. Rather than sexualizing perception, as nightmarishly visualized in Magritte's painting (see fig. 4), however, the challenge that Merleau-Ponty's work issues is to refuse to accept sensation as a passive presentation of the world in service to the remote cogito, the distant, disembodied, male eye/I. Instead, Merleau-Ponty wished to understand perception as a thorough cooperation or collaboration with the world.

In a later text, Merleau-Ponty argued that "we must rediscover the structure of the perceived world through a process similar to that of an archeologist."[35] Knowledge as abstraction, he contended, tends to bury what the body knows beneath the propositions of generalization. By digging beneath these, Merleau-Ponty believed that we would uncover the primary role of perception. Sensory qualities would no longer be taken as "indivisible 'givens', which are simply exhibited to a remote consciousness—a favorite idea of classical philosophy. We see too that colors . . . are themselves different modalities of or co-existence with the world. We also find that spatial forms or distances are not so much relations between points in objective space as they are relations between these points and a central perspective—our body."[36] This is especially

evident in Dürer's illustration of the tracing machine where we see that disembodying the eye is actually a reembodiment of it under the regime or discipline of a device and method.

Merleau-Ponty sharply criticized Descartes' *Dioptrics* as a dismantling of seeing qua image-making. He complained that in the Cartesian analysis of vision "icons lose their powers. As vividly as an etching 'represents' forests, towns, men, battles, storms, it does not resemble them. It is only a bit of ink put down here and there on the paper."[37] For Merleau-Ponty, seeing was about resemblance, not intervening signs of interpretation. And this urges us to see Dürer's apparatus once again as a device for producing resemblance. The signs or geometrical coordinates that convert the object for transposition are finally connected into a single image that magically emerges on the page, and so becomes a "trace." One imagines in the following complaint about Descartes that Merleau-Ponty might have seen in Dürer's device an interface between body and world that was the arch-operation of perception: "The magic of intentional species—the old idea of effective resemblance as suggested by mirrors and paintings—loses its final argument if [as Descartes would have it] the entire potency of a painting is that of a text to be read, a text totally free of promiscuity between the seeing and the seen."[38] How better to explain Dürer's imposition of distorting the woman and covering her genitals? Even as his illustration promoted the device for mechanically reproducing appearances, he reasserted the primacy of the image as a moral likeness, a seduction that preserves the virtue of the beloved. It turns out that we think in images after all. Mere technology would have committed an impropriety and showed the draughtsman to be a Sartrean voyeur.

We need objects as much as they need us, which is one powerful way in which human beings regard the world's intimate relation to themselves. There are, of course, others, such as a rational-instrumental mode, which sees the world as a range of specimens to be objectified within taxonomies of classification; the disciplinary gaze described by Michel Foucault; or the capitalist mode, which sees the world as actual or potential commodities for consumption. But even these are not sharply distinguished from material economies of the sacred. Marx's famous "commodity fetish" is a good example of the overlap between capitalism and belief or magic. And most versions of rationalism from Aristotle to modern natural theology or the hymnists of the Supreme Being overseeing the pageantry of the French Revolution do not hesitate to rely on a deity to provide for the origin and even the ongoing maintenance

of the universe. Dürer's print helps us recognize something important about human vision and sensation generally: it is not pure and it is always embodied, even in the process of reembodying that allows the eyes to see within the body of another person or group, or one's own body transformed by technique or device. The *embodied eye* means that seeing is never independent of touching, hearing, feeling, and the manipulation of the body and environment; and that the study of religious seeing is the study of embodiment. The magic of images turns on their promise to recover what was lost, or overlooked, and to cover what should not be left bare.

Ways of Seeing

The previous chapters showed that seeing is embodied, even when vision is idealized, abstracted, mechanized, or blinded. The many practices of disciplining vision temper it, indeed, appear to disembody it, but each act of training vision is a practice of structuring the body in which seeing happens. In this chapter I will argue that seeing tends to happen in routines, in what I call ways of seeing, by which I mean repeated procedures that organize elements of seeing into characteristic fields or gazes. This is not to suggest that vision is a mechanical procedure that ignores cultural or individual idiosyncrasies. In fact, it is the configuration of somatic and social bodies in ways of seeing that occupies my greatest interest. I want to suggest that we may study seeing as a variety of gazes that link the sight of one body to another. Individuals share ways of seeing, which are forms of sociality. To see, in other words, is to see for oneself, but also with others, and thereby to see with the eyes of a social body. Furthermore, I will argue that a way of seeing is the historical development of a visual routine that organizes a visual field, enacting within its structure the desire, fear, companionship or authority that shape visual experience. But rather than theorize this in abstracto, it is much easier to proceed from a concrete instance, which harbors within it a range of implications for the understanding of seeing.

THE DISCIPLINE OF SEEING

At a vendor's stall in a park in São Bernardo do Campo, Brazil, I came across a fascinating statuette of the head of Jesus (fig. 10). Perched amidst the vendor's

wares, the object presented itself at first sight as a bust. But as I approached it, I realized with some surprise that it was concave, as if it were a negative imprint molded from an original. Strangely, the flesh color and the soft coloration of the hair and beard reversed the form, transforming the shape into a positive. The eyes of the figure were also striking: rhinestones floating in light blue irises sparkled as I moved, drawing my attention to them and suggesting the feeling that the face was looking at me. At first I thought the object was for sale, so I picked it up. The vendor watched me closely. I asked him how much he would charge for it. His name was Antonio and he said the object was not for sale. As I carefully returned the head to its place, he asked me to notice that Jesus saw everything: from any angle he looked at me. To describe to me the kind of power the image possessed, Antonio motioned with his index finger shooting like a dart from his eyes. I moved my head from side to side and noted that he was right: the figure continued to gaze directly at me.

The technical term for the eyes is *omnivoyant*. Antonio would not sell the object because this all-seeing image of Jesus protected his wares from thieves, tirelessly vigilant, seeing anything that Antonio himself might miss. The power of the image, at least for Antonio, consisted of its ability to induce in potential thieves the consciousness of being watched, not just by the owner, but by someone of considerably greater moral authority. By bodily performing the manner of seeing in order to explain the object's power to me, Antonio demonstrated the assertive, projectile nature of the image's act of seeing. By facing any and all viewers at any possible angle, the image squared off with their bodies, casting them in a panoptical gaze, a look that did not allow them invisibility. They were watched as they stood over Antonio's goods and were thereby induced to restrain their ill intentions. At least, that was the desired effect. The power of the image consisted of compelling a visceral sense of intimidation or warning. It was not as strong as the existentially shameful sense of being caught while peeping through a keyhole, as Sartre described the assaulting look of the other. But the image meant business—for the potential thief as well as for Antonio.

The more I thought about the image, the more it revealed a marvelous visual history. Why was it fashioned in a concave manner? Very likely, this was a sculptural interpretation of the Veil of Veronica, an image traditionally understood to have been produced by Jesus himself when he pressed his face in a cloth handed to him as he made his arduous way to Calvary (fig. 11). The unusual concave aspect of the image, the portrait quality, and the steady gaze at

FIGURE 10. Omnivoyant bust of Jesus, São Paulo, Brazil, 2008. Photo: author.

the viewer strongly suggested to me that the statuette was a three-dimensional version of the Veronica, and one that captured very nicely the corporeal origin of the image, a face wiped from the very body of Jesus. The idea implies that the human face is the archetype of the image, and we might suggest the source of the power of images, that is, their ability to come to life as artists of the Veil of Veronica have been so fond of showing. I asked Antonio if he knew the story of Veronica. He replied that he did not.

According to medieval tradition, Jesus received the cloth from a woman named Veronica.[1] Veronicas are images that show the sacred xerography created by Jesus on the day of his death. The visual formula of a Veronica is the portrait image of Jesus gazing placidly and directly at the viewer. This kind of image first emerged in Eastern Christianity as early as the sixth century and became popular in the Latin West later, especially in the twelfth century and afterward. In 1453 Nicholas of Cusa published *The Vision of God*, a mystical, theological reflection occasioned by contemplating a painting of the Veronica by the important artist Rogier van der Weyden, possibly the Veronica reproduced here (see fig. 11). For Nicholas, the experience of being seen by Jesus was not entrapping or intimidating, but quite the opposite. He invited the observer

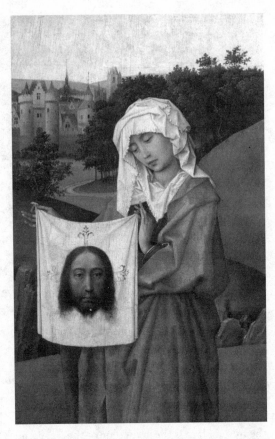

FIGURE 11. Rogier van der Weyden, *Saint Veronica*, detail from right wing of *Crucifixion Altar*, ca. 1440. Kunsthistorisches Museum, Vienna, Austria. Nimatallah / Art Resource, NY.

to note that the gaze trained on several monks gathered about the painting was a moving expression of the divine nature of love: see "how diligently it is concerned for each one, as if it were concerned for no one else, but only for him who experiences that he is seen by it."[2] Nicholas considered the gaze of the Veronica as an instance of God's regard for the human soul: "O Lord, Your seeing is loving; and just as Your gaze regards me so attentively that it never turns away from me, so neither does Your love. . . . You embrace me with a steadfast look."[3] The look was a loving embrace in this instance, and the threat of punishment in the case of Antonio's sentinel. He turned the benevolent tradition into a defensive gaze. This is quite clear from the text scrawled on the base of the figure by whoever sold the image to Antonio. What was originally a message of comfort became a message of warning, transformed by Antonio's use of the image: "meu olhar te acompanha" (my gaze goes with you). If the

image's producer intended a pastoral message of continual presence for devotees of Jesus, Antonio sharpened and redirected the meaning in order to dissuade thieves: there is no hiding or escaping from the eyes of the omnivoyant Lord.[4] The statement speaks what the eyes do, addressing the reader in the first person just as the eyes regard each viewer.

Already two ways of seeing are apparent: a *reciprocal* gaze, in which the image returns the gaze of the viewer (or vice versa); and a *unilateral* gaze, in which the direction of vision moves dominantly from one party (the image) to another (the viewer), in which case the viewer may feel something like Sartre caught in the act of peeping; or the viewer may resort to furtive glances against the current of the commanding glare. In addition to the gaze, there is the object or image to consider; the setting in which the image is presented; the viewer who encounters the image with a particular disposition; and other viewers, whose experience is shaped collectively by their relation to one another. And finally there is the archive, in this case the story and tradition and all other images of the Veronica that inform the participant's understanding of Jesus. The image instantiates all of this. The referent of all of this is "Jesus," the product of the gaze, the apprehension of faithful seeing. This referent is accessed in the networked configuration of a visual field and the archive of representations of him that enable the viewer to recognize an image as portraying Jesus. The referent is the motif that comes to life in the visual field, arriving in a gripping moment of enchantment to behold the viewer through the animated mask of the image.

To see is to enter into a long history of seeing, to submit to the discipline of visual structures that mediate the authority of a teacher, ruler, institution, or saint. The sacred, in this way of thinking, is constructed within particular configurations of image, viewers, archive, and setting. Each of these elements form varying networks of relations. The archive plays a special role in the recognition of the sacred by linking the viewer to tradition, which the image updates or brings to life. How does a viewer look at an image and recognize him as Jesus? The image is part of a concatenation of images, a long chain of visual references that eventually vanishes in the past. Visual traditions are sources that inform or condition what a viewer sees. An image of Jesus will likely be one that performs within a repertoire of images known to the viewer. The image that instantiates this archive within the immediate context of need and community will reveal itself with force to the viewer as the likeness of Jesus. Likeness depends on what a viewer wants Jesus to be like—his appearance

corresponds to his person and what the viewer seeks from him. An archive offers a large variety of Jesuses. Finding the suitable one means finding the Jesus who speaks to one's situation. Because the archive is often housed within old memories dating from childhood, hovering on the dim edge of consciousness, finding an image that vivifies them may come with a powerful grip of recognition.[5]

In order to understand the cultural construction of seeing, it is necessary to grasp its historicity. Human vision is both social and biological. Biology itself enables human sociality, but I mean that seeing is both learned and biologically inherited. What concerns me is the ways in which biological acts of seeing are deeply inflected by culture, how seeing is disciplined or trained over time to perform in certain ways. This happens in the way parents teach children, but this training is a medium for conveying and instilling practices and techniques shared with contemporaries as well as foregoing generations going back many centuries. A way of seeing can be historically understood as transmitting distinctive social relations worked out over time. In this sense, a gaze is a visual marshalling of force that enacts a characteristic set of social relations. Embedded in such visual routines or disciplines are power relations, or at least the traces of their historical articulation. Take, for example, the history of the Veil of Veronica.

The image of Jesus known as the Veil of Veronica is similar to many other stories of images not made by human beings. These stories emerged in the early Byzantine era and testify to the inextricably religious and political power of images. One of these stories dates to the sixth century C.E..[6] Sometime after 560 in Cappadocia, the story goes, a pagan woman named Hypatia found a portrait in a pond she recognized as Jesus. She converted to Christianity when the image transferred itself to her mantle. When the church in which the image had been placed was destroyed by barbarian raiders, the local authorities took the image in public procession to attract support and donations for the reconstruction of the church. By 574 the original image had been installed in the imperial collection of relics in Constantinople. There it continued to produce miraculous copies of itself, and it also healed the sick. Another, even earlier story of a similar nature relates that the pagan King Abgar of Edessa, suffering from an incurable disease, invited Jesus to come heal him. Jesus sent a disciple instead, on whose face the king saw a vision and was healed when the disciple laid hands on him, and then Abgar converted. Averil Cameron argues that the story developed a pictorial aspect in the late sixth century, when

Evagrius, the Orthodox writer, told the account of Edessa's escape from Persian aggression.[7] In that version, Jesus told Thomas to take to Abgar an image of himself made by pressing a cloth to his dampened face. The image resulted in Abgar's healing and conversion.[8]

That images of heavenly origin would be associated with victory over rivals is not surprising when we consider that this was a common practice in the ancient Greek world. Ewa Kuryluk, for example, points to the triumph of the Greeks over Troy issuing from the removal of the image of Athena, fallen from heaven, from the goddess's temple at Troy by Odysseus and Diomedes.[9] Scholars have noted that the story of the Mandylion, or cloth of Abgar, became popular in Byzantium during the Iconoclastic Controversy in the eighth century, when the authority of the "true" image of Jesus lent legitimacy to the cause of icon venerators.[10] In 944, the emperors Romanos and Constantine VII were able to secure the Mandylion from the Muslim ruler of Edessa and bring it to Constantinople, where it was victoriously received. The image was escorted "round the outside of the walls [of the city] as far as the Golden Gate, and then entered the city with high psalmody, hymns, and spiritual songs and boundless light from torches and, gathering together a process of the whole people, they completed their journey through the city center; they thought that because of this the city would receive holiness and greater strength and would thus be kept safe and remain impregnable forever."[11] The image healed the lame and performed other miracles. After stopping in the Hagia Sophia, where the image was laid on the throne of mercy, it was taken to the imperial palace, where it was placed on the throne and venerated by the court before being installed in the palace chapel, "for the glory of the faithful, for the protection of the emperor, and to ensure the safety of the whole state and the Christian community."[12]

Innocent III, Roman pontiff from 1198 to 1216 and inaugurator of the Fourth Crusade, wished to promote the Veronica motif over the older and distinctly Byzantine legend of Abgar's Mandylion.[13] The Latinization of Veronica would have served the preacher of the Crusade. Although the Fourth Crusade went woefully off-script by perpetrating violence against Constantinople, Innocent had certainly wanted to assert the priority of the Latin rite and the preeminence of the papacy, which the Byzantines had rejected. Asserting the honor of the Veronica as *the* true image clearly suited Latin interests. In 1216 Innocent issued a prayer addressed to the image of the Veronica and affixed an indulgence of ten days to the recitation of the prayer before the image.[14]

Innocent's campaign to cultivate honor for the Veronica, to use it as what one scholar has called "a public magnet" for attracting funds to support the hospital that Innocent had established, started a long history of special regard in the late Middle Ages and beyond.[15]

For Innocent and his contemporaries, the object was a relic, sheathed in precious metal and displayed on ritual occasions, indulgenced, and venerated as one of a kind. But over the course of the next century and more, the Veronica became an icon. During the fourteenth century, the Veronica was added to the *arma Christi*, the instruments used by Roman soldiers to torment Jesus. This was no doubt the consequence of regarding the Veronica as a blood relic, formed by the blood on Christ's face when he held the cloth to his face. But it was as an icon that the Veronica underwent reproduction without losing its sacred status. Relics were partible to very small parcels of matter without forfeiting the presence and efficacy of the sacred. The Veronica was not parceled out literally, but it did have a history of reproducing itself on several occasions.[16] What allowed it to be reproduced almost ad infinitum as print and painting in the late Middle Ages was the iconic gaze of Christ, which, as Nicholas of Cusa's discussion of it shows, was capable of conveying the being or presence of the image's prototype. The Veronica maintained the aura of its source precisely because the act of Jesus looking at the viewer was copied. The relic was not the cloth that touched his face, but the image of his looking. And this was a unique mode of visuality in the West. There had long been sacred images that performed miracles. But the Veronica introduced a new sensibility in Latin Christendom, as evidenced by Cusa's remarks: the visual piety of seeing and being seen as a way of entering the presence of God.[17]

The Veronica appeared commonly in concert with images of other relics and the *arma Christi* in portrayals of the Mass of St. Gregory, such as the late-fifteenth-century engraving by Israel van Meckenem (fig. 12), where we see an astonished Gregory saying Mass in the midst of attendants and a large company of onlookers. The scene portrays the very instant of Gregory's consciousness of the miracle of the appearance of Christ in the sarcophagus on the altar. He and his attendants appear to gesture in surprise while the crowds to either side of them remain fixed on the three figures before the altar. The image of Gregory's Mass has been seen by some as late medieval affirmation of transubstantiation: the ritual metamorphosis of the bread and wine of the Eucharist into the body and blood of the sacrificially crucified Jesus. The axial alignment of the Veronica far above, the Cross, the body of Jesus, and the Communion

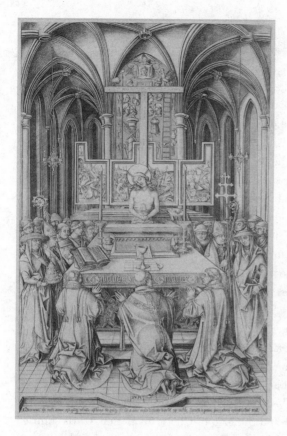

FIGURE 12. Israel van Meckenem, *The Mass of Saint Gregory*, ca. 1490–1500. Engraving, 46.8 × 29.5 cm. 441LR. Photo: Madeleine Coursaget, Louvre, Paris, France. Courtesy Réunion des Musées Nationaux / Art Resource, NY.

chalice seems to suggest as much. And it is noteworthy that no host appears—the empty plate for the host is only half visible beneath the cloth on which the chalice stands, suggesting that Jesus himself is the bread of the Eucharistic meal.[18] Yet stressing the origins and ritualistic nature of the elements of the Eucharist is one thing; arguing pictorially for the metaphysics of transubstantiation is another. The doctrine of transubstantiation, as Caroline Bynum has pointed out, though established by the Fourth Lateran Council in 1215, was not officially defined until the Council of Trent, in response to the Protestant Reformation's heterodox interpretation of the Eucharist.[19] There was no prevailing need to defend the doctrine in so widespread a fashion before then. Bynum directs our attention to the fact that what the viewer of the image "always sees is the possibility of seeing."[20] Others within the scene, sometimes Gregory and usually most if not all of those attending him, do not see the miracle of the Man of Sorrows appearing before them. But the viewer does.

What then is the image's purpose? We might see in it a visual engagement of contemporary viewers, a concern to show them the grandeur of clerical authority, to teach them something about seeing as the recognition of power. The sumptuous detail of Gregory's liturgical dress and the pageantry of those with him (two Cardinals flanking the altar hold the pope's tiara and cross; behind them stand two bishops), the solemn liturgical moment, the precious codex and finely appointed altar all underscore that this rite of penance and forgiveness was conducted by the clerical office. The fact that many depictions of the Mass of St. Gregory were indulgenced confirms the suspicion that beholding the scene was keyed to penance. The church's exercise of the Office of the Keys was clearly a reason to focus the viewer's attention on the ceremonial action of the priesthood. The presence of priests in such regalia recalls the words of the Fourth Lateran Council, convened by Innocent III, in establishing transubstantiation as dogma: "surely no one can accomplish this sacrament except a priest who has been rightly ordained according to the keys of the Church which Jesus Christ Himself conceded to the Apostles and to their successors."[21] Joseph Koerner has aptly suggested that "images of the Mass of St. Gregory celebrated clerical agency."[22] Indeed, the way in which the clergy are shown urges us to concur that the scene foregrounds the ritual efficacy of the priest, who is typically shown bearing the crucified figure on his richly embroidered cope. In the version reproduced here, Gregory's round tonsure echoes the chalice above it and the halo of Christ further up. Christ himself responds to the authority of the priest's words of consecration, an obedient revivification, which the sober demeanor of the Veronica above affirms by calmly gazing beyond the scene, into the world of the viewer. The risen Jesus validates the priest's office with a somber look that is transmitted to the group crowded about the altar. Nearest Gregory are prelates and churchmen of various rank, including the offices of the ecclesial hierarchy invested with the authority to perform the Mass. In this setting and in its high placement, the Veronica becomes a crown or visual seal of ecclesial authority.

The motif of the Mass of St. Gregory was another late medieval concoction (neither the Veronica nor the instruments of the Passion had any role in the older traditions of St. Gregory's vision), part of the cult of relics, especially those associated with the blood of Christ, which enjoyed great popularity in Netherlandish and German territories in the thirteenth and fourteenth centuries.[23] Yet the tendency to worship the blood of Jesus and associate the Veronica with its cultic display led some to redirect the interpretation of the iconic

image of Christ. This is where Nicholas of Cusa enters the narrative with his limpid interpretation of the gaze of Christ as a living presence. As Bynum has put it, "Not concerned with the fate of particular particles or relics, Cusa's argument that neither Christ's blood nor his humanity was ever separated from divinity is at heart a worried concern to keep Christ ontologically whole."[24] The presence of Christ was not registered in relics of blood, but in the penetrating and omnivoyant gaze that addresses each viewer with poignant regard.

Our abbreviated account ends abruptly in 1527, when Lutheran imperial soldiers from Germany occupied the city of Rome and hauled out the Veronica for auction in a tavern, a rowdy indignity that conveyed Protestant disregard for the papacy and its propaganda poster of Jesus. It was an ignoble end for an image that represented a long history of mediating divine power for use in human affairs.

In such condensed form the histories of the Mandylion and the Veronica bear a characteristic pattern of mediating the interests of power at crucial junctures. The "true image," the image "not made by hand" (acheiropoieton), the countenance of Jesus is turned to face a threat to those in power. Whether the image was pressed to use for its capacity to defend, heal, aggrandize, or vindicate, it was an instrument that exerted influence. But the face of Jesus did so because it was also an independent agency. When the Veronica in Rome, venerated by Innocent III, was about to be returned to its resting place after use in procession in 1216, "it turned round of its own accord, so that it stood on its head with the forehead below and the beard at the top." The pope, we learn in a chronicle dating from the same century, "was shocked, taking it as a bad omen and on the brothers' advice wanted to make amends to God. He therefore composed an elegant prayer in honor of the image," and assigned an indulgence to the image, the first of its kind.[25] Other accounts from the thirteenth century relate fear of direct viewing of certain Veronicas either because the image "caused mortal fear in the onlooker" or because a pope who "once dared to look at it . . . lost his sight at that very instant."[26] As a consequence of this danger, Veronicas were sometimes covered. The history of the authorization of the image and its deployment as an object of power, evident in its use by pope, prelate, emperor, or regime, is a history of seeing, a construction of vision as a ritualization of power that unfolded in tandem with the visual engagement of the devout with the Veronica motif.

In his critique of Clifford Geertz's distinction of religion from aesthetics and politics as possessing an essential character of its own evident in

representations or symbols that ultimately correspond to singular, irreducible ideas or mental conceptions of reality, Talal Asad urged scholars of religion to scrutinize religious practices and utterances by considering that "their possibility and their authoritative status are to be explained as products of historically distinctive disciplines and forces."[27] Religious practices and artifacts, in other words, are formed on the anvil of the history of power. Images are not the brain-born offspring of pure aesthetic sensibilities. The history of the Veronica makes that clear. Instead, we need to discern in the social life of images the creation of ways of seeing that draw from and articulate power relations; the lure of images as living agencies; the needs or desires of the devout; the structuring of class, race, and gender; the interests of institutions; and the practices of teaching and disciplining the body to engage images as moral, spiritual, or magical technologies.

The power of images relies in part on the way in which these forces are engaged in the appearance of the image. For example, the facial expression of Jesus in many instances of the Veronica before the Baroque era is notably passive. He does not cry out dramatically or wince in pain or weep from the abuse he was suffering en route to his execution. He is not without pathos, but he appears to avoid emotional extremes. But this is not an unambiguous look, for it has been read differently over time. On some occasions Jesus is regarded as the innocent victim of Jewish conspiracy or pagan brutality. In a letter that purports to be addressed to the Roman emperor Tiberius, the converted Abgar urges him to punish Jews for their treatment of Jesus.[28] Later medieval accounts kept this element alive, reporting in one instance that an image of the Lord's face in the Lateran palace in Rome was "so badly damaged by a Jew . . . that blood flowed from the wound and covered the right side."[29] On other occasions, the passive Jesus of the Passion is viewed as suffering misery caused by sinful Christian viewers in the meditative rigors of a recriminating visual piety (see chapter 2).

The appearance of Jesus in the Veronica and in other images in the Passion were often taken to spark outrage or indignation on the one hand, or shame on the other. The look a viewer encountered by gazing at the image of Jesus structured a visual field that was forged by fears and desires embedded in a history of practices that was reinforced by interests and power relations. Even though Antonio told me that he'd never heard of Veronica, the visual practice of deploying the gaze of this image of Jesus remained at work on his table of wares in Brazil. The power of this gaze to protect the vendor's merchandise was the long product of a history of a healing, protecting, vindicating icon.

Seeing the Veronica is an interface with this history, an entrance into a system of visual relations that modulates power.

The sacred commodification of indulgences in the case of the Veronica alone suggests that images and their viewing are part of a cultural economy of the sacred and may be studied as a range of gazes or visual fields. In the next chapter I will take up the issue of economies of the sacred, but in what follows here, I would like to sketch eight such gazes. I must do so without the benefit of a robust historical account of how each gaze is formed over time, but I hope that the foregoing remarks make clear that my aim is *not* to posit a universal taxonomy, but rather to outline tools for a historically grounded understanding of the social career of seeing. A fuller treatment of the historicity of each gaze that I will delineate must wait for another occasion.

GAZES

My claim so far has been that seeing an image happens as the particular relation of several components: a viewer, other viewers, an image or object, a setting in which viewers and an image engage one another, and an archive of images or symbols referring to a person, force, deity, or spirit that is made accessible within or through the image. I use the term *gaze* as a synonym for a visual field or way of seeing. A gaze is not timeless or universal. Yet seeing is a universal human phenomenon in the barest biological sense. Human beings gaze steadfastly into a friend's eye, avert their eyes from the gaze of a superior, ignore the visual plea of an inferior, block the vision of a malignant stare, scan a large gathering in order to see with and what others are seeing. These behaviors and many others can be found at work in the most divergent instances across time, but we do not know what they mean until we carefully scrutinize the context and history of each act. Seeing, in other words, is a combination of biology and culture. Any attempt to make it exclusively one or the other of these is bound to failure. Yet because I consider a gaze to be a way of seeing that is indebted to and operates within the specific history of a culture, nearly all of the examples that I examine are drawn from one (broad and varied) religious culture, the Christian tradition, which is the tradition in which I may claim scholarly expertise.

A few more preliminary remarks may be helpful. By *gaze* I mean something less encompassing and fixed than "scopic regime," which Martin Jay has perceptively discussed.[30] Nor do I have in mind the widely discussed notion

of gaze as an *enduring* visual engagement, something that is the opposite of the glimpse or glance.[31] Nor do I mean the monolithic "male gaze" as it has been extensively discussed in film theory and feminist criticism.[32] As a way of see-ing, a gaze is a practice, conscious or unconscious, which structures social rela-tions, self-concept, and experience of the sacred. And there are not one or two gazes, but many available to viewers in any given culture. Yet however many different visual fields there may be in different societies over the course of human history (perhaps dozens), a smaller number is primary, and might be found at work across cultural boundaries, informed by very different histories. The typology I present is not intended to ignore differences, only to show that the study of visual fields can be pursued in very different religious traditions.

It is the social reticulation or network of features composing a gaze in which I am especially interested. I want to know how seeing makes bodies visible, but also how seeing may be said to reembody viewers by giving them group eyes and accompanying shared ways of feeling, and by bringing them into compelling relations with others, mortal and divine. Ways of seeing are visual situations in which viewers assume a position within a set of relations. I am defining a body not as a static, self-contained reality, but as relational, that is, as defined by the configuration of forces, interests, applications, history, and assumptions that operate within and through it. By taking up a way of see-ing, a viewer adopts a particular constellation of factors. A way of seeing is a pattern or framework in which viewers assume a connection to other bodies within a matrix of possibilities. By participating in a way of seeing, a viewer enters a community of viewers and sees from the perspective of a collective body, a social body characterized by shared feelings or sentiments. As a result, the registers of visibility shift and what was once invisible looms into view.

Every image is experienced as an interactive part of this relational scheme, whether it beckons our attention, challenges our gaze, invites us into another world, or moves us to turn our eyes away. Sacred images mediate the sacred and viewers, embodying access to it in acts off imploring, touching, kissing, hearing, reviling, and fearing—all propelled by the deeply felt assumption that the transcendent other will respond accordingly. As I have tried to understand it, an image is not an essence, but an activity, a historically evolving process that emerges as a configuration of forces, predispositions, and practices. Seeing is a proactive gesture, a way of fixing the transient, a means of looking for what one wants or needs. But as I have already noted, seeing is also submission to exist-ing forms of seeing. Sometimes what we think we want is being prescribed for

us—propaganda and advertising are obvious examples, but devotional images can be a more subtle form of persuasion and inducement. Seeing should be examined, therefore, as both a matter of agency and as a medium of power.

The approach I am taking is not image- or object-centered, but practice-centered. The point is neither to divine metaphysically nor to specify formally what an image is, but to describe what it *does* at any one moment, or what is done by means of it. That enables the interpretation of visual culture as a constructivist enterprise: the study of a visual field as a social network of interactions that structures acts of seeing. Depending on how the components are organized, a number of fundamental gazes or visual fields can be identified. A particular gaze, therefore, is a relatively discrete pattern or way of seeing that is historically and socially constructed. As such, a gaze should constitute a primary object of analysis for the scholar of visual culture.

I want to stress that a gaze is more than an image. This becomes manifest in the way an image interacts with viewers, serving to position them within a world, that is, configuring their relation to a past, a present, or a future; toward other human beings; and toward such intangibles as nation, state, civilization, or deity. A gaze is a form of sociality, prompting a disposition toward groups and institutions as well as presenting others as objective realities meeting one's look. A gaze seeks to inform human relations and therefore disposes (but does not rigidly determine) viewers to behave in a certain manner, enhancing certain possibilities and diminishing or eclipsing others. Rather than a rigid template, a gaze is a recognizable pattern that operates until some aspect within or beyond its structure changes and a different visual field emerges. Gazes last seconds or minutes or indefinitely, depending on the needs they serve and the material setting in which they operate. A gaze may be as ephemeral as lifting a stereoscope to one's eye to glimpse a three-dimensional tourist attraction or as enduring as Jeremy Bentham's penitentiary panopticon, in which the arrangement of prisoners' cells about a guard tower solidify power relations into a single, life-long action of domination and submission.

Visibility may be said to be the product of a gaze. We tend to see, in other words, what our participation in a visual field enables us to see. That may be a deity or an angel or a spirit, but the sacred is more than such supernatural entities. The sacred may be a regard for a mythical past, a national destiny, a compelling narrative, a social order, a people, a totemic founder or hero, a place, or a ritual enactment. A way of seeing opens up the possibility of seeing what nonparticipants will miss or fail to recognize. Belief is a disposition to

see, hear, feel, or intuit a felt-order to the world. As a form of intuition, believing finds in the world a tendency or need to exist in a certain way. Sacred ways of seeing inform and enable this intuition.[33] And the intuition is always more than a mystical quiver deep inside one. It finds itself in the broader social and natural landscapes of human experience, in power, in sickness, in desire, and in narratives that enfold the self into the social bodies of family, tribe, language, myth, and such modern collective bodies as race, civilization, and nation. Envisioning or imagining are fundamental aspects of seeing. To see something is more than laying one's eyes on it. To see is to sense, intuit, and collectively imagine what lies within or beyond an image.

A MORPHOLOGY OF VISUAL FIELDS

I have argued that a gaze is any visual field that configures viewers; an artifact; a place or setting; and an archive of images, objects, or symbols in order to mediate the viewer's relation to a referent, that is, a transcendent force, person, time or place. The particular arrangement of these elements bears the impress of a history of relations among authorities, institutions, peoples, and places. That history presses upon present circumstances as a discipline of seeing in the form of a visual field. People learn to see in specific ways that allow them to see with others, and thereby share membership in a social body. While *gaze* is commonly defined as the apprehension of others from the subjectivity of an eye, by focusing on the entire visual field I define a gaze as a visual structuring of relations that organizes power as a situation in which people find themselves in relation to one another, a social body, and a sacred referent. I outline eight different gazes here, but my point is not to deduce any particular number.[34] These are simply the varieties that I have repeatedly encountered. There are no doubt more to be described, and any gaze will certainly vary from one culture and historical epoch to another.

The *unilateral gaze* constructs vision as operating in one direction, enforcing a singular set of relations on seer and seen such that the seer wields power asymmetrically and the seen, insofar as it is seen, occupies a subaltern, submissive position. In the unilateral gaze, to be seen is to be powerless, subject to the manipulative, overwhelming, objectifying gaze of authority. This gaze, gloomily described by Jean-Paul Sartre, is perhaps most clearly exemplified by the searching glare of the Eye of Sauron perched ominously atop the Tower of Barad-dûr in Tolkien's *Lord of the Rings*.[35]

The unilateral gaze is also evident in Foucault's discussion of panopticism. Although Foucault insisted in the instance of the panopticon that "visibility is a trap," it is important to note that not all examples of the unilateral gaze are malevolent, even though constant inspection or surveillance remains the operative purpose of the unilateral gaze.[36] We have already seen two examples of the duality of the unilateral gaze: the all-seeing eye of Jesus—as an apotropaic device protecting the vendor's wares (see fig. 10); and the symbol of the all-seeing eye of God on the verso of the Great Seal of the United States (see fig. 2)—in which the eye proclaims the favorable age of American democracy, the providential approval of the new nation. But if the unilateral gaze blesses some, it harms others. Jesus threatens thieves while protecting the vendor; and the eye of God blesses the social body called "America" while it cursed those who found themselves on the wrong side of "manifest destiny"—Native Americans, Mexicans, slaves. In every case, the *unilateral* gaze orders vision as running in the single direction from seer to viewer (or viewed) such that inspection remains ever in force. It is important to register both viewer *and* viewed as the terminus of the unilateral gaze since the visual current emanating from the dollar bill intends the *viewer* to bask in its munificence whereas the eye of Sauron intends to reduce the person *viewed* to enslavement. In other words, the unilateral gaze may empower the viewer with agency or brutally take it away.

An efficacious answer to the malevolent type of unilateral gaze is another visual field, a countervailing configuration that seeks to protect one from becoming the object of the evil eye's power by restructuring the gaze to render one invisible to the evil eye. This may be called the *occlusive gaze*. It is evident in the use of amulets to ward off evil or attract good fortune. The *hamsa* (fig. 13), the stylized figure of a hand inscribed with Hebrew text (or Arabic, in the case of Muslim versions), is displayed on one's person, in the home, or hanging from the mirror of one's car to make one invisible to the evil eye, whose piercing gaze is best eluded by concealing the owner behind the hand of the hamsa. To be seen by the evil eye is to be touched by it, to come under its control. With the occlusive gaze, however, the vision of the evil eye is touched—by the hand of the hamsa that blocks it. The act of being seen is so daunting, the prospect of being locked in the overpowering grip of the eye so unsettling, that an amulet like the hamsa substitutes its blank screen for the one who wears it, rendering its owner invisible to evil. Figure 1 is another example: the dunce-boy, gripped by the concerted gaze of his classmates and

teacher, covers his eyes in order to block their piercing, shaming judgment of him.

Where the occlusive gaze hides the viewer, the *aversive gaze* of the viewer hides the divine, preserving its otherness by veiling it in invisibility. Recall the aversion of George Washington to looking "full in the face" anyone of higher social station. Teresa of Avila compared the way "we cast down our eyes" when approaching God to the manner in which a poor person presents himself before an emperor.[37] One also thinks of religions that stress the necessity of divine transcendence. Seeing the divinity is a form of idolatry, a reduction of divine majesty and sovereignty, according to Reformed theologian John Calvin. Images, he insisted, are able to teach nothing about God because they substitute a human conception for divine reality.[38]

But aversion is not blindness; it is literally a form of circumspection—a looking *around* rather than looking *at*. Calvin neither proscribed art nor the value of seeing as a form of religious praise. Rather than wishing to see God,

believers, Calvin urged, should gaze upon the divine handiwork of the natural creation, to see there not God, but God's glory. God "was arrayed in visible attire when, in the creation of the world, he displayed those glorious banners, on which, to whatever side we turn, we behold his perfections visibly portrayed."[39] In contrast to devotional images, nature allows us knowledge of the true divinity, not a human misrepresentation of one. In effect, fixing on the majesty of nature averted the believer's gaze from the presumption of seeing God to an acceptable act of visual piety, a way of seeing that acknowledged divine transcendence and rendered the reverence God was due by recognizing in nature the evidence of his power and sovereignty.

The reciprocal gaze is the opposite of the unilateral gaze inasmuch as it structures a two-way iconic colloquy between viewers—human and divine. Many images invite our attention, urging us to return the look in a steady gesture of attention. One thinks immediately of Cusa's account of the Veronica (see fig. 11), or, beyond the Christian world, of *darśan* in Hindu visual piety where the exchange of looks constitutes an act of worship. Devotees of Marian apparitions often describe Our Lady's icon engaging them in a moving visual exchange. Such images look toward viewers, seeking out their gaze in order to enter into a sacred relation. In terms that easily apply to other portraits of Our Lady (fig. 14), Mélanie Calvat described the gaze of Mary at La Salette in 1846: "When my eyes met those of the Mother of God . . . I felt inside me a happy revolution of love and a declaration that I love Her and am melting with love. As we looked at each other, our eyes spoke to each other in their fashion, and I loved her so much I could have kissed Her in the middle of Her eyes, which touched my soul and seemed to draw it towards them and make it melt into Hers."[40] The intense relationship seems to forget everything around it, letting it slip blissfully into the oblivion of invisibility.

Religious seeing commonly involves a visual relation that does not engage the viewer in a reciprocal exchange, but absorbs one nevertheless in a kind of ocular adoration. This *devotional gaze* is evident in rapt absorption of devotees before the cult image, which they regard with a way of seeing that can recall the longing of the lover for the beloved. The asymmetry of this gaze is not the same as the unilateral since viewers willingly submit themselves rather than being externally compelled. Devotion may structure the current of seeing in precisely the opposite direction than the unilateral gaze: vision runs from the viewer to the divine rather than vice versa. This allows worshipers to submit themselves to acts of self-forgetting or intense absorption that enhances prayer,

FIGURE 14. José Thedim,
*International Pilgrim Statue
of Our Lady of Fatima*, 1947,
polychrome mahogany,
ca. 40 inches high, detail.
Photo: author.

suggestion, contemplation, and imagination. The devotional gaze cultivates a
proper obeisance to the ancestor, saint or guru, who may repay devotion with
blessings.[41] The result is a kind of self-transcendence that can be very empow-
ering, allowing the devotee to slip the bonds of pain, guilt, fear, or oppression.
Although it trains vision intently and unilaterally upon the object of devotion,
the devotional gaze does not invert the unilateral gaze, but organizes vision to
carry viewers away from themselves into a self-effacing relation of devotion to
the sacred. This may mean closing one's eyes, or plunging into the darkened
interior of the ritual space of a bedroom or shrine. In either case, it means leav-
ing vision behind, literally not-seeing, as in the case of the praying female figure
shown in a Protestant tract illustration from early-nineteenth-century Amer-
ica (fig. 15): she bows her head in nocturnal shadows and closes her eyes, joining
her hands in submission on top of a large Bible. Having spent a devotional time
reading and contemplating Holy Writ, she is now absorbed in nonvisual, but
fully embodied, address to God. The devotional gaze is a bodily engagement in
which the devotee adopts a posture of address to the saint, ancestor, or deity.

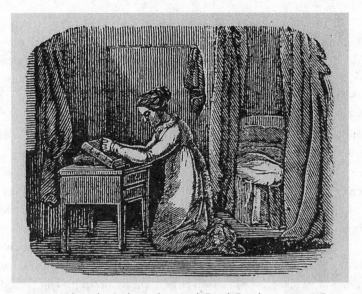

FIGURE 15. Alexander Anderson (engraver), Dinah Doudney at prayer. From Rev. John Griffin, *Early Piety; or The History of Miss Dinah Doudney, Portsea, England* (New York: American Tract Society, 1825). Photo: author.

This transition from a way of seeing to not-seeing is important to note because the study of visual culture does well not to fix on seeing alone, but to discern its vital and organic relation to other forms of sensation. For instance, figures 14 and 15 suggest that seeing glides quite readily into a way of feeling. Seeing is only part of human experience and often serves as a transitional behavior to other, nonvisual forms of sensation, serving thereby to heighten feeling or hearing or touch. Meditation is a good example. It may begin by fixing the gaze on an object. The ensuing absorption may lead to states of consciousness in which seeing ceases after having rendered a key instrumental service. Seeing, in other words, takes place within a larger ecology of sensation and religious practice. (A comparable gaze appears to engage visitors at art museums, where they are invited to gaze disinterestedly at works of art, before which they forget themselves as they marvel at surfaces, contours, and forms, at bodies and heroes. Prohibited from touching the object and constrained to admire it within the bounds of civil decorum, with hushed consideration of its self-contained completeness, mounted on a pedestal and lit for maximum visibility, shorn of original context, location, and use, the viewer is compelled to regard the object as if it were made for such ahistorical, rarified contemplation.)

Where the devotional gaze involves the viewer quieting, forgetting or even transcending himself, the *virtual gaze* entails projecting oneself into a persona in order to interact with other personae in an artificial space. This performance occurs in two different ways—as role-playing and as a projection into an avatar. The first is most common in children's games such as playing house, cops and robbers, war, or princess. In each case, children collectively perform roles in routine, but unscripted, improvisational play. Fantasy is a practice common to adults as well as children and engages a similar form of role-playing, one in which people picture a version of themselves in scenarios that may have little or nothing to do with their ordinary lives.[42] The second form of virtuality consists of play that substitutes virtual selves or avatars such as dolls, puppets, toy soldiers, model trains, or race cars for those who operate them. Players identify with the persona of a toy figure and engage in improvisational play with other avatar-operators. Second Life, the virtual online world, is another instance of this genre of virtuality, one in which large numbers of people engage in different online religious communities.[43] The virtual gaze is configured by rules of performance, which players accept as boundaries that condition their interaction. Not a look, but rather a field of visual engagements, the virtual gaze consists of creating a space in which an alter ego can be fashioned and enacted.

The example of children playing suggests that virtuality is not limited to the digital realm of pixilated screens. Civil War reenactments or Christian Passion Plays are adult examples of virtuality in which the self portrays another in re-creating a past event. Other examples drawn from religious practice are grottoes, often built to smaller scale to welcome visitors into winding passages and chambers that engulf them in an almost surreal, hand-crafted space. The Nativity crèches constructed each Christmas season over which family members dote are familiar miniature worlds that may invite not only contemplation, but a kind of vicarious occupation. Tibetan Buddhist mandalas reconstruct elaborate interior spaces occupied by deities and imaginatively inhabited in meditative practice. In every instance, the practitioner executes a concentrated ritual of imaginative construction in which the self is introduced into a fictional space where a role is enacted in accordance with a different set of rules and often with other avatars.

Virtual projection enables vicarious participation. The annual reenactment of the Passion of Jesus by Latinos during Holy Week is a familiar sight in the United States (fig. 16). On the occasion pictured here, a group of Roman soldiers prepare Jesus to take up the cross and begin the harrowing march to

FIGURE 16. Via Dolorosa, Holy Week Passion reenactment, Valparaiso, Indiana, Holy Week, 2008. Photo: author.

Calvary. Onlookers solemnly watch the silent scene. Local Latinos perform the ritual procession across the small town of Valparaiso, Indiana, led by a police car. The actors and those following them cross the main street, halting traffic as the company sings and the soldiers whip Jesus, who stops at each Station of the Cross. The virtual gaze allows one to view oneself through an imaginative act of self-alienation, either by dressing up and role-playing or by peering into another world—a miniature realm of another time or culture and to envision there a way of being different from the ordinary regime of one's daily life.

Sometimes visual construction of the sacred does not mean fixing on the divine, but literally seeing the social body of belief in the community. This experience takes shape in a visual field of its own, one I call the *communal gaze*, which is fitted to the architectural articulation of the sacred. The image of a large worship space in Seoul, Yoido Full Gospel Church (fig. 17), the likes of which could be found across Asia, North America, and Africa nowadays, conveys the sort of experience that many have: seating in the round allows communicants to see one another worshipping. The large electronic image on

FIGURE 17. Yoido Full Gospel Church, Seoul, Korea, July 2002. Courtesy of Stewart Hoover.

the screen above the stage, fed by cameras that are tirelessly scanning the audience in order to broadcast their engagement, enhances the collective vision of the social body of belief. This mode of seeing means experiencing the sacred as a collective consciousness, enhancing the contagious effervescence that Durkheim found so crucial to the social power of ritual. Among Christians, it facilitates a sense of the community of faithful gathered together to feel, hear, and see themselves as something more than individuals, as the body of Christ, they might say. I have used a Christian example to describe the communal gaze, but there is no reason to limit this visual field to Christianity. It happens in festivals and processions and communal rituals in African religions, Hinduism, political rallies, civil ceremonies, and any number of other non–Christian examples.

Finally, in what I call the *liminal gaze*, images establish limits or thresholds that act to circumscribe a people, a nation, or even a civilization. The liminal gaze marks the end of one's world and the beginning of another, constructing a view of the other as beyond the pale of one's own ways. The other world may represent chaos, barbarism, the wild, or some other abiding menace to one's own realm of order. Images of racial, ethnic, sexual, or religious differences

often serve to limn imagined thresholds. An example of this visual operation is captured by a famous photograph entitled "The Vanishing Race," by Edward Curtis (fig. 18), showing a line of mounted Navajo filing into a dusty distance. The scene was photographed and has been regarded in elegiac regard for the fate of Native Americans in the Anglo struggle for land. As a result, this photograph has been viewed within a gaze that regards the Indians as moving inexorably away from the viewer, who is construed by the liminal visual field as the survivor, belonging to the social body that remains as the Navajo (and traditional Native American culture generally) vanish from the scene of American history. Whether lamented or celebrated, whether viewed as tragedy or triumph, it was a trope that captured the American white imaginary in the course of the nineteenth century. The Indians had to vanish in order to make room for the ascendant white nation. This photograph envisioned or limned the advancing edge of white progress and the receding boundary of the Indians, lost to the present, resignedly disappearing into the past, buried in time, indeed, to the ideology of manifest destiny, burying themselves by calmly departing into oblivion.[44] The photograph portrays their disappearance as something to which they acquiesced. The liminal gaze structures a relation between viewers as dominant and what is viewed as inferior or subject to a different fate. In the liminal gaze the viewer achieves invisibility while the subject becomes spectacularly and transiently obvious. The viewer, however he may mourn the situation of the other, occupies a different destiny because the gaze places him in the social body that escapes oblivion.

The liminal gaze casts its subject as a type, representative of another social body. In the case of propaganda, the subject is reinvented as a stereotype. Propaganda relies on spectacle to establish the boundary that sharply separates the credible, respectable, or decent from the other. Fundamentalist Christian tracts such as those by Jack Chick construct a liminal gaze of everyone whom its narrow Christian view excludes from salvation: homosexuals, humanists, liberal Christians, Jews, Muslims, Catholics, Wiccans, and all Asian religions. The only option allowed them is conversion. Otherwise, they are consigned to or portrayed as residing in hell, the ultimate liminal zone in a Fundamentalist worldview.[45] Generally speaking, the liminal gaze marks the edge of *us* and the beginning of *them*, delineating those being seen and those doing the seeing. The Danish cartoons of Muhammad are a contemporary instance of this; Orientalist portrayals of Arabs and Jews are an older example. Films and television programming are awash with images of cults, witches, and demon-crazed

FIGURE 18. Edward S. Curtis, *The Vanishing Race*, 1904, photogravure. Courtesy of the Library of Congress.

witch doctors.[46] Frenzied, snake-handling rural Protestants are common examples of a group that is sensationally portrayed in order to underscore their liminal status, setting them off from the social body to which gaping viewers belong. The list is as long as the human need to "other" whoever is regarded as alien.

THE SHUFFLE OF SEEING AND NOT-SEEING

Objects operate in tandem with gazes as visual media for the sacred to take place. For example, the icon works effectively within the reciprocal gaze; the amulet in the unilateral and occlusive gaze; images and reliquaries in the devotional gaze. Masks may activate the unilateral gaze. Changing the object may change the gaze: if one replaces an amulet with a work of art, the result may be a change from the occlusive gaze to the devotional gaze of the museum visitor. Likewise, changing the gaze may transform the object: by shifting from the reciprocal to the unilateral gaze, a viewer changes the all-seeing Jesus from an icon into an amulet. A mask contemplated on the wall of a museum will

be seen within the aestheticized disinterest of a devotional gaze, where it is admired for its artistic properties not feared for its magical power. Placed over the face of a ritual performer, the mask may become animated within a virtual gaze or transformed into the penetrating glare of the unilateral gaze.

It is also important to regard the visual fields in relation to one another. The gazes I have sketched operate as rivals, antidotes, and alternatives. The unilateral and the reciprocal gazes, for example, organize vision in diametrically opposite ways. The unilateral structures vision as an arc in which one party is dominant while the reciprocal gaze consists of a mutual engagement. But if reciprocity is not an option, the occlusive or the aversive gaze may operate as antidotes to the tyranny of the unilateral gaze. The communal and the liminal gazes are likewise complementary: whereas the liminal gaze demarcates the boundary of the familiar and the domain of the alien or other, the communal and virtual gazes visually define the common or shared character of a group and organize their interactions with one another. The devotional gaze is able to evacuate personal consciousness by inducing absorption in the object of contemplation. The aversive gaze preserves the invisibility of a divine power by seeing instead its manifestations or figurations as adjacent signs of its power. In each case, the term describes the connection between the viewer and a referent, which is crafted by the object or visual medium, the occasion on which it is regarded, presence of viewers to one another, and their expectations of the referent and the occasion.

Viewers deftly slip into and out of the apparatus of a gaze. If one way of seeing does not make visually accessible what one seeks, an alterative may be preferred. Gazes deliver their goods according to what I have elsewhere called various "covenants" that viewers negotiate with images.[47] These consist of expectations of what an image can provide and how viewers should interpret them accordingly. Consider the quick succession of visual schemes as one pages through an illustrated magazine or watches the evening news on television. One image I engage reciprocally because a beautiful model gazes directly into my eyes, appearing to invite my response. The promised intimacy vanishes with the next image, say, the grisly scene of a terrorist bombing, which causes me to avert my gaze by quickly turning the page or changing the channel. When I do, I may be relieved to witness a proud moment of my nation's troops marching into the devastated neighborhood in search of the insurgents who detonated the bomb that killed innocent civilians. I am urged to regard the military as defining the sharp difference between the civilized "us" and the

barbaric "them." When the military apprehends a terrorist, the newspaper or television news program displays his photograph for my careful inspection, which I am invited to indulge by gazing upon his face, the face of a fanatic madman who deserves my contempt. In a matter of seconds, my conscious-ness has fluidly taken the shape of four very different visual fields—the recip-rocal, occlusive, liminal, and unilateral—each of which structures my relation to what I see, *and don't see*. The ways of seeing are often organized to create a succession of visual fields that composes a narrative—a familiar story about the goodness of beauty, the evil of the hideous enemy, the righteousness of my nation, the visibility of justice. In this manner we imagine our place in the world and are challenged by counter-images and counter-gazes to feel the shortcomings of what we imagine.

The visual fields outlined here are ways of seeing, or put another way, forms of making visibility. At the same time, they are also ways of rendering some-thing else invisible. Liminal vision, for example, allows viewers to see only what it considers worthy of seeing, in effect rendering progressively invisible whatever is desired to be expelled from the boundaries of one's consciousness or world. Whereas the aversive gaze secures the invisibility of the other—its prestige, status, mystery or divinity—the occlusive gaze preserves the invis-ibility of the viewer menaced by a greater power.

The power of images is sometimes their ability at dissemblance, which is a way of seeing and not-seeing. Not-seeing may even be treated as a visual practice that produces invisibility. One might easily enumerate different ways of not-seeing that make this clear. For example, *ignoring*, or deliberately not-seeing; or *missing*, which is an unconscious act of not-seeing. Another is *mor-phing*, where we refuse to see one thing by turning it into another. Thus, those who wanted to see a cross at Ground Zero refused to see a chaotic mass of detritus (see fig. 50). Yet another way of not-seeing is *omitting* or *excluding*. Visibility and invisibility are made to complement one another, as in Albrecht Dürer's visualization of the Ascension of Jesus (see fig. 8): the artist cropped the ascending figure, leaving only his feet visible. By not-seeing most of Jesus, the viewer is invited to imagine the unseen. Finally, *destroying* images renders them invisible, which suggests that iconoclasm is part of a larger visual strat-egy of removing one image in order to put another in its place.[48]

These remarks on not-seeing suggest that visibility consists of varying ra-tios of seen and unseen. One of the primary ways in which any gaze works is by concealing or minimizing one element in order to highlight another. In

other words, we ignore some things in order to dwell on others. There is an economy to vision, which means that attention is focused on one object at the expense of another. So by meeting the loving gaze of Our Lady in a reciprocal embrace, devotees pay less attention to rival looks. By fixing their attention on Native Americans passing into the invisible distance of extinction, other Americans need not share the present with them as the reciprocal or communal gaze would entail. The liminal gaze precludes any other way of seeing. By investing attention in the interactive presence of other worshipers, the communal gaze discourages the isolation of worshipers in private absorption. And the use of the protective hamsa renders the owner invisible to the evil eye in the unilateral gaze. If visibility is not simply a natural event, but a cultural one, the same must be said of invisibility.

Icon and Interface

Religions commonly organize access to the transcendent in the form of relationships between humans and nonhuman powers. The two parties participate in forms of exchange that turn on such gestures as gift, praise, petition, vow, and reply. Both parties bring to the engagement a respective set of expectations and resources that enable a negotiation of relations.[1] Human interactions with spirits, ancestors, gods, and other forces unfolds in and around things. Things such as images often mediate relations. In this chapter I would like to consider first a general account of how these mediations operate within systems of exchange, or sacred economies. Then I will turn to the specific case of iconicity as one prevalent and powerful way in which images mediate relations and exchange in religion and beyond it, as will be evident in the secular career of the icon in modern society.

OUTLINES OF SACRED ECONOMY

Practices of negotiation with transcendent powers may be regarded as an economic behavior. In fact, religious forms of exchange not only resemble formal systems of economic value, but frequently operate in tandem with or even as economic relations. This is clearly the case in the gift economies classically described by Marcel Mauss.[2] Or take, for example, pilgrims at a shrine or oracle who offer some manner of payment to a priest or official for their services. The resulting wealth can be considerable, filling the coffers of the temple, its priesthood, and attracting merchants who set up stalls along the way to the

temple. Municipal authorities may become involved by managing the crowds and taxing the income or otherwise profiting from it.[3]

Yet reducing religion to economics is not helpful, because it renders the sacred epiphenomenal and therefore occludes from view what it is, I believe, religion does that economics may never do: transcendentally anchor a moral or sacred economy as a management of social relations devoted to a good that surpasses death. The sacred economy is premised on a beyond, an order of being that lies beyond death, an endless domain that is the source of wealth or spiritual capital that exceeds human finitude. Acquisition and expenditure of that capital are the business of a sacred economy. Any such economy will be driven by an existential human indebtedness to a source that inhabits the far side of mortality. This may be gods, ancestors, or impersonal mechanisms governing rebirth. In every case, the sources of power transcend human control, but they do cooperate in prescribed forms of entreaty. The claim of any religion is that human life is beholden or indebted to these powers in what I am calling a sacred economy. This debt of existence cannot be redeemed by mere human effort; it is something that no finite source of wealth may equal or any earthly power may fully control. This asymmetry is what buoys a sacred economy. Human assignation of value meets its limit in death. Exchange with the transcendent bridges that divide and serves to integrate relations among people with relations to the transcendent. Both sacred and secular economies rely on systems of credibility, that is, on belief or trust, but they invoke different authorities to bolster the terms of exchange.

Access to spiritual powers is secured through various negotiations designed to establish a predictable, reliable relation. The medium of the exchange takes many forms—barter, gift, pledge, money, debt/credit, and symbolic reparation.[4] These forms of exchange and many others are found in every religion. For example, shamanisms of different kinds operate through exchange between clients and spiritual adepts, whose services are purchased in the form of barter. In Buddhism and Hinduism karma operates as an account of merit and demerit that rises and falls with a person's actions. Release from this debt occurs only when it is canceled, at which point rebirth ceases.[5] Of more immediate relevance, the increase in karmic merit "purchases" better rebirth (Buddhism) or reincarnation (Hinduism). Ancient Judaism understood temple sacrifices as the ritual negotiation of relations between the Israelite and Yahweh. In the Gospel of Matthew Jesus taught his disciples to pray: "forgive us our debts, as we also have forgiven our debtors" (6:12). According to Jesus, human relations

are intertwined with relations between human and divine.[6] Something of the same view prevails in Islam. In the Qur'an the outlines of a moral economy are evident when Allah tells the Prophet that "Those who receive God's scripture, keep up the prayer, give secretly and openly from what We have provided for them, may hope for a trade that will never decline: He will repay them in full, and give them extra from His bounty" (35:27–30) and "What you have runs out but what God has endures, and We shall certainly reward those who remain steadfast according to the best of their actions. To whomever, male or female, does good deeds and has faith, We shall give a good life and reward them according to the best of their actions" (16:95–97). In early Christianity, the key role of relics emerged as the specie of the cult of the saints, replacing older forms of patronage with a new system of devotion to the martyr-saint as patron.[7] Later, relics formed a kind of international economy of the sacred when they were sought after by abbots, bishops, popes, dukes, and princes, throughout Christendom.[8] In later medieval Roman Catholicism, the church dispensed spiritual capital from a heavenly treasury accrued by Christ's redemptive acts and the actions of Mary and the saints. The church issued drafts on this account in the form of indulgences to pilgrims, who received time off from the rigors of purgatory by performing acts of piety in the form of making pilgrimage to churches and shrines and praying before indulgenced images like the Veil of Veronica or the Mass of St. Gregory (see fig. 12). The Protestant Reformation railed against the practice, and the notion of the heavenly treasury tied to the purse strings of the papacy. Protestants placed in its stead a new spiritual economy of the free gift of grace.[9] Though "free" in the sense that sinners did not earn it, upon accepting the redemptive offer of forgiveness, they were expected to behave in suitable fashion. Some modern-day Evangelicals, advocates of what is generally called the "prosperity gospel," maintain that God enriches those he favors. In a statement by a group of Protestant theologians (who are acutely critical of the development), prosperity gospel is defined as "the teaching that believers have a right to the blessings of health and wealth and that they can obtain these blessings through positive confessions of faith and the 'sowing of seeds' through the faithful payments of tithes and offerings."[10]

In every case, as widely different as they are in history and cultural circumstances, not to mention conceptions of the holy, the source of the sacred relation always eludes complete investment in any exchange, always remains transcendent. Even in the case of karma, a system completely impersonal and mechanical in operation, one cannot change it. The transcendent nature of the

economic system is irreducible to the terms of any transaction, though indeed it may bind itself to a set of contractual terms. In the case of Christianity, Judaism, and Islam, the divine condescends to the human in order to enrich it or to demand something from it, and to maintain relations between itself and its human counterparts. Asymmetry is evident throughout the range of the visual practices of exchange. There are many to describe as well as different material forms in which the exchange occurs. I would like to frame consideration of the icon by comparing it to two other common mediums of religious exchange: the token and the amulet. Each of these three devices operates differently as a visual medium, articulating social relations and conveying power in the process. Their differences from one another aside, they all fail to embody fully and lastingly what they point toward, and that is precisely what makes them promote a sacred economy. If each were what Jesus once called a "pearl of great value" (Matthew 13:46), which one acquires by selling all he possesses in order to attain salvation, thus paying human debt in full, the need for a system of exchange would abruptly end.

In the case of the token, the image, act or object offered as a sign of devotion is plainly never equal to the service rendered. The libation of oil or wine is far less in real value than the rain, harvest, children, health or prosperity that is requested. The token marks a turn or a pledge, an event in the narrative of one's life or the life of a community. The token is a sign of respect, evidence of bearing in mind the status of the spirit or ancestor. Small things can work wonders. The token performs as a public testimony of recognition or remembrance. Gods or ancestors who are forgotten may take umbrage and thwart a mortal's enterprise. Or if offered afterwards, the token remembers the assistance and praises the patron. The ex-voto retablo is a good example. People beseech the Virgin's help and make a vow or pledge. When she delivers them, they make good on the promise by placing an image *ex-voto,* or out of thanks, in the public setting of a church dedicated to Our Lady. The retablo is how the devout remember and acknowledge the favors of the Virgin, issuing from their pledge to recognize her power to assist them.[11] A token, then, occludes, shapes, or highlights memories that the owner of the token wants to remember. In this regard, we might say that the token constructs any number of visual fields—occlusive, aversive, or devotional—depending on what story the owner wishes to tell. If I select a small reproduction of the Statue of Liberty to commemorate my visit to New York City, that is one way to forget the bad traffic, expensive food, or cheap hotel that otherwise plagued the trip. Aspects

of the past are made accessible in the token and are told as a story whose point the narrator considers important. Thus, the votive retablo records the story of deliverance in text and image. This token serves to recognize the Virgin's willingness to assist the devotee. The image is what the devotee offers back to the Virgin as a sign of gratitude. The pilgrim, to cite another example, offers the pain, inconvenience, and pious effort of the long trek as the coin of devotion, receiving in turn the indulgence, healing, or some other spiritual favor in response, memorialized by the souvenirs that pilgrims commonly buy or receive.

The amulet consists of a portion of a powerful original artifact and therefore maintains an ontological connection that is the avenue of their power. Amulets operate as objects, not in the first instance as representations. In this respect the amulet is different than the token, which does not stand in the place of the original, which is not present in the token, but is remembered by it, accessed by the story that occasioned the token. The token materializes a story, its referent, without which its capacity to signify is nullified. The amulet, by contrast, includes some aspect of the original in itself, as a synecdoche, part for whole, drawing power from it and applying it physically to a threat such as the evil eye or the curse of a rival. Yet for this to occur, some manner of hosting the sacred is necessary. Without the device of a narrative or text to anchor the relic housed within the amulet, the devout will fail to recognize the sacred presence. The bone fragment of a martyr, for example, falls into an oblivion of insignification without the story of its origin, the image of its reliquary or the presentation of its enshrinement to anchor its identity and to direct the pilgrim toward its veneration. With the proper signage and recognition, the sacred must be recognized by the special intervention of a dream or miracle, alerting a devotee to the location and identity of a relic. Once they know to see an object as a relic, the faithful honor it and enjoy a relationship with the martyr. One regards an amulet within an occlusive visual field if the object is to shun the evil eye, or in a devotional gaze if the object depicts a saint who is protective. But in order for this power to be made available, the object must be scripted, inscribed with identity. The history of the cult of the saints in Christianity, for example, is replete with accounts of discovery that redeploy bones in narratives that empower them, enabling devotees to engage the objects within visual fields that make them useful. The saint has lain forgotten in an unmarked grave, but making his presence known through a miracle, is rediscovered, and translated to a new shrine that guarantees his recognition—at least until circumstances change and memory fails once again.[12]

ICONICITY: THE POWER OF INTERFACE

I am using the term *icon* to designate a large category of images that is informed by but not limited to the sacred images of the Orthodox Christian tradition. Orthodox icons can be narrative, depict scenes involving many figures, can be monumental or very small. For my purposes, however, *icon* pertains to the portrait image of a sacred person, which was the primary form of icon that was brought back to Western Europe by Crusaders, where the imagery exerted considerable influence, not least of which was on the history of portraiture from the fifteenth century onward. The devotional portrait-icon fit into the Western cult of the saints and the sacred economy of relics and indulgences as well as the growing emphasis on private devotion and prayer visually conveyed in the devotee's personal relationship with his saint or Our Lady.[13] *Icon* in the West should not, therefore, be reduced to the Eastern conception of the term, but understood within its own history of reception. In the context of its Western career, the icon performs on a basis that includes the legacy of the Orthodox sense, but is not limited to it.

I would like to pose a taxonomy of sacred objects that offers a somewhat different conceptual use of icon. Whereas the token remembers the holy, acting as a testimony to narration that links speaker to listener, reader, or viewer, and an amulet embodies a portion of a sacred artifact to perform its work on behalf of its owner, the icon visually presents itself to the viewer as the likeness of a sacred person, most familiarly in the form of a visage that returns the viewer's look in what we described in chapter 3 as the reciprocal gaze. The icon mediates two parties in a face that forms a common, interactive boundary. Such a face receives one's attention and returns it. Like a face, an icon is both a surface and a depth, which combine to create a sense of presence, something that is there yet not fully visible.[14] The devout pause before the icon to petition the saint, to engage the holy figure by honoring his image and then to await the saint's response. The devout speak of the icon and the saint virtually indiscriminately because, in some sense, the person is there to be seen and to listen to the devotee's pleas. Because the saint's likeness draws from and therefore participates in the saint's being, it is he who faces the devotee in the icon. When devotees gaze upon the face of the saint in a holy image, they do not imagine they are looking at a mask or an arbitrary sign, but at the saint himself. More than the surface that marks one ending and another beginning, the face is a depth that ontologically mingles seen and unseen. As such, the icon is

the site of *interface* between the devotee and the saint. Just as the flesh of the face is the living mediation of self and other, so the icon is the countenance of the saint, that is, the place where he is present to the viewer. The icon enables interface as a special kind of visual mediation. What this means for devotion is key: the face of the icon is where one pays attention, where the devout deliver their obeisance, where they engage in the sacred economy of exchange by offering the saint their devotion, pleas, promises, and thanks.

Mauss offers further occasion for consideration of the relationship of interface to the sacred economy of gift exchange. Rather than content himself with a straightforward description of the social balance of goods exchanged, Mauss was compelled to discuss what he called "the force of things" as the motive power driving the gift and the obligation to reciprocate.[15] Exchange was grounded in the connection of persons. For this, he relied on the idea of the "face" as it informed Northwest American Indian potlatch, where "to lose one's prestige is indeed to lose one's soul. It is in fact the 'face', the dancing mask, the right to incarnate a spirit, to wear a coat of arms, a totem, it is really the persona—that are called into question in this way and that are lost at the potlatch."[16] Face is the mask of the spirit or totem, which the individual dons to embody the larger persona, and incarnate thereby the social body. Losing the mask or emblem that enables access to the social body means losing something of one's own being. Gift exchange, therefore, was about more than the exchange of commodities or spending money (indeed, Mauss even argued that "things sold still have a soul,"[17]) for, as he said of Maori law, the legal tie was between souls and mediated in things "because the thing itself possesses a soul, is of the soul. Hence it follows that to make a gift of something to someone is to make a present of some part of oneself."[18] Face constitutes the site where exchange happens as the intermingling of souls.[19]

The power of the face as a privileged medium of encounter and exchange is at work in the category of the "true image," which, as we noted in the last chapter in the case of the Veronica, originated miraculously, in heaven, or from the very face of Jesus, and is faithfully maintained in reproduction. The cloth that Jesus pressed against his face bore away his features. But visual portrayals of the cloth throughout the later Middle Ages and after showed not an inverted, negative impression, but rather a positive one, that is, the face itself, not its imprint. The image gives the original, or may be said to show the transformation of the imprint into the original. Jesus's face hovers in the concave space of

the cloth. The image was more than a sign, it was a presence, the medium of a miracle. The omnivoyant statuette that I saw in Brazil (see fig. 10) captured this metamorphosis very nicely by the illusion of the inverted imprint appearing to be convex. The implication is that the likeness of Jesus persists in the image, something of the original remains present in the copy. The statuette of the Veronica is the trace or imprint that morphs into its prototype. Thus, the copy is not a loss of being, but rather its continuity.[20] The Veronica is powerful for devotees because it enhances access to Jesus. He returns one's gaze. Before this picture the devout enjoy his presence by entering his look. This species of gaze pertains to images that I define as iconic, whether they are Christian or religious at all. One need only think of John Montgomery Flagg's ubiquitous 1917 recruitment poster: a glowering Uncle Sam stares and points at the viewer, with the caption "I want you for U.S. Army." Looking at the image means seeing the person, not merely his picture, and being seen by him. Figured in this icon, the nation announces its expectations of dutiful citizens, who are provoked to respond. Both the Veronica and the Flagg lithograph are clear examples of what I mean by interface.

Interface is a compelling example of the embodiment of seeing, of vision as bodily encounter. Interface occurs when the body finds an efficacious fit with another object or person, resulting in a larger or extended body, one capable of an expanded range of work or feeling. Uncle Sam gazes and points, suggesting that his sight touches citizens, in the same way that Antonio demonstrated the effect of the all-seeing eyes of his statuette of the protective Jesus. Interface with an image is the work of an icon, which is not an arbitrary sign for devotees. In the case of the Veronica, the image is the body (face) of Jesus looking back in a gaze that I have described as reciprocal. The devout respond with their bodies, greeting the icon, genuflecting, bowing their heads, kneeling, prostrating themselves, folding their hands, speaking to the icon, kissing it, stroking it surface. Their engagement is not intellectual, but fully enfleshed. To see the faces and stories of the sacred figures is to move toward them, to enter their countenance or visual presence. Icons are faces and human beings have a unique regard for faces. A face is not a mask or a sign, but a thick, living surface that begins in the unseen domain of feeling and ends in the visible world of others, limning the threshold of visibility. Neuroscientists studying facial recognition among humans observe that the brain "responds differently to faces and non-face objects."[21] Moreover, the human face and voice are the

two features that the brain processes more quickly than any other signal.[22] We care about the face and devote enormous attention to it because it is a font of information that matters to us.

In fact, the face and images of faces are more than "information." They constitute presence. A human face is a living surface that registers emotion, sensation, and thought. If a mask is a frozen face hiding what is behind it, an icon is the visual trace of a living face that beckons and receives the viewer's regard to reveal the disposition of the sacred person returning the gaze of the devotee. To see the icon is to be addressed by the person, to see him seeing oneself. Where the token marks and records by inscription the historical entrance of the holy into one's life, and the amulet materially plies the power of the holy in one's life, the icon perforates the fabric of the life-world with a conduit, engaging the viewer in an interactive relation with the holy. This interface turns on the face-to-face address, one's presence before the icon, which is an embodied relation, not an immaterially visual one. Experienced bodily as a countenance, the icon is more than a sign. It has power precisely because devotees are inclined to regard it as a face, a living surface that returns their gaze.

I want to focus on the icon as a historical artifact and on interface as its operation because these remain powerful visual forms in our own time, whether the imagery is religious or not. Obviously the meaning of *icon* derives from the history of Orthodox Christian theology and practice. But as I have suggested, this visual category need not be restricted to that history. In fact, the term has traveled far beyond its particular religious origins. It is necessary to trace something of this cultural history, at least a sketch of it, in order to account for the tenacity of the category and its family of meanings as they relate to contemporary critical discourse and the study of visual culture. In doing so, I hope to demonstrate the foundations of the visual covenant in *sacred* and in *moral* economies, each of which structures the experience and practice of iconicity. Sacred economy pertains to religious images; moral to images that operate in non-religious domains. I understand *icon* to designate a capacious visuality that has taken shape within the Western cultural tradition from Byzantium to the present. I will examine El Greco's *Burial of the Count of Orgaz* (fig. 19) as an opportunity for seeing how the icon works. In order to show the historical persistence of the icon as a way of seeing, I close the chapter with consideration of latter day iconicity. This will afford us the opportunity to think about the role of icons in the sacred economy of Christianity and the moral economy of modern secular society.

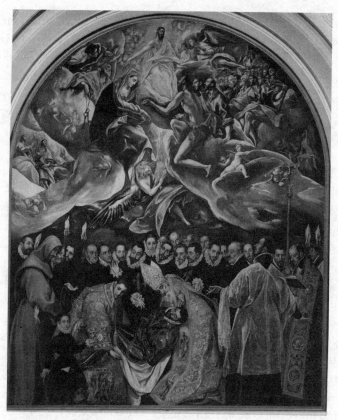

FIGURE 19. El Greco, *The Burial of the Count of Orgaz*, 1586–88. Canvas, 460 × 360 cm. S. Tome, Toledo, Spain. Erich Lessing / Art Resource, NY.

THE SACRED ECONOMY OF INTERCESSION: ICONS, SAINTS, AND THE TRAFFIC OF SEEING

In his eighth-century defense of icon veneration, John of Damascus argued not only for the power of the icon to act as a medium that relayed honor to its archetype, he situated all things within a set of universal hierarchies classically expressed by Pseudo-Dionysius.[23] This ontological architecture was crucial for Byzantine theology and visual practice because it explained the structure of the universe, and how it conveyed thought as action from the human to the divine, and how the hierarchy conveyed divine grace and energy to humanity as a metaphysical economy of petition and favor. In other words, the structure of the universe accounted for the nature of divine and human relations in light

of the Incarnation. Because God had embodied himself in Jesus and invested his grace and power in the saints and martyrs as his friends, marked by their imitation of Jesus, God provided the means for the deification of humanity, that is, the material redemption and spiritual transfiguration or sanctification. In Orthodox theology, *theosis*, or deification, was a material infusion by divine energy. Jesus was the union of divine and human that returned the human to its original state of peace with God. The Incarnation redeemed human nature: the Word became human and "our whole nature was restored to ancient blessedness, through which that nature has ascended from the lowest parts of the earth beyond every principality and is seated on the very throne of the Father."[24] Theosis deifies human nature not by transforming it into something it is not, but by participation, by union. In a practical sense, taking on the image of the icon was one way in which theosis may be said to have happened. John of Damascus recounted a story of John Chrysostom acquiring the physical appearance of the icon of Paul, which he devotedly venerated: "he would gaze at it and attend to him as if he were alive, and bless him, and bring the whole of his thoughts to him, imagining that he was speaking with him in his contemplation." When one of his disciples looked at the icon one day, he was startled to see the likeness of John and Paul, who were so similar that the disciple considered them "the very same."[25]

There was good reason, according to John of Damascus, to portray the saints and to venerate them via their icons. The saints were the army of Christ, those who did his bidding, enacted his will. "Should not we, who depict God, make images of the saints?"[26] Not to do so, he made clear in another treatise on the same subject, was to offend the one who proclaimed the saints his friends: "So one who does not honor the saints does not honor the Lord himself."[27] Early images of Christ and Mary, showing them enthroned and surrounded by the saints and angels, signaled the hierarchy that structured the universe and demonstrated how the icon was a key form of interface, an honored way of engaging the hierarchy to participate in the reality of redemption and to benefit from the system of relations that the cult of saints allowed. They were part of a spiritual bureaucracy or system of intercession that welcomed the devotion of the petitioner, asking for assistance of one kind or another. The saints conveyed the petition to Christ by interceding on behalf of the human request. This was not regarded as a distancing from God, as the Iconoclastic party averred, but rather as the very means for respectfully, confidently approaching him. To ignore the saints, especially for John of Damascus, to

disregard their visual devotion through the icon, was to insult God himself by spurning his friends.

The structure of the universe as negotiated by the visual cult of the saints is admirably described by *Burial of the Count of Orgaz* (see fig. 19), painted in 1586–88 by Domenikos Theotokopoulos, better known as El Greco. This picture may be analyzed as an unfolding of the process of interface, or what happens in the reciprocal gaze, the engagement with an icon. My claim is that seeing the human face in the visual field structured by the icon operates as an entry into a larger set of relations. In some sense, every human face is an icon inasmuch as its surface and engaging exchange with others mediates a priority, placing itself before those viewing it. "Before" here carries not only a spatial sense, but an equally ethical one. Emmanuel Levinas and others have worked out the philosophical articulation of this encounter. To see the face of another is to be addressed with the duty or call to respond, to be responsible. Thus, according to Levinas, the priority of the other, standing *before* me, is the basis of human sociality.[28] Icon veneration builds upon one of the most common visual experiences of the human species—the face-to-face encounter with another whose priority I experience as my responsibility to him or her. The relation implies an indebtedness—the existential condition for sacred and moral economies described above. I owe the other, my debt is the condition of my social existence (and everyone else's): I stand in obligation to the other before me.

Perhaps the deepest existential experiences of the indebtedness that Levinas describes is the primacy of the face-to-face relation of parent and child. The relationship of the two, from birth, is profoundly dependent on the visual connection immediately established and carefully maintained and relied upon in the gaze engulfing them.[29] This intimate tie characterizes the most cherished of icons in Byzantine tradition: the Madonna and Child, as it is called in the West, and the Theotokos, or Mother of God, in the East (fig. 20). In this famous instance, the Vladimir Madonna, we see a common and beloved visual formula. Mary looks directly into the eyes of the viewer, but then directs our gaze with her hand to the object of her affection, the Christ child, who gazes intently into her eyes. The viewer's gaze intersects with Christ's in the eye of the Mother of God, making her the medium of divine encounter, embodied access to the divine. The tender relationship between mother and child has been adored for centuries and is a favorite devotional image because this tenderness secures the hope of devout viewers that their petitions to the Mother of God will enjoy a powerful advocate before Christ. The mother bore

FIGURE 20. Madonna of Vladimir. Russian Icon, eleventh to twelfth century. Tretyakov Gallery, Moscow, Russia. Scala / Art Resource, NY.

the child and participated in his life of suffering and the passion at his life's end. As a result, she enjoys, as El Greco's painting clearly shows, a vaunted place of authority in the canopy of heaven, ideally poised to intercede for the soul before the centrally placed Son and Judge, who, as in Michelangelo's *Last Judgment*, which El Greco saw in Rome, is seated over the universe to render his lasting decisions with the graceful gesture of his hands. One of Christ's hands hovers, in El Greco's picture, just above his loving mother, and the other above John the Baptist, who, as celestial advocate, looks at Christ and appeals to the Virgin.[30] The juridical matter before this heavenly court is the soul of Don Gonzalo Ruis of Toledo, Lord of Orgaz, whose infant-soul is directed

FIGURE 21. El Greco, the painter's son, Jorge Manuel, detail of figure 19.

into a celestial birth canal, whence it will shortly enter the presence of the enthroned magistrate. But El Greco assures us that the nobleman will arrive in good stead, having as his advocates no less than the cousin (John) and the mother of the judge.[31]

But I have rushed to the mystical peak of the image; it is best to return to its beginning, down below, in the lower left, where the viewer's gaze is first arrested by the oval face of a boy, whose eye seeks ours out quite placidly (fig. 21), engaging viewers in a reciprocal gaze. He directs us inward with a quiet gesture, to the supine body of a dead man. The boy is no mere lad. He is the painter's son, Jorge Manuel, born in 1578, the date inscribed (with the double-entendre "Domenikos Theotokopoulos made this") on the handkerchief emerging from his pocket. The identity of the boy is noteworthy for my account since I premise the emotional appeal of the icon, the hope with which the devout look to it, on the visual bond joining parent and child. Moreover,

in the fundamental visual gesture of the icon, the look of the boy seeks out the viewer's gaze and secures it for an ensuing series of relays that culminate in a circular colloquy of gazes and gestures among Jesus, John, and Mary. From the boy's pointing finger the eye moves across the figure of the dead Count, held by no less than Saints Augustine and Stephen, to the hand of the priest in the right foreground. His transparent surplice prepares viewers for what they will encounter as they follow the priest's gaze upward toward the translucent, glowing clouds that part to allow the passage of the count's soul. Along the way, we pass by a row of portrait heads, dressed not in the costume of the fourteenth century, when the nobleman died (1323), but in the style of the Toledo of El Greco's day. These contemporaries, one or two of whom have been identified as friends of the painter, look downward at the miracle taking place before them, or upward, at the invisible event taking place overhead.

The story is that in 1327 the body of Don Gonzalo was removed from its resting place in the Augustinian monastery of St. Stephen, in Toledo, for reburial in the Church of St. Thomas, to which Don Gonzalo had bequeathed the means for enlargement and redecoration.[32] Because he was remembered for his good deeds toward the Augustinians of St. Stephen's monastery, and for his devotion to St. Thomas, the caballero's reburial merited special attention. It was sanctioned by the miraculous appearance of two of Christianity's leading saints: Stephen, the first martyr, whose death by stoning was recounted in the Book of Acts, and who was the patron of the monastery in Toledo, and Augustine, Bishop of Hippo, leading doctor of the church and founder of the Augustinian order. The two descended from heaven to deposit the count in his new burial site. It may seem a bit much in retrospect, but the story was crucial for the litigation necessary to extract the endowment of an annual sum due to the Church of St. Thomas by the township of Don Gonzalo's domain. Payment, however, had been deferred by the inhabitants since 1564. Andrés Núñez, parish priest of the church, filed suit and won a favorable verdict in 1569. Because the decision included the entire account in arrears, the Church of Saint Thomas was awarded a substantial sum.

Perhaps it had been necessary for Augustine himself to approve the transfer of the body to soothe the feelings of the local Augustinians, who were losing the wealthy and pious knight's presence in their monastery. Don Gonzalo had been an important benefactor of the monastery. There had been a long medieval history of such "translations" and their legitimation by miracles, especially in the case of "sacred thefts" of relics.[33] But that was a matter of

the fourteenth century. In the sixteenth century the situation was different. If anyone had doubted the notion that Augustine and Stephen had condescended to attend the translation, there was little reason for skepticism now. Long-suffering faith in saintly care was amply rewarded; the efficacy of intercession richly vindicated. Augustine and Stephen had taken care of those devoted to them. Their elaborate presence may be intended to underscore the real reason for the successful lawsuit. A monumental image that lauded the cult of the saints and the power of their intercession, as well as the reward of a good man's ecclesial benefactions (especially as a triumphant lesson to stinting townspeople), El Greco's painting was deeply engaged in the politics of the Counter Reformation, whose cause Catholic Spain, under the leadership of Phillip II, considered paramount. Artists could not have asked for a more glorious commendation of their craft to patrons. Sts. Stephen and Augustine are even dressed in their own icons—the illustrated panels woven into their lumbering mantles. This is a picture that hymns the dedication of wealth to the cause of being remembered, with the assurance that everyone wins: artist, patron, church.

And laity, it is very important to add. El Greco's painting endorses the cult of the saints, not just the apotheosis of a benefactor. The picture maps out the very process of intercession and addresses itself not only to the wealthy, but, in the glistening eyes and sober face of the youthful Jorge Manuel, to the viewer who pauses devoutly before the image in the Church of St. Thomas (see fig. 21). His look invites the viewer into the composition, as we have noted, to join his contemporaries assembled in the long line of gentlemen who witness (to) the event. They were not there, in 1327, to see the count translated, but they attest to its reality and take their place beneath the heavenly realities that open above them as a consequence of the event. They mark the present, which slides ineluctably from the past into the future, that is, to the judgment of souls. As gentlemen, they are also the patron class. Who better to endorse pious works of art?

While recalling the format of Michelangelo's Last Judgment, the picture sounds none of the fresco's towering gloom. For the devout viewer who brought to the Church of St. Thomas the burdens of life, the image deftly initiated a rising series of relays, that is, a succession of intercessory gestures that carried petitions to the feet of Christ himself. Heaven and earth are not ruptured from one another in the dualistic metaphysics of the Reformation, but are as near to one another as the incandescent clouds glowing just overhead, opening

up to reveal the assembled hosts and the hierarchy of sacred personages. The scheme conveys a very different sacred economy than the one endorsed by Luther and Calvin, who argued for direct, unmediated access to the redemptive grace of Jesus. For El Greco and his patron, for Counter-Reformation Spain, the saints and Mary were God's friends, his representatives, those in whom he had invested his authority in a spiritual bureaucracy that structured the universe in a vertical ascent and descent of offices. By picturing the ascent of the nobleman's soul through the court of saintly testimony and intercession and by staging the soul's presentation before the judgment seat of Christ, El Greco underscored a key difference between Reformation and Counter-Reformation. Luther insisted that those justified by grace need not fear the Last Judgment, nor even regard it as judgment. In one sermon he placed the following words in the mouth of Christ regarding "the picture of Christ as a judge": "Do not picture Me thus, do not regard Me as a judge. Instead of invoking the saints, appeal to Me, your true Mediator and Saint. Just come to Me."[34] El Greco, by contrast, showed the fundamental role of the saints and martyrs in helping to secure salvation by witnessing in the heavenly court on behalf of the soul. Where Luther nullified the salvific role of the saints, Catholic reaction was to reassert their place. As John of Damascus had implied, ignoring the icon of Christ questioned the very truth of the Incarnation. Likewise, refusing to honor the place of his saints meant refusing to honor the determinations of God himself. The devotion of Christ to his mother and to his family member and forerunner, John the Baptist, represented by El Greco as an intimate circle at the summit of his painting, vouched safe the inclination of the Savior to honor the requests laid before him by these lofty advocates of mere mortals.

So I return to the face of the painter's son, gazing at us so serenely, and discern a parallel between him and his father, here below, and Jesus and his mother, there above (see fig. 21). Parent and child remain the essential force that compels the viewer's gaze to respond in kind to Jorge Manuel's. (And El Greco's surname, Theotokopoulos, written on the boy's handkerchief, echoes the Greek term for Mary, *Theotokos*, Mother of God.) Condensed in the viewer's response to this face is the *interface* with everything that follows. That is the power of the icon: that it allows intimate connection with the ultimate by means of a special economy, by means of a medium of exchange, a currency that runs a long way on the swift feet of promise, on credit that will make good. Everything is there, waiting in the boy's face, and if you do not see it, then you are not looking with the eyes of faith, with the expectation and need

that are invested in the mounting system of intercessions that end in the graceful dance of hands in the domed apex of the picture. Their circular movement receives the petition, then issues its response, whose favor reverses the ascent, moving downward through the ministrations of the saints and the office of the church into the earthly stratum of the faithful gathered about the dead knight, and communicated finally by the steady gaze of Jorge Manuel. The interface takes time to explain, to narrate, but happens instantaneously in the visual economy of iconic veneration. It begins when the viewer looks at Jorge Manuel and ends when the boy looks back.

Interface is a term familiar in computer technology, referring to the compatibility of systems or devices, that is, their capacity to connect and communicate with one another. This usually means one device plugging into another such that they become an integrated, single system operating harmoniously. The idea extends to the ethics of human encounter and to the believer's experience of gazing upon Christian icons. At different times in their religion's history, Christian writers have stressed the notion that vision transfers the properties of the seen to the viewer. Recall the story told by John of Damascus regarding John Chrysostom. It is an ancient idea, one that is to be found in many times and religious settings. For example, Plato censured Homer for portraying the gods' passions, since actors impersonating such gods on stage (wearing theatrical masks called "personae" by the Romans) were in danger of becoming like those they imitated. Similarly, parents fear the exposure of their children to images of violence and sensuality because children may in some respect become like what they behold.[35] Interface blurs the distinction between two parties and empties the self of the viewer into the new register of being. The lure of the young boy's gaze in El Greco's painting, so familiar in Renaissance and Baroque art, establishes a connection to viewers, leading them into the sacred event, into a world of faith.

THE PORTRAIT ICON AND MODERN VISUALITY

The icon persists in the modern imaginary because it offers interface with a reality (supernatural or mundane) that is grounded in the compelling bond between parent and child. This is clearly at work in devotional practices informed by pictures of the Madonna and Child in Roman Catholicism. One may also find it among Protestants.[36] But this discussion of icons may strike many readers as odd since the typical notion of an icon is the small, devotional

portrait of a saint, Mary, or Jesus, who gazes quietly at the viewer from just inside of the picture frame, establishing what viewers cherish: an immediate connection or relationship that is deeply felt and sought after by the devout. The reception of the Byzantine icon in Western Europe during the late Middle Ages tended strongly to prefer the small devotional image of Christ, Mary or the saints, over the much larger mosaic or frescoed imagery adhering to the domes and walls of Eastern churches, portraying scenes from the Bible or large, looming portraits of Christ as Lord of the Creation. This preference was due in no small way to the fact that the smaller icons were those pilfered by Crusaders and brought back to Western European monasteries, churches, and courts as sacred booty. Consequently, they were available to the pious for devotion and to artists for emulation.[37] But another reason is also important to bear in mind. The smaller portrait style, more conducive to intimate inspection and the direct gaze of veneration, suited the contemplative spirituality represented admirably by Nicholas of Cusa, who wrote, we recall, about the omnivoyant image of Christ, a Veronica by Rogier van der Weyden (see fig. 11).[38] "O Lord," he uttered gazing upon the image that returned his gaze, "when You look upon me with an eye of graciousness, what is Your seeing, other than Your being seen by me? In seeing me, You who are *deus absconditus* give Yourself to be seen by me."[39] The icon was the hidden deity looking back, revealing himself in the gaze, presenting himself for the caress of the human other. And endorsing a conception of personhood as the unique, interior identity or soul that mirrors the intimate personal reality of the deity.

But once we step beyond the religious context of the Byzantine and Western icon and enter the modern and secular world of the "cultural icon," how is it that the word continues to have anything even remotely similar in meaning to the Christian icon? A clear definition by two scholars of contemporary visual culture offers a useful way to approach the continuity of the term. Marita Sturken and Lisa Cartwright state that an icon "is an image that refers to something outside of its individual components, something (or someone) that has great symbolic meaning for many people. Icons are often perceived to represent universal concepts, emotions, and meanings." The authors then look at two paintings of the Madonna and Child as images in which many people find "universal concepts of maternal emotion, the essential bond between a mother and her offspring, and the dependence of that child upon her."[40] Sturken and Cartwright hasten to point out that claims for a cultural icon's universality are, in fact, tendentious, operating in favor of a particular cultural perspective—in

this case, the interest of Christianity. The claim for universality is likely identi-
cal to the claim for immediacy: the point is to conceal the cultural apparatus
that underlies the relationship of a viewer to the image, rendering it invisible.

In spite of the many differences between an icon in the Eastern Orthodox
tradition and the icon on one's computer desktop, uses of the same term are
connected by an important semantic strand. In both cases, *icon* means an access
or entry point, a portal that opens up into something greater, wider, deeper.
Interface with a printer, for instance, allows a computer to do something it
otherwise could not. In both instances, seeing the icon is an interface with a
greater referent. An icon is in some manner intimately linked to what it medi-
ates. Whether the icon pictures the face of a saint (linked to it by the ontology
of likeness) or the icon is a collective representation of a larger set of examples
(the Madonna image as a representation of motherhood), or whether the icon
is a kind of exemplar of what fans desire to become (the singer Madonna as
icon of sex appeal): in every case the icon shares something with what it refers
to such that the image is experienced as more than a sign. It is regarded as
participating in its referent. The power of the icon turns on how it negotiates
an absence to render a presence. To see the icon is to enter the visual presence
of its referent, to interface with it. The interface entails morphing one thing
into another. By holding a hammer, my hand's soft surface is transformed into
a hard one good for pounding nails. Hand and hammer form an interface. By
interfacing with a printer, a computer is able to transform its electronic text
into a printed one. Seeing an icon is like seeing a face, which is the gateway
to the person embodied in the face. To behold the icon is to draw close to
another—as a devotee, a fan, or a consumer. It is this special character of the
icon that makes it a powerful feature of the cult of the saints, but also what
lends the commodity its mystique or aura in capitalist economics, which Marx
called the "commodity fetish," that is, the infusion of the commodity with an
excess value, an immaterial quality—in his view, alienated labor, disguised by
the spell of the commodity's prestige, glamour, eros, or "Italianicity," to draw on
Roland Barthes' famous example of an advertisement for spaghetti.[41]

The quest for something mysterious, an elusive essence or aura, is evident
in the application of the terms *icon* and *iconic* to other kinds of objects in
modern society. Traditional icons supply the image in the place of the missing
body of the saint. Modern icons posit the absence of something whose re-
placement they promise. Commercial advertisements, for example, frequently
turn on telling consumers they lack something that can be fulfilled in the

product they promote. Popular iconic imagery often fills another kind of absence, the loss of a bountiful past. Thus, Norman Rockwell's popular images have often been called "national icons or archetypes."[42] For example, on the front page of my local newspaper on Thanksgiving Day, 2010, appeared Rockwell's 1943 war poster, *Freedom from Want* (fig. 22). Most Americans will not remember it as wartime propaganda, but as a touching celebration of the vaguely religious American holiday of Thanksgiving. An elderly couple, patriarch and matriarch presiding over the family gathering, present a gigantic turkey to their loved ones, who've come together to share the ritual dinner. The spectacle of a formally set table and convivial conversation is anchored by the ancient pair, who are oblivious to the banter of their offspring as they lovingly provide the substance of the meal. They are the prototypes of lesser emanations encircling the table, and as such the couple are Rockwell's object of sentiment: the true meaning of Thanksgiving recovered in an act of devotion, the doting pair's act of generosity, a bounty that recapitulates the progeny that their love produced.

The local newspaper capped the reproduction of the image with the phrase "Iconic American Images."[43] Why are Rockwell's pictures iconic? The seeking gaze of one face radiates from the lower right, where a figure turns to look directly at the viewer, creating an entry into the image in a reciprocal gaze. Yet this image is not an icon in the traditional sense. If the term is to apply, as its repeated use suggests it may, we need to adjust the definition of icon somewhat. If a sacred icon offers interactive visual contact with the saint, this cultural icon and many others produced by Rockwell may be said to offer visual access to something unmistakably American: they personify the ethos or character of the nation—the thoughts, values, ideals, feelings, perceptions, or mental images that *are* America.

Of course, for either image to be iconic, the viewer must be prepared to believe something. In the case of the Christian icon, the image acts as an icon to those with faith that the pictured saint is available in a reciprocal gaze. In the case of Rockwell, the images are iconic to those who actually believe the pictures capture something desirable—the good old days, America of yesteryear, the way it ought to be. Without that faith, they are not icons at all, but delusions or misconceptions or lies. But for many Americans, Rockwell's images are true, or at least they portray the way things ought to be or once were. Right or wrong, if that is so the scholar of American culture has in the corpus of Rockwell's imagery the opportunity to see inside a widely shared imaginary.

FIGURE 22. Norman Rockwell, *Freedom from Want*, 1943. The
Norman Rockwell Art Collection Trust, the Norman Rockwell
Museum, Stockbridge, Massachusetts.

Indeed, the curator of an exhibition of Rockwell paintings commented,
"Whether you know the name Rockwell or not, his pictures have entered our
psyches." That is the domain of the modern, secular icon: the collective mental
space of a social imaginary. "You only have to look to the Thanksgiving image,"
the curator continued, "that everyone aspires to at Thanksgiving and so rarely
achieves."[44] This second comment captures something important about Rock-
well's pictures: they dwell on loss. Whereas *Freedom from Want* was created
by Rockwell to celebrate what the American cause in World War Two meant
to protect, the image since then has come to mean the ideal of Thanksgiving
that, as the curator put it, "everyone . . . so rarely achieves." His work commonly
posits a fading national ideal, one that must be recovered and secured because
it exists in the past and did everything to create the bounty of the all-too com-
placent American present.

The power of the icon consists of the ability to fill the absence caused by death, which is the characteristic difference of a sacred economy. Rockwell's pictures are icons because they testify to that generative, but fragile past that becomes available in the moral economy of civil ritual. Looking at *Freedom from Want*, it is not immediately clear that the chatty, smiling family members recognize the venerable presence and lineage of their prototypes serving them the totemic turkey. Rockwell's America is commonly glimpsed through veils of sentiment, constructed as a nostalgic look at yesteryear. His images are icons in this regard: they open up a view to this fond past and move the viewer to long for its fabled return. Whereas the Orthodox icon collapsed distance into the immediacy of interface, Rockwell's icons shift from the spatial register to the temporal. The absence in question is temporal, not spatial. Because his icons seek to behold a fading or vanished national ideal, time poses the barrier to be negotiated in the pursuit of presence.

The temporality of the modern icon is evident in another way in Rockwell's oeuvre. The operation of yearning in his images could also be inverted into looking for a desired future. Rockwell was able to capture longing as a way of seeing, which constructed the image as a sort of icon opening wishfully onto an ideal state of affairs in the future rather than the past. An image that poignantly demonstrates the secular operation of an icon is a remarkable painting entitled *Girl at a Mirror* (fig. 23), which appeared on the cover of the *Saturday Evening Post* in 1954. The girl is gripped by her own image before a mirror, gazing questioningly at herself, or at the possibility of becoming another self, built upon the model resting on her lap, a glamour shot of actress Jane Russell. She seeks to put on the very look of the future, to see herself as the face of a more glamorous version of herself. The image gives us a poignant instance of interface. The image also suggests that the mirror-stage described by Lacan and others (see chapter 1) may not be limited to early childhood. Encountering one's specular self acts as a ritualized negotiation in the shift in self-conceptions. By looking longingly at her reflection through the lens of Jane Russell's icon, the girl envisions a new possibility for herself. She sees a new specular I, a different self looking back, one that urges the embodied self to respond to the image. The specular self is a new look, the way the girl wants to appear—to herself and to others. The image is more than an image—it participates in her desired reality, reshaping the embodied self to its own image.

Rockwell's touching picture suggests that the modern human self is not static, but caught up in an unstable state of becoming. The mirror, the

FIGURE 23. Norman Rockwell, *Girl at a Mirror*, 1954. The Norman Rockwell Art Collection Trust, the Norman Rockwell Museum, Stockbridge, Massachusetts.

looking-glass, peers into the future, enabling or at least promising the transition to a future state of the self. In quest of her refashioned ego, the girl has cast aside the doll, which lies still frozen in the gesture of sitting on its mother's lap. We see a moral economy at work, an act of exchange in the midst of negotiation. If she engaged the doll in what I described as the virtual gaze in her childhood, creating herself vicariously by directing the doll's play, she intersects the reciprocal gaze with the devotional gaze, looking alternatively to the cultural icon of the film star and the adolescent image in the mirror before her. Having leapt from the visual exemplar of the Madonna and Child (echoed by the girl and her doll) into the stream of images pouring from Hollywood and American advertising, the girl barters a new way of addressing herself and the world. Her state of undress, perched before the mirror in an undergarment, her ungainly bare feet and her modestly enclosed arms, show that the project

of self-fashioning is precariously underway. Will she succeed? Lacan's view of the image, distinctly negative, suggests she will not. There is no Real to grasp, only a mythic construction to pursue. And the image, he opined, was not a benevolent power, but quite the opposite.[45] "In the matter of the visible," he wrote, "everything is a trap."[46] The devotional gaze would mean in this dark sense a containment or imprisonment of the girl in a consumerist fantasy-self, a cultural construction fed by the commodity-fetishism of popular film.[47]

Yet there may be signs that suggest growth, a painful but organic development of self. That the girl hovers in a liminal stage is made clear by the fact that she sits on a toy box, a relic of her childhood, while on the floor we see the accoutrements of the new look—lipstick, a compact, a brush, and a comb. The arrangement of her hair, an ingenuous act of conformation to the prototype on her lap, suggests a sort of secular iconic veneration, an *imitatio Christi* that seems to have left the devout soul something less than fully convinced. If the gap between himself and the Veronica charged Nicholas of Cusa with Christ's presence, Jane Russell's icon inspires but does not yet achieve emulation in the girl's self-imaging. Here, at the beginning of a new epoch of the girl's selfhood, we espy the backstage of the modern theatre of the self, how stages of preparation consist of images consumed in the production of identity. To see a finished self, the picture fondly implies, is not to see the traces of its construction. The terms of the trade—one image for another, that is, the doll for the film idol— remain visible as a visual transaction in the cultural marketplace of identity. If Christian interface with the iconic image of Christ was intended to result in the believer's taking on the image of Christ by means of a self-emptying absorption before the savior's iconic visage, Rockwell's girl engages in an interface that she hopes will bestow a new look, a new face, which she wagers the mirror will conjure forth. In each case, the viewer *pays* attention with an expectation of a return for the price. Seeing is a fervid medium of exchange.

Rockwell's picture urges us to consider that the reciprocal gaze applies very well to modern visual experience, even the very different circumstances of secular fashion and commodities. One reason for this is the role of images as the means of exchange. The point of the reciprocal gaze, in other words, is to get what one sees, which is what one wants or needs, which is what the past assembles and the visual field organizes in a vast apparatus that the eyes of faith cloak desperately, hopefully beneath desire. Whether it is theosis, imitatio Christi, or the secular therapy of commoditized self-fashioning, icons mediate access to the desideratum in the visual operation of interface.

The Senses of Belief

The Matter of the Heart

Touching and Seeing

One way that seeing works is to promise touch. In English, the verb *behold* suggests this relationship between sight and touch. *To see* can mean "to want to touch" or "to want to be touched by another," especially if one uses the related verb *to look*. *To look for* means "to expect," "to seek out," "to long for." The element of desire is evident in each, and that is one reason why cultured despisers of imaging from Plato to Calvin have commonly attacked the practice of making or admiring images: they invite the indulgence of desire. Seeing is dangerous because it leads to touching. Scholars who have studied the connection of touching and seeing have used the term *haptic visuality* to describe a certain powerful mode of vision—seeing that maps the visual terrain in terms of touch, texture, proximity, all sensory features that the hands and the body use to register the material character of something.[1] Human vision is able to anticipate these features since its stereometric construction is able to perceive mass, relative size, distance, movement, and texture. Seeing participates in touching by virtue of mapping some of its key attributes.[2] The optical and the haptic are not identical, but they work together to construe better the worlds of experience that engage human beings. The moralists militate against the hardware of human sensation: seeing and touching are firmly linked and work powerfully together.

How does the collaboration operate in religious materiality? How is seeing related to a tactile interpretation of the sacred? If seeing is the promise of touching, religious seeing would mean encountering the sacred in material terms. The history of the devotion to the Sacred Heart of Jesus offers a case

in point. The devotion's historical development is intricately articulated by the controversial issue of the materiality of the heart itself and by the relationship between seeing the heart and engaging in the economies of forgiveness that were debated by the Sacred Heart's detractors and proponents. On the one hand, seeing the heart of Jesus connected viewers materially to the sacred by engaging them in a penitential economy. The tangibility of the heart of Jesus, gripped and held forth in images by Jesus himself, offered for adoration, beckoned a devout response in an exchange that was understood to repay the deity for the expense of offenses against him. On the other hand, critics claimed that visualizing the heart as an organ and adoring it perverted the real work of grace, which was invisible and undertaken entirely by God himself in the action of the Holy Spirit.

Yet the history of the heart's materiality is even more intricate than such theological points might suggest: devotion to the heart may be usefully studied as a rhetorical development over the course of two centuries and more. Variously defining the heart as an erotic substitute, as an organ of iconic power, as a metaphor, or as a symbol, some advocates of its adoration have even come in recent years to eliminate the heart altogether from the portrayal of the Sacred Heart of Jesus. In every case, seeing the heart in a particular form constituted a way of understanding the relationship of the material and the spiritual. Seeing was a way of longing to touch and be touched by the sacred. This chapter explores the relation between touching and seeing, matter and spirit, in terms of several different moments in the controversial history of the devotion to the Sacred Heart.

THE EROTICS OF PAIN

Devotion to the heart of Jesus occurred in the Middle Ages, but the modern devotion began in the seventeenth century, most distinctively with the Visitationist nun, Margaret-Mary Alacoque (1647–90), whose autobiography, completed in 1685, provides a remarkable account of an extreme case of devotion. From a very early age, according to the autobiography, Alacoque experienced a visceral repugnance at sin.[3] Her father died when she was eight years old. The following year she was sent to a convent for education where she remembered herself as a shy, retiring girl who for many years struggled with family members, especially her mother, to be able to pursue the vocation of a nun. The absent father and oppositional mother became a pattern that structured

her relationship to Jesus and the eventual series of mothers superior who were tasked by her extraordinary mortifications and visions for the remainder of her life.

The piety that took shape in Alacoque's experience as a young woman and throughout her years as a religious turned on the twofold nature of Christ as lover and judge, passionate spouse and relentlessly demanding disciplinarian. She longed to be his lover and his slave. Suffering became the medium for satisfying both impulses: crucified and abused to share his suffering, punished and tortured to expiate the offenses made against him—by her own sin and the ingratitude of humanity in general. The visual display of Jesus's suffering served as revelation and as a medium for drawing near to him. Early on, Jesus would appear to her "under the form of the crucifix or of an Ecce Homo, or as carrying His cross." The imagery filled her with "the ardent desire . . . to suffer" in order that she might render herself "conformable to my suffering Jesus."[4] As much as Jesus demanded her self-mortification and berated her vanity, he also favored her with the assurance that he would deliver her from the travail of her worldly life. As her family arranged to present her suitors for marriage, Alacoque praised Jesus as "the most beautiful, the wealthiest, the most power-ful, the most perfect, and the most accomplished amongst all lovers."[5] Wooed by him, Alacoque longed for the religious life and submission to "the Divine Spouse of my soul," who asked her if she would "agree to His taking posses-sion and making Himself Master of my liberty." She "willingly consented" and asked her family that "all suitors should be dismissed."[6]

In 1671, she was accepted at the Visitationist house in Paray, where she trained her energies on the erotic relationship she experienced. "[Jesus] pur-sued me so closely," she wrote, "that I had no leisure except to think of how I could love Him by crucifying myself."[7] When she received the habit, Jesus revealed that the time of espousal had arrived and he "acquired a new right over me. . . . [A]fter the manner of the most passionate of lovers, He would, during that time, allow me to taste all that was sweetest and most delightful in the tokens of His love."[8] Her colleagues and those in charge at the convent were disturbed by the young nun's experiences, excessive zeal, and sometimes bizarre behavior. She was constantly the subject of skillful, if frustrated, inter-vention to induce her to eat and to restrain her from extreme self-discipline. Many came to consider her possessed by the devil.[9] The resistance dismayed Alacoque because she felt it only hindered the intimacy and intensity of her relationship with Jesus. When she consulted him, he counseled submission to

the mother superior. Yet her compulsion to suffer for and with Jesus was irrepressible. At root, it appears, was a stringent aversion to the self, the ego that needed to be evacuated in order to satisfy Christ's demand for justice and to join him in his own cruel agonies. Extreme suffering constituted a radical form of empathy, a self-emptying dismantlement of the self as Alacoque's way of seeking an intimate connection with Jesus. After professing her vows in 1672, she was favored with the continual presence of her divine lover. The presence "imprinted in me so deep a sense of self-annihilation, that I felt, as it were, sunk and annihilated in the abyss of my nothingness, whence I have not since been able to withdraw myself."[10] This experience led to her first mystical encounter with the Sacred Heart, which was steeped in the contemplation of the Sacrament of the Altar, abnegation of self, and the erotic pleasure of her lover:

> One day . . . I was praying before the Blessed Sacrament, when I felt myself wholly penetrated with that Divine Presence, but to such a degree that I lost all thought of myself and of the place where I was, and abandoned myself to this Divine Spirit, yielding up my heart to the power of His love. He made me repose for a long time upon His Sacred Breast, where He disclosed to me the marvels of His love and the inexplicable secrets of His Sacred Heart, which so far He had concealed from me. Then it was that, for the first time, He opened to me His Divine Heart in a manner so real and sensible as to be beyond all doubt. . . .[11]

The trope of the heart as the object of love, whether courtly, erotic, or romantic, was long established in a set of artistic and literary traditions in European culture.[12] Alacoque's Jesus drew on these images and figurations in conveying his affection for her. Jesus told her that his heart was aflame with love for all people, but especially for her, and that he would have this love spread through her to everyone to convey its benefits. "After this He asked me for my heart, which I begged Him to take. He did so and placed it in His own Adorable Heart where He showed it to me as a little atom which was being consumed in this great furnace." After removing her heart to place it within his chest, Jesus returned it to her body, leaving a wound in her side, whose pain, he told her, would always remain.

The intermingling of eroticism and pain became most blatant shortly later in an especially repellant account. Caring for a sick person at the convent who had vomited, Alacoque "was constrained to take it up with my tongue and to swallow it." She wrote that she experienced great "delight" in doing so as an act of conquering herself. But she was not alone: "And He, Whose goodness alone had given me the strength to overcome myself, did not fail to manifest to me

the pleasure He had taken therein. For the following night, if I mistake not, He kept me for two or three hours with my lips pressed to the Wound of His Sacred Heart," that is, the wound in the side of his heart, which mirrored the wound in the side of her own body.[13]

Alacoque's spirituality was deeply shaped by a long-established adoration of the Host, associated with the medieval festival of Corpus Christi. Alacoque said that it was while stationed before the Blessed Sacrament one day that she felt moved to return her love to Jesus, "rendering Him love for love." It was then that Jesus asked her to set apart the Friday following the seven days dedicated to Corpus Christi for "a special Feast to honour My Heart." He asked her to take communion on that day "in order to make amends for the indignities which It [his heart] has received during the time It has been exposed on the altars."[14] Reference to his heart was visualized for Alacoque in the image of a human heart. This had been developed by the mystic Jean Eudes in France during her lifetime, and may have been the source for her, if not in every detail. In any case, she eventually celebrated the devotion to the Sacred Heart by directing the novices in her house, over whom she had charge a decade later (1685) to arrange "a little altar whereon they placed a small ink etching representing the Divine Heart."[15]

The image is striking for its strong emblematic character (fig. 24). Couched in the allegorical language of Baroque emblems, the image configures names, symbols, and images into an ideogram. A Valentine heart encompasses the oblong image of the wound placed by Longinus's spear, which is referenced by the three small spears within the heart. The wound emits streams of blood and contains the word *charitas*. A cross rises from the aorta, as do small rivulets of fire or heat.[16] The central ensemble is circumscribed by the crown of thorns, which is in turn surrounded by the names of the Holy Family and the parents of the Virgin. The pairing of married couples—Joseph and Mary, Joachim and Anna—leaves the unpaired name of Jesus. But reasoning from Margaret-Mary Alacoque's espousal of Jesus, we might take the missing term to be her own name, which is perhaps alluded to by "Maria," which appears between Jesus and Joseph. (It bears remembering that Alacoque once carved the name of Jesus into her own chest, at her heart, with a penknife.[17]) This is, of course, a figural interpretation of the image, but since Jesus sought out Alacoque for the distinctive revelation and couched his relation to her in explicitly romantic terms, we are perhaps not unjustified in regarding Alacoque's emblem as a veiled expression of her peculiarly masochistic relation to Jesus.

FIGURE 24. Saint Margaret-Mary Alacoque, *The Sacred Heart of Jesus*, 1688, engraving on paper. Courtesy of Peter Nevraument.

A psychological interpretation of Alacoque's extreme behavior and visions is virtually unavoidable. In short, it seems clear that she projected her self-loathing on Christ's intolerance of impurity, making her self-abuse a form of love for him. His pleasure was her humiliation and his pain was her pleasure to ease. And her self-mortification was considerable. She starved herself and purged herself following meals; she wrote in her own blood a letter dictated by Jesus; and on another occasion, as already mentioned, cut the name of Jesus into her flesh.[18] Blood, wounds, pain, vomit, and viscera, most notably the heart, were not simply metaphors in Alacoque's acutely sensuous spirituality. The heart was more than a figure of love. It was a sublimation of severely repressed sexual impulses that served to conduct thinly disguised intimacies between the two lovers. She longed for the intercourse and enjoyed an imagined version of it in the emblematic image of the heart.

But that is not all she wanted. Alacoque's religious experience, extreme and extraordinary as it was, was more than scantly cloaked masochism. It was her persistent quest for spiritual fulfillment in the mystical presence of the deity, a radically embodied spirituality that regarded suffering as the medium of union. Even this, pathological as it will surely seem to many, finds a place within the history of Catholic spirituality. But it is also very unusual and certainly not the ideal experience pursued by most Catholics, lay or religious.

Nevertheless, Alacoque was eventually canonized, her autobiography remains in print, and the devotion she founded has flourished around the world. The devout regard this as proof of divine endorsement. More interesting to the scholar, however, than the success of Alacoque's legacy is what it says about the importance of the body in religion. Not just extreme religion, like Alacoque's, but the religion of the laity, popular belief on the scale of millions. The history of the devotion to the Sacred Heart of Jesus offers a rich instance in which to scrutinize the development of belief and practice, the relationship between seeing and touching, and the role that images play in articulating the discrete moments of the piety's history.

THE RHETORICAL MOMENTS OF THE DEVOTION: FETISH, ICON, METAPHOR, SYMBOL

The evolving piety begins with Alacoque's erotics of pain, in which she boldly imagines herself to be the spouse, friend, daughter, slave, and lover of Jesus. In this phase, the heart, which passes out of her chest and into Christ's, is the transmogrification of the sexual act, that is, a powerful medium for touching and being touched. In the fervidly envisioned realm of Alacoque's experience, substitution means something akin to an actual switching of one for the other, such that the heart is not a type or symbol or allusion. It is one physical object being used in the stead of another, one that carries a taboo. Though the term is problematic, it would seem that the heart is a fetish, the visceral object that conceals by taking the place of the proscribed organ.[19] The word *fetish* was first developed to designate the "superstitions" of so-called primitive peoples. A fetish was a charm or amulet, a cult object worshiped for its power to act for good or ill with spiritual force. In latter-day psychoanalytic discourse, the fetish is a substitute object that ascribes to the mother the penis she does not have, castrated, the male child fears, by the angry father who threatens to do the same to the incestuously driven child.[20] Freud used the term because the pathological obsession with the substitute object recalled the worshipful attachment to the cult object among "primitives," ensconced in fear and passionate desire.

Alacoque's fixation on the heart of Jesus strikes one as fetishistic inasmuch as the heart is a substitute for the passionate connection she longed to enjoy with Jesus as lover. But I do not wish this assertion to entail a reductionism of religion to sex in her case. The heart may take the place of the penis and the

vagina, but it also operates as an embodiment of a relationship that is more than sex, however disturbing or repugnant. The power of the fetish, while not for everyone, indeed, not for any but the extreme few, resides in its embodiment of a robust and deeply compelling relationship between the lovers. The fetish allows them to engage their passions without limiting their encounter to the strictly genital. The heart effects a visceral connection of Jesus and Alacoque. It is the organ that passed from the chest of one to the other, and therefore operates as a kind of radical empathy, the means of self-evacuation into the other. This empathy is the result of Alacoque's self-loathing: she feels herself out of her own body and into Christ's because she despises herself, denying herself any self-pleasure, any satisfaction in being herself. Suffering assaults and dismantles the self and projects it beyond itself into identity with Jesus. By ravaging her own body with extreme asceticism, Alacoque became the material analogue of Christ's body. The interchangeability of the heart, or the analogy of her wounded body to Christ's wounded heart, interlocked pleasure and pain in the heart, the meeting point or intercourse of lovers.

As a fetish or substitute, the heart does something that straightforward sexual intimacy cannot. The fetish plays, scolds, lures, veils, postpones, deflects, intensifies, ritualizes. In short, the fetish takes on a life of its own. The fetish becomes the thing to which the devotee is devoted. It is the precious gift that the lover offers in lieu of their forbidden tryst. It is the powerful object whereby the lover is recalled, evoked, summoned, touched, and reexperienced. It is the secret language of romance that alludes to what lovers long for. And for Alacoque, the Sacred Heart is that into which, for which, she welcomes annihilation. It is the bliss of the encounter, both the thing she enjoys and the token or emblem of what she enjoys.

But the intimacy that the heart meant for her was not what others, at least most others, came to experience. In order to take Alacoque's devotion from the heavily penitential domain of cloistered practice to the parish for widespread lay use, Jesuit sponsors had to shift its appeal from Baroque eroticism and allusion to direct address. To do so, they stressed the literal character of the heart. Artists promoting the devotion followed Pompeo Batoni's 1767 painting for the Jesuit church in Rome, Il Gesu, which portrayed Jesus holding his heart forth and gazing directly to the viewer (fig. 25). The image deftly shifts from addressing Alacoque in her vision to engaging the viewer, any viewer.[21] The veiled allusion of an emblem is replaced by the homiletic diction of forthright statement: "Behold this heart, which has loved men so much that it has spared

FIGURE 25. Pompeo Batoni, *Sacred Heart*, 1767. Il Gesu, Rome, Italy. Scala / Art Resource, NY.

nothing, even to exhausting and consuming itself in order to testify to them its love."[22] Batoni's Jesus holds his radiant heart in one hand and gestures openly with the other. This second hand references the heart, but also the viewer. Jesus looks directly into the viewer's eye, and therefore far beyond the remote region of the monastery, relying on the reciprocal gaze to take the devotion to the masses. The image stresses revelation understood as a literal unveiling, a showing of the heart itself, shared with the viewer for the sake of establishing an intimate connection that invites pious response by virtue of pathos. The rest of Jesus's speech to Alacoque conveys this strong mixture of pity and indignation: "Behold this heart, which has loved men so much . . . and in return I receive from the greater number nothing but ingratitude by reason of their

irreverence and sacrileges, and by the coldness and contempt which they show Me in this Sacrament of Love [the Eucharist]."[23]

Batoni's picture accomplished several things. First, showing the heart qua organ pulled from its proper place and lodged between Jesus and those looking upon him made the heart itself part of an iconic or reciprocal gaze. Viewers looked at the heart as Jesus looked at them. The triangulation of heart, Jesus, and viewer made the image of the Sacred Heart more than a sign. It was a revelation, a showing or unveiling that enacted a relational give-and-take. It was not a picture about a theological meaning; it was an *icon* that opened a way to beholding a vital connection. Second, his image recast the devotion in the familiar Baroque visual language of the miraculous literally understood, allowing it to fit effectively within the popular sacred economy of penitential reparations, indulgences, and the material promise of assuaging divine wrath. The close association of Eucharist and Sacred Heart is striking since the Eucharist was understood to be the real body and blood of Jesus concealed beneath the appearance of bread and wine. Likewise, the literal appearance of the Sacred Heart concealed the organ of love that Jesus showed Alacoque.

Batoni's image and the devotion it embodies mark a second moment in the devotion's history. If Alacoque's emblem veiled her erotic love, substituting the heart as love organ for Christ's organ of love, displayed to her as an expression of his erotic love for her, Batoni's picture of the Sacred Heart replaces the fetish: the heart held forth by Jesus is no longer a substitution for his penis, but none other than the literal organ of the heart. The private sexual relationship is replaced by the public cult. Now everyone could behold—touch and be touched by—Christ's heart. Joseph de Galliffet, student of Alacoque's confessor and author of the major defense of the devotion, first published in 1726, insisted on the literal character, denying that it was merely "metaphor."[24] Batoni's picture registers this important move: Jesus holds the corporeal organ in his hand. The picture portrays what Alacoque described. No arbitrary symbol or allusive metaphor, the beating organ focuses the viewer's attention on its bodily fact. The material reality of the heart shifts the devotion from the fetish of Alacoque's spiritual eroticism to the heart as organ of divine love. This literalism exposed the devotion to biting criticism since it seemed to fix attention on the organ itself, separating it from the bodily unity of Jesus. Galliffet mounted a defense that identified the human heart as the bodily mechanism of love. To do so, he had to endorse an ancient physiology, one that conflicted sharply with contemporary medical science. The heart had come to be understood

as a pump powering the circulation of blood by William Harvey, René Descartes, and others.[25] But Galliffet cited Aristotle and St. Thomas to support his contention that the human heart was the seat of vitality in human beings.[26] Because the heart is the locus of life in a person, it is the heart that touches the soul and shares its sensations. "The feeling so universal among the nations of the world," he asserted, was "to regard the heart as the seat and the principle of love, as the *natural* symbol of love."[27] Because the heart was the bodily means of experiencing love, it was the organ that naturally communicates to the soul what the body feels. "Spiritual love," Galliffet drew from St. Thomas, "becomes sensible love through the heart."[28] Worship given the material heart passed through it to the person of Jesus, which was joined to his body.[29]

But criticism of the separation of the heart from the body persisted, as we shall see. Many Catholic critics, most prominently, Jansenist theologians and bishops across Western Europe, objected to the partitioning of the body of Jesus. As a result, iconography of the Sacred Heart developed in the nineteenth century returned the heart to the body without fully planting it there (fig. 26). Images showed a glowing image of the heart placed over the body of Jesus and usually being pointed to by him. During the nineteenth century, the Sacred Heart became a portrait of the loving Savior, an image through which the devout saw and were seen by their Savior. If Batoni portrayed the heart accompanied by Jesus, nineteenth-century devotional artists commonly reversed the preponderance, focusing attention on Jesus, who in turn displayed or referred to his heart. The heart was pictured on the person of Jesus, who pulled aside his clothing to reveal it, all the while looking steadfastly into the eyes of the beholder, explaining in his very face and gesture, in his embodied presence to the eyes of faith, what the Sacred Heart meant. Not a theological abstraction, the meaning was affective and material—it was the person of Jesus.

Where Alacoque associated the displayed heart with the humiliation and insults directed at Jesus by Christians who abused or ignored the Eucharist, the new visual practice in the nineteenth century was to engage viewers with a tenderly sympathetic Jesus. If (erotic) passion for Jesus was suffering (*passio*) in her experience of what I have characterized as empathy (feeling into), in the nineteenth century, sympathy (sym-*pathy*, feeling with) replaced the association of suffering and passion. A corresponding shift in the meaning of being touched pertains to sympathy: viewers are touched or moved sympathetically, moved on behalf of the tender Savior. The move to sympathy as the dominant tone of the devotion marks the primary framework for the modern career of

FIGURE 26. Artist unknown, *Sacred Heart of Jesus*, late nineteenth century. Photo: author.

the Sacred Heart. As a more pastoral aspect of the devotion, sympathy posits an affinity or inclination between Jesus and the soul. Jesus is shepherd, father, or friend to the soul, not lover. In the visual piety of sympathy, the image of Jesus visualizes the recognition of the soul and Jesus as sympathetic or attuned to one another. The aim is to be recognized and accepted by Jesus, seen by him and drawn close to him. As a result, the heart became less organ and more image. This is not to say it became a symbol per se, but the representation that led to the true heart. The heart was a metaphor of the love of Jesus, his attitude toward his followers. The nineteenth-century Sacred Heart appeared in the midst of the breast of Jesus, embedded in the person rather than appearing by itself (see fig. 26) and held in the hand of Jesus (see fig. 25). The "forgetfulness of self" that Alacoque passionately pursued at Jesus's command ("I was to cling to nothing, to empty and despoil myself of everything, to love nothing but Him, in Him and for the love of Him, to see in all things naught but

Him and the interests of His glory in complete forgetfulness of self"[30]) was gradually metamorphosed into a self-effacing modesty palatable to a broad lay devotion. Masochistic self-loathing became unassuming meekness, humiliation became humility. This was accomplished not by putting new words into Alacoque's mouth, but deftly editing her autobiography. The Sisters of the Visitation of Paray, the convent in which Alacoque had lived, issued an edition in 1867 that suppressed certain passages, which were not restored until the sisters issued a new translation in 1924.[31]

This third moment of the devotion's rhetorical history could be said to arise when the Sacred Heart had come to operate principally as a metaphor. Neither fetish nor symbol, a metaphor is both itself and something else. To say, as Alfred Noyes put it in his well-known poem, "The Highwayman," that "the road was a ribbon of moonlight over the purple moor" is not to evacuate the road of its "roadness" such that it was no longer a road, but to enhance the reader's imagination of the scene by bestowing on the road a compelling duality.[32] Metaphor describes the field of vision in which things are estranged from their common-sense reality, but not sundered altogether from it. Metaphor opens up a distance between the viewer-reader and the object in order to endow the object with an additional reference or meaning. Metaphor is a semiotic status of ambivalence that performs ontologically: the road is a ribbon, but it's also still a road. It is a sinuous ribbon in the eye of the Highwayman as he surveys the dark moor ahead of him. The power of metaphor resides in its ontological claim. The road is not *like* a ribbon; it is one. The importance of this is that the poetic utterance transforms or metamorphoses the road into something else, which transposes the reader's consciousness to the field of vision unfolding before the galloping Highwayman. We see what he sees, we don't think in the similes of a poet. The difference is one of immediacy conveyed by the ontological transposition of metaphor. And yet, it's just a metaphor. The road remains a road. What has been shaped is the reader's perception or imagination of it.

To apply this to the Sacred Heart, the image operates as a metaphor rather than fetish when it is the flaming, wounded heart of Jesus offered as the substance of forgiveness. To say the heart of Jesus is love is to speak metaphorically. The image is a metaphor when it asserts visually that gazing upon the heart is looking upon Christ's act of love: giving his heart and substance for the redemption of humankind. He is no longer intimately sharing himself with his lover, but showing the means by which he has saved all whom he loves.

This shift is from a visceral substitution of heart for penis to a transformation of body into sacrificial offering. For Alacoque, the heart was this and more. For most of her followers in the eighteenth and nineteenth centuries, the heart lost its function as fetish or substitute and became a metaphor of divine compassion as the gaze of the viewer refocused from the heart to the person bearing the heart. This is not to say that the heart lost its nature as a bloody organ. But now the devotional discourse spoke of the heart of Jesus as his love, the charity or compassion that is afire in his redemptive acts of self-sacrifice, and the love he would inspire in others not simply by example, but by a kind of emanation or better, convection of the heat that emanates from the heart, streaming in radiant beams from its center. The operative action shifts from empathy to sympathy.[33]

As the piety developed during the nineteenth and twentieth centuries, the moment of metaphor developed in some cases into a fourth phase, which may be called symbolic. One senses this shift subtly at work in an instructional text by an English priest, published in 1853. John Bernard Dalgairns conveys in the following passage the inherent tension between symbol and reality, love and heart, organ and figure, now tipping toward the symbolization of the heart:

> Therefore, though, of course, it is taken as a symbol of the tenderness, compassion, and love of Jesus, it is, not a mere figure and expression, but His own very Heart which we worship. Its pictured image on the altar is only in a relative sense the object of worship, though Jesus declared to sister Margaret Mary that He took an especial pleasure in the honour paid to that sacred symbol. Still the Mass and the Feast were instituted to honour, not the picture, but His Sacred Heart which is now in heaven . . . But when the Church bids us sing in that part of the office which most expresses her intention, *Cor Jesu charitatis victimam venite adoremus*, we cannot doubt that she proposes at once the Person of Jesus, to be the primary or material object of our devotion, and the real Heart of flesh and blood, taken as a symbol of His love, to be its formal cause, or, to use plainer language, its motive.[34]

Dalgairns was still at pains to affirm the actual heart of Jesus, but he reduced it to a "motive," a literary figure whose principal purpose "as a symbol of His love" was to direct one to the person of Jesus.

This significant shift to the symbolic occurs when the metaphor condenses into a sign, which takes place in polemic, in teaching, and in theological discourse. The *symbol* of the heart is used to signify theological meaning. It is an aid to memory, an abstract device, a pictogram or hieroglyph that stands

for an experience as much as for a conviction, even a dogma. It is the stuff of catechisms and creeds. The symbol is conducive to education, to teaching children and converts, to the mass circulation that graphic reproduction enables. It promotes formulae and procedures that exert powerful structuring among large numbers of people, promotes mass movements, and delivers a devotion from one generation to another. During the first half of the twentieth century, devotion to the Sacred Heart came to regard the Heart as a symbol of Jesus's compassion, the emblem of his love for humanity. Avoiding as excessive or even pathological the blood and pain prized by the Baroque versions of the piety, parish priests, religious educators, and catechism teachers used the ubiquitous iconography of the Sacred Heart hanging in classrooms and fellowship halls to teach submission to Christ as Lord and as the symbolic expression of his self-sacrificing love. Many twentieth-century Catholics saw the image as a visual device encoded with meaning that needed to be deciphered. As a symbol it became a didactic tool in teaching Catholic doctrine, used to bridge two or three generations of Catholics, especially in America, where the immigrant generation remembered older forms of the devotion while their children and grandchildren could find the penitential practices and Baroque sensibilities repulsive and "old world." Thus, the image could become a symbol of an outdated, ethnic Catholicism. The older piety could be remembered, if wincingly, by many educators and priests, especially in the wake of Vatican II, who relegated the pictures to backrooms or the trash bin. The use of the image came to turn on memory, especially in rites of commemoration, remembering priests and community figures under the blessing of the Sacred Heart of Jesus, or in trying to forget an embarrassing version of the faith in the face of modernity. Whether it was a symbol of teachings or a symbol of what is best forgotten, the Sacred Heart did not develop a new iconography in this symbolic phase, but relied on existing images.[35]

While some opponents of the devotion removed pictures of the Sacred Heart from parishes and Catholic schools, the image itself vanished even within the circle of those devoted to the Sacred Heart (fig. 27). This remarkable development took place in the later twentieth century, when some came to feel that the symbolic device on Christ's chest was not necessary, and because it offended some who considered it an inappropriate intrusion on the central focus of the devotion: Christ himself. If the nineteenth-century iconography of Jesus pointing to the heart while looking at the viewer (see fig. 26) shifted

FIGURE 27. Vincenzo Gasparetti, *Sacred Heart of Jesus*, 1996, bronze, life size, Shrine of the Sacred Heart of Jesus, Karen, Kenya. Photo: author.

attention from the heart in Batoni's painting (see fig. 25) to the person of Jesus and the devotee's relationship with him, the new portrait type fixes entirely on the single, unified person of Jesus whose fingers points only to himself.[36] While the new image might seem to confirm previous reservations among Catholic critics about the "new devotion," namely, that picturing the organ of the heart sundered it from the unity of the body of Jesus, nevertheless, latter-day devotees consider themselves faithful adherents to the Sacred Heart. But removing the image of the heart from the breast of Jesus does allow them to focus on what one priest told me was "the whole person" of Jesus.[37] Indeed, it is difficult not to see in this sentiment an acknowledgement of the ultimately Jansenist objection to the iconography.

CRITIQUE AND COMPETITION: RIVAL SACRED ECONOMIES
IN THE HISTORY OF THE SACRED HEART

The history of the devotion of the Sacred Heart is an embattled one, exhibiting centuries of polemical writing for and against it, long theological treatises devoted to defending it from critics, promoting the official proclamation of a feast day in its honor, and beatifying and eventually canonizing Margaret-Mary Alacoque. Debate over the meaning and propriety of the devotion is important for the study of religious visuality because it provides something much more significant than a dense chronicle of theological disquisition. Whatever else they were, the debates were also about the role of materiality in religion inasmuch as we understand image and matter as fundamental features of rival economies of the sacred. Seeing and touching interweave in various ways through the history of the devotion and inform different notions of engagement with the divine. At the heart of this debate was a clash over the role of the body in penitence, that is, the operation of the human body in the subtle negotiations concerning the relationship of human and divine.

As described in chapter 4, a sacred economy is a system of exchange that organizes the relationship between a human being and a divine power. For example, Alacoque revealed that Jesus instructed her "to honour My Heart, by communicating on that day [participating in the Eucharist on the first Friday following the Festival of the Blessed Sacrament] and making reparation to it by a solemn act, in order to make amends for the indignities which it has received during the time it has been exposed on the altars."[38] Jesus, she promised, would reciprocate with abundant benefits to those who honored his Sacred Heart.[39] Galliffet commended the task of reparation as the "principal end" of the devotion.[40] Later endorsements of the devotion by bishops and other prelates granted indulgences to those who participated, releasing them from amounts of time in Purgatory. In other words, the value of the devotion was linked to the satisfaction of debt, both their own and that of others caused by offenses against God. Discussing the Feast of the Heart of Jesus, Galliffet carefully linked it to the sacraments of Penance and the Eucharist. Following Holy Communion, the devotee is directed to make reparation.

> This reparation is nothing more than an act of sorrow, mingled with love and confusion, coming from the depths of the heart and arising from the sight of the outrages and neglect which Jesus has suffered, and has each day to suffer, in the Holy

Eucharist. Prostrate in spirit at the feet of our Divine Saviour we show Him our sorrow, and try by profoundly adoring Him and paying Him every kind of homage, to make Him compensation and reparation for all the offences we have ourselves committed against Him and those committed by an infinite number of others, and we would thus cancel them if it were possible.[41]

Devotion to the Sacred Heart took the form of penitence and was clearly associated with the Eucharist, the body of Jesus. According to Alacoque, Jesus had instructed her to take Holy Communion "as often as obedience will permit thee."[42] The devotion was tied closely to the Eucharist in order to provide a personalized sense of divine presence in the sacrament and to direct devotional response to the sacrament and its reputed abuse. In images like Batoni's, the Sacred Heart was the body of Christ returning the viewer's look. Attachment to the heart of Jesus was a Baroque figuration that followed the late medieval material devotion to the body of Jesus—Corpus Christi, the Wounds of Christ, the scourged body of Jesus's Passion, the Eucharistic host, forms of embodiment which we saw informed late medieval visual piety reflected in the Veil of Veronica (see figs. 11 and 12) and that relied on the sort of imagery produced by Dürer (see figs. 5 to 8). But the Baroque piety was one that selected the intimacy of the heart as a way to engage Jesus in an emotionally compelling exchange, a relationship of romance, affection, tender intimacy, and even eros, in the case of Alacoque herself. The association of the Heart with a portrait of Jesus whose look sought out the penitent viewer enhanced the interactive appeal of the heart as a special form of touching and being touched by the Savior.

The power of the new devotion for its adherents resided in intensification of atonement and penitence as embodied and visual practices. And it was precisely this that attracted opposition to the devotion and its visual forms. Galliffet opened a brief chapter on pictures of the Sacred Hearts of Jesus and Mary with a sad acknowledgement that the image of the Sacred Heart of Jesus has "even been subjected to a kind of persecution on the part of the opponents to the devotion to the Heart of Jesus."[43] He claimed that the Heart was "the centre of those sufferings that worked out our redemption."[44] The heart, physical expression of Baroque inwardness and embodied spirituality, was the site of the injury Jesus received in life and in the disregard for the Eucharist ever since. Because the heart was understood to be the seat of a person's life, it served as the vehicle of suffering and feeling. Addressing the heart of Jesus with adoration and petition was therefore of special efficacy. Galliffet

considered the visual aspect of the devotion to be of central importance because reparation was readily made through honor paid to the image:

> This ought to be one of the chief interests of those who are devout to the Heart of Jesus: they should zealously endeavour to obtain this glory for the Sacred Heart, in order thereby to make reparation for the injury the devil has done it, by inspiring men with a dislike for its picture. They should have the picture exposed for veneration with the greatest possible magnificence in churches, in houses, in private oratories. They should carry it along with them as a precious token of their love for Jesus Christ, and as a defence against the temptations of the devil, who must fear and shun this image more than any other.[45]

The image was a talisman as well as a form of honoring Jesus and paying reparations for offenses to him and to the Sacrament of the Altar. The devotee was urged to "carry" it, that is, to place it on one's body, touch it, display it. Its power was tapped by physical contact. Carrying the image was part of the reparation to be paid, that is, part of the penitential economy that the Jesuits promoted by means of the devotion. Alacoque urged a fellow nun working zealously among Huguenots to dedicate herself to the Sacred Heart in order to enhance her success and sent her "a little act of consecration, which you can wear over your heart together with a picture."[46]

In fact, Alacoque urged many nuns to display on their tunics a small, engraved reproduction of the emblematic image printed on paper (see fig. 24).[47] In a letter of 1689 to her spiritual director, Fr. Croiset, she insisted on the use of the image of the heart and linked it directly to blessings that followed from its display: "It must be honored under the symbol of this Heart of flesh, whose image He wished to be publicly exposed. He wanted me to carry it on my person, over my heart, that He might imprint His love there, fill my heart with all the gifts with which His own is filled, and destroy all inordinate affection. Wherever this sacred image would be exposed for veneration He would pour forth His graces and blessings."[48] The practice marks a development in Alacoque's project, moving from the earlier, especially ascetic days of carving Jesus's name into her flesh to attaching a paper engraving over her heart. The imagery helped her shift from the internally directed project of self-mortification to the public program of promoting the devotion. During the final years of Alacoque's life, the hieroglyphic image came to mark the social body of the devotion, aligning the individual bodies of devotees in the manner of a shared totem.

The devotion to the Sacred Heart appealed to many people because it enhanced penitence by making it less ascetic, more tender and sympathetic. The devotion became a penitential ideal promoted by the Society of Jesus. But this sponsorship also accounted for the bitterest antagonism toward the devotion. Jansenism's stark opposition to the Jesuits turned on the order's rejection of Jansenism's Augustinian understanding of grace and penitence. Moreover, Jansenists attacked the Jesuit support for the submission of national churches to the papacy. Jansenism championed a notion of spiritual liberty, which the Jesuits found Protestant in spirit, but which prelates and priests who opposed a strong Vatican role in the church welcomed as consistent with ancient ecclesiastical practice. We can also recognize in the stark opposition of the two groups an abiding difference over the role of the human body in the preparation to receive grace. In the following discussion, two rival Catholic conceptions of embodiment and body practices will emerge in the polemical barrage and serve to clarify the outlines of rival sacred economies.

The Jesuit promotion of the Sacred Heart dates from Alacoque's lifetime. Her confessor, beginning in 1675, was a young Jesuit named Claude de la Colombière, who enthusiastically endorsed her visions of the Sacred Heart even while her convent struggled to deal with her eccentricities.[49] The Jesuits came to make special use of the Sacred Heart over the course of the eighteenth century because they recognized in it a powerful appeal to a penitential economy that stressed indulgences, the Eucharist, the sacramental life of the church, and obedience over against Protestants on the one hand, and reformers such as the Jansenists within the Catholic Church on the other. As the Counter-Reformation movement par excellence, the Society of Jesus had set itself against the theological, liturgical, ecclesiastical, and metaphysical programs of the reformers in the endeavor to champion the interests of the Catholic Church and reverse the inroads made in northern Europe by Lutherans and Calvinists. In France, a principal target was the Huguenots, a Calvinist sect, who were subjected to violent persecution by Cardinal Richelieu, which was continued after his death by Louis XIV, who revoked the Edict of Nantes in 1685. But opposition to reform also was exercised within the Catholic Church by opponents of Jansenism, a movement that began with the eponymous Cornelius Jansenius's study of Augustine's theology, *Augustinus* (1640), and extended to the eve of the French Revolution. The controversy between Jesuits and Jansenists, especially in France, has been extensively discussed, so my discussion will focus only on aspects related to the Sacred Heart.[50]

Politically, the controversy dealt with national control of the French church and state versus Ultramontanist control from Rome. The debate's relevance for the history of devotion to the Sacred Heart may be summarized here as regarding different views on grace and the material practices of penance. Theologically, the debate centered on the understanding of divine grace. Basing their view of grace on Augustine's notion of predestination, Jansenists argued that the saved are elected by God for salvation and that the effect of divine grace upon them is therefore irresistible in accord with God's sovereignty. All others are rightly damned, irredeemable from their native state of complete corruption. According to Jansenist polemic, Jesuits were latter-day representatives of the Pelagian heresy fought vigorously by Augustine, who opposed his notions of predestination and efficacious grace to the emphasis on free will and the power of human beings to participate in their salvation by the assent they give to the gift of divine grace. In this regard, devotion to the Sacred Heart amounted to reliance on a means of grace that obviated the rigor of Jansenist introspection and penitential discipline.[51]

The principal organ of the Jansenists was the weekly underground newspaper *Les Nouvelles Ecclésiastiques*, which began publication in 1728 in response to the contested career of the papal bull "Unigenitus" (1713), Clement XI's denunciation of the theology of Jansenius.[52] A frequent target of scorn and criticism in the paper was Jean-Joseph Languet de Gergy, general vicar of the diocese of Autun, which included the parish of Paray-Le-Monial, site of Alacoque's convent. Languet examined her life and vigorously promoted her cause. He published a Latin edition of her autobiography and in 1729, then Bishop of Soissons, published *The Life of Venerable Margaret-Mary*, which *Les Nouvelles Ecclésiastiques* regularly characterized as a "novel." Languet's *Life* was read by Jansenist critics as exhibiting the sensational features of a steamy romance. As Archbishop of Sens a few years later, Languet published a catechism that came in for explicit criticism in the pages of *Les Nouvelles Ecclésiastiques* for its treatment of grace. "Actual grace, says Monsieur Languet, is that which *disposes* us to be saints, or to become so *when we cooperate with it*. We call this actual, adds the new doctor, because it is a transitory and interior movement by which God *excites* us and *helps* us to do good. In this lesson of the Catechism of Monsieur Languet we do not find a single word about the force and the power of the grace of Jesus Christ. . . ."[53] The italics are the reviewer's, serving to accent what he considered the Pelagian character of the Archbishop's theology: the autonomously human power to work with God

in effecting the good and pleasing him.[54] Conducted in tandem with frequent Communion, devotion to the Sacred Heart was one of the practices encouraged by Jesuits for satisfying the offense of sin. For Jansenists, this made the devotion doubly suspect: it was a way of mechanically usurping divine grace and it was a devotion endorsed by Jesuits.

Central to the debate was the acquisition of grace through the sacrament of penance. The Jansenists insisted that the true form of penitence was contrition. In order to partake of the Eucharist, and receive thereby forgiveness of sin, the believer must undergo prolonged introspection, a rigorous and withering self-inspection that results in a dismantling of pride and self in the recognition of no merit whatsoever. That was a contrite heart. Only after achieving such contrition, or self-emptying, could the sacrament be received to good effect. Antoine Arnauld, often called the chief polemist of the Jansenists, issued a mammoth work in 1643, *On Frequent Communion*, in which he attacked the Jesuit position as heretical, arguing that preparation for receiving the Eucharist must involve extensive efforts at contrition, meaning that frequent communion was not suitable, and that one preserved the honor of Jesus by refraining from Communion while pursuing contrition. Arnauld's long treatise drew on a range of authorities to argue for a vigorous penitence as the basis for achieving contrition.

The bodily nature of this procedure was unmistakable, and it was a part of an economy that was corporeally severe. "The sacrament of penance," Arnauld proclaimed, "was established by Jesus Christ in order to enable purity of soul, or to put it better, in order to make reparation for it, and . . . it follows that in order to satisfy fully the intention of Jesus Christ, all who are chosen by grace must pass through this arduous baptism, which includes many tears, afflictions, and labors, according to the council and all the fathers, to prepare oneself for the Eucharist."[55] The pursuit of contrition was a viscerally embodied effort for Arnauld and the Jansenists, and was registered in the tears and fasting of self-examination. Arnauld urged his readers "to know the satisfaction that consists in fasting, in alms, and in the other exercises of the spiritual life." "God," he assured them, "will take residence in your heart when you have fled the world: he will open his arms to you provided that you return to him in groans and sighs; when your tears will speak for you, he will listen to their voice: he will forsake the plan to punish you, when he sees that you are punishing yourself."[56]

The Jesuits countered this ascetic rigor with the more practical service of what they called *attrition*, that is, an attitude of submission motivated by fear

of eternal punishment. Attrition was clearly something that a much greater number of people could practice, and therefore Jesuits encouraged frequent communion in order to secure forgiveness. According to the Jansenists, if few people could practice contrition, it was only evidence that God does not provide efficacious grace to many. While Jesuit polemic complained that this wrongly portrayed the God of the Bible as cruel, the Jansenist reply was that it underscored the power and sovereignty of a God who acted according to his own counsel.[57] The Jansenists rejected the efficacy of the devotion to the Sacred Heart, insisting instead that the oldest forms of self-mortification such as fasting and alms-giving, as well as prayer and uncompromising self-inspection leading to abasement of the self, were the tried-and-true means of achieving a contrite heart. It was a practice of the few, and it is striking that so many of the Jansenists were well-placed members of the French elite. Retirement from worldly affairs was the Jansenist ideal, and it is no mistake that the central institution was Port-Royal, a convent whose abbess was Angelique Arnauld, the sister of Antoine.

The history of theological debate is of greater interest to scholars of material culture when its controversy sheds light on the ritual and devotional practices of lived religion and bears directly on differing ideas about the role of devotion in regard to the body, which have something important to say about the relationship between seeing and touching. Though obviously part of an elaborate theological apparatus, penitence was a ritual form of belief that was of ardent practical concern to ordinary people as well as to theologians, confessors, religious, clergy, and ecclesiasts. Devotion to the Sacred Heart appealed to the Jesuits (as well as to many others) because it took seriously the response of the devout to the sacrificial offering of grace by Jesus. Human beings had the power to respond, to exercise free will in response to Jesus's offer of his heart. Devotion to the heart of Jesus repaired the insult and offense against him. Such atonement was the work of the devout. Each person was called to struggle toward making amends, paying reparations for the insults to God caused by sin. This was to be done by penitential means, availing oneself of the Eucharist, undertaking ex-voto pledges such as pilgrimage; praying the rosary; attending masses on feast days; displaying and contemplating the image of the Sacred Heart, as well as images of saints, Jesus, and Mary; and through the acquisition of indulgences issued by popes and bishops in connection with the adoration of the Host, feast days, pilgrimage, or various novenas or other devotional practices. All of these served as the means for repaying the honor

taken from God by human transgressions. All served as forms of delivering grace, blessing, and spiritual favors to the practitioner. All were regarded as the individual's response to the offer of forgiveness.[58]

The Jesuit promoters of Alacoque's mysticism framed the devotion to the Sacred Heart as a corporeal materiality keyed to the practice of penitence. The supersensual object of faith—divine love—was hailed as the actual organ. Seeing the heart of Jesus meant grasping the promise of the Savior and engaging in a material economy of the sacred, paying homage to Jesus as compensation for debt. Jansenists believed that extensive effort at dismantling the self, which consisted of ascetic body practices such as fasting and other forms of mortification, was necessary to receive the offering of grace that would regenerate the soul. Both Jansenists and Jesuits believed that human efforts mattered. They differed, however, on the role of the body in question. The Jansenist saw the body as the medium of contrition, removing the self from opposition to God by the penitential efforts of rigorous self-inspection. The sacred economy was driven by God, whose grace alone was efficacious. The Jesuits focused instead on the body of Jesus, offered to all in the Sacred Heart. The human response was to engage in body practices that honored the Heart—displaying images, saying the rosary, attending Mass, and so forth. Such material practice paid the reparations owed God and secured the ready offer of forgiveness. The resulting debate over the efficacy of the rival body-economies of penitence calls attention to differing conceptions of the body within Catholicism. The Jansenists insisted, in Arnauld's words, that the truly penitent must "uproot their love of this world, which is enmity with God," that they must "remove from their heart the affections of the age."[59] Those seeking grace were taught to do so in the medium of the rigorously controlled body.

Although Jansenism displayed a bold disavowal of the popular visual piety involving sacramentals, devotional images, and the material culture of penitence promoted by the Jesuits, Jansenism accorded a key place to *introspection* in its theology of contrition. Consequently, Jansenism should not be contrasted as iconoclastic with Jesuit spirituality, which is famous for the role of interior imaging prescribed by the Ignatian *Spiritual Exercises*. Jansenist works not infrequently pose the human situation regarding divine grace in a distinctly visualist manner. For example, in his small book, *On Submission to the Will of God*, Pierre Nicole framed matters succinctly in strongly ocular terms: "There is a view of God which brings one to unity with him and exposes one to the light of his divine eyes; and there is another [view] that prompts

one to flee him and to shield oneself as much as one can from his presence."[60] According to Nicole, one of the chief polemicists and the principal editorial force, with Arnauld, among the Jansenists in Paris, the visual framework of the view acted as a self-emptying gaze for radically reorienting mortals so that they might recognize the sublime majesty of God in tandem with their own humiliation. "It appears," he wrote in his *Discourse on the Weakness of Man*, "that it was to dispel this natural illusion [of human greatness] that God, intending to humble Job beneath his sovereign majesty, made him as it were go out of himself in order to contemplate the great world and all the creatures that fill it, thereby to convince him of his impotence and weakness, causing him to see how there are things and effects in nature that surpass not only his force, but also his intelligence."[61]

Rather than deploy the ego-squashing machinery of the unilateral gaze or the corresponding optics of the sublime, the Sacred Heart image relies on a reciprocal or a devotional gaze to appeal to devotees and to establish a visual connection with them. The Jesuit approach was calculated to find a far broader basis in popular devotion. Seeing the body of Jesus, the bloody heart held forth for visual inspection, was the avenue for penitential engagement. Jesus touched the soul in his act of presenting his heart, embracing the devotee with the lighter touch of sympathy. Seeing became the medium of being moved, of sharing moral affections or fellow feeling. The image of the Sacred Heart came to be beloved for its beauty. This opened the way for the development of an aesthetic of sacred beauty in the next century. Dalgarins, the nineteenth-century defender of the devotion, stressed the aesthetic means of the devotion's appeal: "God uses what is naturally attractive in order to win us to Him, and when we think that we have been simply gazing on something beautiful, we suddenly find that God has caught us with His gentle craft, and that its beauty has been a channel of grace to our souls."[62]

Sympathy, or feeling for others, may be defined in several different ways, but for devotees to the Sacred Heart it came to have much to do with a deeply felt sensation of debt or obligation, which fit neatly over penitential reparation by signaling its economic operation in the medium of vision. To see the suffering of Jesus was to be moved by it to response, which was the offering of one's sympathy as a reparation for his injury. Consider the following summary of the effect of the Sacred Heart in an American edition of one of the devotion's periodicals: "The thought of the infinite love of our Divine Lord gives rise to the desire to make a return of love; the sight of the Sacred Heart of our Lord,

so infinite in dignity, and overflowing with all perfections, awakens a desire to render It every homage; and the reflection that this infinite love has met with such a return, arouses a feeling of grief and sorrow, and a desire to make reparation for such injuries, especially as regards the Sacrament of Love, the Blessed Eucharist."[63] The position is consistent with Alacoque's view, but fixes on the sight of the image and the pathos it engenders. Seeing the Sacred Heart was belief in a modern world in which the claims on the bodies of the devout were far too demanding for withdrawal and the vigorous spiritual calisthenics of the Jansenist elect. The aim instead was to appeal to the masses of Catholics by a visual devotion that might achieve a broad "sympathy" or "union" with Jesus.[64] But the union in question was not mystical. It was affective and mobilized, an aesthetic sympathy geared to action in the world. As we will see in the next chapter, the idea of sympathy as shared moral feeling went on to have a broad social career in Europe and America.

The image of the Heart acquired a presence in devotional life that directed responsive action. One nineteenth-century catechism articulated the bodily power of the image to elicit a sympathetic response. Asked if the meaning of the image can be conveyed to the catechist "when your eyes rest on a picture of the Sacred Heart," the prescribed reply is: "Yes. The Heart which Jesus presents to me recalls His love, which naturally demands that I should love Him. . . . And if I notice Jesus's gaze fixed upon me, His right hand, which seemed to ask for my heart, do I not hear the words, 'Learn of Me, for I am meek and humble of heart. Follow me?'"[65] Jesus looked for followers with his "outraged" and imploring gaze, and found them. While the Jansenists had been content to withdraw to the oratory and monastery, the Jesuits set their sights on a larger arena.

The Look of Sympathy

Feeling and Seeing

Sacred objects and devout viewers engage one another in a variety of felt relations. Consider the way the children comport themselves before the American flag in a photograph by Jacob Riis from the early 1890s (fig. 28). They stand at attention, saluting, aware that they are being looked at—by the photographer, by their teachers, by one another, by the girl who holds the flag. But also by the flag itself, or by what may be said to look through it, peering at them through the eye of the sacred object. To turn aside, to refuse to salute, to smirk, or chat with one's neighbor would be to deprive the flag of its due, and almost certainly to suffer the teacher's disapproval. But they seem aware of something more than a symbol and their fellow classmates. The ritual of civil piety appears to conjure a special presence. This presence emerges in the visual field of the communal gaze: the children look reverently upon the flag, but also upon one another looking at the flag. Yet the flag itself is the object of their visual devotion, as the words of the Pledge of Allegiance made clear, written in 1892 by Baptist minister Francis Bellamy: "I pledge allegiance to the flag . . . and to the republic for which it stands . . ." The pledge venerates not only the idea of nationhood symbolized by the flag, but *this* flag. The children are constructed as citizens of the United States in two coincidental visual fields: the communal and the devotional. The combination rivets them in attention and shapes their bodies and minds simultaneously as patriotic devotees of the nation. Whatever the children were thinking individually at that moment, in a collective, embodied sense they were doing the same thing. In this way the ritual taught them to belong to a single social body.

FIGURE 28. Jacob Riis, Flag veneration exercise at Mott Street Industrial School, ca. 1890. Courtesy of the Library of Congress.

A contemporary guide to flag veneration in American public schools, which likely scripted the event at New York City's Mott Street Industrial School pictured in figure 28, demonstrates that evoking the sense of national presence was precisely the aim of such ritual practice. Colonel George T. Balch, Civil War veteran and examiner of the public schools of New York City, opened his *Methods of Teaching Patriotism in the Public Schools* (1890) with an epigraph from a sermon by the Rev. Henry Ward Beecher, in which the clergyman proclaimed that a thoughtful person looking at a nation's flag "sees not the flag, but the nation itself."[1] The children present themselves to the flag and to one another because doing so makes them part of a national body, which they feel in the reverent attention of their own bodies. The theatricality of the moment pictured in Riis's photograph suggests that he was there to document the emerging educational practice of enforcing patriotic solemnity among students by conducting ritual veneration of the national flag. In effect, a devotional gaze was staged in the classroom for the purpose of inducing civil piety. By placing students within the visual field of devotion, schools sought to reembody the

children, to teach them to think and feel and see as part of the social body of the devoted American citizen. How was this understood to work? That is the task of this chapter. Of special interest is the relationship between seeing and feeling, which will allow us to explore how seeing participates in the larger enterprise of affectively organizing social life.

The social practice of securing the nation by venerating its symbol is part of a history of ideas and practices about nationhood and about feeling as a medium of participating in national community.[2] As democracies formed in the course of the eighteenth century, European and American thinkers reflected on the nature of social bonds that might keep social relations stable in the wake of more traditional arrangements. Civil religion was one idea, most famously discussed by Rousseau, as the minimal tenets of a common faith that would bolster the social contract, holding together the society by rewarding virtue and punishing vice. Another was the idea of civil society, which likewise sought to maintain a just compact between individuals and community.[3]

A great deal of eighteenth-century social thought was devoted to the problem of human relations. One treatise that contributed importantly to considerations of the nature and importance of morality for social conduct was Adam Smith's *Theory of Moral Sentiments* (1759). As noted in chapter 1, Smith described what he believed was the basis of the moral structure of society by investigating the human capacity for fellow feeling, or sympathy. When placed within the history of the social construction of feeling and the felt-life of religion, Smith's book offers a useful starting point for the modern history of feeling and its relevance for the study of religious visual culture.[4]

The Theory of Moral Sentiments undertakes an ingenious psychological analysis that grounds moral conduct in the experience of seeing and being seen. According to Smith's empiricist account, moral behavior sprang not from innate principles, but from the feelings of approbation and censure that children encountered in the gaze of others from their earliest days. Children learn to internalize this gaze and use it to scrutinize their own intentions and behavior. Sympathy was the felt-connection that motivated behavior intended to elicit approval. Smith believed that moral judgment was an individual procedure of introspection: "We suppose ourselves the spectators of our own behaviour, and endeavour to imagine what effect it would, in this light, produce upon us. This is the only looking-glass by which we can, in some measure, with the eyes of other people, scrutinize the propriety of our own conduct."[5] But it was an odd looking-glass because it combined the self and the self-looking-at-itself.

The self did not look back, but was split into two irresolvable acts. It was not a reciprocal gaze that Smith imagined, but an internalized unilateral gaze. The self sees itself with the eyes of others.

The idea of sympathy went on to enjoy an important career, becoming a key term in the discourse on philanthropy in the nineteenth century and eventually in social reform. The optical trope of Smith's treatment of sympathy anticipated a visual tradition of sympathy, moral appeal, and campaigns for reform that culminated at the end of the nineteenth century in the photographic work of the journalist and social reformer Jacob Riis, who helped establish documentary photography as a form of investigating the social problems of poverty, tenement housing, disease, and the American urban underclass. By tracing the history of thought and practice concerning the visuality of sympathy from Smith to Riis, we are able to explore how images generate and regulate feeling as a means of achieving social well-being and cohesion. Deeply encoded in the life of fellow feeling may reside an antipathy for those who are not like "us." The history of feeling is by no means all sweetness and light. It will become evident that the felt-life of religion exhibits a tension between welfare and solidarity. By scrutinizing how images were used to generate sympathy, we will see that the sense of community depends on both feeling for one's fellows (sympathy) and feeling against certain others or aliens (antipathy).

FELT-LIFE AND MORAL SENTIMENTS

Adam Smith began his analysis of the sentiments by objecting to the view that self-interest drove moral conduct. Smith sought to distinguish civil society as rooted in "the fellow-feeling for the misery of others."[6] No matter how selfish people are, they all are moved by the fortune or misfortune of others. Pity and sorrow, he claimed, may be observed in even "the most hardened violator of the laws of society."[7] Sympathy, or the experience of feeling what others feel, arises in everyone and Smith regarded its formation as the moral life of humanity. Yet our senses cannot by themselves, he noted, deliver to us what another person feels. Smith used an excruciating example to argue his point: "Though our brother is on the rack, as long as we ourselves are at our ease, our senses will never inform us of what he suffers." It is "by the imagination only that we can form any conception of what are his sensations."[8] The imagination copies our own senses and uses these impressions to project us into the place of another: "By the imagination we place ourselves in his situation, we conceive ourselves

enduring all the same torments, we enter as it were into his body, and become in some measure the same person with him, and thence form some idea of his sensations, and even feel something which, though weaker in degree, is not altogether unlike them."⁹

The idea of sympathy became important for Protestant enterprises in moral reform, social benevolence, and charity. But in practice, the moral career of sympathy was never without an aspect of self-interest. On the Fourth of July, 1828, John H. Kennedy, an advocate of the emigration of free blacks and former slaves to the West African colony of Liberia, and assistant to the secretary of the American Colonization Society, delivered an address at the Sixth Presbyterian Church in Philadelphia entitled "Sympathy."¹⁰ Kennedy organized his discourse around the motif of the passerby beholding the slave in misery. In response, the slave asked white pedestrians: "Is it nothing to you, all ye that pass by?" (Lamentations 1:12, the text for Kennedy's sermon). Like Smith's account of projecting oneself into the situation of others, Kennedy insisted that sympathy was an obligation. He regarded sympathy as a natural human bond that compels response. Kennedy argued that the compulsion to react to suffering followed from "the community of interest subsisting between all the members of the human family. There is not only the material body of the Naturalist, and the Body Politic of the Statesman, but there is an ampler Body which includes every member of the human family. When a member of any body suffers the other members suffer with it."¹¹

Kennedy then turned to the question of slavery in the United States. This allowed him to narrow the contours of the "body" from the entire race to the national community of America and to relate the biblical text to the present: "As Americans we are specially interested in the circumstances and sorrows of the slave. We are the persons in the present instance who 'pass by,' the witnesses, and who have it in our power to disburden ourselves while benefiting them. Our Country suffers, and as lovers of our country we cannot be indifferent to what affects her standing and interests."¹² Yet the logic of the national body, as Kennedy understood it, urged colonization rather than immediate emancipation. The motive of self-interest is unmistakable. Whites in Philadelphia and other northeastern cities found free blacks competitive in the labor market and increasingly resentful of racism. But the Colonization Society couched its rationale in the rhetoric of paternalism. Exclusion from equality in the United States, Kennedy reasoned, doomed the black to degradation and ruin. "The remedy is, that he be removed from those moral disabilities he

is now subject to. The Colonization Society has provided an asylum on the North-western coast of Africa where he may enjoy every advantage."[13] Kennedy assured his audience that once a viable nation was in place, many slave owners would voluntarily release their slaves for the purpose of emigration. His message was that blacks would do best in a nation of their own.

In effect, sympathy in this instance did not mean empathy, but condescension in order to preserve difference, and therefore the homogeneity and integrity of America as a *white* community. Advocates of colonization wanted free blacks to have their own racially homogeneous community—on another continent. The stakes were high, according to Kennedy. Slavery, he warned the congregation, threatened "*our* ruin." By "withholding from others what [Providence] has freely bestowed on *us*," slavery would "sweep this promising empire" to destruction.[14] According to the pro-colonizer's logic of sympathy as fellow feeling with the national body, it was imperative for its well-being that blacks be removed from it. Some southern slaveholders promoted colonization of free blacks because they hoped it might remove from their midst a stimulus for slaves to long for freedom. For northern whites in favor of colonization, sympathy did not mean longing for tolerant coexistence, but the urge to do justice to blacks by giving them their own national body (which whites hoped would resolve the otherwise intractable problem of racial difference). "If I were a coloured man," wrote Archibald Alexander, Princeton theology professor and proponent of colonization, "I would not hesitate a moment to relinquish a country where a black skin and the lowest degree of degradation are so identified." But it was an act of sympathy that carried with it a complementary white revulsion: "I cannot but feel pity for the groveling views of many coloured men, now residing in a state of degradation in this country, who in Liberia might rise to wealth and independence, and perhaps to high and honourable office." Blacks, in other words, should have wanted to leave and merited only pity (not sympathy) if they did not do so.[15]

The point was made visually in imagery issued at the time by the Colonization Society of the State of Pennsylvania, founded in Philadelphia in 1826. A "View of Monrovia" on a certificate of membership in the Society (fig. 29) portrays several well-dressed black Americans disembarking on the coast of Liberia, where they are warmly welcomed by residents. The image seems to register Alexander's stark contrast of pity and pride. American black émigrés enter their own national domain in the dignified manner that Alexander promised them. The rolling landscape envisions an African land of plenty, an

FIGURE 29. P. S. Duval & Co., "View of Monrovia," hand-tinted lithographic illustration from a life membership certificate in the Pennsylvania Colonization Society, 1830. Courtesy of the Historical Society of Pennsylvania.

apt counterpart to the fond myth of Edenic America. Replete as it was with evidence of prosperity, faith (note the church steeple marks the highest point of the city), and peaceful community, this pastoral glimpse of the capital of Liberia offered American blacks the prospect of respectability that many whites hastened to remind them they could not expect to command in the United States.

But the illustration conceals the countervailing view of many African American leaders in the United States who had no intention of emigrating and made remaining where they were a point of honor. Richard Allen, founding bishop of the African Methodist Episcopal Church, rejected the idea of colonization, pointing out that "This land which we have watered with *our tears* and *our blood*, is now our *mother country*."[16] In his rousing "Appeal to the Colored Citizens of the World," David Walker denounced the colonization movement and lamented the support it received from some blacks (by 1830 only 1,400 had relocated to the colony). Walker insisted that "This country is

as much ours as it is the whites, whether they will admit it now or not, they will see and believe it by and by."[17] Walker called on fellow blacks to throw off *apathy*, lack of feeling, which he identified as the consequence of enslavement and oppression: "Oh! My coloured brethren, all over the world, when shall we arise from this death-like apathy?—And be men!!"[18] In place of white condescension and lamentation no less than black apathy, African American leaders urged black self-awareness and pride in the explicitly visual form of the beauty of being black. "I would have you understand," Dr. John S. Rock told a mixed-race gathering in Boston in 1858, "that I not only love my race, but am pleased with my color," a point he made quite clearly by contrasting "the fine tough muscular system, the beautiful, rich color, the full broad features, and the gracefully frizzled hair of the Negro, with the delicate physical organization, wan color, sharp features, and lank hair of the Caucasian."[19] The importance of black pride was signaled in equally visual terms by Thomas Morris Chester during the second year of the Civil War when he called on African Americans to replace the iconography of white heroes with black ones:

> Take down from your walls the pictures of Washington, Jackson, and McCellan; and if you love to gaze upon military chieftains, let the gilded frames be graced with the immortal Toussaint [L'Ouverture]. . . . Remove from the eyes of the rising generation the portraits of Clay, Webster, and Seward, and . . . hang in the most conspicuous place the great Ward, the unrivalled [Frederick] Douglass, and the wise Roberts. . . . Tear down the large paintings in which only white faces are represented, and beautify your walls with scenes and landscapes connected with our history. . . . If you wish bishops to adorn your parlors, there are the practical [Richard] Allen, the pathetic [Daniel] Payne. . . .[20]

Chester's proposal was clever and bold—particularly during the early years of the Civil War, when news from the front was repeatedly gloomy for the Union. He shrewdly proposed engaging the iconoclasm of ousting images of white figures in order to install inspiring black counterparts. Iconoclasm is a powerful technique of not-seeing applied to revision. Rather than being a discrete visual field or gaze, iconoclasm is what one does to a gaze in order to subvert it, to deny its operation and power—in this case, the devotional gaze of white culture heroes. By either destroying an image (hard iconoclasm) or merely removing it from view (soft iconoclasm), iconoclasm curtails the operation of the way of seeing that an image activates, and by extension derails access to the social body that the gaze enabled. Chester's iconoclastic intervention was intended to rout the dearth of fellow feeling (apathy) among blacks

THE

ANTI-SLAVERY RECORD

Vol. II. No. I. JANUARY, 1836. Whole No. 13.

A FACT WITH A SHORT COMMENTARY.

FIGURE 30. Execution of a slave, *The Anti-Slavery Record*, vol. 2, no. 1, January 1836, wood-engraved cover illustration. Photo: author.

and instill in its place a compelling affective social bond (pride). He felt this was especially important to do among black children, "the rising generation." The new devotional gaze would invoke the social body of the race symbolized in such black culture heroes as Toussaint, Douglass, Allen, and Payne.

Seeing was imbued with intense feeling in different ways by different parties in American debates over race. Whereas advocates of colonization exploited pity to stoke support for the emigration of free blacks to Africa and black leaders countered apathy with racial pride, northern abolitionists provocatively used antipathy to inspire revulsion for slavery among whites. Abolitionist journals frequently used wood engravings on their covers as dramatic illustrations of acts of cruelty against slaves. For example, in 1836 *The Anti-Slavery Record* included a print of an owner executing a slave who refused to submit to flogging for sending the impish child of the master away from disturbing his family (fig. 30). A psychologically penetrating discussion of the story portrayed by the image followed in which slavery was shown to operate as a social

system of antipathy, the very opposite of sympathy. The master must abuse the slave lest he come to recognize the slave's humanity and be compelled to regard the slave as an equal: "Kind treatment will infallibly produce some degree of self-respect on the part of the slave, and this self-respect will not well brook any arbitrary and unreasonable exercise of power."[21] Antipathy was designed to produce apathy among slaves, as Walker had pointed out.[22] But the visual testimony of the print—judging from the slave's fine dress, the cruciform gesture of his arms, and the strong sense of family life in spite of obviously humble circumstances—was that antipathy, in fact, had failed to reduce the slave to apathy, requiring the desperate slave owner to commit the brutish act of murder.

The lesson also drawn from the event was the dehumanizing effect of antipathy on white masters. The writer was not surprised that the slave owner avoided trial. Prosecuting and punishing him would only have informed slaves that they had rights and would have encouraged them to insist on appropriate treatment from their owners. Expecting anything less from the community of white slave owners was unreasonable in light of the dynamics of slavery as a social system. Sympathy was distorted by self-interest into a community of antipathy. To illuminate his point, the writer considered the case of how schoolmasters responded to the corporeal punishment of students:

> We say there is an *esprit de corps*, a spirit of the class, among the schoolmasters, which stimulates them to honor their profession, by taking the part of its members. This spirit leads them naturally and almost inevitably to sympathize with the master rather than with the scholar, at least, in all not very flagrant cases. But if, in the mild and beneficent institutions of society, the judgment of men is liable to be warped, and their sympathy to be perverted, how much more in the harsh system of domestic bondage, where a common avarice is to be added to the *esprit de corps*, which takes sympathy from the slave and gives it to the master.[23]

The social body or community was animated by a complementary configuration of sympathy and antipathy. Human beings define themselves by social location, by feeling themselves into the body or presence of others. The national community that sympathy mediates is an imagined one, as Benedict Anderson suggested.[24] It is a social body that feeling creates through such ritual practices as the Pledge of Allegiance, patriotic parades, and the display of the flag on national holidays. These make feeling public and shared and construct in the process the transcendent nation, mediating it in the ritually configured social body of citizens. The nation is a way of seeing, a community of feeling whose

imagined boundaries are constructed by inclusions and exclusions. By practicing antipathy toward the suffering of slaves, whites created a social body that robbed them of the capacity for sympathy. Frederick Douglass captured this in his description of the bodily effect of the "fatal poison of irresponsible power" in the demeanor of one of his owners, Mrs. Auld, whose voice, shortly after his arrival as a young slave, lost its "sweet accord" and "changed to one of harsh and horrid discord; and that angelic face gave place to that of a demon."[25]

THE SOCIAL CONSTRUCTION OF THE SACRED

To belong to a community is to participate, to take part, to perform a role, to find a place within the imagined whole, which I have called the social body. Belief, it is important to point out, is not simply assent to dogmatic principles or creedal propositions, but also the embodied or material practices that enact belonging to the group.[26] The feeling that one belongs takes the shape of many experiences, unfolds over time, and is mediated in many forms. Moreover, belonging is nurtured by the *aesthetic* practices that are designed to generate and refine feeling on the crossed axes of human relationships and human-divine interaction.

By *aesthetic* practices I do not mean the philosophy of the beautiful as the term came to be used in the late eighteenth century, but rather "sensuous cognition," which is what the word was originally coined in 1735 to signify, based on Aristotle's use of the Greek word *aisthesis*, which means "perception" or "sensation."[27] The difference is important because it allows us to study the arts and media as ways of felt-cognition without being restricted to rigid hierarchies of taste that govern the judgment of beauty. It is the social operation of feeling propelled by images, objects, spaces, sounds, and movement that secures the relevance of material culture in the study of religion. This assumes that material culture, and the arts generally, are ways of generating, transmitting, refining, and sharing feeling. Material culture, and visual culture as a subdivision of it, is not principally the expression of ideas or doctrines, but rather the cultural production, circulation, and reception of felt-knowledge. This means that images and their uses should be examined for the ways in which they help to create forms of sympathy, empathy, antipathy, and apathy—feeling with, feeling into or as, feeling against or other than, and feeling not at all.

The unifying bond of ritual practice seems apparent in Riis's photograph of children saluting the flag (see fig. 28). The lesson is being learned in their

individual bodies as well as corporately in their collective or social body: to be an American is to stand together, side by side, revering the flag as a single national body. Civil piety was acquired by means of an embodied discipline, a training of young bodies no less than minds. This was certainly the intention of the ritual's author, Colonel Balch. He wrote that the purpose of his methods of making patriotic citizens was "to make an intensely enthusiastic and thoroughly loyal American citizen of every child in every school of this society."[28] For him and many like-minded Americans at the time (and since), the body of the nation was infected by foreign blood that needed to be naturalized by the disciplined practices of nationalism. In the preface to his book, Balch warned that American civilization had been "diluted" by "a vast number of [immigrants, who] bear in their physical and mental features the indelible impress of centuries of monarchical or aristocratic rule and oppression." In response to this threat to the health of the national body, Balch urged schools to adopt "such heroic remedies as will in future protect us from evils and dangers."[29] The metaphor moving through his text is the healthy body assailed by sickness from without. As a consequence, it was the physical effort of training the body in a daily regimen of flag veneration that offered to mold the newcomers into the firm social body of national loyalty (the students in the photograph are children of immigrants attending school in the heart of the slum district in lower Manhattan). It is not surprising that allies in his cause were hereditary organizations like the Daughters of the American Revolution (DAR), membership in which was limited to those who were blood relatives of participants in that war. It was the DAR, along with Balch, that led the charge to sacralize the national flag by lobbying for flag desecration laws.[30] For his part, Balch assured his readers that corporate veneration effectively molded the felt-life of children: "it will be possible to so direct the child's thoughts, to so surround it as it were with the atmosphere of patriotic feeling, that ... [the child] will insensibly become interested in and permeated with the thought or impression you are essaying to convey."[31]

If the flag veneration pictured in figure 28 organized the somatic bodies of patriotic citizens into the social body of the nation, it also was intended to engage citizens in reverence for a transcendent and sacred referent. Balch believed that the bodily veneration of the flag would generate the all-important feelings of allegiance upon which national cohesion depended. Veneration of the flag in public schools would manufacture sympathy, the communion of feeling that safeguarded the nation. The daily practices Balch prescribed

FIGURE 31. Unidentified photographer, "Prayer time in the Nursery, Five Points House of Industry," ca. 1890. Museum of the City of New York, The Jacob Riis Collection.

would serve "as a means of reaching and affecting the emotional side of the child's nature, and thus so exciting its imagination and touching its heart that it will unconsciously, but none the less effectually, become interested *in its personal relation to this great nation*."[32] The italicized phrase was perhaps meant to invoke the familiar Evangelical formula of cultivating a personal relationship with the savior. Balch went on to describe the child's "political faith" as a citizen of the American republic, and he scorned parochial or sectarian schools (Roman Catholic, Lutheran, Episcopalian, Quaker, and Jewish) in the United States as competitors to the public school system because he felt they instilled a rival allegiance to the primacy of American nationhood.

Balch's book appeared in the same year that *How the Other Half Lives* was published. Riis included in it an image by an unidentified photographer (fig. 31) that bears comparison to his schoolroom photograph (see fig. 28). Five Points House of Industry, located a few blocks from Mott Street, was a nursery that appears as a dark, cavernous space engulfing the luminous gathering of orphans in prayer. The children have been huddled in a semi-circle and

instructed how to pose. Most obediently close their eyes, but two or three gaze at the camera. "It was one of the most touching sights in the world," Riis wrote, "to see a score of babies, rescued from homes of brutality and desolation."[33] Sally Stein has aptly pointed out that the image preaches a confident faith in institutions as "the only real cure for the moral impoverishment embedded in the 'other half.'"[34] Riis's photograph of the school children (see fig. 28) likewise advocated the benevolence of the industrial public school as the necessary institutional intervention to make faithful citizens of immigrant children. In both instances, and in many others in *How the Other Half Lives*, Riis availed himself of a familiar Victorian device. Like Dickens, one of his favorite authors, Riis used children to trigger pathos in his viewers. The nursery image was intended to elicit compassion for their plight and the urgency of social reform. "Too often," Riis alerted his viewers, "their white night gowns hide tortured little bodies and limbs cruelly bruised by inhuman hands."[35] But prayer, like flag veneration, promised to transform the individual body into the redeemed social body of the nation.

IMAGES AND THE SOCIAL BODY OF FEELING

If Balch insisted that the challenge of immigration be met by assimilating foreigners to the American social body through nationalistic rituals, Riis responded to the plight of the poor by appealing to the public conscience of Christians. But where Adam Smith regarded sympathy as the imaginative projection of oneself into the situation of another person, Riis, like Kennedy, understood sympathy as the practice of pity, which always entailed the feeling of difference between middle-class viewers and the poor upon whom they looked. Feeling for the poor did not mean an empathic emptying of the self, but being moved on their behalf. Like many reformers, Riis sought to arouse sympathy for the poor, but he did so by stoking a holy anger or righteous indignation that was aimed at the slum lords and at Christian indifference. His images undertook a visual campaign that entwined sympathy and antipathy, an intermingling of impulses to pity and to revile. The indignity of abolitionist discourse moves through *How the Other Half Lives* and was applied to the task of reform. But the imagery and text of his book also manifest antipathy toward some immigrant groups in the tenements. Riis tended to sympathize with or condescend to those groups that were ethnically inclined (i.e., visually able) to become like the Anglo-Saxon, Christian majority. Both forms

of feeling—sympathy and antipathy—were linked to Riis's Christian self-understanding and mission. Parsing this dual aesthetic role demonstrates how images operated within a social infrastructure of religious feeling. Circulating in mass visual media and drawing on broadly shared religious ideals, the social life of feeling performed complementary acts of inclusion and exclusion.

As a police reporter writing for several newspapers during the late 1870s and 1880s, Riis had witnessed a dozen years of crime and degradation in the slums of lower Manhattan before publishing his sensational article, "How the Other Half Lives," in *Scribner's Magazine* in 1889. In less than a year, Charles Scribner's issued an expanded version of this and other essays of the time by Riis in a volume by the same name, which made the author's international reputation. But the immediate audience to which he addressed himself was New York City, for he sought to engage the middle-class reading public of the city as a community of conscience that needed to respond collectively to the social problems created by tenement housing. "Our city has lost opportunities for healthy growth that have passed not to return," he wrote, lamenting that lessons in urban planning that had not been learned. "Other cities that took time to think have profited by them, and have left to New York the evil inheritance of the tenement, the Frankenstein of our city civilization."[36] As the criminal monster spawned by an arrogant metropolis, the tenements were presented in the article and in the subsequent book as the subject for a campaign in social reform that would only commence with the city's recognition of the problem. That meant achieving a level of self-consciousness in which public conscience would move the city to recognize itself as a moral community united in fellow feeling.

Religion played an important role in the arousal of public conscience and the mobilization to action. Several times in his book, the Lutheran Riis mentioned attending in 1888 a public conference of Protestant clergy in the city on the subject of "how to lay hold of these teeming masses in the tenements with Christian influences."[37] Two of the speakers at that conference, the Rev. A. F. Schauffler, the manager of the New York City Mission Society, and Rev. Josiah Strong, encouraged Riis that same year when they saw his photographs. Another participant, the controversial reformer Rev. Charles Henry Parkhurst, invited Riis to speak at his church, Madison Square Presbyterian.[38] It is a striking list of figures. Parkhurst was an outspoken public critic of political corruption in New York City, attacking Tammany Hall from his pulpit in celebrated sermons in 1892. Schauffler worried about the spiritual vacuum

created in lower Manhattan as churches vacated the district for fairer locations uptown. He noted a net loss of fourteen Protestant congregations below Fourteenth Street during the previous two decades.[39] "We do not find fault with the churches for moving up-town, but we call your attention to the fact that the southern part of the island is proportionately being abandoned . . . the result is that the power is in the north, while the evil is down in the south, for the most part."[40] Schauffler feared that this opened the district to the perfidious influence of "the Anarchist," and ended his presentation with a rhetorical flourish: "Shall it be Christianity, or shall it be Anarchy?"[41]

Josiah Strong was a Congregationalist minister whose widely read book, *Our Country* (1886), advocated domestic mission work and stoked fears over immigration, "Romanism," Mormonism, and Socialism. He was confident that "North America is to be the great home of the Anglo-Saxon, the principal seat of his power, the center of his life and influence," which could extend, he stated at the close his book, to hastening the second coming of Jesus.[42] Yet, at the 1888 conference, Strong espoused a compassion that recognized no racial boundaries: "When I get near enough to a man to see in him the image of the Lord Jesus Christ, whether he be white or black, red or yellow, I must needs love him."[43] One might question Riis's commitment to reform by identifying his interests with capital and the genteel establishment to which he aspired as a new American, as some have done.[44] Scholarship in recent years has helpfully challenged the noncritical assessment of Riis's work long established in popular accounts and biographies. But neither critical revision nor popular hagiography has regarded the complex place of religion in Riis's work and career.[45] It is possible to discern in his imagery and writings an appeal to the Christian community of New York to respond with a moral outrage that would help put an end to the tenements. Riis was galvanized by the comment of a Brooklyn builder at the meeting of Protestant clergy who asked the assembly: "How are these men and women to understand the love of God you speak of, when they see only the greed of men?" Riis noted in his autobiography that when he heard that "I wanted to jump out of my seat and shout Amen!"[46] Riis also reproached fellow Christians for not taking a position against "the murder of the home in a tenement population of a million souls" and shamed them further by praising Felix Adler, secular Jewish leader and founder of the Society for Ethical Culture, as "among the strongest of moral forces in Christian New York."[47]

Riis organized *How the Other Half Lives* as a narrative that takes the reader inside tenements and beer dives, along streets, and into dark alleys. Along the

way he flings darts at the conscience of Christian New Yorkers, pointing out, for example, that "the agent of the Christian people who built that tenement will tell you that Italians are good tenants, while the owner of the alley will oppose every order to put his property in repair with the claim that they are the worst of a bad lot."[48] It was the entire city to which Riis directed his barbs: its politicians and slum lords, to be sure, but also its respectable Christian middle class and unresponsive churches. All were implicated, in his view: "If it shall appear that the sufferings and the sins of the 'other half', and the evil they breed, are but a just punishment upon the community that gave it no other choice, it will be because that is the truth," he declared with prophetic gravity at the opening of his book, and closed with a call for "the gospel of justice."[49]

In his autobiography Riis described his use of photography as a form of "evidence": "We used to go in the small hours of the morning into the worst tenements to count noses and see if the law against overcrowding was violated, and the sights I saw there gripped my heart until I felt that I must tell of them, or burst, or turn anarchist, or something."[50] Due to limitations in print technology, less than half of the illustrations appearing in *How the Other Half Lives* were halftone reproductions of photographs that he had taken on site as a journalist since 1888 or had borrowed from other photographers. The majority of images were wood engravings made from photographs. Yet his dozens of stereopticon lectures in the late 1880s and 1890s used lantern slides that were made directly from glass plate negatives, and his autobiography (1901) reproduced several of his photographs.[51] One photograph showed an English coal-heaver's home (fig. 32). The laborer, his wife, and their two young daughters confront the viewer with a moral appeal that Riis found haunting, and hoped his readers would, too. Viewers face the family's small, dark world, and face the gaze of each member of the family. A reciprocal gaze denies the viewer the comfort of looking from afar—one is seen seeing those one looks upon, and thus made present to them. The reciprocal gaze levels viewer and those one views to a common moral plane. The family members line the wall of the cramped space, which is bound on the left by "a heap of old rags, in which the baby slept serenely, [and] served as the common sleeping-bunk of father, mother, and children." Riis was especially drawn to the mother's face: "Her smile seemed the most sadly hopeless of all in the utter wretchedness of the place, cheery though it was meant to be and really was. It seemed doomed to certain disappointment—the one thing there that was yet to know a greater depth of misery."[52] Viewers face the photograph in a kind of confrontation.

FIGURE 32. Unidentified photographer, "In Poverty Gap, An English Coal-Heaver's Home," ca. 1890. Museum of the City of New York, The Jacob Riis Collection.

The poor look back, as if to ask what viewers will do, silently interrogating them in the manner of Kennedy's questioning slave and recalling the interior look of disapproval that Adam Smith described.

Early and enthusiastic response to Riis's magazine article came from The King's Daughters, a Christian fraternal order founded in 1886 in New York City by Margaret Bottome, the wife of a Methodist clergyman. They invited Riis to address their group at the Broadway Tabernacle, where he presented the article in the form of lantern slides. At the lecture he invited the members of the order to "make this work theirs," which they did, opening an office in the Mariner's Temple in the fourth ward in the summer of 1890.[53] A review of *How the Other Half Lives* in the Brooklyn *Daily Eagle* paired the book with William Booth's evangelical exposé of London's slums, *In Darkest England and the Way Out:* "What General Booth, of the Salvation army, does for London slums and their victims, ... from the church standpoint, Mr. Jacob A. Riis does for darkest New York from that of the other great saving power, the press, in

FIGURE 33. Jacob Riis, "In the Home of an Italian Rag-Picker, Jersey Street," ca. 1890.
Museum of the City of New York, The Jacob Riis Collection.

his admirable book."[54] The reviewer asserted that "all well to do New York
should read his menacing story and ponder it and his dismal photographs. . . .
The grimly picturesque result in both text and engraving is not so bad as Lon-
don can furnish, perhaps, but a pretty bad blot, nevertheless, upon our Ameri-
can Christian civilization."

Christian viewers faced in Riis's photographs of the poor an uncomfortable
claim on their conscience: they could not easily ignore the condition of the
poor without violating the fundamental moral commitments of their faith.
This may have inspired Riis to photograph his subjects in the iconographical
formula of the Madonna and Child, as in Riis's "In the Home of an Italian
Rag-Picker, Jersey Street" (fig. 33). Riis photographed the Italian mother and
child from an unusually low angle, the better to capture her heavenward look.
She is pictured in a sordid interior that brings to mind the stable of Jesus's
birth. The rag-picker himself is absent, as is Joseph in many images of the Ma-
donna and Child. This allows viewers to focus their attention on the tender
relationship between mother and child in humble circumstances. Riis's image

constructed a moral analogy whose effect on viewers must have been intended to be unsettling: the indifference shown by contemporaries to Mary and the infant redeemer was comparable to the modern Christian's attitude toward the urban poor.

Riis's use of images like the English coal-heaver's home and the Italian rag-picker's wife and child was intended to arouse the feeling of appalling disgust in order that it might prompt a complementary shame and pity among viewers, which would mobilize the force of conscience, the introspective glare of disapprobation described by Smith. The imagery stares back at viewers with an abject look deployed by the reformer to initiate a chain-reaction of feelings. Riis's work is certainly replete with examples of spectacle, images of an excess of degradation that moved viewers to dismay. Such urban scenes had fascinated New Yorkers before Riis began taking pictures and can be found in popular venues such as *Harper's Weekly*, where wood engravings from the 1860s to the 1880s frequently detailed the squalor of the tenements and lives of immigrants.[55] Winslow Homer's "Chinese Clubhouse," 1874 (fig. 34), is a montage of scenes in a club in Chinatown in which sailors gamble with dominoes as others smoke opium, all in the impious presence of ritual objects enshrined on altars (draped with bogus text banners). This kind of reportorial imagery (Homer sketched the scenes on location), which foreshadowed Riis's photographs in many respects, indulged in an urban tourism in which extraordinary sites were presented as picturesque spectacle. But in a few instances, such as figures 32 and 33, Riis transcended spectacle to engage viewers in self-scrutiny. Spectacle became speculum, mirroring moral deficiency and issuing the call to act.

The engagement of the Christian community with shame stimulated by the wretched countenance of tenement denizens in photographs recalls a powerful aspect of Adam Smith's theory of sympathy. By making photographs into mirrors, Riis could turn them on the Christian public. The scrutiny of the misshapen bodies, ragged clothing, and domestic squalor of the poor may recall the visual activation of conscience offered by Smith. "We examine persons limb by limb," he wrote, "and so by placing ourselves before a looking-glass, or by some such expedient, endeavour, as much as possible, to view ourselves at the distance and with the eyes of other people."[56] Smith suggested that the result was a bifurcation of the individual into what he referred to as the "agent" and the "spectator," the first of whom is judged by the second.[57] The internalization of the exterior gaze to which the individual is subjected formed a moral

FIGURE 34. Winslow
Homer, "Chinese
Clubhouse," *Harper's
Weekly*, March 7, 1874,
wood engraving. Photo:
author.

reflexivity that was the basis of conscience. Moral agency meant self-scrutiny, rigorous introspection. The bifurcation of the self is what allows people to place themselves in the situation of another. Self-alienation was the condition for sympathy.

The idea of the human self as formed in tandem with its image in a social mirror appealed to social psychologists in Riis's day. In 1902, Charles Horton Cooley used the phrase "the looking-glass self" to describe the process of recognizing oneself in others.[58] According to Smith's theory of moral sentiments and Cooley's model of the self, the viewer of Riis's images was not a unitary being, but an agent and a spectator conjoined in moral engagement. In the morphology of gazes discussed in chapter 3, we could say that moral self-consciousness results from an integration of reciprocal and unilateral gazes. The photographs used by Riis both return one's gaze and stare at the viewer,

that is, both implore and scold. What to do about this is the moral situation in which viewers find themselves. The internal spectator joins the agent to others constituting the community of feeling, the sense mediated by the images of all those sharing moral regard with the individual. But these others need to be specified as a discrete community of feeling in order to be compelling, in order, that is, for the emotional concatenation to persist from the prick of conscience to conviction to action. In effect, viewers confront themselves in the image, or one might say, in the manner of Smith's internal gaze, are confronted by the spectator.

Yet, as already implied in the case of Kennedy's notion of sympathy with slaves and with attitudes toward immigrants shared by Balch and fraternal organizations such as the DAR, the power of images to fuse communities of feeling harbors a dark side. Sympathy did not have to entail, as Smith and Cooley intended, putting oneself in the place of others. Nor did it have to mean condescending to them. Sympathy often operated as a form of fellow feeling that distinguished one group from another, building up one social body at the expense of another. I alluded earlier to the tension between welfare and cohesion in social thought on civil religion and civil society. This comes to the fore when we consider that *including* readily involves some manner of *excluding*. Shaping sympathies relies on limning boundaries, which can mean invoking antipathies. Boundaries are where one social body is conceived to end and another to begin. I say "conceived" because boundaries are not merely physical, but largely symbolic.[59] They express imagined difference and sameness, elaborated from actual or presumed differences such as race, ethnicity, religion, sexuality, class, or gender. The cultural work of representations of boundaries is to enhance the differences and make them a part of a community's self-conception, or ideology. The symbols of community, the signage of a social body, are themselves heavily charged as signs of difference no less than commonality. These are especially visible in Riis's tour of the slums when he encounters other religions. His description of the Jewish enclave in the fourth and seventh wards dwelt on difference: "The jargon of the street, the signs of the sidewalk, the manner and dress of the people, their unmistakable physiognomy, betray their race at every step."[60] But it was religion that subsumed all forms of Jewish otherness: "So, in all matters pertaining to their religious life that tinges all their customs, they stand, these East Side Jews, where the new day that dawned on Calvary left them standing, stubbornly refusing to see the light."[61]

Next door, in the infamous sixth ward, lodged between Five Points and "Jewtown," were the Chinese, who exhibited a comparably tenacious difference:

> Between the tabernacles of Jewry and the shrines of the Bend, Joss has cheekily planted his pagan worship of idols, chief among which are the celestial worshipper's own gain and lusts. . . . It is doubtful if there is anything he does not turn to a paying account, from his religion down, or up, as one prefers. . . . I fear . . . that all attempts to make an effective Christian of John Chinaman will remain abortive in this generation; of the next I have, if anything, less hope. Ages of senseless idolatry, a mere grub-worship, have left him without the essential qualities for appreciating the gentle teachings of a faith whose motive and unselfish spirit are alike beyond his grasp.[62]

Although Riis did not photograph Chinese altars, Homer's engraving (see fig. 34) captures the damning view of his description, with joss sticks before the enshrined image and banner. The juxtaposition of altars with gambling and opium smoking suggests not only the impiety of the Chinese club members, but may regard their religion as no more than an idolatrous means of securing good fortune.

If religion fueled the engines of benevolent fellow feeling that marked the heart of the community, it also fired the resentments that delineated the community's sharply perceived edges. Mediated in word and image, sympathy and antipathy comprised an aesthetic lens that focused response to poverty into a community-generating sentiment, resulting in two kinds of complementary images. On the one hand was concern for the welfare of one's neighbor as a sympathetic projection of oneself; on the other, concern for the cohesion of the social body aroused by fear of the poor and the immigrant stranger. The perceived menace of ethnic enclaves and anxieties about immigrant assimilation led the same man who documented the deplorable conditions of rag-pickers and coal-heavers (see figs. 32 and 33) to celebrate the regimented decorum of the immigrant children in Mott Street Industrial School (see fig. 28). The photographs mark either side of a single coin for Riis. Indeed, they plot a desired trajectory for the Americanization of the immigrant and the accompanying arc of Christian feeling—from moral outrage to national pride.

The Enchantment of Media

Hearing and Seeing

"Did you hear the shofar this year?" This is how a Brazilian woman characterized the importance Rosh Hashanah for Jews in her community. "People ask me this every year. Every year. Everyone whispers during the service, 'When is the shofar?' The first time I saw it, I was expecting a huge, majestic horn, something like the long horns of those cattle on the open range in Brazil. But when I saw the little sheep horn and then heard it, I was underwhelmed. 'This is the shofar'? I wanted to ask. Yet everyone around me became suddenly quiet and listened with absolute attention. Then I understood. It was a call to the tribe and they responded with complete silence." A Catholic woman described her youthful experience of the Catholic Mass in Brazil. "When the priest says the words of consecration, the altar boy rings a bell. It is at that moment when the Mass was most wonderful for me. The people were quiet. Not a sound. And when the bell rang, you knew you must go to your knees, or bow your head." The sound of the bell created the keen consciousness of a moment, characterized by a powerful presence, or the expectation of something about to happen. "You knew you were in the presence of something sacred. You were a witness as you watched the priest hold up the Host and prepare the chalice of wine," she told me. She also remembered from her youth the use of the *catraca* on Holy Friday, during the week of Christ's Passion, when a man walked about the vicinity of the church in her town and produced a coarse rapping noise on a wooden paddle with a hinged metal device. The purpose of the unusual sound was to announce the moment of the death of Jesus. That evening the man marched before the burial procession of Jesus, making the sound. The

instrument demanded the respectful hush of townspeople as the procession passed, producing an envelope of silence in which "they were meant to reflect about their sins and their lives."[1]

In each case, sound created silence and silence offered the temporal space in which the formless presence of the sacred took shape. For participants in the Mass the ringing bell signaled the arrival of the sacred and was registered in the bodies of the worshipers, who bowed or kneeled. Their eyes watched the priest's work of ritual consecration as they listened to the looming sound of silence. This description captures the many antinomies of religious worship. Sound versus silence, time versus space, presence versus absence, shape versus shapelessness, embodied versus disembodied, visibility versus invisibility. Religious worship thrives on these polar pairings, but it does not regard them as paradoxical. Indeed, religious practice appears to evoke the sacred by mediating the apparent oppositions and then integrating them with one another. The dramatic effect of the catraca combined with the visual spectacle of the procession. The ringing silence of the Mass focused the participants' attention on the ritual actions of the priest. The sound of the shofar united those gathered in the synagogue into the singular, far-flung company of the nation of Israel. Time was cancelled, distance reduced to the clarion call of the ancient device. The new year is welcomed into the midst of a people whose antiquity is joined to the present moment.

A fascinating power adheres to sound in these accounts. Sound is enchanting, in part because it induces silence, its very opposite, and because it embellishes spectacle. The woman describing her surprise at the meager size of the shofar was nevertheless amazed by the effect of the sound among those gathered to observe Rosh Hashanah. The object that produced the sound was infused with an aura by the dramatic effect of the sound and its ritual timing. Sensation in each instance was enchanted—more powerful than it ordinarily is, capable of producing considerable public effects, quieting people and gathering them into a single company, a unified social body. The assembled individuals are moved to imagine a shared identity. The enchantment of media occurs as a synergism: discrete bodies configured by sound yield an embodied sense of community.

The process creating sacred sound and silence also produces sacred objects—the shofar, the bread and wine, the liturgical regalia of the Mass. More accurately, the result of the moment is a sense of something unique or powerful, impressive—sacred. Sound produces things as well as silence, and bodies

respond with a sense of shared presence. The communal effect of sound is remarkable, as recent studies of religious soundscapes have shown.[2] We might say with Emile Durkheim that this communal effect, the conjuring of a sense of a single social body, *is* the sacred. To participants, of course, the sacred inheres in the sound or the object making it, or in the ritual event that generates the sound. Individuals feel themselves in the presence of a deity, a force or personality or call that assembles the group. But this presence can also arise in solitary moments, when a person prays or mediates while alone and feels herself to enter the presence of a larger reality. Embodied by sound as well as other forms of sensation, the sacred is an imagined connection to a social whole as well as a ritualistic immersion in it.

Certainly the sacred described in the accounts above is a social or public event by nature of the ritual itself—the Jewish New Year ceremony, the Catholic Mass, the Passion week burial procession conducted in the streets. Each is meant to articulate a shared moment. The sound is heard by many at once. But the occasion of sacred sound also happens privately. For example, the ambient sounds (or silence) that a lone visitor experiences at a rural labyrinth or a remote shrine becomes a powerful part of the sacred character of the visit. But whether the experience is public or private, the location of the sacred in things or special moments is the enchantment of a medium of sensation. To feel the sacred is to be in the grip of enchantment.

We might think of the relation of silence to sounds in the way that many visual culturalists have come to regard the relation of iconoclasm to imagery.[3] Silence is, or can be, the aural equivalent of invisibility. Rather than studying the destruction of images or the lack of sound as an isolated or single phenomenon, it is more helpful to regard each in the larger context of their creation and social operation. When we do, as in the case in the last chapter with Thomas Morris Chester, we see that people destroy images not simply because they hate or fear them, but because doing so allows them to install a different image that might open the way to an alternative way of seeing and an alternative social arrangement. Likewise, silence is used by sound-makers to punctuate sound, to initiate a new sequence of sound, or to highlight another medium such as space or objects or movement. Sound commonly operates in tandem with other forms of sensation such as sight, tactility, or smell. It is the particular relation among the senses in a given situation that needs further scrutiny. I would like to argue that the enchantment of a medium often relies on subordinating one medium of sensation to another. Thus, sound and

hearing are enhanced by suppressing images and the sense of sight. Alternatively, silence or the suppression of sound can augment the impact of an image, action, or space. Sorting out the interrelations of sensations and media may reveal a complex interaction that is not really suppression as much as it is careful manipulation. Accordingly, in order to understand more about the embodied nature of religion, we need more subtle conceptual tools for analyzing the intricate interdependencies of the senses and the media that shape, deploy, and extend them. The concept I would like to examine for this purpose is *sublation*.

Anxiety about the body as unruly and susceptible to irrational and corrupted influences that elude the curbing effects of conscience and reason are at least as old as Socrates and move through most religions of the modern world. Protestantism has often registered fears about the power of media as appealing to the passions or instincts even as it has exploited media in teaching, evangelism, and various social communication campaigns. I would like to focus my attention on the way in which Protestants have relied on an aesthetic of mediation. This may seem counterintuitive at first because many art historians and theologians are apt to regard Protestant imagery as kitsch, as aesthetically impoverished. Yet Protestantism has developed an aesthetic that operates on its own terms by sublating space, bodies, and visual imagery. The Hegelian term *Aufhebung* (sublation) designates a dialectical process of eliminating or negating something, but the negation results in a synthesis. And that is how *Webster's Ninth Collegiate Dictionary* defines the verb *to sublate*: "to negate but preserve as a partial element in synthesis."[4] *Sublation*, in other words, signifies a single process of canceling and preserving. I believe that the process is at work among Protestants when consciousness of space, embodiment, and imagery are pushed to the background as apparently passive, self-alienating media in which a preeminent content is enthroned or hosted. The body, or key aspects of it, is rendered an "absent presence."[5] But only apparently absent, or absent in the sense of having been sublated.

Consider this example (fig. 35) of what may be referred to as an *imagetext*, that is, neither essentially image nor text, but a synthesis of the two.[6] If some Protestants are anxious about images, this artifact visualizes text and textualizes imagery in order to produce a hybrid form. The text, a nineteenth-century devotional meditation from German-speaking Pennsylvania, is made to visualize a "Spiritual Maze." The meandering text takes the reader through a labyrinth as a sheep in search of its shepherd. The wandering reader becomes a microcosmic version of the Christian's journey through life. The text ends

FIGURE 35. "Geistlicher Irrgarten" [The Spiritual Maze], ca. 1840,
41 × 31 cm, printed by E. Benner, Sumnytaun, PA. The Roughwood
Collection, Library Company of Philadelphia.

with the word *Amen* in the center of the top line, and begins at the upper
right. The garden circles around "four springs of grace," which appear within
the interior, and are associated with the four streams of paradise, the diffi-
culties of life, the symmetry of beginning and ending, and the corruption of
the fall into sin. The introductory text continues, with a tortuous grammar
that echoes the contortions of the maze: "like a lost sheep man wanders about
until God stretches forth His arm of grace over him, and through His Holy
Spirit convinces him from His divine law as from a spiritual mirror, opens his
eyes that he may see and recognize his deepest misery, with the desire to be
redeemed from it."[7] Although Protestants appear to eliminate or remove the
materiality of image, space, or body, in fact, these remain as the condition for

apprehending or focusing on something else, namely the sound and message of words, which in this case are read aloud. The language of the wandering text is rendered in rhymes, so reading aloud rewards the ear.

The physicality of the act of reading the Spiritual Maze is accentuated by the manner in which the reader must turn the sheet of paper around in order to read the text, which was printed running across, up, down, and upside down. One reads the text, but actively uses one's body to do so. The text takes on the quality of an object as well as an image. By subordinating image to text, the Spiritual Maze uses form or shape to accentuate the *iconicity* of the text. By this I mean that reading the text performs what it says. The body of the reader does what the text recounts, the meaning or message of the text. Form and content mirror one another. Other examples of this are not difficult to think of—take, for example, the red-letter Bible, in which the words of Jesus are printed in red. This typography sets them off as special such that one reads and pronounces them with gravitas, with a solemnity that enhances their capacity to signify. In this instance of sublation, the visuality of the printed words serves to augment the semantic operation of the text. The pious reader is not conscious of the red type as image, but of the text's sonic performance as Jesus's own words. In this case and the Spiritual Maze, we see the power of an enchanted medium at work: the aural presence of Jesus in his words and the eye's meandering consumption of the Spiritual Maze bring both texts to life, imbuing them with a presence that relies for its efficacy on the sublation of vision.

The somatic aspect of reading and listening encourages us to consider the relationship between sublation and mediation. Hegel used the verb *aufheben* in a way that contrasted mediate to immediate, as abstract to concrete, in which the dialectical movement toward synthesis worked through the alienation of something from itself, that is, from thesis to antithesis. But *mediation*, as the term is currently used by scholars of media and religion, means something thoroughly concrete: the way in which media are integral aspects of religious practice. Mediation designates a form of religious practice that does not simply instrumentalize media artifacts, but materializes belief as a practice. Media are how believers cancel the distance between themselves and the world. This bears directly on the way in which media are enchanted. It involves a kind of alchemy or transmutation of one thing into another. Mediation is an embodied process that might be understood to be as corporeal in its own way as eating. Mediation as consumption means that what one consumes becomes part

of oneself. This is literally modeled on eating and sublation is a fundamental aspect of it. One organism ends the life of another organism by eating it, yet something of the other becomes present in and identical with the consumer. In a logic as old as the practice of ritual cannibalism, the consumed is preserved in a synthesis of consumer and consumed. This paradigm of sublation signals the fundamental role of embodiment in mediation. It also suggests how organically related religion is to mediation.[8]

What does this mean for the study of sensation in religious practice? Hearing operates in productive tension with seeing and the body. One way of thinking about this is in terms of a society's sensory hierarchy, in which seeing may be ranked lower than hearing, or vice versa. But often the senses, usually represented by particular media—images, texts, preachers, audiences, spaces, musical instruments—are not actually inimical toward one another, but structured in a way by virtue of sublation, a kind of ideological integration, such that they operate in tandem to enable one another, doing so in accord with an ideology that prefers either sound or sight or touch. Thus, seeing might be suppressed to enhance hearing, or the body might be quieted in order to augment attention, whether visual or aural or olfactory. The differences are as much ideological as they are motivated by actual effects. It is important, in other words, for many Protestants to stress how much better the spoken word is than the image in conveying scriptural truth—not because pictures fail to transmit information, but because they are associated by scripture with idolatry and perhaps because many Protestants contend that the Bible is the word of God recorded by authors who were inspired by God to *write* what they did. And the Hebrew God, after all, created the universe by speaking it into existence. Words, therefore, are closer to the primeval act of divine authority than images. And images were the cultural means of ancient Israel's many lapses into polytheism. It was the first and second commandment that called monotheistic Israel into existence and which served countless prophets as the basis for an ongoing critique of an imperiled identity for the struggling nation.

MODES OF SUBLATION: SPACE, SOUND, BODY

The sublated medium is not destroyed, but made to return as a sounding board or matrix. As another example, consider this cover illustration from a tract against images by the Wittenberg reformer, Andreas von Karlstadt (fig. 36). The image portrays the wholesale destruction of pictures, but it does so

FIGURE 36. Artist unknown, *Andreas Bodenstein von Karlstadt*, cover of tract, *Von der Abtuhung der Bilder*, ca. 1600, engraving. Photo: author.

by pitting one image against another: Karlstadt "himself" stands in the fore-ground gesturing to the melee behind him, performing as a visual sermon on the subject of his written discourse. Images must be removed, yet it is an *image* that preaches the sermon against images. Imagery is both canceled and pre-served, made to witness against itself as part of a synthesis in which the por-trait of Karlstadt becomes an effigy that countenances the destruction of other portrait images (of saints).

In Protestant visual and material culture, images often serve to underscore the iconicity of texts; bodies are disciplined to attune the ears to the prevailing soundscape and to predispose feelings to arise as if separate from the body; and spaces host sound and allow light to lift the eyes from objects and to il-luminate the spaces and plain walls that reverberate with sound. The sublated medium performs unobtrusively—all the better to turn words into pure con-tent, delivered in an unadulterated, immaterial form. Consider the picture

of Karlstadt once again: how long would you look at it before realizing that Karlstadt too is an image? He and the scene behind him are each framed by an arched format, but where the space recedes on the right into the scene of iconoclasm, the person of Karlstadt is silhouetted against a plain, flat ground. The effect compels us to assign him as speaker/writer to a superior register, a higher grade of reality that confirms his veracity as judge over mere images. Their negation allows him to slip by the censors of consciousness and perform as *Karlstadt himself en parlant*. We say to ourselves: "There is Karlstadt telling us that pictures must be removed from churches." Why is he different ontologically than what happens behind him? The scene behind him is the object of his ostensive gesture (note his hand), which is the index of his speech. His talking touches our ears by instrumentalizing the image behind him. We see him speaking and therefore listen by fixing on what he is saying, ignoring his image in order to hear what he has to say about the other images.[9]

Further examples of this process taken from the history of Protestant material culture will clarify what I have in mind. In every case, it will become apparent that sublation is a means of rendering images, architecture, or bodies transparent in order to foreground content articulated in words and sounds.

Critics of Protestantism commonly regard its historical episodes of iconoclasm as evidence of an instinctive hostility to aesthetic experience in art and architecture. Yet some scholars have contended that implicit in the removal and destruction of objects and the practice of whitewashing is a larger ideological operation, one that Protestant iconoclasts spoke of as the removal of clutter, filth, or refuse in order to restore the church to a pristine state.[10] This was something that reformers John Calvin and Ulrich Zwingli, for example, earnestly believed to be the task of reformation: to remove the corruption of centuries in order to return the church to its apostolic purity. Clean walls provided undistracted spaces for imagining the purified state of the Gospel, serving as sounding boards for reverberating the Word of God in sermons. But more than merely instruments for sound, the barren walls also limn spaces for the luminosity of divine truth to bathe the community of the faithful. Protestant consciousness of the aesthetic is registered in historical discourse that became topoi, if falling shy of official nomenclature: "beautifully white," "blankness," and "Calvinist interior."[11] As historian Victoria George notes very sensitively in her study of Protestant iconoclasm during the sixteenth century, committees directing the whitewashing and purging of churches spoke of "making good" the walls, an expression that recommends we train our ears

to discern a moral resonance to the look of whitewashed worship spaces. Pure walls were a compelling metaphor for the notion of starting over enabled by removing what Zwingli scornfully dismissed as the Catholic "rubbish-heap of ceremonials." Iconoclasm was part of a larger strategy of renewal. There is also textual evidence that whitewashing was understood as a ritual comparable to blotting out sin, "painting out" traces of "corruption."

This suggests that by removing images Zwingli advocated a position that resulted in the creation of a new aesthetic.[12] The church interior was to function as a yoke or matrix in which the worshiper was directed to recognize the grace of God as the singular means of redemption. That means, paradoxically, that there was something humans could do to prepare themselves for redemption: they could remove anything that promoted sin. The architectural result was a space that appeared blank in one respect, but could at the same time be regarded as consonant with the spiritual or invisible beauty of God. If, as Victoria George has argued, Zwingli believed that color introduced a concession to the sensuous, material aspect of human existence, namely, vanity and preoccupation with dissemblance or deception, that meant that whitewashed church interiors became the launch pad for redirecting the gaze to the spiritual beauty of the invisible.[13] God, according to Zwingli, was spirit and best approached by the worshipful creature in like form, that is, in mind, or "purity of mind." Corporeality in worship substituted for spirit/mind the created substance of bodies, which confused God with creatureliness, and thereby became idolatrous. Luminous, white interiors offered the most immaterial settings for transcending materiality in worship.[14]

What these spaces moved toward visually is clear in the paintings of Pieter Saenredam, which capture the Reformed transfiguration of former Catholic churches, a purged and clarified space in which we see a preacher orating in the pulpit on the right, or the fascinating panel in an altar piece by Lukas Cranach the Elder, showing Luther preaching in a church that has been purged (fig. 37), yet only in order to host the visual evocation of his preaching: the crucifixion planted between the speaker and his listeners. The space has been emptied, materiality negated, but only to make place for an image that mediates speaker and listeners. The scene is odd, almost surreal. The image of Jesus is not a sculpture, but Jesus himself nailed to a cross that is casting a shadow across the austere floor as the company of people gaze quietly upon him. While the Catholic dogma of transubstantiation held that each celebration of the Mass crucified Jesus once again for the forgiveness of sins, Luther contended

FIGURE 37. Lukas Cranach the Elder, *Martin Luther preaches before the Crucifix*, 1540. Stadtkirche, Wittenberg, Germany. Bildarchiv Preussischer Kulturbesitz / Art Resource, NY.

that preaching was the new medium for 'beholding' the event and receiving its metaphysical benefits. With his hand on the Bible and his finger pointing resolutely to the Crucified, Luther is shown uttering the Gospel, performing the Pauline scripture that "faith comes from what is heard, and what is heard comes by the preaching of Christ" (Romans 10:17). Seen in this way, the image is a kind of pictographic demonstration of a Lutheran theory of communication that illustrates the integration of printed text, speech, and vision. The fluttering Gothic drapery about Jesus's waist seems to capture the breath of Luther's utterance, which is simultaneously the presence of the Holy Spirit in the spoken words of faith. We see what they hear. The obdurate reality of the cross implies that seeing and hearing operate in tandem. And recall Luther's retort to the Protestant iconoclasts—that he could not think of the passion of Jesus without seeing the images of it in his heart. The claim suggests that for Luther mental imagery and words enjoyed an integral relation, that one was the medium of the other.[15] Cranach's treatment of the barren interior serves to host this parity of print, speech, and image. But the image was not an icon. It was a visual form of utterance and text, a kind of affective information.

We find the same legacy in Protestant church design and decoration in following centuries. British and American Protestants are well known for their minimalist interiors. These spaces encourage worshipers to focus on the speaker or minimal décor such as a plain cross as they pray or sing or listen to the sermon. Auditors appear to be quite passive, as images of contemporary Protestant worship may suggest (see fig. 40 below). But appearances are deceiving. The bare interiors allow listeners to park their bodies and heighten

hearing, to make ears of the entire body, as it were. Hardly disembodied, their bodies are manipulated and disciplined in order to enhance and focus audition. Sound washes over the body and arrests it, punctuates it with solemnity and the rhetorical structure of the homily. Silence and stillness deepen the receptacle of sound, making the assembled bodies part of a resonance chamber. As Cranach's painting of a group listening to Luther's sermon suggests (see fig. 37), the silence and stillness of the listeners form a matrix in which the spoken word takes shape. Protestants believe that the body is the temple of the Holy Spirit and the heart its seat. So they gather in clean, well-lit, and sound-swept interiors that replicate the metaphor of their individual and collective bodies. In this way their bodies are no less part of the medium of hearing God's word than the preacher's voice.

This engagement of body and space is especially evident in a striking photograph by Paul Kwilecki, which shows a group of African Americans encircled in prayer early one Sunday morning at St. Mary's Missionary Baptist Church in Baconton, Georgia (fig. 38). They have gathered for a service of consecrating themselves, and have joined hands in a barren, white room. Kwilecki has captured a moment of their prayer in the austere enclosure whose stark walls are relieved by only a single small window. Wearing their Sunday best, they become a single body that constitutes the human architecture of worship in a minimalist space, which accommodates the quiet and solemnity of the occasion. Far from being a dismissal of architectural form or the human body, this style of architecture encourages an acoustic form of embodiment in worship. The body becomes a way of hearing. Looking at Kwilecki's photograph, one imagines that the unadorned walls served very well to reverberate the sound of the prayer and that they welcomed the intimacy of the gathering, during which the leadership of the church assembled to consecrate themselves to dealing with the challenge of dwindling church membership.[16]

Whether standing in prayer or sitting during a sermon, the body is put to rest in order to augment hearing and make it a soul-receptacle like the church interior. This pushes the body below the threshold of consciousness, but by no means eliminates it or makes it irrelevant. Studies in the cognitive sciences have shown that "body posture can affect attention and certain kinds of judgment," or, more generally, that "bodily movement and the motor system influence cognitive performance."[17] People sit attentively when they wish to conduct a detailed hearing of a sermon or lecture. That is, they lean forward or sit upright; their eyes are widened in a stare or narrowed in focus, training

FIGURE 38. Paul Kwilecki, "Consecration service prior to Sunday morning service," St. Mary's Missionary Baptist Church in Baconton, Georgia, 1984, print 11–284–33. Courtesy of the Kwilecki Family and the Rare Book, Manuscript, and Special Collections Library, Duke University.

vision on the speaker. By not seeing other things, they enhance their capacity to listen. In other words, vision is sublated and hearing intensifies. The process of sublation enables a key distinction between media: one medium becomes instrumental while the other becomes identical with its content, and therefore operates as if it makes the transcendent immanent. The instrumental media of the body, image, and wall fade from consciousness in order to refocus attention on the message of the spoken word. The two media are stacked, one on top of the other, allowing the instrumental to host the "purely" meaningful. As long as the host or instrumental medium remains unconscious, the hosted medium of sound remains spiritual or identical with content, the ghost housed in the machine of a material medium, which operates by effacing itself.

This is achieved by a careful balancing act. Consider, for example, the case of the Masowe weChishanu Church, a Protestant group in Zimbabwe that has been studied by anthropologist Matthew Engelke.[18] The group is notorious for its rejection of material forms. They do not worship in buildings, but gather in small groves, along a river or by the side of the road in order not to become attached to church buildings and their appointments.[19] They are

so anxious about material objects that they even refuse to use Bibles, arguing that the Holy Spirit speaks directly to them through the prophets among them.[20] Yet Engelke notes that the group makes ritual use of pebbles in prayer and healing. These are common pebbles found on the ground and given by prophets to those seeking assistance. The practices of use vary, from carrying the stone with one to dropping it in water that is then drunk. Engelke observes that the "paradox of the pebble is its being special-because-it-is-not [special]."[21] The plain object disclaims any value, yet it is understood to carry the blessing of healing. In the logic of sublation, by cancelling intrinsic value, the pebble is able to convey spiritual power immediately, effecting what the weChishanu Christians prize most: a "live and direct" relationship with God. But it does so as a material object and a component of the healing.

Although it is often said that Protestants have no use for images, elaborate spaces, or material forms of expression and worship, the evidence presented here argues the opposite. Materiality is something they rely on by means of the indirect or paradoxical technique of sublation. It is how they use images that distinguishes Protestants: they deploy them to endorse the reliability and authority of texts or voices. Images as well as architecture function to underscore the iconicity of words, which Protestants elevate above materiality as they do souls above bodies. In order to understand Protestant experience of media, we need to develop an aesthetic analysis. This will allow scholars to regard aesthetics not simply as the science of the beautiful, but as the felt-life of Protestant media practices. Doing so will show us how important the body is for Protestants and how powerful mediation is as a form of sensation or as the material practice of belief. At the heart of Protestant aesthetics is a dualist construction of pure content, the dominion of words and ideas, over against image and space as the material domain of the body. In the dialectical logic of sublation, word and image are more than simply locked in opposition. They are arrayed in order to allow a characteristic experience of content as *pure*, unadulterated by human flesh and imagination.

RECOVERING THE PROTESTANT BODY: LISTENING WITH FOLDED ARMS

How does the body engage in listening? Protestantism is sometimes regarded as *gnostically* anti-body.[22] But a growing body of scholarship is productively exploring the bodies, images, objects, dress, food, healing, and sexuality of

modern Protestants.[23] And there is no shortage of examples of robust body practices among diverse Protestants to testify to the often overlooked somatic cultures of Evangelicalism, such as the ecstatic preaching and response of evangelical revival meetings, the active engagement of African Americans in worship, or Pentecostal and Charismatic as well as Evangelical praise worship styles. For example, a photograph by Paul Kwilecki of an African-American congregation in Georgia in 1983 (fig. 39) shows a circle of women singing and holding hands. In the midst of the small gathering dances another woman, gripped in ecstasy. The event comes near the end of a foot-washing service. The act of washing the feet of others is itself an explicit body practice. And the ecstatic dance is another. Note how the circle of women forms an architecture of bodies within the small church interior. Gender seems to play a role in the event as we see men outside of the circle. And small girls sit watching in the pews as the older women conduct the ritual. In addition to these worship styles, the generalization of Protestant antimateriality discounts the ritual solemnity and liturgical formalism—during which the body moves in carefully prescribed gestures and ceremonial dress—at work in Lutheran and Anglican forms of worship. And the claim ignores the key role that singing and musical performance play in many versions of Protestantism.

But beyond these instances, we also find that the body assumes an even more subtle, but nonetheless active role in shaping worship by enabling listening. We may speak of listening styles. For those listening to extended discourses such as lectures or sermons, the body is held in subdued postures that act to park it, to keep it still, to subdue communication other than the signaling of attentiveness and respect. This becomes evident in another photograph by Kwilecki, which shows a group of Georgia Baptists listening to a revival sermon (fig. 40). Movement would be distracting to the speaker as well as to the listener and other listeners. Broad gestures like outstretched arms or arms held behind the head or feet placed wide or propped against a chair or pew in front of the sitter would signal excessive relaxation and informality. Note that heads are generally held level, facing the speaker directly, and the eyes trained on the speaker. In academic lecture halls as well as church naves, listeners usually keep their arms in contact with their bodies and the legs enfolded. There is an axis of attention that is largely observed in order to keep the listener attentive, awake, and unobtrusive. The body performs attention, not amusement or pleasure. In doing so, the listener's body does not draw attention to itself, but

FIGURE 39. Paul Kwilecki, "Nearing the end of the foot-washing service," 1983, print 69–1183–16a. Courtesy of the Kwilecki Family and the Rare Book, Manuscript, and Special Collections Library, Duke University.

pays attention to the speaker. By focusing corporeally on the act of listening, the body enhances the listener's ability to hear.

Although gesture and posture are culturally determined practices whose signs are not universal, the study of the corporeal literacy of a group does well to speak of *somatics* as well as *semiotics*, that is, to recognize that the body exerts a logic of its own and does so at a nonverbal level. Whereas semiotics is the study of signs, somatics might be defined as the study of embodiment. Marcel Mauss was certainly correct in his seminal study of embodiment to assume that techniques of the body are learned, which means they are not natural, but culturally endowed.[24] That means that gestures, postures, expressions, and movements are signs, but I want to argue that they are signs embedded in a medium experienced as continuous with the physical world. Some images are construed in this way too, but they are focal points, whereas the body is a self-effacing medium that enables us to focus on objects, to attend to them with a heightened consciousness. The body hosts cognition, sites it, mediates it. What we might call "medial signs," coming between the self and the other, operate below the level of consciousness in tandem with other modes of

FIGURE 40. Paul Kwilecki, "Mt Pleasant Baptist Church," revival gathering, Georgia, May 1977, print 29–577–16. Courtesy of the Kwilecki Family and the Rare Book, Manuscript, and Special Collections Library, Duke University.

sensation. So the flesh (skin, muscles, sinews, bones) works in concert with the eyes or ears to enhance the perception of an image or a sound.

To sit in church is to sit with others, to conform to the social body of the group. While there is nothing inherently sacred about Protestant homiletic attention, sitting together is more than sharing conventional signs of listening. It is listening as a single body. The listeners may not share the same thoughts— indeed, almost certainly they are not, but they do share the social disposition of a corporate embodiment. The experience of community, of belonging to the social body, does not rely on group-think, but on the sensuously, materially promoted imagination of unity. Identity is not just what happens in discursive thought; it is also the result of an embodied accord. In the case of Protestants listening to a sermon, the body has been taught or disciplined to behave in a way that enhances listening in order to attend to the information provided by the preacher. But it also importantly conveys solemnity, respect, and submission to authority. And no less important, observing honored techniques of the body in this instance integrates the listener into the social body of listeners, the congregation attending to the pastor's sermon. Sitting in unison is no less important for mainstream Protestants than praying or singing together. The

assembled congregation is consuming the Word of God together, as a single body, and this affirms its sense of what "church" is: the body of Jesus, that is, all assembled in his name.

Would things appear different in observing Catholic congregants listening to the priest's homily? Probably not. Where one will see noticeable differences, however, are in varying ways that liturgical Protestants, Evangelicals, Charismatics, and Catholics pray. Photographs of Catholics at Mass often show them kneeling, hands joined in a gesture of prayer, gazing fixedly into the middle distance before them as they recite in a mantra tone the words of the Rosary or the Ave Maria or Paternoster separately. Liturgical Protestant corporate prayer in church services commonly bears a few telling differences. Heads are held low and eyes shut. Protestants often stand to pray, and often listen to the pastor pray on their behalf. They certainly pray together such forms as the Lord's Prayer or the Apostles Creed, and when they do, they adopt the mantra tone of group prayer, beginning, pausing, and ending together. Many Evangelical and all Pentecostal and Charismatic Protestant groups pray quite differently, making use of outstretched or upraised arms, inclining their heads upwards, swaying, holding hands, and clasping their eyes shut. Closing the eyes allows for greater concentration—on the content of the words or on their emotional impact. Holding the eyes open in a fixed middle distance may assist the recitation of formulae such as Catholic liturgical prayers like the Ave Maria.

Focusing on the content of prayer is characteristic of Protestants who tend to think of the efficacy of prayer not in repetitive formulae, but in terms of passionate reflection on the words. This difference has everything to do with the Protestant understanding of the holy as mediated in words. Protestants regard the sacred as information, as content-laden delivery of proper knowledge. God is in the information, the knowledge of salvation and divine intention for one's life. The sermon takes on the primary role in worship, along with prayer. Hymn singing is key because it is shared recognition of what is worthy and important for one's life. In this light, how people sit to listen to a sermon directly shapes the Protestant experience of the sacred, which we must characterize in terms of attention, submission, solemnity, and proper demeanor. The body is not irrelevant or dispensable, it is a vital part of the medium of orality. The body is part of the social apparatus of attentive and socially edifying audition. This applies to religious and nonreligious settings, but in the case of Protestantism where hearing is a privileged medium for the transmission

of the sacred-as-information, the somatic elements of hearing are part of the reception of the sacred.

The implications for the Protestant experience of space are directly related to this analysis of hearing. Protestant worship regards distractions as especially bothersome in worship because the reception and processing of information is primary. This explains why pews are organized in narrow rows along the building's central axis, facing the elevated platform of the pulpit, from which the pastor speaks. The seating is not meant for special comfort. The hard, perpendicular design, traditionally unupholstered, is intended to keep the body of the auditor erect and attuned to the act of listening. It also accounts for the often unadorned, plain white walls lining the nave and sanctuary. Such surfaces reverberate sound and do not tempt the eye with distraction. Protestants do not use ecclesiastical space for purposes other than listening and gathering to worship. The sacred does not happen in things, but in word, deed, and feeling. Protestant spaces of worship are therefore most commonly associated with the production and reception of sound, whether music, song, liturgical chant, or spoken words.

Catholic churches, by contrast, house apses, side altars, reliquaries, shrines, cult statuary for the purpose of pilgrimage, devotional practice, intercessory prayer, and sacramental rites. Devotees arrive throughout the day at many Catholic churches to pray before a saint's image, light candles, burn incense, post messages to the saint, and then leave. Protestant sanctuaries might remain unlit and empty through the course of the week following Sunday, or be used only for choir practice or committee meetings. They become sacred sites of destination only on Sunday morning for public worship. Evangelical and Pentecostal churches are even less dedicated to purpose. Often designed as shell spaces with open floors, they are completely flexible and wired for sound amplification. Where Protestant churches are traditionally halls intended to accommodate the sound of organ or piano music for vocal accompaniment, Evangelical worship style prefers arenas, often with stages in the round. This creates the possibility for comfortable, open seating arrangements that organize listeners around a central stage, making listeners viewable by one another and allowing them enough space in the rows of seats to stand, move freely, raise arms and faces in the communal gaze of worship. In this visual field and the mode of worship it encourages, the body is not meant to fade into hushed immobility as a support for listening, but to serve as a more active form of engaged listening and participation. Sophisticated electronic sound systems

compensate for loss of favorable acoustic properties, allowing the congregations both strong auditory and visual effects.

In each case, space, sound, vision, and embodiment are integrated to serve a particular conception of the sacred and its access. The medium of worship is not singular, but integral. The body of a worshipper needs to be trained differently in each case in order to participate fully in the respective spatial modality of worship. Marcel Mauss argued that in the most common body practices, such as walking, sitting, eating, or throwing, "we should see the techniques and work of collective and individual practical reason rather than, in the ordinary way, merely the soul and its repetitive faculties."[25] People behave the way they do because they have been taught to execute such behavior. They have acquired these techniques as abilities that are taught within larger social units such as nations and classes, and serve to differentiate them according to "societies, educations, proprieties and fashions, prestiges."[26] Mauss believed these techniques of the body operated as part of a faculty of "practical reason" because "the art of using the human body" is learned by imitation in order to create a meaningful world, one in which particular habits enable children to recognize and be recognized by those in authority, a world in which women and men are attractive to one another, a world in which the decent and indecent, able and inept, clean and unclean are properly observed and therefore able to define those who belong to a society and those who do not. Children or newcomers learn to be members of a society by virtue of the education of their bodies. People count, cut their meat, bathe, put on their clothing, sit, squat, gesticulate, wave, and laugh in ways peculiar to the social bodies to which they belong—their tribe, city, nation, race, or religion.

Mauss's analysis is especially interesting when we think of the way people listen in church. He stressed the importance of education in the transmission of body habits. This is, of course, particularly important in the case of children, who must be taught everything a society considers important about the use and comportment of the body. The child, like the adult, "imitates actions which have succeeded and which he has seen successfully performed by people in whom he has confidence and who have authority over him. The action is imposed from without, from above, even if it is an exclusively biological action, involving his body."[27] This pertains to the training of Protestant children to listen to sermons, or at least to learn to sit as if they are doing so, or to sit without distracting those around them during the long routine of worship services. For parents who have labored at the task, it is no small matter. Children

eventually learn, more or less, to comport themselves in the sober setting of formal worship. Much of what children and church members learn is bodily comportment. A range of gestures, postures, and expressions are at work in the attentive listener, in whose body stillness, composure, and enclosure are widely practiced techniques of attention. The point is not only that such habits communicate attentiveness, they enact it. The element of practical reason identified by Mauss suggests that practicing such habits actually generates a state of attention. Children are not taught merely to mimic the outward appearance of their parents or teachers, but to emulate the attitude conveyed by postures and prized by the community as appropriate for the prevailing respectability that defines membership in the community.

When we once again look at Paul Kwilecki's photograph of Baptists at a revival meeting in Mount Pleasant, Georgia (see fig. 40) with these ideas in mind, the image offers a host of suggestions about understanding techniques of the Protestant body. The rigid wooden pews, regularly spaced and aligned, organize the sitters in uniform rows, an arrangement that encourages the observation of a common repertoire of sitting. One can see the repetition of the same postures from person to person. They sit upright, in the same angle, holding their heads still. There is a regime of attention each is careful not to upset. Their faces are impassive and their bodies maintained in an enclosure: the arms conform to the shape of the trunk or legs, joined in folded hands held motionless on the lap or at the knees. Shoulders are kept in parallel with the back of the pew and the heads are quietly balanced on the shoulders. Each face gazes without movement at the speaker. Only the mother with an infant and small child is compelled to violate this silent protocol, though the boy has already learned the ability to sit still at his parent's side.

Although we catch only a glimpse of the smooth white wall enclosing the nave of this Southern Baptist church, it is perhaps enough to remind us of the powerful integration of space, sound, and body which our discussion has underscored as the primary elements in the mediation of the sacred that defines different religious traditions. In the religious world that Kwilecki documents in this and other photographs (see also figs. 38 and 39), a plain style of architecture and furnishing endorses a corresponding body practice that enhances listening as the principal medium of the sacred. This way of thinking encourages us to imagine embodiment as a cultural paradigm achieved in the integration of techniques of the body, spatial organization, and communicative practices like speaking and listening. The Protestant body in this instance

is shaped by a habitus given to a concept of the sacred as information. Other forms of Protestantism practice a different mode of embodiment, one that is able to accommodate the sacred as an emotional experience, a movement of the Holy Spirit manifest in each worshipper as a intense feeling that takes the shape of swaying, uttering sounds, singing, waving, or crying. Kwilecki's photograph of black women encircling one of their fellow members engaged in an ecstatic dance captures this mode of worship. Like the white Southern Baptists, these Protestants practice their worship in a plainly decorated interior, one that does not interfere with the human architecture they erect about the dancer. Indeed, the power of this form of worship consists in part in this alternative and improvisational body architecture. For these Protestants, the body itself hosts the presence of the divine. Rather than informational, the Charismatic mode of the sacred is deeply affective. Each form constitutes a distinct aesthetic sensibility, one invested in a sympathetic repertoire of body techniques used to generate a social body, a felt-community of religious experience that relies on the practical reason of shared feelings keyed to techniques of the body, as Mauss suggested.

One way of studying the discrete aesthetic sensibilities at work in religious practice is to study corporate worship in terms of the visual fields identified in chapter three. The image of Luther preaching by Cranach (see fig. 37) is helpful for exemplifying a characteristically Protestant visual engagement. The members of the congregation sit quietly, looking at the floating image of the crucified Jesus as the image of what they hear Luther preaching. Perhaps Luther's hand rests on Paul's letter to the Galatians, chapter 3, where he wondered at the faltering faith of the churches of Galatia "before whose eyes Jesus Christ was publicly portrayed as crucified" (Gal 3:1). Whatever the text, the enfolding of hearing and seeing could not be more literally illustrated. Another Lutheran diagram, this one from the twentieth century, reiterates the idea in a catechetical manual (fig. 41). Illustrating the Lutheran understanding of redemption, the image portrays God and a human being looking to the crucified Jesus. Lutheran dogma regards humanity as sinful and in enmity with God. The two see one another in negative terms: humans avoid the unilateral gaze of an angry and wrathful deity; God, for his part, would see a humanity fallen, unjustified, and worthy of damnation. Jesus intervenes as the satisfaction of God's demand for perfection and satisfies the human need for reconciliation with an angry deity. As the mediation of the two opposites, Jesus visually constitutes their relationship in what amounts to a two-sided

God sees Christ and is satisfied; the sinner sees Christ and is satisfied.

FIGURE 41. Lutheran catechetical illustration, in Erwin Kurth, *Catechetical Helps.* New York: The Studio Press, 1944, 112.

instance of the occlusive gaze described in chapter 3. The diagram suggests that redemption for Lutheran theology, and perhaps for Protestant theology more generally, may be understood as a visual process of God not seeing sin, and humanity not seeing a vengeful divinity. But the diagram also suggests that the rays of vision originate in God and are visibly transmuted as they pass through Jesus. When God's vision reaches humanity, it is after having been transformed by the sacrificial body of the crucified figure. The invisible "God" acquires an optical corporeality for the occasion of regarding humanity. But the diagram also suggests that God maintains his transcendence, because the human being cannot see God himself, who is portrayed only as an abstract signifier, the word *God*, the unseen and unilateral origin of vision.

The human figure kneeling with folded hands before the Crucified Jesus wears his Sunday suit. The gesture and clothing suggest that he is engaged in an act of formal worship, and this comports with Lutheran liturgical worship. It requires little effort to generalize from the image to the familial characteristics of Protestant worship in general, in which hearing the Word constitutes the reception of the "good news" of redemption. Protestant worship, as we have noticed, consists of a flow or emanation of information, which the visual rays in the diagram approximate. The sacred information arrives from the preacher and, as Cranach's painting shows, originates in the Word of God, the Bible, on which Luther's hand rests (see fig. 37). This may imply that those attending to the preacher's words, in Cranach's painting as well as in Kwilecki's photograph of Baptists in Georgia (see fig. 40), are engaged in a complex array

I am come a light into the world, that whosoever believeth on me should not abide in darkness.

St. John 12:46

FIGURE 42. Warner Sallman, Jesus at lectern, 1954. Courtesy of Warner Press, Anderson, Indiana.

of gazes. A triangulation of speaker, listener, and image mediates the human relation to the divine. Likewise, the figure of Jesus in the catechetical diagram hides and averts human and divine vision. Jesus hides the human figure from God's unilateral gaze, which would otherwise fall upon feeble humanity and demand justification that humans are unable to provide. Jesus prevents human eyes from trying to see what they cannot and protects humans from falling under the furious gaze of the deity. At the same time, Jesus protects God's transcendence while committing it to an enduring relationship with humanity. Although it is obviously true that no preacher appears in the diagram, the presence of the spoken word as the source of faith in Protestantism is there. And one can find the coincidence of Jesus and preacher in popular Protestant visual culture of the same period. Figure 42 is an example: Jesus stands before a lectern, Bible open, reading God's word, incarnating it in the act of doing so.

The Word of God embodies him in a latter-day version of Cranach's picture. To hear is to see. The proof of the authority of the word is plain to see.

What is it to *hear* redemption—in the sound of the blowing of a sheep's horn or the words of a preacher? This brief reflection may indicate something of the complexity of the sensory relations that mediate the sacred. Important for the purpose of this chapter, the Lutheran catechetical diagram implies something of the nature of the transaction that listening entails. People hear and watch a sermon, and do so with all of their body, together with those seated or standing around them. The enchantment of sensation, the ability of listening to the speech of a preacher to become an encounter with the divine, takes place as the sublation of one form of sensation in order to enhance another. Image and body, in the case of listening to a Protestant sermon, are subordinated to the act of hearing in order that listeners might hold or see what is said, that is, might grasp or glimpse in what is said the content whose truth transforms their being from condemned to redeemed. That one might hear this transfiguration, make it occur in the reception of information, suggests an enchantment of sound that body and eye help enable, even though they appear to be rendered impassive. In fact, that very impassivity serves as a condition for submitting the self to the truth of what is heard. Hearing is the appropriate sensation for grasping or beholding the truth because it entails a quieting of the self—a somatic submission—and because it preserves the active aspect of the generation of the message. Hearing comes to the properly receptive hearer from a source that is superior to the hearer. The rigorous structuring of the visual field of the sermon's audience, organized in rows of still bodies that signify solemnity and respect and that prepare the ear to attend by the practice of carefully learned techniques of the body—all of these features combine to enchant hearing, making it capable of more than hearing. The people attend to their salvation: they hear the "good news" with folded arms and earnest faces, then go home to eat corn and beef and mashed potatoes that taste better on Sunday afternoons than on any other day.

At the Cusp of Invisibility

Visions, Dreams, and Images

Apparitions and visions are phenomena in which people report *seeing* something. Sometimes they describe ocular experiences of things; other occasions suggest more subjective events comparable to dreams or mental occurrences that have no corresponding physical manifestation. But whether staged within or without the brain, people say they saw something. To what degree does the verb *to see* apply equally well to each experience? Do mental or visionary phenomena belong to visual culture? If so, how may they be studied by the scholar? To this line of questioning we may easily add other internal forms of imaging such as dreams, fantasies, and memory. Recent work among scholars of visual culture has begun to take up these difficult questions.[1] The view that I shall argue in this chapter is that external and internal images, as Hans Belting has nicely put it, "may be considered as two sides of the same coin."[2] Studying them in tandem is how scholars may proceed to treat internal imagery as part of visual culture. My working assumption is that for people to report seeing something, there must be involved, sooner or later, an image or visual sensation that appeared to them or that took shape afterward and became the focus of their reflection and report. External images are the medium for grasping and maintaining the internal, which are even more ephemeral, unstable, and evolving than anything material. This holds for hoaxes, for mistakes, and for anything that believers genuinely believe to be true: images that are fleeting, private, inscrutable, or contrived are all made available and credible by a process of visualization.

We may begin with the challenge of modern science: internal images do not exist. Contemporary cognitive sciences and brain imaging studies suggest there is no interior image in the sense of a picture or film exhibited in the brain. Descartes argued this long ago as a way of putting to rest the theory of consciousness that posited the epistemological equivalent of a homunculus resident within the soul. Where is the image, then, which constitutes the coin of visual culture? *Image*, W. J. T. Mitchell has suggested, means the immaterial motif that floats in thought like a Platonic essence or idea, whereas *picture* is the thing you hang on a wall.[3] We might say that the slippage of *image*, designating both external and internal seeing, stipulates the problem and challenge we face in capturing the visuality of internal images. Seeing is distributed across mental and material domains—hovering in memory and perched on mantelpieces, emerging in narratives and dirty windows, in desire, and on spotty tortillas. Pictures, in Mitchell's physical sense, are the product of the search for images, the morphing of patterns into recognized motifs. Thinking, wanting, remembering, and feeling all take shape in hand with perceptual and social experience. People find the images and pictures they want, or decide they want those they find. Visual culture includes strange things like apparitions and visions because these phenomena belong to culture, are themselves constructed, at least inasmuch as rely on images and visual patterns to attain the effect they do. This chapter will pursue the cultural relationship between visibility and invisibility by examining the role of images in fixing the apparition, which hovers at the tenuous border between seen and unseen.

ART AND INSPIRATION

Throughout the Middle Ages, accounts of miraculous images, visions, apparitions, and dreams comprised a visual piety that bears comparison to modern forms of visuality such as the miracles and apparitions that are documented on the internet, television, and the covers of tabloids.[4] For example, in 1993, the television program "Miracles and Other Wonders," showed a story of how an inexpensive copy of Warner Sallman's 1940 painting, *The Head of Christ*, miraculously exuded oil and healed a boy with terminal cancer. As the video shows, the image was ritually installed as an icon in a Coptic church in a suburb of Houston, where the boy lived.[5] The continuity between the treatment of a modern, mass-produced devotional image of Jesus and ancient icon veneration is striking.[6] To these kinds of Christian phenomena one may easily

add UFO sightings, hauntings, premonitions and visions, wonders performed by angels, and fulfilled prophecies of Nostradamus, to glimpse only the tip of the supernatural iceberg of the modern world.

The fact is that much of what used to be reported as happening many centuries ago still occurs. On the whole, apparitions and visions have not diminished, nor has the interest in hearing about them. Consider, for instance, the importance of the Byzantine and pre–Christian idea of the divine origin of sacred images, which is seen today especially in images of Mary and Jesus. As we saw in chapter 4, the "true image" in the form of the Veil of Veronica remains a compelling visual motif among Christians today.[7] Related phenomena are not difficult to enumerate among artists and promoters of sacred art. What has changed, however, though perhaps not dramatically, is the way of explaining the origin and operation of mental imagery.[8] The idea of artistic inspiration adapted to religious revelation enables artists to transform old imagery into new, and forget the mundane visual source. This allows devout artists and admirers of their work to explain artistic inspiration as a miraculous or visionary operation, an act of visual revelation whose medium is the creative imagination. The divine enters the modern world through the individual psyche, where it arouses the imaginative vision of the artist. As we will see, this subjective or psychological manifestation is also characteristic of the modern Marian apparitions.[9]

In 1797, the Romantic art enthusiast Heinrich Wackenroder told the story that Raphael was able to paint such beautiful images of the Madonna because "the picture had fallen into his soul like a heavenly beam of light." Wackenroder's persona was an art-loving monk who claimed to have found the account written in the hand of the Renaissance architect, Bramante, and squirreled away in a monastery. According to the narrative, Bramante related what his friend, Raphael, had told him. In the midst of painting a picture of the Virgin, Raphael experienced a powerful dream:

> Once, during the night, when he had prayed to the Virgin in a dream, as had often happened to him before, he had suddenly started out of his sleep, violently disturbed. In the dark night his eye was attracted by a bright light on the wall opposite his bed and, when he had looked closely, he had perceived that his picture of the Madonna, still uncompleted, had been hung upon the wall, illuminated by the gentlest light, and had become a perfect and truly living image. The divinity in this picture had so overpowered him that he had broken out into hot tears. It had looked at him with its eyes in an indescribably touching manner and, at each

moment, had seemed as if it wanted to move; and it had seemed to him as if it also really were moving. . . . The next morning he had arisen as if newly born; the vision had remained firmly stamped in his mind and his senses for eternity. And, thereupon, he had succeeded in portraying the Mother of God each time just as she had appeared to his soul.[10]

The important role of the heart in Wackenroder's account (he entitled his book *Herzensergiessungen eines kunstliebenden Klosterbruders*, or *Outpourings from the Heart of an Art-loving Friar*) served as a transitional subjectivization of belief, inherited from the early modern era. Over the course of the eighteenth century the imagination came to be regarded as a mental faculty of creative feeling that participated in thought, art, taste, and moral sentiment. As a result, the imagination came to serve the artist as the interior where spirit and artistic invention intermingled. Given the importance of the heart in Pietism as well as Baroque Catholic spirituality (think of the development of the devotion to the Sacred Hearts of Jesus and Mary since the seventeenth century), it is not surprising that Wackenroder would identify heart, soul, and imagination as one in the same spiritual and creative faculty, and fix on the dream as the passionately felt medium of artistic revelation.[11]

To this fictional narrative, which clearly recalls medieval accounts of miraculously moving images of the Virgin, Jesus, and the saints, may be added two that are closer to the present day.[12] First is the explanation of creative vision embraced by the French Catholic painter James Tissot, who devoted two trips to Palestine in order to collect and process his impressions of the Holy Land for the preparation of his monumental two-volume set, *The Life of Our Saviour Jesus Christ*, issued in France in 1896–97, in London in 1897–98, and in New York in 1899.[13] In an article dedicated to the artist and his several hundred images for the project, the American writer Cleveland Moffett described Tissot's method for readers of *McClure's Magazine*. The artist, he said, gathered rough sketches on site, walking about Jerusalem and the countryside, but did not work up finished pictures during his two visits there. He returned to his studio in France for that purpose, where a mysterious kind of mental alchemy took place.

But now a strange thing would happen, a rather uncanny thing, did we not know the many mysteries of the human brain. Scientists have called it "hyperaesthesia," a super-sensitiveness of the nerves having to do with vision. And this is it—and it happened over and over again, until it became an ordinary occurrence—M. Tissot, being now in a certain state of mind, and having some conception of what

he wished to paint, would bend over the white paper with its smudged surface, and, looking intently at the oval marked for the head of Jesus or some holy person, would see the whole picture there before him, the colors, the garments, the faces, everything that he needed and had already half conceived. Then, closing his eyes in delight, he would murmur to himself: "How beautiful! How wonderful! Oh, that I may keep it! Oh, that I may not forget it!" Finally, putting forth his strongest effort to retain the vision, he would take brush and color and set it all down from memory as well as he could.

According to Moffett, the "high degree of sensitiveness" possessed by many artists "gives them, literally, the power of beholding visions."[14] The vivid capturing of essential materials was understood as a selective process of memory that some contemporary French artists practiced as a way of sifting important from inessential aspects of their subjects.[15] Memory was part of the creative process, which it certainly was for the development of modern apparition imagery, which, as we shall see, remembered the visual features of the contemporary appearances of the Virgin as more or less consistent with the iconographical tradition of her Assumption and Immaculate Conception (fig. 43).

A final instance of the visionary faculty of a pious artist of the modern world repeats the adaptation of the visionary origin of sacred images. As with the previous two examples, this one displays the modern motif of regarding the artist as the vehicle of miraculous images. If medieval Western and Byzantine traditions could discover icons and holy pictures in trees, fallen from heaven, painted or completed by angels, or received as self-transporting images that traveled through the air or over the sea in search of a new shrine, modern artists locate the miracle in their imaginations, the site of divine inspiration, which their drawings and paintings then serve to document.[16] As he told the story in the 1940s, Warner Sallman, a pious illustrator for the YMCA, the Salvation Army, and his own church body, the Swedish Evangelical Covenant, was faced with a publication deadline. One night in January 1924, unable to produce an illustration for a commercial assignment, he went to bed in frustration. "The clock was nearing two when suddenly and vividly there appeared to his mind's eye a picture. How clear it was! Impelled by this revelation he hastened out of bed, sat down at his board, and made a three-inch thumbnail sketch of what he had envisaged." Convinced that "this revelation was from God, he fell into a deep and peaceful sleep."[17] The next morning Sallman produced a larger and more finished version of the image. Years later he conceded that he had actually seen the reproduction of a painting of Christ

FIGURE 43. Bartolome Esteban Murillo, *The Immaculate Conception (Soult)*, 1678, oil on canvas, 274 × 190 cm. Museo del Prado, Madrid, Spain. Erich Lessing / Art Resource, NY.

by the French artist, Léon Lhermitte about a year earlier (fig. 44; cf. fig. 42).[18] It is helpful to remember that, for his part, Raphael owed no little debt to his teacher, Perugino, as the striking similarity of their Madonnas recalls. I point this out not to debunk the visions attributed to each image-maker, but to suggest the fundamental role that images continue to play in visions in the modern period. It seems that visions tend to occur when there is a significant visual density that bestows upon pictures a recognizability such that viewers experience a strange familiarity when they see them. That pictures of Mary or Jesus (or Elvis for that matter) look right, as if they fit templates, suggests that they feel authentic, filling the expectations that devout viewers bring to them.[19]

FIGURE 44. Léon Lhermitte, *The Friend of the Humble*, 1892, oil on canvas, 61 ¼ × 87 ¾ inches. Gift of J. Randolph Coolidge, courtesy of Museum of Fine Arts, Boston.

These examples highlight the way in which images help make visions and apparitions work. The narratives assert that the image resulted from a mental vision of some sort, amounting to a material transposition from the interior of the mind, a copy of its cerebral or empyrean original. In fact, copies may be said to antedate their putative originals because the two participate in a mutually constitutive or dialectical process. This is not to pursue a modern, secular dismantling of spiritual visions, but to describe the visual construction of the sacred as a process that incorporates the history of images into the fixing of the apparition.

Not only are image-makers still producing miraculous images of a sort, popular religious practice affords dozens of examples of apparitions of angels, Jesus, and Mary that give the visual culturalist a welcome opportunity to understand more about the relationship between mental revelations and devotional imagery. As an example of how visibility takes shape within a religious culture, we may consider examples of the modern apparitions of Our Lady (figs. 45 and 46). It is surely noteworthy that in imagery that eventually issued from different forms of devotion to her, Mary appears as a small, doll-like figure, chastely dressed, hovering daintily in the air or perched on bushes

FIGURE 45. José Thedim, *International Pilgrim Statue of Our Lady of Fatima*, 1947, polychrome mahogany, ca. 40 inches high. Photo: author.

or amidst flowers. She wears white drapery, gestures tenderly, and speaks only to one child or at most a few children. Why does she appear this way? Why does the Virgin look the way she does? What are the visual mechanics of apparitions?

We should begin by noting the historicity of Mary's visual form. The patterns of her appearance over the centuries in two streams of images are striking. In a long line of images of the Assumption and the Immaculate Conception by artists such as Velazquez, Zurburán, and Murillo (see fig. 43) we find a clear iconographical tradition taking shape; and in images of the more recent apparitions (see figs. 45, 14, and 46) a clearly indebted way of visualizing Our Lady. The overarching pattern is pervasive and striking. There is a familiar look to her, however much it has evolved and changed since the early modern era. She is almost never shown seated, but rather standing, even

FIGURE 46. Our Lady of Lourdes, Marian Shrine, University of
Notre Dame campus, South Bend, Indiana, 1896. Photo: author.

floating erect before the children and viewers of the image.[20] Her hands are
typically joined in some manner. Her face appears full and radiant, either gaz-
ing downward at the children or the earth of humankind below, or she looks
heavenward. In any case, her gaze signals her role as mediator. She is dressed
in a full-length gown and an outer mantle. She bears a halo of stars or light.
The visual formulae establishing her appearance are unmistakable in spite of
the many variations over time.

MISRECOGNIZING MARY

Despite all these tenacious elements in the pictorial recipe, it is remarkable
that accounts of Mary's apparitions show that the children did not recognize

her. As many scholars have noted, when she appeared at La Salette, Lourdes, and Fatima she was not immediately identified as the Virgin Mary.[21] Why, in view of this iconographical consistency, didn't the children recognize her at once? Clearly, these images are not what they saw. Recognition is a slower, more complicated process. Consideration of the formative first days of several apparitions will make this clear.

Mélanie Calvat described the appearance of "a most beautiful lady" on the mountain of La Salette in 1846. Over the course of several months as they recounted the event, Mélanie and her friend, Maximin, continued to puzzle over who the figure might have been. Both children had seen her only unclearly and inside a bright light. Maximin reported that she was crying and that the seated figure had her face buried in her hands. Upon her first appearance to Bernadette at Lourdes in 1858 and to the children at Fatima in the spring of 1917, the figure was also known only as a "lady." Bernadette called her "aquero," a vernacular pronoun meaning "that one." Bernadette did not know her name during several apparitions over a period of two weeks until the woman told her "I am the Immaculate Conception." A turn-of-the-century journalistic account summarizes the appearance on the first two days, conveying Bernadette's uncertainties for American readers of a mainstream magazine: "Then she glanced toward the rocks, and was half blinded by a great light which gathered against the side of a cliff, where an aperture like a rude oval window sank into the crag. . . . Bernadette fell to her knees in her fright, but kept her eyes on the niche above the cavern. Little by little in the light she discerned a white form, and she trembled lest this figure should be the devil." The next day, after suffering her parents' disbelief in the event as "childish nonsense," she returned to the spot against their orders, impelled by townsfolk who urged her to go "armed with a bottle of holy water, to ascertain whether or not it was the devil she had to deal with."[22]

At Fatima, Lucia and Jacinta referred to the figure they saw as "a beautiful Lady," but did not know her name.[23] The lady had been preceded over a two-year period by other apparitions: by "a person wrapped up in a sheet" in 1915 and in the following year by a young male figure, "whiter than snow, transparent as crystal when the sun shines through it," who identified himself as an angel.[24] And it's not as if the children were unfamiliar with devotional imagery of Mary doing miraculous things. Sister Lucia recalled many years later that around 1914 a statue of Our Lady of the Rosary on the altar of her parish church had appeared to smile at her.[25] The lady who appeared in the summer

of 1917 did not tell the children her name until the third apparition, on July 13. They had intended to keep the entire affair a secret from the first, which they might have done, since the apparition was only visible or audible to the three of them (a feature common to virtually all modern Marian apparitions). Clearly, the identity was not a foregone conclusion from the beginning, but developed, gradually congealing in the larger matrix of the children's experience as the affair became more and more public and the difficulties for the children mounted into a significant crisis. The identity was adapted to appearances as the meaning became clear.

Likewise at Medjugorje, where on June 24, 1981, six children saw what an official website narrative describes as "an incredibly beautiful young woman with a little child in her arms." The children were "surprised and frightened" and "afraid to come near," though the text states that "they immediately thought her to be Our Lady." But they remained unsure. In the first days, the vision occasionally acted erratically, suddenly leaving and then returning. After two more sequential days of seeing the apparition, they took the advice of some local women and, borrowing a page from the account of Bernadette, took holy water with them in order "to make sure that it was not Satan." After the figure appeared to them, one of the children, "took the water and splashed it in the direction of the vision, saying 'If you are Our Blessed Mother, please stay, and if you are not, go away from us.'"[26] When the figure confirmed to them who she was, the children were assured.

Misrecognition seems to be a fundamental feature, even a commonplace of modern Marian apparitions. But it did not begin there. The motif is found in biblical accounts where Christ's own disciples failed on much more famous occasions to recognize him. It is described as having occurred several times, both before Jesus's death, when he approached his disciples walking over the water in Galilee, and after, when he appeared to the Marys outside of his tomb, and when he walked along the road to Emmaus with two followers. The Gospel of Matthew relates that one windy night on the Sea of Galilee Jesus appeared to his disciples, "walking on the sea." When they saw him "they were terrified, saying, 'It's a ghost!' And they cried out of fear. But immediately he spoke to them, saying, 'Take heart, it is I; have no fear" (Matthew 14:25–26). James Tissot pictured the scene, rendering Jesus aglow, emanating a spectral aura, as if to account for the disciples' misrecognition (fig. 47). His radiance, frontal presentation, raised hands, and direct gaze recall the iconography of Marian apparitions. No doubt early members of the Jesus cult faced a situation

FIGURE 47. James Jacques Joseph Tissot, *Jesus Walks on the Sea*, 1886–94, opaque watercolor over graphite, 11 ³⁄₁₆ × 4 ⅞ inches. Brooklyn Museum.

comparable to promoters of new Marian cults: how to make the narrative self-authenticating? The incorporation of misrecognition may help demonstrate the later certainty of the first devotees: they approached the mysterious event with a skepticism that resulted in a tested reassurance. They were not looking for Mary or Jesus to appear, who did so entirely on their own. As with Jesus's disciples, the children's misrecognition of Mary at Fatima and elsewhere serves to underscore the unexpected nature, and therefore to confirm the reliability, of the appearance.

As a topos, the disguise of the sacred person also serves to engage the reader-viewer in the mystery and revelation of sacred power. As onlookers, believers are taken back to the moment of mystery, the origin of the subsequent cult, and allowed to glimpse its elusive beginnings. Perhaps the misrecognition

is meant to posit the visual innocence of the children. And yet it is striking that the popular literature on the Marian apparitions commonly glosses over or even eliminates the episodes of misrecognition. At some point in the life of the devotion, perhaps, certainty seeks a new register, one from which all doubt has been expelled. For the faithful who seek healings or other blessings from a long and officially recognized intercessory figure like Our Lady of Fatima, the precise details and the confirmatory function of the topos are simply no longer necessary. The misrecognition is forgotten and the image on devotional cards or the statuary placed in grottos becomes the way Mary appeared, clear as day.

The act of misrecognizing is not just a literary or rhetorical device. It has a visual career that is relevant here. It is part of a process of remembering that is also a kind of forgetting. As the children remembered the original apparition, it congealed into Our Lady, helped along eventually by images. The blurry image of a burst of light developed into a pretty, doll-like lady perched in clouds. In time, the devotion forgets that process and fixes entirely upon the devotional image. One is reminded of a similar act of forgetting in the inspiration of pious artists, who overlook the borrowing that constitutes the empirical basis of their visions. Thus, Sallman appears to have ignored or forgotten the source of his image of Jesus.[27] The two processes, forgetting and misrecognizing, are inversions of one another. Images seem to facilitate a transposition or metamorphosis that is basic to the forms of visual piety under discussion. In the first case, an image veils or forgets its source in order to produce a strangely compelling, revelatory, virtually iconic portrait; in the other, the apparition is not recognized, and is later replaced by an image that effectively cancels the misrecognition by becoming the faithful representation of the apparition. This identification of image and apparition is sealed when the image begins to work miracles, as in the case of The Pilgrim Statue of Our Lady of Fatima (see figs. 45 and 14).[28] At that point it becomes important to cease to recite the original confusion.

But the visual construction of a sacred likeness is what interests the student of visual culture, so retracing the development of devotion to Fatima may serve as a case study. Scholars studying the modern apparitions have noted that, generally, the figure of Mary has only subsequently been identified by someone other than those who experienced the apparition, that is, someone who did *not* see her, but wants to secure her appearance and meaning in relation to the church as institution and authority.[29] This suggests that the expectations and the setting under which the children first encountered their apparitions did

not provide the interpretive cues that allowed them to see the Virgin Mary. It is not really clear what the children saw because the visibility of the apparition took time to be resolved. It took hectoring parents and priests and the intrusion of civil authorities. It required theological paradigms, emergent ritual viewings, the fervent response of the local community, and the determinative intervention of sympathetic clergy for the visibility to take shape.[30] The children saw something, perhaps, but as the accounts themselves make clear, they did not see what we see when we look at the established devotional imagery of each apparition. The firm visual bearings of an iconographical type, the easily recognizable, universally familiar formula of devotional iconography, is a later arrival, only gradually developing as the community of belief sorted out a system of visual communication that would make the elusive, ineffable, and idiosyncratic features of an apparition into an available protocol of devotion. It is easy, indeed, quite tenable for believers to conflate image and apparition. Pious biographers of Sister Lucia, for example, take quite for granted that when she referred to the apparition as a "lady" in her early written and oral accounts, she meant nothing different than "Our Lady," which was what she said later. But critical analysis, whether it is the nonbelieving scholar or the church's skeptical investigator, must look beneath this conflation. The power of religious ways of seeing to hide fault lines and evolving narratives and erase contradictory details must always remain in mind, not simply as a form of false consciousness, but as a creative form of thought and practice. Scholars need to see the cloaking or transformative effect of images and gazes not merely as forms of deception, but as how visual piety works. The misrecognition of Mary, which is later forgotten, inverts the procedure observed in cases of artistic inspiration where artists veil a source, thus forgetting it.

Rather than dismiss such instances as disingenuous or nothing more than plagiarism, scholars who wish to understand apparitions as forms of visual culture should place them in a different interpretive register and recognize that religious vision is a form of imagination that relies on the transposition of images. The point is to enrich and deepen the understanding of the manner in which images collaborate with the imagination and communities of viewers. The ritual and theological meaning of the apparition of the Virgin is not clear until an image helps clarify or solidify what the children saw, because *what the Virgin looks like is what she is like*, that is, what her meaning and message will be. Likeness or visibility is a structure of relations, a way of seeing that is a way of feeling. Rather than direct portrayals of what the children saw, the images

of the apparition are better understood as the devotion's codification or fixing of how to enter into and maintain a devotional relationship with Mary.

What Lucia saw at Fatima evolved from the 1915 manifestation to the angel of 1916 to the lady of May and June 1917 to Our Lady in July, and her development did not stop there. Indeed, Our Lady continued to evolve as Sister Lucia gradually disclosed through successive memoirs and visions, beginning in 1925 and stretching until 1941. But the constancy of images served to stabilize the person beneath or behind or within these semantic shifts and embellishments. Images anchor a shifting meaning by appearing to come after the original event in just the way that a fragment of a circle is morphed by the human eye into a complete circle. In other words, seeing contributes to what is seen. I made this point in chapter 2 regarding the image of the Crucifixion ascribed to Dürer's influence (see fig. 5): the depiction of the event purports to be what happened, but the picture is actually shaped by what occurred long after the event portrayed in the woodcut. Likewise, images of Our Lady take shape after the event of her appearance, which they appear to capture by making the apparition visually accessible. More accurate perhaps would be to say that apparitions or visions occur within the stream of images, which is already there, moving through the minds of viewers as the wherewithal for seeing what they want very much to see. And so Our Lady appears to them in the body of an image, a faithful event, surely, an act of visual piety. A good example of this is the statue (see fig. 45) that travels around the world as the official Pilgrim Statue of Our Lady of Fatima, which was not carved until 1947, when it was pronounced by Sister Lucia to be the image that most resembles what she saw in 1917. The reciprocal gaze that welcomes devout viewers when they encounter the statue obliterates the uncertainty of the original phenomenon, planting the new image in the viewer's imagination such that Our Lady as she appeared to children at Fatima appears now in the statue.

In addition to this kind of image-apparition relation, there is another large category of visual appearance, a different mode of apparition, one that inverts the role of the image just outlined. On some occasions it is the image that comes first—as a picture of Jesus in a forkful of spaghetti, in the suds of a beer glass, or on a tortilla. Even if these are no more than mere stunts, the manner in which they match figure to picture makes my point. Each involves the resolution of "visual noise," that is, the interpretation of marking as a recognizable pattern. More seriously, the figure of the Virgin on buildings is what it is precisely because it evokes the image believers already knew and

is apprehended by a faith that welcomes the likeness (fig. 48). The difference between the two kinds of apparitions is that the second type is not a private revelation, an appearance limited to a single person—recall that at Fatima, in the presence of hundreds, even thousands, it was only Lucia and Jacinta who saw Our Lady and Francisco who heard her. In the second kind of apparition, Our Lady manifests herself very publicly as an image in such common objects as a wall, a tree, or food. In these instances one recognizes the figure as Marian by discerning its similarity to one or more models in the lexicon of familiar images. The viewer must recognize a match, a correspondence to a prevailing prototype, otherwise the apparition does not occur. It is a matter of discovery, of seeing what was not there, what others may still not see, what must be sought for and once recognized is unforgettable. Devout viewers do not resolve the likeness by gradually settling on a visual type to represent it, but begin with the visual fact of the image and proceed to determine what it means by asking why the Virgin has appeared at this time, in this place? The response, if it's a religiously earnest one and not only an entertaining spectacle, involves a material appropriation of the image, a devotional recontextualization of the site. As news about the apparition circulates, pilgrims begin to visit and transform the site, surrounding and framing the images with candles, votive offerings, and other images. An improvised architecture of enshrinement emerges, at first perhaps composed principally of human bodies, which gather about the image and transform it into a spectacle by virtue of a concerted gaze as well as by the many things they deposit before the image. As a result, the developing gestalt of the apparition is fixed and its meaning ascertained by the testimonies and sharing of stories among pilgrims.

Another instance, available on the internet, is the postmortem appearance of Pope John Paul II in a photograph of a bonfire in Poland, which was burned to mark the second anniversary of the pontiff's death in 2007.[31] The fiery image makes us keenly aware of the importance of visual media. The apparition could not exist without being a photograph. Who could have glimpsed the effigy by staring into the roaring flames of a bonfire? In fact, the Polish man who snapped several photographs of the commemorative bonfire was quoted as saying, "It was only afterwards when I got home and looked at the pictures that I realized I had something."[32] John Paul II did not become visible in the actual and very narrow flicker of time that the shape of flame existed. His apparition only came to exist in the photograph, which captured

FIGURE 48. Guss Wilder III, Appearance of Madonna image on the window panes of a corporate office building, Clearwater, Florida, 1996. Courtesy of Guss Wilder III and Gary Posner.

an instant seen from one angle and made it into an enduring gestalt with a meaning, a sign bearing an intention for faithful viewers. The photographer found warrants to bolster his perception. The bonfire was intended, after all, as a remembrance of the Holy Father by his countrymen. Furthermore, when the photographer showed the picture to a local bishop (showing not all of the pictures he took—only the one with the image in it), the bishop told him that John Paul II had "made many pilgrimages during his life and he was still making them in his death." The devout recognize in the frozen contour of the flame the resemblance of a familiar image. Press accounts of the apparition paired the bonfire flame with a photograph of the pontiff near the end of his life, seen from an angle that bore close resemblance to the effigy in flame. Once the two images are seen together, the second retrospectively tailors the bonfire

snapshot until devout viewers can see nothing else. The identification of flame and pontiff erases the fact that the *image* of the pope is the reality to which the photo appears to allude.

THE MATTER OF VISION

The role of the materiality of the medium is key to understanding the visual culture of apparitions. This has also been studied in the use of Polaroid photography in pilgrimages to Marian apparition sites (fig. 49).[33] In the imagery that has emerged from visual practices using Polaroids at shrines and places where Mary continues to show herself, two uses of photographs have become prominent: images that are understood to document her appearance, and images that serve as occasions for divination, registering her messages for the faithful in a visual code. In the first case, Mary's appearance is commonly associated with the sun, a brilliant burst of light that confirms her presence, not often by limning her figure, but announcing her appearance in a blaze of light. Such photographs allow the devout to see her glory and participate in the message preached by the visionaries who first glimpsed her appearance and who now continue to receive her messages and share them with the community that gathers at the site.[34]

In the other instance of apparition imagery, the visual medium is a system of coded disclosure, conveying sacred information revealed to those with the faith necessary to receive it. Auras, reflections, glints, and all the visual disturbance or noise produced by as luminous or chemical effects in Polaroid photography are regarded by the faithful as forms of heavenly communication.[35] As in any divination practice, chance plays an irreducible role in this process. By removing human intentionality from the production of marks, the element of randomness opens the door to supernatural causation. Because disconfirmation is impossible, all that is required is the need to find the hand of God at work in one's life. The specific intention of God is determined by interpreting the marks according to a flexible lexicon of symbols that read the marks as a hermetic code. The principle is not unlike the visual suggestion of tarot cards.[36] Naturally, this code is all the more telling when applied by those motivated by the desire and propelled by the predisposition to tailor a message to their own situation, that is, to enter into personal communication with the divine.[37]

The internet is very helpful as a medium because origins are quickly forgotten and a vast reservoir of images is easily accessible. The circulation of images

FIGURE 49. Matt Gainer. Followers of Maria Paula Acuña share Polaroid photographs, Mojave Desert, June 13, 2006, color photograph. Courtesy of Matt Gainer.

and anecdotes facilitates new narratives. Fragments invite recontextualization and the internet provides an endless transmission of anecdotes. But this is only half of the process. The internet not only circulates fragments, it creates new contexts for redeploying them in narratives and practices, as well as for maintaining extended relationships among devotees. Chat rooms, email lists, and websites operated by religious groups, such as those investigated by Paolo Apolito in his study of Catholic visionary virtual communities, install imagery in the apparatus of apocalyptic or millennial beliefs, applying revelation and apparition to world events or moral crises, and to international campaigns that promote the cause of beatifying or canonizing new saints.[38]

The power of images to appear just about anywhere assures believers of their veracity. It happens all the time, in a process that is traceable, for example, from the discovery of a cross buried in the wreckage at Ground Zero to its delineation and final installment as an enduring monument. Why find a cross buried in tons of wreckage (fig. 50)? Finding the cross may have compensated for not finding any survivors, and its discovery was also motivated by the need to recover a religious framework in which to see the suffering and loss. This is why the cross appeared, why it became visible, and why its visibility underwent successive degrees of clarification, culminating in the erection of

FIGURE 50. Cross, Ground Zero, Manhattan, New York, 2008.
Photo by Jolyon Mitchell.

the cross on a concrete pedestal as a monument at Ground Zero.[39] This was
a process of formalization that directly parallels the formation of shrines at
spontaneous apparition sites, rendering them less spontaneous by changing
the mark into an unambivalent epiphany. With the Marian apparitions the
images come later, sometimes decades later, to tailor the distant event to the
devotion of the millions. In the case of image-apparitions, the visual miracle
comes first, embodying the sacred event itself. Yet it is important to recognize
the larger family resemblance of the two kinds of apparition: in both instances,
the images create an interface with a sacred manifestation. In each case, the
enduring function of imagery is to establish a form of address that is occa-
sioned by a situation that requires interpretation, an opening that beseeches

a response from the devout. The inquiry, in turn, is converted into a visual invitation for engagement.

Apparitions of both kinds—which may be called internal and external—occur where there is a confluence of need, desire, precedent, belief, and the accommodating visual noise of a medium. I do not propose to observe a strong distinction between internal and external apparitions, because whatever the triggering phenomenon may be—an involuntary muscular twitch around the eye, a blob of chemistry in a Polaroid, or the dazzling aura of Mary herself—it requires an apparatus of interpretive response to become visible. Of greater interest are the visual operations of these two modes of apparition: in the external case, the image is the very medium of an apparition, and invites an interpretation; and, in the opposite way, the image is the end point of a search for interpreting an original, internal experience. In the first instance, the image holds an interpretive lens on the present, moving the devout to ask why the image has appeared, what does Mary intend with her sudden visual appearance. In the latter case, an image punctuates a quest, lending it finality, capping the interpretative search with an abiding answer. In that case, once the devout possess the official image of Our Lady, they no longer search for the object of devotion: they have found it. So the image might be said to fulfill, but also in some sense to erase, the quest for meaning. The image stabilizes the original ambivalence of the apparition by helping to forget that the ambivalence ever existed. The perfected (visually resolved and devotionally programmed) visibility of the statue or holy card image entirely replaces the irregularity, indetermination, idiosyncrasy, and virtual invisibility of the original apparition. It does this in the same way that the original accounts of the apparitions at Fatima, for example, have been rerembered by the later memoirs, which have replaced the mysterious figure with Our Lady of Fatima. Accordingly, the popular tracts on Fatima include little or no indication that there was ever any doubt about the Virgin's identity.

When Warner Sallman was asked in 1961, twenty years after his well-known painting *Head of Christ* had appeared, if he had based it on Lhermitte's 1892 painting (see fig. 44), he conceded that he had seen the French image before he conceived of the early version of the picture in 1924. But Sallman would not admit to the plagiarism that some critics had charged him with. "I don't wonder that people say the [Lhermitte] painting influenced my drawing," he

commented. "Isn't everything we create a composite of what we have subconsciously stored through the years?"[40] Zeuxis and Raphael are both said to have explained their creation of ideal beauty as composite integrations of discrete images.[41] So why not Sallman? And if invoking the mechanism of unconscious influence can help, all the better. What makes his picture appear authentic to many people is the way it subsumes the centuries-old practice of portraying Jesus with a solemn expression, slender face, long brown hair, large blue eyes, and a demeanor that is dutifully submissive to his father's will. Sallman updated this physiognomy for his contemporaries, who commonly responded to this image the way other Christians do to images of Mary and the saints, that is, by recognizing him. The picture looks like Jesus for many viewers because it shows them an image of what they already thought he was *like*. And how did they know he was like that? From the dense archive of images they had already seen and condensed in their minds into a collective representation that Sallman instantiated in his picture. The strangest, most transcendent realities have a way of becoming the most familiar. The power of recognition is the power of seeing what you always knew as if you were seeing it for the first time. As one person put it, looking at Sallman's picture of Jesus: "there he is . . . in person."[42] Or as another told me, he'll know the Lord when he arrives among the crowds of heaven because he's already seen his picture.

NOTES

PREFACE

1. Talal Asad, *Genealogies of Religion: Discipline and Reasons of Power in Christianity and Islam* (Baltimore: Johns Hopkins University Press, 1993), 29.

2. Daniel Dubuisson, *The Western Construction of Religion: Myths, Knowledge, and Ideology,* trans. William Sayers (Baltimore: Johns Hopkins University Press, 2003), 164.

3. See, for example, Timothy Fitzgerald, *The Ideology of Religious Studies* (Oxford: Oxford University Press, 2000);Dubuisson, *Western Construction of Religion;* Russell T. McCutcheon, *The Discipline of Religion: Structure, Meaning, Rhetoric* (London: Routledge, 2003); and Tomoko Masuzawa, *The Invention of World Religions: Or, How European Universalism Was Preserved in the Language of Pluralism* (Chicago: University of Chicago Press, 2005).

4. Aaron W. Hughes, "Haven't We Been Here Before? Rehabilitating 'Religion' in Light of Dubuisson's Critique," Review Symposium, Daniel Dubuisson, *The Western Construction of Religion, Religion* 36 (2006), 131.

5. Jonathan Z. Smith, "Religion, Religions, Religious," in *Relating Religion: Essays in the Study of Religion* (Chicago: University of Chicago Press, 2004), 194.

6. Jonathan Z. Smith, *To Take Place: Toward Theory in Ritual* (Chicago: University of Chicago Press, 1987), 105–6.

7. Peter L. Berger, *The Sacred Canopy: Elements of a Sociological Theory of Religion* (Garden City, NY: Anchor Books, 1969), 25; Berger cited both Otto and Eliade in his notes. See Rudolf Otto, *The Idea of the Holy: An Inquiry into the Non-Rational Factor in the Idea of the Divine and Its Relation to the Rational,* trans. John W. Harvey (Oxford: Oxford University Press, 1958), 5–7; Mircea Eliade, *The Sacred and the Profane: The Nature of Religion,* trans. Willard R. Trask (San Diego: Harcourt, Brace & World, 1959), 20–65.

8. Emile Durkheim, *The Elementary Forms of Religious Life*, trans. Karen E. Fields (New York: Free Press, 1995), 327.

9. Ibid., 349.

10. Ibid., 351.

11. Ibid., 231.

12. Ibid., 232.

13. Ibid., 233.

14. Ibid., 233.

15. Asad, *Genealogies*, 31.

16. Robert A. Orsi, *Between Heaven and Earth: The Religious Worlds People Make and the Scholars Who Study Them* (Princeton: Princeton University Press, 2005), 5–6, 73–74.

17. See my introduction in David Morgan, ed., *Religion and Material Culture: The Matter of Belief* (London: Routledge, 2010), 1–12; also Morgan, *The Sacred Gaze: Religious Visual Culture in Theory and Practice* (Berkeley: University of California Press, 2005), 6–15.

CHAPTER I

1. The image appeared in *McGuffey's New First Eclectic Reader*, a revised edition of the original (1836), published in 1857 and subsequently reissued in 1863 and 1885. On William Holmes McGuffey, his widely used schoolbooks, and the Protestant piety that pervaded them, see John H. Westerhoff III, *McGuffey and His Readers: Piety, Morality, and Education in Nineteenth-Century America* (Nashville: Abingdon, 1978). For publication history and biography, see Stanley W. Lindberg, *The Annotated McGuffey: Selections from the McGuffey Eclectic Readers 1836–1920* (New York: Van Nostrand Reinhold Co., 1976).

2. A fascinating recent study of audiences and the history of their study is Richard Butsch, *The Citizen Audience: Crowds, Publics, and Individuals* (New York: Routledge, 2008). The idea of collective and individual bodies is old and varied. Most famously in modern historical studies is the brilliant study of the political theology of medieval kingship (consisting of body politic and body natural) in a classic book by Ernst Kantorowicz, *The King's Two Bodies: A Study in Mediaeval Political Theology* (Princeton: Princeton University Press, 1997), first published in 1957. The idea of a body politic was socialized in Victorian Europe and the United States in a number of ways, see Mary Poovey, *Making a Social Body: British Cultural Formation, 1830–1864* (Chicago: University of Chicago Press, 1995). For a study of the relevance of the social body to embodiment, see Nick Crossley, *The Social Body: Habit, Identity and Desire* (London: Sage, 2001).

3. Mark L. Johnson, "Embodied Reason," in *Perspectives on Embodiment: The Intersections of Nature and Culture*, ed. Gail Weiss and Honi Fern Haber (New York: Routledge, 1999), 81.

4. William Barrett, *Irrational Man: A Study in Existential Philosophy* (Garden City, NY: Doubleday, 1958), 77.

5. Plato, *The Symposium*, trans. Walter Hamilton (London: Penguin, 1951), 92–95, 209e–212c.

6. Ibid., 95, 212c.

7. A richly informed account of the tradition of opposition to ocularcentrism among modern French theorists is Martin Jay, *Downcast Eyes: The Denigration of Vision in Twentieth-Century French Thought* (Berkeley: University of California Press, 1993); see also Jay's essay, "Sartre, Merleau-Ponty, and the Search for a New Ontology of Sight," in *Modernity and the Hegemony of Vision*, ed. David Michael Levin (Berkeley: University of California Press, 1993), 143–85.

8. Sophocles, *King Oedipus*, in *The Theban Plays*, trans. E. F. Watling (London: Penguin, 1974), 61, lines 1293–96.

9. Adam Smith, *The Theory of Moral Sentiments* (Amherst, NY: Prometheus Books, 2000), 163.

10. Ibid., 163, emphasis added.

11. Ibid., 164.

12. Ibid., 164–65.

13. Ralph Waldo Emerson, *Nature*, in *The Essential Writings of Ralph Waldo Emerson*, ed. Brooks Atkinson (New York: Modern Library, 2000), 6.

14. George Washington, *Rules of Civility*, ed. Richard Brookhiser (New York: Free Press, 1997), 53; emphasis added.

15. Sophocles, *King Oedipus*, 63–64, lines 1372–84.

16. Jean-Paul Sartre, *Being and Nothingness*, trans. Hazel E. Barnes (New York: Pocket Books, 1966), 350, emphasis in original, here and in the following quotes.

17. Ibid., 352.

18. Ibid., 310.

19. Ibid., 352.

20. Sigmund Freud, *A General Introduction to Psycho-Analysis*, rev. ed., trans. Joan Riviere (New York: Pocket Books, 1953), 423.

21. Sartre, *Being and Nothingness*, 358.

22. Ibid., 346–47.

23. Martin Jay has discussed the deeply antiocular nature of Sartre's philosophy and his "obsessive hostility to vision" (149) in "Sartre," 149–60. A substantial and withering critique of Sartre's book is Herbert Marcuse, "Existentialism: Remarks on Jean-Paul Sartre's *L'Etre et le Neant*," *Philosophy and Phenomenological Research* 8, no. 3 (March 1948): 309–36.

24. Roland Barthes, *Camera Lucida: Reflections on Photography*, trans. Richard Howard (New York: Hill and Wang, 1981), 45.

25. Ibid., 53.

26. Ibid., 55.

27. Jacques Lacan, "The Mirror Stage as Formative of the *I* Function as revealed in Psychoanalytic Experience," in *Écrits: A Selection*, trans. Bruce Fink (New York: W. W. Norton, 2002), 4.

28. Michel Foucault, *Discipline and Punish: The Birth of the Prison*, trans. Alan Sheridan (New York: Vintage Books, 1995), 200–209.

29. Jeremy Bentham, "Panopticon" (1787), in *The Panopticon Writings*, ed. Miran Bozovic (London: Verso, 1995), 29.

30. Foucault, *Discipline and Punish*, 201.

31. Ibid, 200. Lacan had said the same in 1964: "In this matter of the visible, everything is a trap," Jacques Lacan, *The Four Fundamental Concepts of Psycho-Analysis*, ed. Jacques-Alain Miller, trans. Alan Sheridan (New York: W. W. Norton, 1981), 93.

32. Foucault, *Discipline and Punish*, 201.

33. Ibid., 174.

34. René Descartes, *Meditations on First Philosophy*, trans. Michael Moriarty (Oxford: Oxford University Press, 2008), 61.

CHAPTER 2

1. Roland Barthes, *Camera Lucida: Reflections on Photography*, trans. Richard Howard (New York: Hill and Wang, 1981), 5, 9.

2. André Bazin, "The Ontology of the Photographic Image," in *Classic Essays on Photography*, ed. Alan Trachtenberg (New Haven: Leete's Island Books, 1980), 237–44 (Bazin's article was originally published in 1945). For an intelligent argument that places photography securely within the history of image making, see Joel Snyder and Neil Walsh Allen, "Photography, Vision, and Representation," *Critical Inquiry* 2 (1975): 143–69. For quite a different, strongly contrary view of the history of photography, see Jonathan Crary, *Techniques of the Observer: On Vision and Modernity in the Nineteenth Century* (Cambridge, MA: MIT Press, 1990), 13.

3. Hans Belting, "Image, Medium, Body: A New Approach to Iconology," *Critical Inquiry* 31 (Winter 2005), 312; see also Belting, "In Search of Christ's Body. Image or Imprint?" in *The Holy Face and the Paradox of Representation*, ed. Herbert L. Kessler and Gerhard Wolf, Villa Spelman Colloquia, vol. 6 (Rome: Nuova Alfa Editoriale, 1998), 1–11; and Belting, *Bild-Anthropologie: Entwürfe für eine Bildwissenschaft* (Munich: Wilhelm Fink Verlag, 2001), 143–88.

4. Martin Jay, *Downcast Eyes: The Denigration of Vision in Twentieth-Century French Thought* (Berkeley: University of California Press, 1993), 588.

5. Bazin, "Ontology of the Photographic Image," 238.

6. Ibid., 238.

7. David Freedberg, *The Power of Images: Studies in the History and Theory of Response* (Chicago: University of Chicago Press, 1989), 1.

8. Matthew Arnold, *Culture and Anarchy and Other Writings*, ed. Stefan Collini (New York: Cambridge University Press, 1993), 190; see also 79.

9. I have explored definitions of visual culture at greater length in *The Sacred Gaze: Religious Visual Culture in Theory and Practice* (Berkeley: University of California Press, 2005), 25–47.

10. The print was long attributed to Dürer, but recently some scholars have argued that the image "may in no way be counted among the works certainly by Dürer," Rainer Schoch, "Die Kreuzingung Christi (Der grosse Kalvarienberg)," in *Albrecht Dürer: Das druckgraphische Werk*, ed. Rainer Schoch, Matthais Mende, and Anna Scherbaum, 2 vols., (Munich: Prestel, 2002), 500. Other experts insist that the image is based on a design by the master or was completed from a wooden block left uncompleted by him.

11. See Caroline Walker Bynum, *Wonderful Blood: Theology and Practice in Late Medieval Northern Germany and Beyond* (Philadelphia: University of Pennsylvania Press, 2007).

12. In the Eastern tradition of Christianity, one finds the vindication of Thomas associated with the image of Jesus in the story of Abgar and the mandylion, which is discussed here in chapter 3. In a narrative of 945 C.E., we read that it was Thomas whom Christ dispatched to summon Ananias, the servant of Abgar, the Syrian king of Edessa, who'd sent Ananias in search of Jesus's healing power. In a letter that Jesus gives to the servant, he echoes his own words to Thomas in the fourth Gospel: "Blessed are you, Abgar, in that you believed in me without having actually seen me" (238). In another version of the story related in the same document, Jesus gave Thomas the cloth miraculously bearing his image and instructed him to deliver it to Abgar following his ascent into heaven (240), Court of Constantine Porphyrogenitus, "Story of the Image of Edessa," translated by Bernard Slate et al., in *The Shroud of Turin: The Burial Cloth of Jesus?* by Ian Wilson (Garden City, NY: Doubleday, 1978). The account affirms the image as a faithful act of seeing. And the narrative could not have affirmed the embodied nature of this seeing more robustly than its description of Abgar's healing of leprosy: "And so, receiving the likeness from the apostle and placing it reverently on his head, and applying it to his lips, and not depriving the rest of the parts of his body of such a touch, immediately he [Abgar] felt all the parts being marvelously strengthened and taking a turn for the better" (241).

13. Jacobus de Voragine, *The Golden Legend: Readings on the Saints*, trans. William Granger Ryan, 2 vols. (Princeton: Princeton University Press, 1993), 1:221.

14. De Voragine, *The Golden Legend*, 1:217.

15. I have discussed this as a form of "likeness" in "Recognizing Jesus," in *Innovative Methods in the Study of Religion*, ed. Linda Woodhead, forthcoming; see also David Morgan, "Finding Fabiola," in *Fabiola: An Investigation*, by Francis Alÿs, ed. Karen Kelly and Lynne Cook (New York: Dia Foundation, 2008), 11–21; and Morgan, *Visual Piety: A History and Theory of Popular Religious Images* (Berkeley: University of California Press, 1998), 34–50.

16. Albrecht Dürer, *The Painter's Manual: A Manual of Measurement of Lines, Areas, and Solids by Means of Compass and Ruler*, trans. Walter L. Strauss (New York: Abaris Books, 1977), 435. The illustration of the man drawing the woman did not appear in the 1525 edition of Dürer's book, but was prepared by the artist for a revised edition, which did not appear until 1538, a decade after his death.

17. Dürer spoke of "tracing" an object in another device, invented by Jacob Keser, which he described in his 1525 manual, see *The Painter's Manual*, 431. In fact, the image is not a trace, but a construction of a trace.

18. Quoted in Gabriele Finaldi, *The Image of Christ* (London: National Gallery, 2000), 142. The idea of suffering with the suffering Jesus was a fundamental part of a late medieval piety of empathy championed by Franciscans such as Bonaventure and promoted by the popular genre of Meditations on the Life of Christ. For a discussion related to images of Christ, especially the Veronica, see Anne I. Clark, "Venerating the Veronica: Varieties of Passion Piety in the Later Middle Ages," *Material Religion* 3, no. 2 (July 2007), 170–71.

19. Martin Luther, *A Meditation on Christ's Passion*, in *Luther's Works*, vol. 42, ed. Martin O. Dietrich (Philadelphia: Fortress Press, 1969), 9: "when you see nails piercing Christ's hands, you can be certain that it is your work. When you behold his crown of thorns, you may rest assured that these are your evil thoughts."

20. Dürer, *The Painter's Manual*, 391.

21. Crary, *Techniques of the Observer*, 2.

22. Quoted in Dürer, *The Painter's Manual*, 11.

23. Quoted in ibid., 12.

24. Ibid., 435.

25. Martin Luther, *Against the Heavenly Prophets in the Matter of Images and Sacraments*, in *Luther's Works*, vol. 40 (Philadelphia: Muhlenberg Press, 1958), 40:99.

26. Dürer, *The Painter's Manual*, 435.

27. René Descartes, *The Dioptrics*, in *Philosophical Writings*, trans. and ed. Elizabeth Anscombe and Peter Thomas Geach (Indianapolis: Bobbs-Merrill Educational Publishing, 1954), 243.

28. Ibid., 244.

29. Ibid., 244.

30. Maurice Merleau-Ponty, "Eye and Mind," in Merleau-Ponty, *The Primacy of Perception and Other Essays*, ed. James M. Edie (Evanston, IL: Northwestern University Press, 1964), 170.

31. René Descartes, *Meditations on First Philosophy*, trans. Michael Moriarty (Oxford: Oxford University Press, 2008), "Synopsis," 10–11.

32. Maurice Merleau-Ponty, *The Phenomenology of Perception*, trans. Colin Smith (London: Routledge, 2002), 273.

33. Ibid., 373.

34. Descartes, *Meditations on First Philosophy*, 20: "But what therefore am I? A thinking thing." And on the primacy of intellection over perception: "For since I have now learned that bodies themselves are perceived not, strictly speaking, by the senses or by the imaginative faculty, but by the intellect alone, and that they are not perceived because they are touched or seen, but only because they are understood, I clearly realize that nothing can be perceived by me more easily or more clearly than my own mind," 24.

35. "An Unpublished Text by Maurice Merleau-Ponty: A Prospectus of His Work," trans. Arleen B. Dallery, in Merleau-Ponty, *The Primacy of Perception*, 5.

36. Ibid., 5.

37. Merleau-Ponty, "Eye and Mind," 170.

38. Ibid., 171.

CHAPTER 3

1. I have relied on the following insightful studies of the history of the Mandylion and the Veronica: Ewa Kuryluk, *Veronica and Her Cloth: History, Symbolism, and Structure of a "True" Image* (New York: Basil Blackwell, 1991); David Freedberg, *The Power of Images: Studies in the History and Theory of Response* (Chicago: University of Chicago Press, 1989), 206–12; Hans Belting, *Likeness and Presence: A History of the Image before the Era of Art*, trans. Edmund Jephcott (Chicago: University of Chicago Press, 1994), 208–24; Neil MacGregor, *Seeing Salvation: Images of Christ in Art*, with Erika Langmuir (New Haven: Yale University Press, 2000), 85–111; Gabriele Finaldi, *The Image of Christ* (London: National Gallery, 2000), 74–103; and Anne I. Clark, "Venerating the Veronica: Varieties of Passion Piety in the Later Middle Ages," *Material Religion* 3, no. 2 (July 2007): 164–89. Two works of special interest are: Herbert L. Kessler and Gerhard Wolf, eds., *The Holy Face and the Paradox of Representation*, Villa Spelman Colloquia, vol. 6 (Rome: Nuova Alfa Editoriale, 1998); and Ernst von Dobschütz, *Christusbilder: Untersuchungen zur christlichen Legende* (Leipzig: J. C. Hinrichs, 1899), esp. 209–62. Belting has examined the mandylion of Edessa, the acheiropoieton, and the Veronica traditions within the larger history of the "true image" in *Das echte Bild: Bildfragen als Glaubensfragen* (Munich: C. H. Beck, 2005), 47–74 and 120–32.

2. Jasper Hopkins, *Nicholas of Cusa's Dialectical Mysticism: Text, Translation, and Interpretive Study of De Visione Dei*, 3rd ed. (Minneapolis: The Arthur J. Banning Press, 1988), 681.

3. Ibid., 684–85.

4. My thanks to Larissa Grau for this translation.

5. I have considered this element of recognition in *Visual Piety: A History and Theory of Popular Religious Images* (Berkeley: University of California Press, 1998), 34–50.

6. Kuryluk, *Veronica and Her Cloth*, 32–33.

7. Averil Cameron, "The History of the Image of Edessa: The Telling of a Story," in *Okeanos. Essays presented to I. Sevcenko, Harvard Ukranian Studies*, vol. 7 (1983), 85.

8. Kuryluk, *Veronica and Her Cloth*, 38–41; see also Cameron, "The History of the Image of Edessa," 80–94; and Han J. W. Drijvers, "The Image of Edessa in the Syriac Tradition," in Kessler and Wolf, *The Holy Face and the Paradox of Representation*, 13–31.

9. Kuryluk, *Veronica and Her Cloth*, 30.

10. Averil Cameron, "The Mandylion and Byzantine Iconoclasm," in Kessler and Wolf, *The Holy Face and the Paradox of Representation*, 40–54. Cameron asserts that references to the image of Abgar during the first period of Iconoclasm "permit us to

see . . . something of its gradual emergence into a major Byzantine iconophile symbol" (43). See also Cameron, "The History of the Image of Edessa," 88–90; and Hugo Meyer, "Copying and Social Cohesion in Rome and Early Byzantium: The Case of the First Famous Image of Christ at Edessa," in *Interactions: Artistic Interchange between the Eastern and Western Worlds in the Medieval Period*, ed. Colum Hourihane (Princeton: Index of Christian Art, 2007), 209–19.

11. Court of Constantine Porphyrogenitus, "Story of the Image of Edessa," translated by Bernard Slate et al., in *The Shroud of Turin: The Burial Cloth of Jesus?* by Ian Wilson (Garden City, NY: Doubleday, 1978), 249–50. An alternative and authoritative source for this text and others related to the image of Edessa is Mark Guscin, *The Image of Edessa* (Leiden: Brill, 2009). On the social function of icons in Byzantine society, see Averil Cameron, "Images of Authority: Elites, Icons, and Cultural Change in Late Sixth-century Byzantium," *Past and Present* 84 (1979), 3–35, and Meyer, "Copying and Social Cohesion."

12. Court of Constantine Porphyrogenitus, "Story of the Image of Edessa," 250. For further discussion of the entrance of the image into Constantinople see Cameron, "The Mandylion and Byzantine Iconoclasm," 33–35. Cameron points out that within four months of the installation of the Holy Face, Constantine VII had deposed Romanos and exiled his sons. The image had been put to effective use (34).

13. For an account of the rise of the Veronica legend and imagery in Europe, see Gerhard Wolf, "From Mandylion to Veronica: Picturing the 'Disembodied' Face and Disseminating the True Image of Christ in the Latin West," in Kessler and Wolf, *The Holy Face and the Paradox of Representation*, esp. 166–79; and, in the same volume, Christoph Egger, "Papst Innocenz III. und die Veronica. Geschichte, Theologie, Liturgie und Seelsorge," 181–203.

14. Belting, *Likeness and Presence*, 542–43.

15. Egger, "Papst Innocenz III. und die Veronica," 191.

16. In the "Story of the Image of Edessa," we read that twice the image copied itself on ceramic tile, which the author of the narrative referred to as "the unpainted copy of the unpainted portrait, the copy not made by human hands," 240.

17. Belting, *Das echte Bild*, 132, argues that by the mid-seventeenth century, following the demise of the "original" Roman Veronica in 1527, the cloth as relic "had become a distant memory and a mythical object." Belting sees illusionistic depictions of the Veronica by the Baroque Spanish painter Zurburán that allow viewers to imagine the idea of the image, "as if he could imitate the visions of the saints." The cloth vanishes, replaced by an imagined apperception of the original vision.

18. Pointed out in Finaldi, *The Image of Christ*, 150.

19. Caroline Walker Bynum, "Seeing and Seeing-Beyond: The Mass of St. Gregory in the Fifteenth Century," in *The Mind's Eye: Art and Theological Argument in the Middle Ages*, ed. Jeffrey F. Hamburger and Anne-Marie Bouché (Princeton: Department of Art and Archaeology, Princeton University, 2006), 209–40.

20. Ibid., 223.

21. *The Sources of Catholic Dogma*, trans. Roy J. Deferrari, from the thirtieth edition of Henry Denzinger's *Enchiridon Symbolorum* (Fitzwilliam, NH: Loreto Publications, 1955), 169–70.

22. Joseph Koerner, "The Icon as Iconoclash," in *Iconoclash: Beyond the Image Wars in Science, Religion, and Art*, ed. Bruno Latour and Peter Weibel (Karlsruhe: Center for Art and Media; Cambridge, MA: MIT Press, 2002), 185.

23. See Caroline Walker Bynum, *Wonderful Blood: Theology and Practice in Late Medieval Northern Germany and Beyond* (Philadelphia: University of Pennsylvania Press, 2007).

24. Ibid., 126.

25. Quoted in Belting, *Likeness and Presence*, 543; see also Egger, "Papst Innocenz III. und die Veronica," 197–98.

26. Belting, *Likeness and Presence*, 542.

27. Talal Asad, *Geneaologies of Religion: Discipline and Reasons of Power in Christianity and Islam* (Baltimore: Johns Hopkins University Press, 1993), 54.

28. Kuryluk, *Veronica and Her Cloth*, 116; and 116–22, for further, related accounts peppered with bitter antagonism against Jews.

29. Quoted in Belting, *Likeness and Presence*, 542.

30. Martin Jay, "Scopic Regimes of Modernity," in *Vision and Visuality*, ed. Hal Foster (Seattle: Bay Press, 1988), 3–23. Jay takes the term *scopic regime* from Christian Metz and argues compellingly for a plurality of visual subcultures in the historical era of modernity.

31. Edward S. Casey defines gaze in this way in his monumental work, *The World at a Glance* (Bloomington: Indiana University Press, 2007), 4.

32. The most widely cited discussion of this is surely Laura Mulvey, "Visual Pleasure and Narrative Cinema," *Screen* 16, no. 3 (1975): 6–18.

33. I have discussed the idea of "belief" as the condensation of material practice rather than as creedal assent in David Morgan, ed., *Religion and Material Culture: The Matter of Belief* (London: Routledge, 2010), 1–12.

34. I have considered variations of these fields in another essay: David Morgan, "The Visual Construction of the Sacred," in *Images and Communities: The Visual Construction of the Social*, ed. Matteo Stocchetti and Johanna Sumiala-Seppänen (Helsinki: Gaudeamus/Helsinki University Press, 2007), 53–74.

35. See Jean-Paul Sartre, *Being and Nothingness*, trans. Hazel E. Barnes (New York: Pocket Books, 1966), 347–54, where he describes the look of the other as "the gun pointed at me," 354. Tolkien described a momentary appearance of the dreaded Eye of Sauron to the helplessly exposed hobbits: "One moment only it stared out [from the darkness that concealed it], but as from some great window immeasurably high there stabbed northward a flame of red, the flicker of a piercing Eye; and then the shadows were furled again and the terrible vision was removed. The Eye was not turned toward them [the hobbits]: it was gazing north to where the Captains of the West stood at bay, and thither all its malice was now bent, as the Power moved to strike its deadly

blow," J. R. R. Tolkien, *The Lord of the Rings, Part III, The Return of the King* (New York: Ballantine Books, 1994), 235.

36. Michel Foucault, *Discipline and Punish: The Birth of the Prison*, trans. Alan Sheridan (New York: Vintage Books, 1995), 200.

37. St. Teresa of Avila, *Interior Castle*, trans. and ed. E. Allison Peers (Garden City, New York: Image Books, 1961), 88.

38. John Calvin, *Institutes of the Christian Religion*, trans. Henry Beveridge (Grand Rapids: Wm. B. Eerdmans, 1989), 95–96.

39. Ibid., 51.

40. Quoted from "Apparition of the Blessed Virgin on the Mountain of La Salette the 19th of September, 1846," http://198.62.75.1/www1apparitions/http:/pr00007 .htm.

41. For examples of this aspect of the visual piety of the devotional gaze, see Maya Balakirsky Katz, *The Visual Culture of Chabad* (New York: Cambridge University Press, 2010), 93–94; and Allen Roberts and Mary Nooter Roberts, *A Saint in the City: Sufi Arts of Urban Senegal* (Los Angeles: UCLA Fowler Museum of Cultural History, 2003), 21–28.

42. I have in mind as a fruitful analytical approach to the study of this mode of virtuality the classic work of Erving Goffman, *The Presentation of the Self in Everyday Life* (New York: Doubleday, 1959).

43. On religion in Second Life, particularly Jewish, Christian, and Buddhist communities, Shona Crabtree "Finding Religion in Second Life's Virtual Universe," Washingtonpost.com, June 16, 2007, www.washingtonpost.com/wp-dyn/content/article/ 2007/06/15/AR2007061501902.html (accessed August 18, 2010); for a fascinating discussion of Second Life virtuality from an anthropological perspective see Tom Boellstorff, *Coming of Age in Second Life: An Anthropologist Explores the Virtually Human* (Princeton: Princeton University Press, 2008), esp. 118–50 with regard to avatars and personhood. For another form of virtual engagement using digital technology, see Susan Kozel, "Spacemaking: Experiences of a Virtual Body," in *The Book of Touch*, ed. Constance Classen (Oxford: Berg, 2005), 439–46.

44. An illuminating study of the ideology is Brian W. Dippie, *The Vanishing American: White Attitudes and U.S. Indian Policy* (Lawrence: University Press of Kansas, 1982); for Dippie's discussion of Curtis's image and response to it and to the motif of the vanishing Indian, see pp. 208–21.

45. For a discussion of Chick's tracts, see Jason C. Bivins, *Religion of Fear: The Politics of Horror in Conservative Evangelicalism* (New York: Oxford University Press, 2008), 41–87.

46. See Birgit Meyer, "Impossible Representations: Pentecostalism, Vision, and Video Technology in Ghana," in *Religion, Media, and the Public Sphere*, ed. Birgit Meyer and Annelies Moors (Bloomington: Indiana University Press, 2006), 290–312.

47. See David Morgan, *The Sacred Gaze: Religious Visual Culture in Theory and Practice* (Berkeley: University of California Press, 2005), 75–112.

48. On iconoclasm as visual strategy, see Morgan, *Sacred Gaze*, 115–46.

CHAPTER 4

1. For considerations of the primacy of relationship in the study of religion see Robert A. Orsi, *Between Heaven and Earth: The Religious Worlds People Make and the Scholars Who Study Them* (Princeton: Princeton University Press, 2005), 5–6; and Stephen Pattison, *Seeing Things: Deepening Relations with Visual Artefacts* (London: SCM Press, 2007), 201–23.

2. Marcel Mauss, *The Gift: The Form and Reason for Exchange in Archaic Societies*, trans. W. D. Halls (New York: W. W. Norton, 1990).

3. The connections between religion and economy are diverse, and rarely so simple as a matter of economic practices infecting and transforming religion. For example, see Jeremy Stolow's fascinating study of the commercial aspects of Orthodox Jewish publishing, *Orthodox by Design: Judaism, Print Politics, and the ArtScroll Revolution* (Berkeley: University of California Press, 2010). Maya Balakirsky Katz has investigated the role of images of rebbes in trademarking and marketing Chabad Hasidism, *The Visual Culture of Chabad* (New York: Cambridge University Press, 2010). For a study of religion, commerce, advertising, and branding, see Mara Einstein, *Brands of Faith: Marketing Religion in a Commercial Age* (London: Routledge, 2008). Mark R. Valeri shows how eighteenth-century colonial American businessmen embraced market culture and evangelical revival within a moral discourse that regarded the production of wealth as congruent with the values of Christianity—*Heavenly Merchandize: How Religion Shaped Commerce in Puritan America* (Princeton: Princeton University Press, 2010). For an illuminating study beyond Jewish and Christian material see Vineeta Sinha, *Religion and Commodification: 'Merchandizing' Diasporic Hinduism* (New York: Routledge, 2011).

4. Provocative reflections on the economies of religion include Mark C. Taylor, *Confidence Games: Money and Markets in a World without Redemption* (Chicago: University of Chicago Press, 2004) and *About Religion: Economies of Faith in Virtual Culture* (Chicago: University of Chicago Press, 1999); David Chidester, "Economy," in *Key Words in Religion, Media, and Culture*, ed. David Morgan (London: Routledge, 2008), 83–95; and Michael J. Walsh, *Sacred Economies: Buddhist Monasticism and Territoriality in Medieval China* (New York: Columbia University Press, 2010), esp. 8–20 and 50–69. For a broader study of the economy of belief, see Pierre Bourdieu, "The Production of Belief: Contributions to an Economy of Symbolic Goods," *Media, Culture, and Society* 2 (1980): 261–93.

5. On debt and obligation in Brahmanism, see Charles Malamoud, *Cooking the World: Ritual and Thought in Ancient India*, trans. David White (Delhi: Oxford University Press, 1996), 92–108; for studies of karma and its economy in Buddhism see: James R. Egge, *Religious Giving and the Invention of Karma in Theravāda Buddhism* (Richmond, Surrey, UK: Curzon, 2002); Ellison Banks Findly, *Dāna: Giving and Getting in Pali Buddhism* (Delhi: Motilal Banarsidass Publishers, 2003); and on merit and material culture, John Kieschnick, *The Impact of Buddhism on Chinese Material Culture* (Princeton: Princeton University Press, 2003), 157–219.

6. Gary Anderson, "Redeem Your Sins by the Giving of Alms: Sin, Debt, and the 'Treasury of Merit' in Early Jewish and Christian Tradition," *Letter & Spirit* 3 (2007): 39–69, and Gary Anderson, *Sin: A History* (New Haven: Yale University Press, 2009).

7. Peter Brown, *The Cult of the Saints: Its Rise and Function in Latin Christianity* (Chicago: University of Chicago Press, 1982).

8. See Patrick J. Geary, *Furta Sacra: Thefts of Relics in the Central Middle Ages*, rev. ed. (Princeton: Princeton University Press, 1990).

9. For a theological discussion of this gift economy of Protestantism and its relation to global capitalism, see Kathryn Tanner, *Economy of Grace* (Minneapolis: Fortress Press, 2005).

10. Chris Wright, John Azumah, and Kwabena Asamoah-Gyadu, "A Statement on Prosperity Teaching," *Christianity Today* 53 (December 2009), online: http://www .christianitytoday.com/ct/2009/decemberweb-only/gc-prosperitystatement.html (accessed November 17, 2010).

11. Elizabeth Netto Calil Zarur and Charles Muir Lowell, eds., *Art and Faith in Mexico: The Nineteenth-Century Retablo Tradition* (Albuquerque: University of New Mexico Press, 2001); and Jorge Durand and Douglas S. Massey, *Miracles on the Border: Retablos of Mexican Migrants to the United States* (Tucson: University of Arizona Press, 1995).

12. See, for example, the case of Ambrose, who, following a dream in 386, maintained that the location of the relics of Gervasius and Protasius had been revealed to him—Saint Ambrose, *Letters*, trans. Sister Mary Melchoir Beyenka, O.P. (Washington, DC: Catholic University of America, 1954), 380. For a fascinating study of the process of finding, appropriating, and stealing relics, see Geary, *Furta Sacra;* and for a study of the process associated with cult statuary in India, see Richard Davis, *Lives of Indian Images* (Princeton: Princeton University Press, 1997).

13. This has been discussed by many authors. See, for example, Sixten Ringbom, *Icon to Narrative: The Rise of the Dramatic Close-Up in Fifteenth-Century Devotional Painting*, 2nd ed. (Doornspijk, The Netherlands: DAVACO, 1984), 23–52; and Henk van Os, with Eugene Honee, Hans Nieuwdorp, and Bernhard Ridderbos, *The Art of Devotion in the Late Middle Ages in Europe, 1300–1500* (Princeton: Princeton University Press, 1994).

14. For a consideration of the face as combining screen and perforation, what the authors call a "white wall / black hole system," see Giles Deleuze and Felix Guatarri, *A Thousand Plateaus*, trans. Brian Massumi (London: Continuum, 2004), 185–93.

15. Mauss, *The Gift*, 42.

16. Ibid., 39.

17. Ibid., 66.

18. Ibid., 12.

19. Speaking of gift exchange among aboriginal peoples in Australia, Mauss concluded that "souls are mixed with things; things with souls. Lives are mingled together, and this is how, among persons and things so intermingled, each emerges from their

own sphere and mixes together. This is precisely what contract and exchange are," *The Gift*, 20.

20. I have explored this in greater detail in an essay entitled "Finding Fabiola," in *Fabiola: An Investigation*, by Francis Alÿs, ed. Karen Kelly and Lynne Cook (New York: Dia Foundation, 2008), 11–21.

21. David Poeppel and Clare Stroud, "The Nature of Face Recognition: A Perspective from the Cognitive Sciences," in *Dynamics and Performativity of Imagination: The Image between the Visible and the Invisible*, ed. Bernd Huppauf and Christoph Wulf (New York: Routledge, 2009), 136.

22. Ibid., 135.

23. St. John of Damascus, *Three Treatises on the Divine Images*, trans. Andrew Louth (Crestwood, NY: St. Vladimir's Seminary Press, 2003), 40–41. The Byzantine history of the economy of the image has been subtly explored by Marie-José Mondzain in her important book, *Image, Icon, Economy: The Byzantine Origins of the Contemporary Imaginary*, trans. Rico Franses (Stanford: Stanford University Press, 2005). Mondzain argues that the Byzantine distinction of image and icon informs the modern concept of the imaginary, the domain of immaterial images mediated by consumer icons.

24. St. John of Damascus, *Three Treatises*, 33.

25. Ibid., 55.

26. Ibid., 34.

27. Ibid., 115.

28. Emmanuel Levinas, *Alterity and Transcendence*, trans. Michael B. Smith (New York: Columbia University Press, 1999), 30. For a philosophical reflection on Levinas on the face see Paul Davies, "The Face and the Caress: Levinas's Ethical Alterations of Sensibility," in *Modernity and the Hegemony of Vision*, ed. David Michael Levin (Berkeley: University of California Press, 1993), 252–72; and on the face in phenomenological terms see also Jean-Luc Marion, *In Excess: Studies of Saturated Phenomena*, trans. Robyn Horner and Vincent Berraud (New York: Fordham University Press, 2002), 113–23.

29. Experimentation in neuroscience confirms that newborn infants respond to the face and quickly establish an intimate connection to it, Poeppel and Stroud, "The Nature of Face Recognition," 137–38.

30. Sarah Schroth considers other portrayals of the Last Judgment as influences for El Greco's picture, "Burial of the Count of Orgaz," in *Figures of Thought: El Greco as Interpreter of History, Tradition, and Ideas*, ed. Jonathan Brown, Studies in the History of Art, vol. 11 (Washington, DC: National Gallery of Art, 1982), 9–14, and insightfully discusses the image's treatment of the doctrine of the intercession of the saints, 7–9.

31. I rely for information about El Greco's painting on Francisco Calvo Serraller, *El Greco: The Burial of the Count of Orgaz* (London: Thames and Hudson, 1995) and Schroth, "Burial of the Count of Orgaz," 1–17.

32. Serraller, *El Greco*, 7–11.

33. See Geary, *Furta Sacra*.

34. Martin Luther, *Sermons on the Gospel of St. John, Chapters 6–8*, in *Luther's Works*, ed. Jaroslav Pelikan, vol. 23 (Saint Louis: Concordia Publishing House, 1959), 59–60. For the just person, Luther preached, "Judgment has been nullified . . . it concerns him no more than it does the angels. He does not stand in need of a mediator on that Day, for judgment has been disposed of. He does not require the intercession of the saints; nor does he fear purgatory. Unless Christ is a preacher of lies, it is certain that just as Christ does not fear judgment and cannot be judged, so we believers will not be judged," Martin Luther, *Sermons on the Gospel of St. John, Chapters 1–4*, in *Luther's Works*, ed. Jaroslav Pelikan, vol. 22 (Saint Louis: Concordia Publishing House, 1957), 380.

35. See David Morgan, "Image," in Morgan, *Key Words*, 96–110.

36. For discussion of a Protestant Madonna and Child, see David Morgan, *The Sacred Gaze: Religious Visual Culture in Theory and Practice* (Berkeley: University of California Press, 2005), 202.

37. See Hans Belting, *Likeness and Presence: A History of the Image before the Era of Art*, trans. Edmund Jephcott (Chicago: University of Chicago Press, 1994); Daniel H. Weiss, *Art and the Crusade in the Age of Saint Louis* (Cambridge: Cambridge University Press, 1998); and Annabel Jane Wharton, *Selling Jerusalem: Relics, Replicas, Theme Parks* (Chicago: University of Chicago Press, 2006).

38. Scale and devotional use of portrait-icons has been discussed by Ringbom, *Icon to Narrative*, and Henk van Os et al., *The Art of Devotion*.

39. Jasper Hopkins, *Nicholas of Cusa's Dialectical Mysticism: Text, Translation, and Interpretive Study of De Visione Dei*, 3rd ed. (Minneapolis: The Arthur J. Banning Press, 1985), 686.

40. Marita Sturken and Lisa Cartwright, *Practices of Looking: An Introduction to Visual Culture* (Oxford: Oxford University Press, 2001), 36.

41. Karl Marx, *Capital. An Abridged Edition*, ed. David McLellan, Oxford World's Classics (Oxford: Oxford University Press, 1999), 42–44; Roland Barthes, "Rhetoric of the Image," in *Semiotics. An Introductory Anthology*, ed. Robert E. Innis (Bloomington: Indiana University Press, 1985), 190–205.

42. Richard Halpern, *Norman Rockwell: The Underside of Innocence* (Chicago: University of Chicago Press, 2006), 159.

43. Dawn Baumgartner Vaughan, "Norman Rockwell Originals on Exhibit," *The Herald-Sun* (November 25, 2010), A1.

44. Ibid., A8.

45. When asked in one of his seminars about the possibility of an "eye" that protects and therefore behaves benevolently, Lacan replied in the negative: "The eye may be prophylactic, but it cannot be benevolent—it is maleficent. In the Bible and even in the New Testament, there is no good eye, but there are evil eyes all over the place," Jacques Lacan, *The Four Fundamental Concepts of Psychoanalysis*, ed. Jacques-Alain Miller, trans. Alan Sheridan (New York: W. W. Norton, 1981), 119.

46. Ibid., 93.

47. Something of this pertains to Halpern's psychoanalytical reading of Rockwell's picture: "The girl is caught between the narcissistic pleasures of admiring her image and the disconcerting sense of apprehending herself through someone else's eye. This is the essential split under which she labors," *Norman Rockwell*, 115. Halpern writes perceptively of the image and conveys very nicely the sense of a disembodied eye at work in the image. But the idea of the girl's narcissistic pleasure is unconvincing. She might want to be able to admire herself, but everything about her gesture and frown suggests she is unable to do so.

CHAPTER 5

1. The technical literature on haptics and the connections of seeing and touch is quite large. Representative examples are: S. J. Lederman and R. L. Klatzky, "Haptic Classification of Common Objects: Knowledge-Driven Exploration," *Cognitive Psychology* 22 (1990): 421–59; and J. Farley Norman, Hideoko F. Norman, and Anna Marie Clayton, "The Visual and Haptic Perception of Natural Object Shape," *Perception and Psychophysics* 66, no. 2 (2004): 342–51. For a review of the history of major theories of haptic vision, see Stephen Pattison, *Seeing Things: Deepening Relations with Visual Artefacts* (London: SCM Press, 2007), 41–60.

2. An illuminating discussion of the interdependence of tactility and vision, of haptic and optic, is Mark Patterson, *The Senses of Touch: Haptics, Affects, and Technologies* (Oxford: Berg, 2007), 85–87; for a discussion of haptic visuality in current media culture, see Laura U. Marks, *Touch: Sensuous Theory and Multisensory Media* (Minneapolis: University of Minnesota Press, 2002); and Pattison, *Seeing Things*.

3. *The Autobiography of St. Margaret Mary Alacoque*, trans. The Sisters of the Visitation (Rockford, IL: TAN Books, 1986).

4. Ibid., 25.

5. Ibid., 40.

6. Ibid., 41.

7. Ibid., 52.

8. Ibid., 53.

9. Ibid., 89–90.

10. Ibid., 59.

11. Ibid., 67.

12. For a discussion of these tropes in European poetry, music, and literature, see Ole M. Høystad, *A History of the Heart* (London: Reaktion, 2007), 111–50.

13. Alacoque, *Autobiography*, 82.

14. Ibid., 106.

15. Ibid., 108.

16. For a description of one of the earliest images of the Heart emblem, which clearly informed the version reproduced here in figure 24, see *The Letters of St. Margaret Mary Alacoque*, trans. Fr. Clarence A. Herbst, S.J. (Rockford, IL: TAN Books 1997), 72–73 and 275, n. 26.

17. Alacoque, *Autobiography*, 97.

18. For her account of refusing to eat and vomiting after meals, see ibid., 89; on self-mutilations, 97, 115.

19. For a discussion of the term's lineage in anthropology and the study of religion, see Tomoko Masuzawa, "Troubles with Materiality: The Ghost of Fetishism in the Nineteenth Century," in *Religion: Beyond a Concept*, ed. Hent de Vries (New York: Fordham University Press, 2008), 647–67; for an intellectual history of the concept from the eighteenth century to the early twentieth, see Karl-Heinz Kohl, *Die Macht der Dinge: Geschichte und Theorie sakraler Objekte* (Munich: C. H. Beck, 2003), 69–115.

20. See William Pietz, "Fetish," in *Critical Terms for Art History*, ed. Robert S. Nelson and Richard Shiff (Chicago: University of Chicago Press, 1996), 197–207; and Kohl, *Die Macht der Dinge*, 101–6.

21. For treatments of Batoni's image, see Jon L. Seydl, "Contesting the Sacred Heart of Jesus in Late Eighteenth-Century Rome," in *Roman Bodies: Antiquity to the Eighteenth Century*, ed. Andrew Hopkins and Maria Wyke (London: The British School at Rome, 2005), 215–27; and Christopher M. S. Johns, "'The Amiable Object of Adoration': Pompeo Batoni and the Sacred Heart," *Gazette des Beaux-Arts* 132, nos. 1554–55 (July-August 1998): 19–28.

22. Alacoque, *Autobiography*, 106.

23. Ibid., 106.

24. Father Joseph de Galliffet, *The Adorable Heart of Jesus* (Philadelphia: Messenger of the Sacred Heart, 1890), 44. Galliffet's book was translated into French in 1733, which is the source of this English translation.

25. See Seydl, "Contesting the Sacred Heart of Jesus," 218.

26. Galliffet, *Adorable Heart*, 50.

27. Ibid., 53, emphasis added.

28. Ibid., 50.

29. Ibid., 48–49.

30. Alacoque, *Autobiography*, 105.

31. Ibid., 15. Yet even in that edition one especially repulsive passage was left out involving Alacoque and the discharge of a patient suffering from dysentery—see pp. 83–84.

32. Alfred Noyes, "The Highwayman," in *Collected Poems* (New York: Frederick A. Stokes Company, 1913).

33. I have explored empathy and sympathy in the history of visual practice of religion in *Visual Piety: A History and Theory of Popular Religious Images* (Berkeley: University of California Press, 1998), 59–96.

34. John Bernard Dalgairns, *The Devotion to the Sacred Heart of Jesus; with an Introduction on the History of Jansenism* (London: Thomas Richardson and Son, 1853), 93–94, 95.

35. For further discussion of the modern career of the iconography of the Sacred Heart, see David Morgan, *The Sacred Heart of Jesus: The Visual Evolution of a Devotion*.

Meertens Ethnology Cahier 4 (Amsterdam: Amsterdam University Press, 2008), 24–38.

36. I have discussed this development in greater detail in ibid., 39–42.

37. Ibid., 40.

38. Alacoque, *Autobiography*, 106.

39. Alacoque, *Letters*, 50.

40. Galliffet, *Adorable Heart*, 57.

41. Ibid., 194.

42. Alacoque, *Autobiography*, 70.

43. Galliffet, *Adorable Heart*, 275.

44. Ibid., 278.

45. Ibid., 279.

46. Alacoque, *Letters*, 193.

47. Ibid., 67, 70–71, 230.

48. Ibid., 230.

49. For a historical overview of Alacoque's political line of thought and its relation to later French religio-political history of the devotion to the Sacred Heart, see Raymond Jonas's instructive study, *France and the Cult of the Sacred Heart: An Epic Tale for Modern Times* (Berkeley: University of California, 2000), 24–27.

50. Important studies of Jansenism include Dale K. Van Kley, *The Jansenists and the Expulsion of the Jesuits from France, 1757–1765* (New Haven: Yale University Press, 1975); Alexander Sedgwick, *Jansenism in Seventeenth-Century France: Voices from the Wilderness* (Charlottesville: University Press of Virginia, 1977); B. Robert Kreiser, *Miracles, Convulsions, and Ecclesiastical Politics in Early Eighteenth-Century Paris* (Princeton: Princeton University Press, 1978); Henry Phillips, *Church and Culture in Seventeenth-Century France* (New York: Cambridge University Press, 1997); Dale K. Van Kley, *The Religious Origins of the French Revolution: From Calvin to the Civil Constitution, 1560–1791* (New Haven: Yale University Press, 1996); John McManners, *Church and Society in Eighteenth-century France*, 2 vols. (Oxford: Clarendon Press, 1998), esp. vol. 2, 345–69; and Brian E. Strayer, *Suffering Saints: Jansenists and Convulsionnaires in France, 1640–1799* (Brighton and Portland: Sussex Academic Press, 2008).

51. Blaise Pascal summarized the difference in his *Provincial Letters* (1656–57): "The Jesuits maintain that there is a grace given generally to all men, subject in such a way to free-will that the will renders it efficacious or inefficacious at its pleasure, without any additional aid from God, and without wanting anything on his part in order to act effectively; and hence they term this grace *sufficient*, because it suffices of itself for action. The Jansenists, on the other hand, will not allow that any grace is actually sufficient which is not also efficacious; that is, that all those kinds of grace which do not determine the will to act effectively are insufficient for action; for they hold that a man can never act without *efficacious grace*," Blaise Pascal, *The Provincial Letters*, trans. Rev. Thomas M'Crie (New York: Robert Carter & Brothers, 1850), 76. Following Augustine, the Jansenists, of which Pascal remains the most famous, contended that grace

comes entirely from God and that no human action for the good was possible without it. Jansenism's narrow view of salvation followed from its rigidly unilateral conception of grace: only those intended by God to accept his grace would be saved. The Jesuits, by contrast, focused far more attention on the human capacity to respond to the universal offer of salvation achieved in the sacrificial death of Jesus. For the Jansenists, like their contemporary fellow readers of Augustine, the Calvinists, this undercut the majesty and sovereignty of God.

52. On the fascinating publication history, authorship, circulation, and readership of this underground newspaper, see Cyril B. O'Keefe, S.J., *Contemporary Reactions to the Enlightenment (1728–1762)* (Geneva: Librairie Slatkine; Paris: Honoré Champion, 1974), 57–69; and Strayer, *Suffering Saints*, 169–74.

53. *Les Nouvelles Ecclésiastiques* (November 18, 1732), 217.

54. The writers and editors of *Les Nouvelles Ecclésiastiques* waged battle with the supporters of "Unigenitus," an apostolic constitution issued by Pope Clement XI (the highest level of decree produced by popes). The forces aligned with the pope and Louis XIV, who endorsed the bull, against Jansenist bishops and priests were known as the "constitutionnaires." In the first years of publication, Archbishop Languet was associated with the bull and its supporters as the author of the "novel" of Alacoque's life, and the newspaper antagonistically followed the book's reception among supporters of "Unigenitus." Writing from Soissons, one contributor reported that "there is here a Society of Devotees fashioned after the Life of Marie Alacoque by some canons, friends and creatures of Monsieur Languet; they commune every day and make confession two or three times per day. One of these directors, named Mosnier, [has charge over] a woman who is accustomed to revelations and ecstasies. She goes now to Purgatory, now to Hell, sometimes to Heaven; all of these visions speak against those who oppose the Constitution and always in favor of the Constitutionnaires." [Il y a ici une Société de Dévotes formées sur la Vie de Marie Alacoque par quelques Chanoines amis et creatures de M. Languet; ils les font communier tous les jours, et les confessent deux ou trois fois par jour. Un de ces Directeurs, nommé Mosnier, en avoit une qu'il acoutumoit aux révélations et aux extases. Elle alloit tantôt en Purgatoire, tantôt en Enfer, quelquefois en Paradîs; toutes ces visions alloient au détriment de ceux qui sont opposés à la Constitution et toujours à l'avantage des Constitutionnaires.] *Les Nouvelles Ecclésiastiques* (December 10, 1731), 237. Later in the century, after Languet had departed the scene, critical attention shifted from the archbishop and Alacoque to the quickly expanding devotion itself. Writers maintained the Jansenist objection to what they regarded as a Pelagian notion of grace, condemning the devotion as presumptuous. Quoting the Bishop of Amiens in 1768, one critic singled out the promotion of the Festival of the Sacred Heart for its misconception of the efficacious grace of Jesus. "We are compelled to offer," the bishop preached, "[to the faithful] a simple, solid and sensible devotion, one which *makes known* our Lord Savior in himself and that he is for all people, [a devotion which] can only inspire the respect and the love due to him. *This devotion is none other than the Festival to the Sacred Heart of Jesus*, Savior of the human race." [. . . mais parce que le commun de Fideles n'est pas en état de lire ces

savans Ouvrages, nous avons cru devoir leur offrir une dévotion simple, solide et sensible, laquelle *faisant connoître* ce qu'est Notre Seigneur en lui-même et ce qu'il est pour tous les homes, ne peut qu'inspirer le respect et l'amour qui lui font dus. *Cette dévotion n'est autre chose que la Fête du* SACRE COEUR DU JESUS, Sauveur du genre humain.] *Les Nouvelles Ecclésiastiques* (January 30, 1768), 17 (emphasis in original). The writer responded to this with dismay: "A devotion that not only makes Christ known but makes him to love as he ought! What a marvelous invention! How sad that it is known in the church only in the eighteenth century. A devotion, so efficaciously established by the Bishop of Amiens, walks, so to say, as the equal of the sacraments instituted by Jesus Christ himself," ibid: [Une dévotion qui, non seulement fait connoître J.C., mais qui le fait aimer comme il doit l'être! O la merveilleuse invention! Il est triste qu'elle n'ait été connue dans l'Eglise qu'au 18e siècle. Une dévotion si efficace établie par M. de la Motte, va, pour ainsi dire, de pair avec les Sacrements institues par J.C. même.]

55. Antoine Arnauld, *De la fréquente communion, où les sentiments des pères, des papes, et des conciles, touchant l'usage des sacrements de pénitence & d'eucharistie, sont fidellement exposés*, in *Œuvres*, vol. 27 (Paris and Lausanne: Sigismond D'Arnay, 1779; reprint, Brussels: Culture et Civilisation, 1967), 627 (part 3, chap. 17), ". . . le Sacrement de Pénitence est établi de Jésus-Christ, pour nous faire avoir la pureté de l'ame, ou pour mieux dire, pour la réparer, et que vous ne pouvez pas nier, que cette pureté ne soit nécessaire pour communier dignement, il s'ensuit que pour satisfaire pleinement à l'intention de Jésus-Christ, tous ceux qui sont déchus de la grace doivent passer par ce Baptême laborieux, qui enferme tant de larmes, de peines, et de travaux, selon le concile et tous les Peres, pour se préparer à l'eucharistie."

56. Ibid., 600 (Part III, chap. 10): ". . . Dieu recevra les offrandes de vos mains, lorsqu'elles seront nettes de toutes leurs taches; il prendra sa demeure dans votre cœur, quand vous en aurez chassé le monde; il vous tendra les bras, pourvu que vous retourniez à lui dans les gémissements et dans les soupirs; quand vos larmes parleront pour vous, il écoutera leur voix; il perdra le dessein de vous punir, lorsqu'il verra que vous vous punissez vous-mêmes."

57. For a clear examination of Jansenism, Augustine, and Pascal, see Leszek Kolakowski, *God Owes Us Nothing: A Brief Remark on Pascal's Religion and on the Spirit of Jansenism* (Chicago: University of Chicago Press, 1995).

58. Pascal conveyed the Jansenist objection in the *Provincial Letters* when he lampooned the "easy devotions to obtain the good graces of Mary" that Jesuit confessors provided their charges (190). One, for instance, accommodated his followers with such means as "wearing a chaplet night and day on the arm, in the form of a bracelet, or carrying about one's person a rosary, or an image of the Virgin." Serving Pascal's Jansenist polemic, his fictional Jesuit interlocutor stressed the atoning power of even the merest devotional gesture, adducing the instance of "a female who, while she practiced the daily devotion of saluting the image of the Virgin, spent all her days in mortal sin, and yet was saved after all, by the merit of that single devotion" (190). Pascal represented the Jansenist critique of what instrumentalized human effort in procuring forgiveness. By making penance too easy, achieved by no more than the fondling of

rosaries or glances at pious images, Pascal and the Jansenists charged that the Jesuits undermined true contrition and promoted penitential insincerity. Such actions did not involve contrition and therefore did not prepare the heart for the atonement that the Sacrament of the Eucharist offered.

59. Arnauld, *De la fréquente communion*, 721: "de purifier leurs coeurs, c'est à dire, d'en déraciner cette amitié du monde, qui est une inimitié avec Dieu."

60. Pierre Nicole, *De la Soumission à la Volonté de Dieu*, in *Oeuvres philosophiques et morales de Nicole*, ed. C. Jourdain (Paris: L. Hachette, 1845), 121: "Il y a une vue de Dieu qui porte à s'unir à lui et à s'exposer à la lumière de ses yeux divins; et il y en a une autre qui porte à le fuir et à se soustraire auteant que l'on peut à sa presence."

61. Pierre Nicole, *Traité de la faiblesse de l'homme*, in *John Locke as Translator: Three of the Essais of Pierre Nicole in French and English*, by Jean S. Yolton (Oxford: Voltaire Foundation, 2000), 54: "Il semble que ce soit pour dissiper cette illusion naturelle, que Dieu ayant desseign d'humilier Job sous sa Majesté souveraine, le fait comme sortir de lui-même pour lui faire contempler ce grand monde & toutes les creatures qui le remplissent, afin de le convaincre par là de son impuissance & de sa faiblesse, en lui faisant voir combine il y a de choses & d'effets dans la nature qui surpassent no seulement sa force, mais aussi son intelligence." I have not used Locke's translation, but made my own.

62. Dalgairns, *Devotion to the Sacred Heart*, 60.

63. Fr. Tickel, "The Devotion to the Sacred Heart: Historical Sketch," *The Messenger of The Sacred Heart of Jesus* 5, no. 2 (February 1870), 79.

64. "Sympathy with Jesus," *The Messenger of The Sacred Heart of Jesus*, New Series, vol. 1, no. 6 (June 1874): 255–64.

65. Fr. R. Pierik, S.J., "Catechism of the Devotion to the Heart of Jesus," *The Messenger of The Sacred Heart of Jesus* 7, no. 5 (May 1872), 215.

CHAPTER 6

1. Henry Ward Beecher, "The National Flag," in *Freedom and War. Discourses on Topics Suggested by the Times* (Boston: Ticknor and Fields, 1863), 112.

2. See, for instance, John Bodnar, ed., *Bonds of Affection: Americans Define Their Patriotism* (Princeton: Princeton University Press, 1996); Andrew Burstein, *Sentimental Democracy: The Evolution of America's Romantic Self-Image* (New York: Hill and Wang, 1999); and Cecelia Elizabeth O'Leary, *To Die For: The Paradox of American Patriotism* (Princeton: Princeton University Press, 1999). For a history of flag veneration and the Pledge of Allegiance as an important aspect of that history, see Scot M. Guenter, *The American Flag, 1777–1924: Cultural Shifts from Creation to Codification* (Rutherford, NJ: Fairleigh Dickinson University Press; London: Associated University Press, 1990).

3. Jean-Jacques Rousseau, *The Social Contract*, trans. Christopher Betts (Oxford: Oxford University Press, 1994), 166–67. A classic statement on civil society was published in 1767 by Adam Ferguson, *An Essay on the History of Civil Society*, ed. Fania Oz-Salzberger (Cambridge: Cambridge University Press, 1995).

4. For an insightful study of Smith and the social implications of his *Theory of Moral Sentiments* in the context of eighteenth-century Anglo-American thought and literature, see Elizabeth Barnes, *States of Sympathy: Seduction and Democracy in the American Novel* (New York: Columbia University Press, 1997), 20–31. I have examined the history of empathy and sympathy as religious visual phenomena in *Visual Piety: A History and Theory of Popular Religious Images* (Berkeley: University of California Press, 1998), 59–96.

5. Adam Smith, *The Theory of Moral Sentiments* (Amherst, NY: Prometheus Books, 2000), 164.

6. Ibid., 3.

7. Ibid., 3.

8. Ibid., 3–4.

9. Ibid., 4.

10. John H. Kennedy, *Sympathy, Its Foundation and Legitimate Exercise considered, In Special Relation to Africa: A Discourse Delivered on the Fourth of July 1828 in the Sixth Presbyterian Church, Philadelphia* (Philadelphia: printed by W. T. Green, 1828). On the history of the colonization movement, see P. J. Staudenraus, *The African Colonization Movement 1816–1865* (New York: Columbia University Press, 1961).

11. Kennedy, *Sympathy*, 3.

12. Ibid., 5–6.

13. Ibid., 9. See Staudenraus, *African Colonization Movement*, 125–26, for discussion of the paternalistic rationale at work especially in Philadelphia.

14. Kennedy, *Sympathy*, 11. Italics added.

15. Quoted in James W. Alexander, *The Life of Archibald Alexander* (New York: Charles Scribner, 1854), 451–52. This was a position taken not only by whites in favor of colonization. An influential black leader, John Mercer Langston, told the State Convention of Colored Citizens of Ohio in 1841 that he would consider emigration since "we must have a nationality, before we can become anybody," adding that "the very fact of our remaining in this country is humiliating, virtually acknowledging our inferiority to the white man," quoted in Philip S. Foner and George E. Walker, eds., *Proceedings of the Black State Conventions, 1840–1865*, vol. 1 (Philadelphia: Temple University Press, 1979), 223.

16. Quoted by David Walker from a letter of Richard Allen published in the Philadelphia newspaper, *Freedom's Journal*, in Walker, "Appeal to the Colored Citizens of the World," reprinted in *Pamphlets of Protest: An Anthology of Early African-American Protest Literature, 1790–1860*, ed. Richard Newman, Patrick Rael, and Philip Lapsansky (New York: Routledge, 2001), 98.

17. Walker, "Appeal," 97.

18. Ibid., 101.

19. John S. Rock, "Address to a Meeting in Boston, 1858," in *Afro-American History: Primary Sources*, ed. Thomas R. Frazier (New York: Harcourt, Brace & World, 1970), 123.

20. Thomas Morris Chester, "Negro Self-Respect and Pride of Race," reprinted in Newman, Rael, and Lapsansky, *Pamphlets of Protest*, 308.

21. "A Fact with a Short Commentary," *The Anti-Slavery Record* 2, no. 1 (January 1836), 2. Elizabeth Clark has carefully traced the rise of accounts of the suffering slave in antebellum America in tandem with the history of sympathy, "'The Sacred Rights of the Weak': Pain, Sympathy, and the Culture of Individual Rights in Antebellum America," *The Journal of American History* 82, no. 2 (September 1995): 463–93.

22. Walker took the term *apathy* directly from a speech by Elias Caldwell, founding secretary of the Colonization Society, who urged that American blacks who did not emigrate should be kept in "the lowest state of degradation and ignorance" (quoted in Walker, 95) since that would result in a state of apathy. Walker quoted Caldwell further: "The more you improve the condition of these people, the more you cultivate their minds, the more miserable you make them in their present state," Walker, "Appeal," 95.

23. "A Fact," *The Anti-Slavery Record*, 4.

24. Benedict Anderson, *Imagined Communities: Reflections on the Origin and Spread of Nationalism*, rev. ed. (London: Verso, 1991).

25. Frederick Douglass, *Narrative of the Life of Frederick Douglass, an American Slave*, ed. William L. Andrews and William S. McFeely. Norton Critical Edition (New York: W. W. Norton, 1997), 29.

26. See David Morgan, ed., *Religion and Material Culture: The Matter of Belief* (London: Routledge, 2010), 1–12.

27. For a discussion of the term and its implications for the study of religious material culture, see S. Brent Plate, ed., *Religion, Art and Visual Culture* (New York: Palgrave, 2002), 18–24; Birgit Meyer and Jojada Verrips, "Aesthetics," in *Key Words in Religion, Media, and Culture*, ed. David Morgan (London: Routledge, 2008), 20–30; Birgit Meyer, ed., *Aesthetic Formations: Media, Religion, and the Senses* (New York: Palgrave Macmillan, 2009), 6–11; and Morgan, *Religion and Material Culture*, 68–70.

28. Colonel George T. Balch, *Methods of Teaching Patriotism in the Public Schools* (New York: D. Van Nostrand, 1890), 4. See O'Leary, *To Die For*, 151–61, and David Morgan, *The Sacred Gaze: Religious Visual Culture in Theory and Practice* (Berkeley: University of California Press, 2005), 233–40, for further discussion of Balch.

29. Balch, *Methods of Teaching Patriotism*, viii.

30. See Guenter, *The American Flag*, 133–53.

31. Balch, *Methods of Teaching Patriotism*, 5.

32. Ibid., 4, emphasis in original.

33. Jacob Riis, *How the Other Half Lives: Studies among the Tenements of New York* (New York: Dover, 1971 [1890]), 151.

34. Sally Stein, "Making Connections with the Camera: Photography and Social Mobility in the Career of Jacob Riis," *Afterimage* 10 (May 1983), 14.

35. Riis, *How the Other Half Lives*, 151.

36. Jacob A. Riis, "How the Other Half Lives: Studies among the Tenements," *Scribner's Magazine*, vol. 6, no. 6 (December 1889), 643.

37. Riis, *How the Other Half Lives*, 2; see also 113 and 209. See Rev. J. M. King et al., *The Religious Condition of New York City*. Addresses made at a Christian Conference held in Chickering Hall, New York City. December 3, 4 and 5, 1888 (New York:

Baker & Taylor Co., 1888). Riis discussed the conference further in his autobiography, Jacob A. Riis, *The Making of an American* (New York: Macmillan, 1901), 247–49, where he also mentioned his Lutheran upbringing and the fact that he was a deacon in a congregation on Long Island, 53 and 207–98.

38. Riis, *The Making of an American*, 298. He also said he was invited to Plymouth Church, Brooklyn, Henry Ward Beecher's church, then under the leadership of Lyman Abbott, who issued a very positive review of Riis's book, "How the Other Half Lives. A Glimpse at Darkest New York," *The Christian Union*, vol. 42, no. 22 (November 27, 1890), 706–7.

39. Rev. A. F. Schauffler, D.D., "Present Condition of New York City Below Fourteenth Street," in *The Religious Condition of New York City*, by Rev. J. M. King et al., 16.

40. Ibid., 19.

41. Ibid., 25.

42. Josiah Strong, *Our Country*, ed. Jurgen Herbst (Cambridge, MA: Belknap Press of Harvard University Press, 1963), 206, 218.

43. Rev. Josiah Strong, D.D., "The Necessity of United Christian Action," in *The Religious Condition of New York City*, by Rev. J. M. King et al., 164.

44. See Stein, "Making Connections with the Camera," 12. Stein regards Riis's "underlying objectives" as having been his own social elevation from immigrant to respectable member of the middle class, 15. She does not indicate why it is implausible that Riis could aspire to raise his social status even while also working as a believer to reform the social conditions of the impoverished by appealing to Christian sentiment. For a more balanced view, see David Leviatin, "Framing the Poor: The Irresistibility of How the Other Half Lives," introduction to *How the Other Half Lives: Studies in the Tenements of New York*, by Jacob A. Riis, ed. David Leviatin (Boston and New York: Bedford/St. Martin's, 1996), 28–33, 41. An integration of the two motives makes most sense in light of Riis's own statements. The Christian ethic of compassion and its concomitant element of shame should move the middle class to social reform that might end poverty, and thereby establish the middle class as the chosen, American force for good. As an activist in this enterprise, Riis himself enjoyed the recognition of the middle class called to conscientious action.

45. Important historical rereadings of the imagery are Stein, "Making Connections with the Camera," and Maren Stange, *Symbols of Ideal Life: Social Documentary Photography in America 1890–1950* (Cambridge: Cambridge University Press, 1989), 1–29. A major example of Riis hagiography is Edith Patterson Meyer, *"Not charity, but justice:" The Story of Jacob A. Riis* (New York: Vanguard Press, 1974).

46. Riis, *The Making of an American*, 248.

47. Ibid, 247.

48. Riis, *How the Other Half Lives*, 52, 54.

49. Ibid, 2; 209.

50. Riis, *The Making of an American*, 267.

51. Stange has discussed Riis's lectures and use of lantern slides, *Symbols of Ideal Life*, 2–19. Bonnie Yochelson ("What Are the Photographs of Jacob Riis?" *Culturefront*

[Fall 1994], 28–38) and Leviatin (in his introductory essays to *How the Other Half Lives*, by Jacob Riis, ed. David Leviatin, viii–xi, 7) have discussed the important matters of reproduction, Riis's use of photographs by others, and the publication history of *How the Other Half Lives*.

52. Riis, "How the Other Half Lives," 648; *How the Other Half Lives*, 134.

53. Riis, *Making of an American*, 188.

54. "Booth and Riis, Two Books Exposing Darkest London and New York," The Brooklyn *Daily Eagle*, vol. 50, no. 323 (November 21, 1890), 2.

55. See John Grafton, ed., *New York in the Nineteenth Century: 317 Engravings from "Harper's Weekly" and Other Contemporary Sources* (New York: Dover Publications, 1980), 52–67, 183–84, 193, 198.

56. Smith, *Theory of Moral Sentiments*, 163.

57. Ibid, 164–65.

58. Charles Horton Cooley, *Human Nature and the Social Order*, rev. ed. (New York: Scribner's, 1922), 184.

59. An instructive study on the topic is Anthony P. Cohen, *The Symbolic Construction of Community* (Chichester, U.K.: Norwood; London: Tavistock, 1985).

60. Riis, *How the Other Half Lives*, 85.

61. Ibid., 90.

62. Ibid., 77.

CHAPTER 7

1. Interviews with the author, São Paulo, Brazil, June 2010.

2. Alain Corbin, *Village Bells: Sound and Meaning in the Nineteenth-Century French Countryside*, trans. Martin Thom (New York: Columbia University Press, 1998); Leigh Eric Schmidt, *Hearing Things: Religion, Illusion, and the American Enlightenment* (Cambridge, MA: Harvard University Press, 2000); and Isaac A. Weiner, "Displacement and Replacement: The International Friendship Bell as a Translocative Technology of Memory," *Material Religion* 5, no. 2 (July 2009): 180–204. Portions of Corbin's and Schmidt's work have been helpfully anthologized in Mark M. Smith, ed., *Hearing History: A Reader* (Athens: University of Georgia Press, 2004), 184–204 and 221–46.

3. I have examined iconoclasm in *The Sacred Gaze: Religious Visual Culture in Theory and Practice* (Berkeley: University of California Press, 2005), 115–46.

4. The term was clearly defined by William Wallace in his translation and commentary on Hegel's *Encyclopedia of the Philosophical Sciences*:

we should note the double meaning of the German word *aufheben* (to put by, or set aside). We mean by it (1) to clear away, annul: thus, we say, a law or a regulation is set aside: (2) to keep, or preserve: in which sense we use it when we say: something is well put by. This double usage of language, which gives the same word a positive and negative meaning, is not an accident, and gives no ground for reproaching language as a cause of confusion. We should rather recognize in it the speculative spirit of our language rising above the mere "Either-or" of understanding.

William Wallace, *The Logic of Hegel*, 2nd rev. ed. (Oxford: Oxford University Press, 1892), 180. The term has been more recently discussed in relation to Hegel's understanding of dialectic by Errol E. Harris, *An Interpretation of the Logic of Hegel* (Lanham, MD: University Press of America, 1983), 31–34. I do not use the term *sublimation* because that usually invokes a Freudian framework in which the repressed returns to consciousness as something else, morphed into a less objectionable substitute—a cigar for a penis, for example. With sublation, however, the cancellation does not morph the image, body, or wall into an ersatz object, but preserves its materiality by yoking or subordinating it to the preferred medium of sound. Sublation, in other words, is a process of synthetic integration or transformation, not symbolic reference or substitution. For a sophisticated discussion of sublation in regard to the Hegelian *Aufhebung* and material culture studies, see Daniel Miller, *Material Culture and Mass Consumption* (Oxford: Blackwell, 1987), 12, 28–33; for an insightful examination of Pentecostalism's objectification of words that are sublated or reabsorbed in commodified products, see Simon Coleman, "Words as Things: Language, Aesthetics and the Objectification of Protestant Evangelicalism," *Journal of Material Culture* 1, no. 1 (1996): 107–28, esp. 109–10.

5. I take the phrase from Lisa Blackman, ed., *The Body: The Key Concepts* (Oxford: Berg, 2008), 5, who uses it in a discussion of dualism's marginalization of the body.

6. For discussion of "imagetext," see Morgan, *The Sacred Gaze*, 65–67, 269 n. 20; see also Allen Roberts and Mary Nooter Roberts, *A Saint in the City: Sufi Arts in Urban Senegal* (Los Angeles: UCLA Fowler Museum of Cultural History, 2003), 92–96; W. J. T. Mitchell, *Picture Theory: Essays on Verbal and Visual Representation* (Chicago: University of Chicago Press, 1994), 83–107, esp. 89, n. 9.

7. ". . . wie eine irrendes Schaaf herum wandert, bis Gott seinen Gnaden-Arm über ihn ausstrecket, und durch seinen Heiligen Geist aus dem göttlichen Geseß als einem geistlichen Spiegel überzeuget, ihm seine Augen öffnet, daß her sein tiefes Elend sehen und erkennen kann, mit Verlangen daraus erlöset zu werden." "Geistlicher Irrgarten" [The Spiritual Maze], nineteenth century, The Roughwood Collection, Library Company of Philadelphia; reproduced in Don Yoder, *The Pennsylvania German Broadside: A History and Guide* (Philadelphia: The Pennsylvania State University Press, 2005), 183.

8. For further discussion of mediation and religion, see Jeremy Stolow, "Religion and/as Media," *Theory, Culture & Society* 22, no. 2 (2005): 137–63; Birgit Meyer, *Religious Sensations: Why Media, Aesthetics, and Power Matter in the Study of Contemporary Religion* (inaugural professorial lecture, Amsterdam: Faculty of Social Sciences, Frije Universiteit, 2006), 12–17; and David Morgan, "Mediation or Mediatisation: The History of Media in the Study of Religion" *Culture and Religion* 12, no. 2 (June 2011): 137–52.

9. For a subtle and perceptive study of the new visual agenda of the early German Reformation see Joseph Leo Koerner, *The Reformation of the Image* (Chicago: University of Chicago Press, 2004).

10. Victoria Ann George, *Whitewash and the New Aesthetic of the Protestant Reformation* (London: Pindar Press, 2011). For a discussion of iconoclasm that stresses its

role in an encompassing ideological process of production, see Morgan, *The Sacred Gaze*, 115–46.

11. George, *Whitewash*, chap. 2: pp. 28, 20, 23.

12. On Protestant aesthetics see David Morgan, *Visual Piety: A History and Theory of Popular Religious Images* (Berkeley: University of California Press, 1998), 29–50 et passim; Morgan, "Protestant Visual Piety and the Aesthetics of American Mass Culture," in *Mediating Religion: Conversations in Media, Religion, and Culture*, ed. Jolyon Mitchell and Sophia Marriage, (London: T&T Clark, 2003), 107–20; Morgan, "Aesthetics," in *The Encyclopedia of Protestantism*, 4 vols., ed. Hans Hillerbrand (New York: Routledge, 2003), vol. 1, pp. 7–8; and Birgit Meyer, "Powerful Pictures: Popular Christian Aesthetics in Southern Ghana," *Journal of the American Academy of Religion* 76, no. 1 (March 2008): 82–110.

13. George, *Whitewash*, chap. 6.

14. It may prove helpful to work out a Protestant semiotics to help explain the Reformed experience of the whitewashed interior as a luminous vessel for apprehending the spiritual nature of the Word. Zwingli's emphasis on Holy Communion as remembrance seems on one count to drain or disenchant the presence of the Eucharist, reducing it to the arbitrary signifier that marks the absence of Christ. But that is not a full treatment, since he shifts from the ontological presence of the body and blood in the bread and wine to the communal presence of the body of Christ understood as the communion of the saints. In this way the church interior as the site of the gathering of the faithful became the spiritual body of the church and the apt form of worship, just as Zwingli maintained that the focus of the Eucharist was not the elements themselves, but the gathering of the community in the ritual remembrance of Jesus's meal with his disciples. If the finite cannot contain the infinite, as Calvin often asserted, it can certainly direct toward the infinite that which yearned for it, the soul. The whitewashed church interior "hosts" that social, eschatological mode of presence. We need further consideration of the *aesthetic* dimension of this experience. George, *Whitewash*, has provided a very useful study to support this line of inquiry. For a fascinating discussion of semiotics and Calvin, see Webb Keane, *Christian Moderns: Freedom and Fetish in the Mission Encounter* (Berkeley: University of California Press, 2007), esp. 59–82.

Generally speaking, many Protestants undertook a shift from sacred matter (such as relics) and sacred spaces (shrines built around relics) to sacred community engaged in living the sacred history (*Heilsgeschichte*) extended from the paradigmatic storyline of scripture to the latter day. One line of Protestant thought and practice developed a sacred theory of time in the concept of Dispensationalism, laid down in visual charts that articulated the ages of sacred history in discrete dispensations leading from creation to the present, thus mapping time out as revelatory and the proper locus or medium of the sacred. On dispensationalist charts and their use among Protestants, see Morgan, *Visual Piety*, 181–93; and David Morgan, *Protestants and Pictures: Religion, Visual Culture, and the Age of American Mass Production* (New York: Oxford University Press, 1999), 123–98.

15. Martin Luther, *Against the Heavenly Prophets in the Matter of Images and Sacraments*, in *Luther's Works*, ed. Conrad Bergendoff (Philadelphia: Muhlenberg Press, 1958), 40:99. For further consideration of Cranach's fascinating image, see Koerner, *Reformation of the Image*, 175–78.

16. My thanks to Prof. Susan Kwilecki for her comments on the photograph (personal correspondence, October 3, 2010). She was present with her father when he took the image. For her reflections on her father's photographs, see Susan Kwilecki, *Becoming Religious: Understanding Devotion to the Unseen* (Cranbury, NJ: Associated University Presses, 1999).

17. Shaun Gallagher, *How the Body Shapes the Mind* (Oxford: Clarendon Press, 2005), 9.

18. Matthew Engelke, "Sticky Subjects and Sticky Objects: The Substance of African Christian Healing," in *Materiality*, ed. Daniel Miller (Durham: Duke University Press, 2005), 118–39.

19. Ibid., 127.

20. Ibid., 122–23.

21. Ibid., 131.

22. See such polemical works as Philip J. Lee, *Against the Protestant Gnostics* (New York: Oxford University Press, 1987), 129–39, 269–81. Though he makes no mention of Gnosticism, Weber characterized Puritanism as exhibiting an "asceticism [that] turned with all its force against one thing: the spontaneous enjoyment of life and all it had to offer," which recalls H. L. Mencken's celebrated definition of Puritanism as "the haunting fear that someone, somewhere, may be happy." Max Weber, *The Protestant Ethic and the Spirit of Capitalism*, trans. Talcott Parsons (London: Routledge, 2001), 111. For a countervailing view of the body among the early Protestant reformers, see David Tripp, "The Image of the Body in the Formative Phases of the Protestant Reformation," in *Religion and the Body*, ed. Sarah Coakley (Cambridge: Cambridge University Press, 1997), 131–52; and Margaret R. Miles, "'The Rope Breaks When It Is Tightest': Luther on the Body, Consciousness, and the Word," *Harvard Theological Review* 77, nos. 3–4 (1984): 239–58.

23. For the sake of practicality, the following sample is restricted to recent studies of American Protestantism during the nineteenth and twentieth centuries: Leigh Eric Schmidt, "A Church-going People is a Dress-loving People: Clothes, Communication, and Religious Culture in Early America," *Church History* 58 (March 1989): 36–51; Colleen McDannell, *Material Christianity: Religion and Popular Culture in America* (London: Yale University Press, 1995); Simon Coleman, "Words as Things: Language, Aesthetics and the Objectification of Protestant Evangelicalism," *Journal of Material Culture* 1, no. 2 (1996): 107–28; Diane H. Winston, *Red-Hot and Righteous: The Urban Religion of the Salvation Army* (Cambridge, MA: Harvard University Press, 1999); Daniel Sack, *Whitebread Protestants: Food and Religion in American Culture* (New York: St. Martin's Press, 2000); Amy DeRogatis, "Varieties of Interpretations: Protestantism and Sexuality," in *Sexuality and the World's Religions*, ed. David W. Machacek and Melissa M. Wilcox (Santa Barbara, CA: ABC-CLIO, 2003), 231–54; R. Marie

Griffith, *Born Again Bodies: Flesh and Spirit in American Christianity* (Berkeley: University of California Press, 2004); Pamela Klassen, "The Robes of Womanhood: Dress and Authenticity among African American Methodist Women in the Nineteenth Century," *Journal of Religion and American Culture* 14, no. 1 (2004): 39–82; Pamela Klassen, "Ritual Appropriation and Appropriate Ritual: Christian Healing and Adaptations of Asian Religions," *History and Anthropology* 16, no. 3 (2005): 377–91; Jennifer L. Connerley, "Quaker Bonnets and the Erotic Feminine in American Popular Culture," *Material Religion* 2, no. 2 (July 2006): 174–203; Heather D. Curtis, *Faith in the Great Physician: Suffering and Divine Healing in American Culture, 1860–1900* (Baltimore: Johns Hopkins University Press, 2007); and Amy DeRogatis, "'Born Again Is a Sexual Term': Demons, STDs, and God's Healing Sperm," *Journal of the American Academy of Religion* 77, no. 2 (June 2009): 275–302. Theological scholarship has also recently turned to the empirical study of embodiment in Protestant life—see the ethnographically based study by Mary McClintock Fulkerson, *Places of Redemption: Theology for a Worldly Church* (Oxford: Oxford University Press, 2007).

24. Marcel Mauss, "Techniques of the Body," *Economy and Society* 2 (1973): 70–88. The essay was first published in *Journal de psychologie normal et pathologique* 32 (1935): 271–93. For an insightful study of what I am calling *somatics* and *semiotics* in the instance of African figurative sculpture see the important work of Suzanne Preston Blier, *African Vodun: Art, Psychology, and Power* (Chicago: University of Chicago Press, 1995), 133–70.

25. Mauss, "Techniques of the Body," 73. For a fascinating study of bodily practices of memory, see Paul Connerton, *How Societies Remember* (Cambridge: Cambridge University Press, 1989), esp. 79–88. Connerton argues that memory is compiled in the human body through what he calls "incorporating practices," of which he distinguishes three types as forms of social engagement: "ceremonies of the body, proprieties of the body, and techniques of the body" (79). His examples are, respectively, deportment of nobility, table manners, and gesture among ethnic subcultures. Each one represents comparable forms of body practice that train the body and operate as social performance that remembers and enacts identity.

26. Mauss, "Techniques of the Body," 73.

27. Ibid., 73.

CHAPTER 8

1. Colum Hourihane, ed., *Looking Beyond: Visions, Dreams, and Insights in Medieval Art and History.* Index of Christian Art, Occasional Papers, 11 (Princeton: Index of Christian Art, Department of Art and Archaeology, Princeton University in association with Penn State University Press, 2010); Jeremy Biles, "Out of This World: The Materiality of the Beyond," in *Religion and Material Culture: The Matter of Belief,* ed. David Morgan (London: Routledge, 2010), 135–52; William A. Christian Jr. and Gábor Klaniczay, eds., *The "Vision Thing." Studying Divine Intervention.* Workshop Series 18 (Budapest: Collegium Budapest Institute for Advanced Study, 2009); Bernd

Huppauf and Christoph Wulf, eds., *Dynamics and Performativity of Imagination: The Image between the Visible and the Invisible* (New York: Routledge, 2009), esp. 25–75; Hans Belting, *Das echte Bild: Bildfragen als Glaubensfragen* (Munich: C. H. Beck, 2005), 120–32; Hans Belting, "Image, Medium, Body: A New Approach to Iconology," *Critical Inquiry* 31 (Winter 2005): 302–15; Hans Belting, *Bild-Anthropologie: Entwürfe für eine Bildwissenschaft* (Munich: Wilhelm Fink Verlag, 2001); Marc Augé, *The War of Dreams: Exercises in Ethno-Fiction*, trans. Liz Heran (Sterling, VA: Pluto Press, 1999).

2. Belting, "Image, Medium, Body," 304.

3. W. J. T. Mitchell, *What Do Pictures Want? The Lives and Loves of Images* (Chicago: University of Chicago Press, 2005), 85.

4. "Tiny Picture of Christ Weeps Tears of Blood," *National Enquirer*, August 21, 1979.

5. For still imagery from the video see David Morgan, "Image, Art, and Inspiration in Modern Apparitions," in Hourihane, *Looking Beyond*, 266.

6. For a collection of images exhibiting miraculous powers from the Middle Ages to the present, see Joan Carroll Cruz, *Miraculous Images of Our Lord: Famous Catholic Statues, Portraits, and Crucifixes* (Rock Island, IL: TAN Books, 1995).

7. On medieval treatments of *acheiropoieta*, or images made without human hands, see Hans Belting, *Likeness and Presence: A History of the Image before the Era of Art*, trans. Edmund Jephcott (Chicago: University of Chicago Press, 1994), 62–69; James Trilling, "The Image Not Made By Hands and the Byzantine Way of Seeing," 109–27, in *The Holy Face and the Paradox of Representation*, ed. Herbert L. Kessler and Gerhard Wolf, Villa Spelman Colloquia, vol. 6 (Rome: Nuova Alfa Editoriale, 1998); and Herbert L. Kessler, *Spiritual Seeing: Picturing God's Invisibility in Medieval Art* (Philadelphia: University of Pennsylvania Press, 2000), 64–87. For studies of modern apparitions see William A. Christian, Jr., *Person and God in a Spanish Valley*, rev. ed. (Princeton: Princeton University Press, 1989); and Lisa M. Bitel, "Scenes from a Cult in the Making: Lady of the Rock, 2008," in Hourihane, *Looking Beyond*, 283–92, with photographs by Matt Gainer; and additional items cited below. For a modern *acheiropoieton*, see Anna Niedźwiedź, *The Image and the Figure: Our Lady of Czestochowa in Polish Culture and Popular Religion* (Krakow: Jagiellonian University Press, 2010).

8. Even the use of the dream, inspired by an image, is a motif to be found in the Middle Ages, see Ernst Kitzinger, "The Cult of Images in the Age before Iconoclasm," *Dumbarton Oaks Papers*, vol. 8 (1954), 108. Thanks to Cynthia Hahn for this reference. Hahn has written a very helpful overview of vision as concept and practice in the Middle Ages, "Vision," in *A Companion to Medieval Art*, ed. Conrad Rudolph (Oxford: Blackwell, 2006), 44–65.

9. I do not wish to sweep aside the many differences between modern and premodern eras, only to refute the typically Modernist insistence on radical breaks. William Christian concluded in his major early study of Catholicism in Spain over several centuries that two world views had come to coexist: the older piety devoted to shrine imagery and the newer generalized devotionalism. The former focused on local intercessors who had power over nature; the latter, such as the modern apparitions of Mary,

were intercessors between human and divine, see Christian, *Person and God in a Spanish Valley*, 182; also 44–78. An even more modern model, reflecting the perspective of the Second Vatican Council, was also insightfully described by Christian. Christian's view was affirmed by Victor Turner and Edith L. B. Turner in their study of Marian apparitions and pilgrimages, *Image and Pilgrimage in Christian Culture: Anthropological Perspectives* (New York: Columbia University Press, 1978), 206–7.

10. Wilhelm Heinrich Wackenroder, *Confessions and Fantasies*, trans. Mary Hurst Schubert (University Park: Pennsylvania State University Press, 1971), 84. Wackenroder, *Herzensergiessungen eines kunstliebenden Klosterbruders*, in Wackenroder, *Sämmtliche Schriften*, ed. Curt Grützmacher and Sybille Claus (Berlin: Rowohlt, 1968), 13–14:

> Einst, in der Nacht, da er, wie es ihm schon oft geschehen sei, im Traume zur Jungfrau gebetet habe, sei er, heftig bedrängt, auf einmal aus dem Schlafe aufgefahren. In der finsteren Nacht sei sein Auge von einem hellen Schein an der Wand, seinem Lager gegenüber, angezogen worden, und da er recht zugesehen, so sei er gewahr geworden, daß sein Bild der Madonna, das, noch unvollendet, an der Wand gehangen, von dem mildesten Lichtstrahle, und ein ganz vollkommenes und wirklich lebendiges Bild geworden sei. Die Göttlichkeit in diesem Bilde habe ihn so überwältigt, daß er in helle Tränen ausgebrochen sei. Es habe ihn mit den Augen auf eine unbeschreiblich rührende Weise angesehen, und habe in jedem Augenblick geschienen, als wolle es sich bewegen; und es habe ihn gedünkt, als bewege es sich auch wirklich . . . Am anderen Morgen sei er wie neugeboren aufgestanden; die Erscheinung sei seinem Gemüt und seinen Sinnen auf ewig fest eingeprägt geblieben, und nun sei es ihm gelungen, die Mutter Gottes immer so, wie sie seiner Seele vorgeschwebt habe, abzubilden . . .

11. On Wackenroder's artistic spirituality, see Moshe Barasch, *Modern Theories of Art, 1: From Winckelmann to Baudelaire* (New York: New York University Press, 1990), 293–304; on Wackenroder, Pietism, and the heart, see Mary Hurst Schubert, introduction to Wackenroder, *Confessions and Fantasies*, 29–30, 44–52; on the visual history of the Sacred Heart, David Morgan, *The Sacred Heart of Jesus: The Visual Evolution of a Devotion*, Meertens Ethnology Cahier 4 (Amsterdam: Amsterdam University Press, 2008); a study of the heart as a theological and devotional motif in early modern Europe is Bernhard F. Scholz, "Religious Meditations on the Heart: Three Seventeenth Century Variants," in *The Arts and the Cultural Heritage of Martin Luther*, ed. Eyolf Østrem, Jens Fleischer, and Nils Holder Petersen (Copenhagen: Museum Tusculanum Press, University of Copenhagen, 2003), 99–135. A history of conceptions of the imagination from the early modern period to Romanticism is James Engell, *The Creative Imagination: Enlightenment to Romanticism* (Cambridge, MA: Harvard University Press, 1981).

12. Major studies are, of course, David Freedberg, *The Power of Images: Studies in the History and Theory of Response* (Chicago: University of Chicago Press, 1989); and William A. Christian, Jr., *Apparitions in Late Medieval and Renaissance Spain* (Princeton: Princeton University Press, 1981) and idem, *Moving Crucifixes in Modern Spain* (Princeton: Princeton University Press, 1992).

13. See Judith F. Dolkart, ed., *James Tissot: The Life of Christ*, exhibition catalogue (London: Merrell Publishers and Brooklyn Museum, 2009).

14. Cleveland Moffett, "J. J. Tissot and His Paintings of the Life of Christ," *McClure's Magazine*, vol. 7, no. 5 (March 1899), 394.

15. See Petra ten-Doesschate Chu, "Lecoq de Boisbaudran and Memory Drawing: A Teaching Course between Idealism and Naturalism," in *The European Realist Tradition*, ed. Gabriel P. Weisberg (Bloomington: Indiana University Press, 1982), 242–89.

16. See Freedberg, *Power of Images*, 309–10, for discussion of self-transporting images.

17. Sylvia E. Peterson, *The Ministry of Christian Art: A Story of Artist Warner Sallman and His Famous Religious Pictures* (Indianapolis: Kriebel and Bates, 1947), 1. I have discussed numerous variations on Sallman's account in David Morgan, "'Would Jesus Have Sat for a Portrait?' The Likeness of Christ in the Popular Reception of Sallman's Art," in *Icons of American Protestantism: The Art of Warner Sallman*, ed. David Morgan (New Haven: Yale University Press, 1996), 184–87.

18. For Sallman's discussion of the image's source, Léon Lhermitte's *The Friend of the Humble*, 1892, an oil painting now in the Museum of Fine Arts, Boston, which was reproduced in *Ladies' Home Journal*, vol. 39, December 1922, 20, see Margaret Anderson, "His Subject Shaped His Life," *War Cry* (December 9, 1961), 7–8, 10. I have discussed the issue in "Warner Sallman and the Visual Culture of American Protestantism," in Morgan, *Icons of American Protestantism*, 30–31.

19. In her fascinating study of Elvis fans and their visual culture, Erika Doss noted that "Elvis fans continually revitalize his popularity, reworking, reimagining, and reinventing Elvis to mesh with their personal and social preferences," *Elvis Culture: Fans, Faith, and Image* (Lawrence, KS: University Press of Kansas, 1999), 31.

20. The preeminent exception to this is the seated figure of La Salette, yet in this case misrecognition may have resulted from several unusual features of Our Lady: seated, face in hands, weeping.

21. See, for example, Sandra L. Zimdars-Swartz, *Encountering Mary: Visions of Mary from La Salette to Medjugorje* (New York: Avon, 1992), 47–51, 68–77; and Michael P. Carroll, *The Cult of the Virgin Mary: Psychological Origins* (Princeton: Princeton University Press, 1986), 173–81; idem, "The Virgin at La Salette and Lourdes: Whom Did the Children See?" *Journal of the Scientific Study of Religion* 24, no. 1 (1985): 56–74; and Turner and Turner, *Image and Pilgrimage*, 214–26. For a parallel analysis of visions of Jesus, see William A. Christian, Jr., "The Eyes of the Beholders: Systematic Variation in Visions of the Christ of Limpias in Northern Spain, 1919–1936," in Christian and Klaniczay, *The "Vision Thing,"* 65–81.

22. Clifton Johnson, "A Town of Modern Miracles," *The Outlook* 65 (July 7, 1900), 564.

23. Fr. Louis Kondor, S.V.D., ed. *Fatima in Lucia's Own Words*, trans. Dominican Nuns of Perpetual Rosary (Fatima: Postulation Centre, 1976), 28.

24. Ibid., 59, 62.

25. Ibid., 55.

26. "A Short History of Our Lady's apparitions in Medjugorje," at http://www .medjugorje.ws/en/apparitions/.

27. Sallman's is by no means the only occasion on which a pious creator of an image of Jesus forgot the visual source of his vision and its pictorial representation. The same kind of apparently forgotten borrowing occurred when a young man named Mark Cannon, injured in an accident and fallen into despair, produced a drawing of Jesus that was clearly indebted to a well-known film still of Christ from Franco Zeffirelli's 1977 made-for-television film, *Jesus of Nazareth*. But the website offering copies of Cannon's drawing for sale makes no mention of the debt, constructing the following account of the drawing's divine origin instead: "Four hours of intense effort slipped by in a moment. He felt his heart open, when suddenly he was staring into the eyes of Jesus Christ—eyes which he had drawn with his pencil, and which now drew him into their power of His love. It was as if He himself had guided his hand and allowed him to see with his own eyes, and feel with his heart, the true significance of His sacrifice." http://www.crownofthornsprints.com/testimony.htm.

28. I have discussed this statue in particular, David Morgan, "Aura and the Inversion of Marian Pilgrimage: Fatima and Her Statues," in *Moved by Mary: Pilgrimage in the Modern World*, ed. Anna-Karina Hermkens, Willy Jansen, and Catrien Notermans (Oxford: Ashgate, 2009), 49–65.

29. Zimdars-Swartz, *Encountering Mary*, 32; Carroll, *Cult of the Virgin Mary*, 148–72.

30. The powerful role of authorities of different kinds in shaping the discourse and imagery of apparitions recalls in at least one way the powerful influence of police, prosecutors, and other legal authorities in shaping what eyewitnesses report. This has been studied as a forensic phenomenon regarding visual evidence, for example, David F. Hall, Elizabeth F. Loftus, and James P. Tousignant, "Postevent Information and Changes in Recollection for a Natural Event," in *Eyewitness Testimony: Psychological Perspectives*, ed. Gary L. Wells and Elizabeth F. Loftus (Cambridge: Cambridge University Press, 1984), 124–41. The coercive influence of authorities also has been argued to exert catastrophic effects in distorting and prompting the testimony of children in instances of alleged sexual abuse. See, for instance, Lona Manning, "Nightmare at the Day Care: The Wee Care Case," *Crime Magazine: An Encyclopedia of Crime*, online at www.crimemagazine.com/daycare.htm(accessed March 17, 2008). Yet I do not wish to suggest a direct parallel to apparitional visual piety, since doing so would incline us to read apparitions as examples of pathology. A more constructive approach will not ignore instances of delusion when they occur, but neither will it presume that religious visions are merely delusional or that adherence to them by devotees is no more than a form of deception.

31. For the imagery, see http://images.google.com/images?hl=en&q=john+paul+ II+in+fire+image&um=1&ie=UTF-8 (accessed March 2, 2008).

32. See: http://www.dailymail.co.uk/pages/live/articles/news/worldnews.html?in _article_id = 487764&in_page_id = 1811 (accessed March 2, 2008).

33. Daniel Wojcik, "'Polaroids from Heaven': Photography, Folk Religion, and the Miraculous Image Tradition at a Marian Apparition Site," *Journal of American Folklore* 109, no. 432 (Spring 1996): 129–48. For images, messages, and the Flushing Meadows, Queens, New York, apparition site's official webpage, see http://ourladyoftheroses.org/images or http://www.tldm.org/photos/olbysky.htm (accessed March 2, 2008).

34. Historian Lisa Bitel and photographer Matt Gainer are studying the photographic response of pilgrims at an apparition site known as Virgin of the Rocks in the Mojave Desert. Maria Paula Acuña leads devout response to the ongoing apparitions on the thirteenth of each month. Bitel and Gainer presented their project at "Looking Beyond, Visions, Dreams, and Insights in Medieval Art and History," held at the Index of Christian Art, Princeton University, March 14, 2008; see Bitel, "Scenes from a Cult in the Making."

35. Wojcik, "Polaroids from Heaven," 132–34.

36. I have discussed the visual operation of tarot in *The Lure of Images: A History of Religion and Visual Media in America* (London: Routledge, 2007), 251–52.

37. Wojcik, "Polaroids from Heaven," 133–35, stresses divination in his study of a Marian group in New York. I have examined visual divination of symbols embedded in a popular picture of Jesus in *Visual Piety: A History and Theory of Popular Religious Images* (Berkeley: University of California Press, 1998), 124–43. The same occurs in images of a Sufi sheikh, Allen Roberts and Polly Nooter Roberts, *A Saint in the City: Sufi Arts of Urban Senegal* (Los Angeles: UCLA Fowler Museum of Cultural History, 2003), 52–59; and in the photograph of a Hasidic rebbe, Maya Balakirsky Katz, *The Visual Culture of Chabad* (New York: Cambridge University Press, 2010), 98.

38. Paolo Apolito, *The Internet and the Madonna: Religious Visionary Experience on the Web*, trans. Antony Shugaar (Chicago: University of Chicago Press, 2005).

39. For images of the cross and discussion of its formation, discovery, and interpretation with multiple links, see "World Trade Center Cross" at http://en.wikipedia.org/wiki/World_Trade_Center_Cross (accessed April 2, 2008).

40. Anderson, "His Subject Shaped His Life," 8.

41. Discussed in Morgan, *Visual Piety*, 40.

42. Quoted in Morgan, *Visual Piety*, 35. I discussed in this book what I called "the psychology of recognition" as a key aspect of popular visual piety, 34–50.

SELECT BIBLIOGRAPHY

Alacoque, Margaret Mary. *The Autobiography of St. Margaret Mary Alacoque*. Trans. The Sisters of the Visitation. Rockford, IL: TAN Books, 1986.

———. *The Letters of St. Margaret Mary Alacoque*. Trans. Fr. Clarence A. Herbst, S.J. Rockford, IL: TAN Books, 1997.

Alexander, James W. *The Life of Archibald Alexander*. New York: Charles Scribner, 1854.

Anderson, Benedict. *Imagined Communities: Reflections on the Origin and Spread of Nationalism*. Rev. ed. London: Verso, 1991.

Apolito, Paolo. *The Internet and the Madonna: Religious Visionary Experience on the Web*. Trans. Antony Shugaar. Chicago: University of Chicago Press, 2005.

Arnold, Matthew. *Culture and Anarchy and Other Writings*. Ed. Stefan Collini. New York: Cambridge University Press, 1993.

Asad, Talal. *Geneaologies of Religion: Discipline and Reasons of Power in Christianity and Islam*. Baltimore: Johns Hopkins University Press, 1993.

Balch, Colonel George T. *Methods of Teaching Patriotism in the Public Schools*. New York: D. Van Nostrand, 1890.

Barnes, Elizabeth. *States of Sympathy: Seduction and Democracy in the American Novel*. New York: Columbia University Press, 1997.

Barrett, William. *Irrational Man: A Study in Existential Philosophy*. Garden City, NY: Doubleday, 1958.

Barthes, Roland. *Camera Lucida: Reflections on Photography*. Trans. Richard Howard. New York: Hill and Wang, 1981.

———. "Rhetoric of the Image." In *Semiotics. An Introductory Anthology*, ed. Robert E. Innis, 190–205. Bloomington: Indiana University Press, 1985.

Bazin, André. "The Ontology of the Photographic Image." In *Classic Essays on Photography*, ed. Alan Trachtenberg, 237–44. New Haven: Leete's Island Books, 1980.

Beecher, Henry Ward. *Freedom and War. Discourses on Topics Suggested by the Times.* Boston: Ticknor and Fields, 1863.

Belting, Hans. *Likeness and Presence: A History of the Image before the Era of Art.* Trans. Edmund Jephcott. Chicago: University of Chicago Press, 1994.

———. "In Search of Christ's Body. Image or Imprint?" In *The Holy Face and the Paradox of Representation,* ed. Herbert L. Kessler and Gerhard Wolf, 1–11. Villa Spelman Colloquia, vol. 6. Rome: Nuova Alfa Editoriale, 1998.

———. *Bild-Anthropologie: Entwürfe für eine Bildwissenschaft.* Munich: Wilhelm Fink Verlag, 2001.

———. *Das echte Bild: Bildfragen als Glaubensfragen.* Munich: C. H. Beck, 2005.

———. "Image, Medium, Body: A New Approach to Iconology." *Critical Inquiry* 31 (Winter 2005), 302–15.

Bentham, Jeremy. *The Panopticon Writings.* Ed. Miran Bozovic. London: Verso, 1995.

Berger, Peter L. *The Sacred Canopy: Elements of a Sociological Theory of Religion.* Garden City, NY: Anchor Books, 1969.

Biles, Jeremy. "Out of This World: The Materiality of the Beyond." In *Religion and Material Culture: The Matter of Belief,* ed. David Morgan, 135–52. London: Routledge, 2010.

Bivins, Jason C. *Religion of Fear: The Politics of Horror in Conservative Evangelicalism.* New York: Oxford University Press, 2008.

Blackman, Lisa, ed. *The Body: The Key Concepts.* Oxford: Berg, 2008.

Blier, Suzanne Preston. *African Vodun: Art, Psychology, and Power.* Chicago: University of Chicago Press, 1995.

Bodnar, John, ed. *Bonds of Affection: Americans Define Their Patriotism.* Princeton: Princeton University Press, 1996.

Boellstorff, Tom. *Coming of Age in Second Life: An Anthropologist Explores the Virtually Human.* Princeton: Princeton University Press, 2008.

Brown, Jonathan, ed. *Figures of Thought: El Greco as Interpreter of History, Tradition, and Ideas.* Studies in the History of Art, vol. 11. Washington DC: National Gallery of Art, 1982.

Burstein, Andrew. *Sentimental Democracy: The Evolution of America's Romantic Self-Image.* New York: Hill and Wang, 1999.

Butsch, Richard. *The Citizen Audience: Crowds, Publics, and Individuals.* New York: Routledge, 2008.

Bynum, Caroline Walker. "Seeing and Seeing-Beyond: The Mass of St. Gregory in the Fifteenth Century." In *The Mind's Eye: Art and Theological Argument in the Middle Ages,* ed. Jeffrey F. Hamburger and Anne-Marie Bouché, 209–40. Princeton: Department of Art and Archaeology, Princeton University, 2006.

———. *Wonderful Blood: Theology and Practice in Late Medieval Northern Germany and Beyond.* Philadelphia: University of Pennsylvania Press, 2007.

Calvin, John. *Institutes of the Christian Religion.* Trans. Henry Beveridge. Grand Rapids: Wm. B. Eerdmans, 1989.

Cameron, Averil. "Images of Authority: Elites, Icons, and Cultural Change in Late Sixth-Century Byzantium," *Past and Present* 84 (1979): 3–35.

———. "The History of the Image of Edessa: the Telling of a Story," *Okeanos. Essays presented to I. Sevcenko. Harvard Ukranian Studies*, vol. 7, 1983, 80–94.

———. "The Mandylion and Byzantine Iconoclasm." In *The Holy Face and the Paradox of Representation*, ed. Herbert L. Kessler and Gerhard Wolf, 40–54. Villa Spelman Colloquia, vol. 6. Rome: Nuova Alfa Editoriale, 1998.

Carroll, Michael P. "The Virgin at La Salette and Lourdes: Whom Did the Children See?" *Journal of the Scientific Study of Religion* 24, no. 1 (1985): 56–74.

———. *The Cult of the Virgin Mary: Psychological Origins.* Princeton: Princeton University Press, 1986.

Christian, William A., Jr. *Apparitions in Late Medieval and Renaissance Spain.* Princeton: Princeton University Press, 1981.

——— *Person and God in a Spanish Valley.* Rev. ed. Princeton: Princeton University Press, 1989.

Christian, William A., Jr., and Gábor Klaniczay, eds. *The "Vision Thing." Studying Divine Intervention.* Workshop Series 18. Budapest: Collegium Budapest Institute for Advanced Study, 2009.

Chu, Petra ten-Doesschate. "Lecoq de Boisbaudran and Memory Drawing: A Teaching Course between Idealism and Naturalism." In *The European Realist Tradition*, ed. Gabriel P. Weisberg, 242–89. Bloomington: Indiana University Press, 1982.

Clark, Anne I. "Venerating the Veronica: Varieties of Passion Piety in the Later Middle Ages," *Material Religion* 3, no. 2 (July 2007): 164–89.

Clark, Elizabeth B. "'The Sacred Rights of the Weak': Pain, Sympathy, and the Culture of Individual Rights in Antebellum America," *The Journal of American History* 82, no. 2 (September 1995) 463–93.

Classen, Constance, ed. *The Book of Touch.* Oxford: Berg, 2005.

Coleman, Simon. "Words as Things: Language, Aesthetics and the Objectification of Protestant Evangelicalism." *Journal of Material Culture* 1, no. 1 (1996): 107–28.

Connerton, Paul. *How Societies Remember.* Cambridge: Cambridge University Press, 1989.

Cooley, Charles Horton. *Human Nature and the Social Order.* Rev. ed. New York: Scribner's, 1922.

Court of Constantine Porphyrogenitus. "Story of the Image of Edessa," Trans. Bernard Slate et al. In *The Shroud of Turin: The Burial Cloth of Jesus?* by Ian Wilson, 235–51. Garden City, NY: Doubleday, 1978.

Crary, Jonathan. *Techniques of the Observer: On Vision and Modernity in the Nineteenth Century.* Cambridge, MA: MIT Press, 1990.

Curtis, Heather D. *Faith in the Great Physician: Suffering and Divine Healing in American Culture, 1860–1900.* Baltimore: Johns Hopkins University Press, 2007.

Dalgairns, John Bernard. *The Devotion to the Sacred Heart of Jesus; with an Introduction on the History of Jansenism.* London: Thomas Richardson and Son, 1853.

Davis, Richard. *Lives of Indian Images.* Princeton: Princeton University Press, 1997.

Deleuze, Giles, and Felix Guatarri. *A Thousand Plateaus.* Trans. Brian Massumi. London: Continuum, 2004.

DeRogatis, Amy. "Varieties of Interpretations: Protestantism and Sexuality." In *Sexuality and the World's Religions,* ed. David W. Machacek and Melissa M. Wilcox, 231–54. Santa Barbara, CA: ABC-CLIO, 2003.

———. "'Born Again Is a Sexual Term': Demons, STDs, and God's Healing Sperm." *Journal of the American Academy of Religion* 77, no. 2 (June 2009): 275–302.

Descartes, René. *The Dioptrics.* In *Philosophical Writings,* trans. and ed. Elizabeth Anscombe and Peter Thomas Geach. Indianapolis: Bobbs-Merrill Educational Publishing, 1954.

———. *Meditations on First Philosophy.* Trans. Michael Moriarty. Oxford: Oxford University Press, 2008.

de Voragine, Jacobus. *The Golden Legend: Readings on the Saints.* 2 vols. Trans. William Granger Ryan. Princeton: Princeton University Press, 1993.

Dippie, Brian W. *The Vanishing American: White Attitudes and U.S. Indian Policy.* Lawrence: University Press of Kansas, 1982.

Dobschütz, Ernst von. *Christusbilder: Untersuchungen zur christlichen Legende.* Leipzig: J. C. Hinrichs, 1899.

Dolkart, Judith F., ed. *James Tissot: The Life of Christ.* London: Merrell Publishers and Brooklyn Museum, 2009.

Doss, Erika. *Elvis Culture: Fans, Faith, and Image.* Lawrence, KS: University Press of Kansas, 1999.

Douglass, Frederick. *Narrative of the Life of Frederick Douglass, an American Slave.* Ed. William L. Andrews and William S. McFeely. Norton Critical Edition. New York: W. W. Norton, 1997.

Dubuisson, Daniel. *The Western Construction of Religion: Myths, Knowledge, and Ideology.* Trans. William Sayers. Baltimore: Johns Hopkins University Press, 2003.

Dürer, Albrecht. *The Painter's Manual: A Manual of Measurement of Lines, Areas, and Solids by Means of Compass and Ruler.* Trans. Walter L. Strauss. New York: Abaris Books, 1977.

Durkheim, Emile. *The Elementary Forms of Religious Life.* Trans. Karen E. Fields. New York: Free Press, 1995.

Egger, Christoph. "Papst Innocenz III. und die Veronica. Geschichte, Theologie, Liturgie und Seelsorge." In *The Holy Face and the Paradox of Representation,* ed. Herbert L. Kessler and Gerhard Wolf, 181–203. Villa Spelman Colloquia, vol. 6. Rome: Nuova Alfa Editoriale, 1998.

Einstein, Mara. *Brands of Faith: Marketing Religion in a Commercial Age.* London: Routledge, 2008.

Emerson, Ralph Waldo. *Nature.* In *The Essential Writings of Ralph Waldo Emerson,* ed. Brooks Atkinson. New York: Modern Library, 2000.

Engelke, Matthew. "Sticky Subjects and Sticky Objects: The Substance of African

Christian Healing." In *Materiality*, ed. Daniel Miller, 118–39. Durham: Duke University Press, 2005.

Engell, James. *The Creative Imagination: Enlightenment to Romanticism*. Cambridge, MA: Harvard University Press, 1981.

Finaldi, Gabriele. *The Image of Christ*. London: National Gallery, 2000.

Foucault, Michel. *Discipline and Punish: The Birth of the Prison*. Trans. Alan Sheridan. New York: Vintage Books, 1995.

Frazier, Thomas R., ed. *Afro-American History: Primary Sources*. New York: Harcourt, Brace & World, 1970.

Freedberg, David. *The Power of Images: Studies in the History and Theory of Response*. Chicago: University of Chicago Press, 1989.

Freud, Sigmund. *A General Introduction to Psycho-Analysis*. Rev. ed. Trans. Joan Riviere. New York: Pocket Books, 1953.

Fulkerson, Mary McClintock. *Places of Redemption: Theology for a Worldly Church*. Oxford: Oxford University Press, 2007.

Gallagher, Shaun. *How the Body Shapes the Mind*. Oxford: Clarendon Press, 2005.

Galliffet, Father Joseph de. *The Adorable Heart of Jesus*. Philadelphia: Messenger of the Sacred Heart, 1890.

Geary, Patrick J. *Furta Sacra: Thefts of Relics in the Central Middle Ages*. Rev. ed. Princeton: Princeton University Press, 1990.

George, Victoria Ann. *Whitewash and the New Aesthetic of the Protestant Reformation*. London: Pindar Press, 2011.

Goffman, Erving. *The Presentation of the Self in Everyday Life*. New York: Doubleday, 1959.

Griffith, R. Marie. *Born Again Bodies: Flesh and Spirit in American Christianity*. Berkeley: University of California Press, 2004.

Guenter, Scot M. *The American Flag, 1777–1924: Cultural Shifts from Creation to Codification*. Rutherford: Fairleigh Dickinson University Press; London: Associated University Press, 1990.

Guscin, Mark. *The Image of Edessa*. Leiden: Brill, 2009.

Hahn, Cynthia. "Vision." In *A Companion to Medieval Art*, ed. Conrad Rudolph, 44–65. Oxford: Blackwell, 2006.

Halpern, Richard. *Norman Rockwell: The Underside of Innocence*. Chicago: University of Chicago Press, 2006.

Hopkins, Jasper. *Nicholas of Cusa's Dialectical Mysticism: Text, Translation, and Interpretive Study of De Visione Dei*. 3rd ed. Minneapolis: Arthur J. Banning Press, 1988.

Hourihane, Colum, ed. *Looking Beyond: Visions, Dreams, and Insights in Medieval Art and History*. Index of Christian Art, Occasional Papers, 11. Princeton: Index of Christian Art, Department of Art and Archaeology, Princeton University in association with Penn State University Press, 2010.

Huppauf, Bernd, and Christoph Wulf, eds. *Dynamics and Performativity of Imagination: The Image between the Visible and the Invisible*. New York: Routledge, 2009.

Jay, Martin. "Scopic Regimes of Modernity." In *Vision and Visuality*, ed. Hal Foster, 3–23. Seattle: Bay Press, 1988.

———. *Downcast Eyes: The Denigration of Vision in Twentieth-Century French Thought.* Berkeley: University of California Press, 1993.

John of Damascus, Saint. *Three Treatises on the Divine Images.* Trans. Andrew Louth. Crestwood, NY: St. Vladimir's Seminary Press, 2003.

Johns, Christopher M. S. "'The Amiable Object of Adoration': Pompeo Batoni and the Sacred Heart." *Gazette des Beaux-Arts* 132, nos. 1554–55. (July-August 1998): 19–28.

Jonas, Raymond. *France and the Cult of the Sacred Heart: An Epic Tale for Modern Times.* Berkeley: University of California Press, 2000.

Katz, Maya Balakirsky. *The Visual Culture of Chabad.* New York: Cambridge University Press, 2010.

Keane, Webb. *Christian Moderns: Freedom and Fetish in the Mission Encounter* Berkeley: University of California Press, 2007.

Kennedy, John H. *Sympathy, Its Foundation and Legitimate Exercise Considered, In Special Relation to Africa: A Discourse Delivered on the Fourth of July 1828 in the Sixth Presbyterian Church, Philadelphia.* Philadelphia: printed by W. T. Green, 1828.

Kessler, Herbert L., and Gerhard Wolf, eds. *The Holy Face and the Paradox of Representation.* Villa Spelman Colloquia, vol. 6. Rome: Nuova Alfa Editoriale, 1998.

King, Rev. J. M., et al. *The Religious Condition of New York City.* Addresses made at a Christian Conference held in Chickering Hall, New York City. December 3, 4 and 5, 1888. New York: Baker & Taylor, 1888.

Kitzinger, Ernst. "The Cult of Images in the Age before Iconoclasm." *Dumbarton Oaks Papers* 8 (1954): 85–150.

Klassen, Pamela. "The Robes of Womanhood: Dress and Authenticity among African American Methodist Women in the Nineteenth Century." *Journal of Religion and American Culture* 14, no. 1. (2004): 39–82.

———. "Ritual Appropriation and Appropriate Ritual: Christian Healing and Adaptations of Asian Religions." *History and Anthropology* 16, no. 3. (2005): 377–91.

Koerner, Joseph Leo. "The Icon as Iconoclash." In *Iconoclash: Beyond the Image Wars in Science, Religion, and Art*, ed. Bruno Latour and Peter Weibel, 164–213. Karlsruhe: Center for Art and Media; Cambridge, MA: MIT Press, 2002.

———. *The Reformation of the Image.* Chicago: University of Chicago Press, 2004.

Kohl, Karl-Heinz. *Die Macht der Dinge: Geschichte und Theorie sakraler Objekte.* Munich: C. H. Beck, 2003.

Kondor, Fr. Louis, S.V.D., ed. *Fatima in Lucia's Own Words.* Trans. Dominican Nuns of Perpetual Rosary. Fatima:Postulation Centre, 1976.

Kuryluk, Ewa. *Veronica and Her Cloth: History, Symbolism, and Structure of a "True" Image.* New York: Basil Blackwell, 1991.

Kwilecki, Susan. *Becoming Religious: Understanding Devotion to the Unseen.* Cranbury, NJ: Associated University Presses, 1999.

Lacan, Jacques. *The Four Fundamental Concepts of Psycho-Analysis.* Ed. Jacques-Alain Miller. Trans. Alan Sheridan. New York: W. W. Norton, 1981.

———. *Écrits: A Selection*. Trans. Bruce Fink. New York: W. W. Norton, 2002.

Levin, David Michael, ed. *Modernity and the Hegemony of Vision*. Berkeley: University of California Press, 1993.

Levinas, Emmanuel. *Alterity and Transcendence*. Trans. Michael B. Smith. New York: Columbia University Press, 1999.

Luther, Martin. *Against the Heavenly Prophets in the Matter of Images and Sacraments*. Vol. 40 of *Luther's Works*, ed. Conrad Bergendoff. Philadelphia: Muhlenberg Press, 1958.

———. *A Meditation on Christ's Passion*. Vol. 42 of *Luther's Works*, ed. Martin O. Dietrich. Philadelphia: Fortress Press, 1969.

MacGregor, Neil. *Seeing Salvation: Images of Christ in Art*. With Erika Langmuir. New Haven: Yale University Press, 2000.

Marcuse, Herbert. "Existentialism: Remarks on Jean-Paul Sartre's *L'Etre et le Neant*," *Philosophy and Phenomenological Research* 8, no. 3 (March 1948): 309–36.

Marks, Laura U. *Touch: Sensuous Theory and Multisensory Media*. Minneapolis: University of Minnesota Press, 2002.

Marx, Karl. *Capital. An Abridged Edition*. Ed. David McLellan. Oxford World's Classics. Oxford: Oxford University Press, 1999.

Mauss, Marcel. "Techniques of the Body," *Economy and Society* 2 (1973): 70–88.

———. *The Gift: The Form and Reason for Exchange in Archaic Societies*. Trans. W. D. Halls. New York: W. W. Norton, 1990.

Merleau-Ponty, Maurice. *The Primacy of Perception and Other Essays*. Ed. James M. Edie. Evanston, IL: Northwestern University Press, 1964.

———. *The Phenomenology of Perception*. Trans. Colin Smith. London: Routledge, 2002.

Meyer, Birgit. "Impossible Representations: Pentecostalism, Vision, and Video Technology in Ghana." In *Religion, Media, and the Public Sphere*, ed. Birgit Meyer and Annelies Moors, 290–312. Bloomington: Indiana University Press, 2006.

———. *Religious Sensations: Why Media, Aesthetics, and Power Matter in the Study of Contemporary Religion*. Amsterdam: Faculty of Social Sciences, Frije Universiteit, 2006.

———. "Powerful Pictures: Popular Christian Aesthetics in Southern Ghana." *Journal of the American Academy of Religion* 76, no. 1. (March 2008): 82–110.

———, ed. *Aesthetic Formations: Media, Religion, and the Senses*. New York: Palgrave Macmillan, 2009.

Meyer, Hugo. "Copying and Social Cohesion in Rome and Early Byzantium: The Case of the First Famous Image of Christ at Edessa." In *Interactions: Artistic Interchange between the Eastern and Western Worlds in the Medieval Period*, ed. Colum Hourihane. Princeton: Index of Christian Art, 2007, 209–19.

Miles, Margaret R. "'The Rope Breaks When It Is Tightest': Luther on the Body, Consciousness, and the Word." *Harvard Theological Review* 77, nos. 3–4 (1984): 239–58.

Miller, Daniel. *Material Culture and Mass Consumption*. Oxford: Blackwell, 1987.

Mitchell, W. J. T. *Picture Theory: Essays on Verbal and Visual Representation*. Chicago: University of Chicago Press, 1994.

———. *What Do Pictures Want? The Lives and Loves of Images*. Chicago: University of Chicago Press, 2005.

Morgan, David, ed. *Icons of American Protestantism: The Art of Warner Sallman*. New Haven: Yale University Press, 1996.

———. *Visual Piety: A History and Theory of Popular Religious Images*. Berkeley: University of California Press, 1998.

———. *Protestants and Pictures: Religion, Visual Culture, and the Age of American Mass Production*. New York: Oxford University Press, 1999.

———. *The Sacred Gaze: Religious Visual Culture in Theory and Practice*. Berkeley: University of California Press, 2005.

———. *The Lure of Images: A History of Religion and Visual Media in America*. London: Routledge, 2007.

———. "The Visual Construction of the Sacred." In *Images and Communities: The Visual Construction of the Social*, ed. Matteo Stocchetti and Johanna Sumiala-Seppänen, 53–74. Helsinki: Gaudeamus/Helsinki University Press, 2007.

———. "Finding Fabiola." In *Fabiola: An Investigation*, by Francis Alÿs, ed. Karen Kelly and Lynne Cook, 11–21. New York: Dia Foundation, 2008.

———, ed. *Key Words in Religion, Media, and Culture*. London: Routledge, 2008.

———. *The Sacred Heart of Jesus: The Visual Evolution of a Devotion*. Meertens Ethnology Cahier 4. Amsterdam: Amsterdam University Press, 2008.

———. "Aura and the Inversion of Marian Pilgrimage: Fatima and Her Statues." In *Moved by Mary: Pilgrimage in the Modern World*, ed. Anna-Karina Hermkens, Willy Jansen, and Catrien Notermans, 49–65. Oxford: Ashgate, 2009.

———, ed. *Religion and Material Culture: The Matter of Belief*. London: Routledge, 2010.

———. "Mediation or Mediatisation: The History of Media in the Study of Religion." *Culture and Religion* 12, no. 2 (June 2011): 137–52

———. "Recognizing Jesus." In *Innovative Methods in the Study of Religion*, ed. Linda Woodhead, forthcoming.

Newman, Richard, Patrick Rael, and Philip Lapsansky, eds. *Pamphlets of Protest: An Anthology of Early African-American Protest Literature, 1790–1860*. New York: Routledge, 2001.

Nicole, Pierre. *De la Soumission à la Volonté de Dieu*. In *Oeuvres philosophiques et morales de Nicole*, ed. C. Jourdain. Paris: L. Hachette, 1845.

Niedźwiedź, Anna. *The Image and the Figure: Our Lady of Czestochowa in Polish Culture and Popular Religion*. Kraków: Jagiellonian University Press, 2010.

O'Leary, Cecelia Elizabeth. *To Die For: The Paradox of American Patriotism*. Princeton: Princeton University Press, 1999.

Orsi, Robert A. *Between Heaven and Earth: The Religious Worlds People Make and the Scholars Who Study Them*. Princeton: Princeton University Press, 2005.

Pascal, Blaise. *The Provincial Letters*. Trans. Rev. Thomas M'Crie. New York: Robert Carter & Brothers, 1850.

Patterson, Mark. *The Senses of Touch: Haptics, Affects, and Technologies*. Oxford: Berg, 2007.

Pattison, Stephen. *Seeing Things: Deepening Relations with Visual Artefacts*. London: SCM Press, 2007.

Plate, S. Brent, ed. *Religion, Art and Visual Culture*. New York: Palgrave, 2002.

Plato. *The Symposium*. Trans. Walter Hamilton. London: Penguin, 1951.

Riis, Jacob A. *The Making of an American*. New York: Macmillan, 1901.

———. *How the Other Half Lives: Studies among the Tenements of New York*. New York: Dover, 1971.

———. *How the Other Half Lives: Studies in the Tenements of New York*. Ed. David Leviatin. Boston and New York: Bedford/St. Martin's, 1996.

Ringbom, Sixten. *Icon to Narrative: The Rise of the Dramatic Close-Up in Fifteenth-Century Devotional Painting*. 2nd ed. Doornspijk, The Netherlands: Davaco, 1984.

Roberts, Allen, and Mary Nooter Roberts. *A Saint in the City: Sufi Arts in Urban Senegal*. Los Angeles: UCLA Fowler Museum of Cultural History, 2003.

Rousseau, Jean-Jacques. *The Social Contract*. Trans. Christopher Betts. Oxford: Oxford University Press, 1994.

Sartre, Jean-Paul. *Being and Nothingness*. Trans. Hazel E. Barnes. New York: Pocket Books, 1966.

Schmidt, Leigh Eric. "A Church-going People is a Dress-loving People: Clothes, Communication, and Religious Culture in Early America." *Church History* 58 (March 1989): 36–51.

———. *Hearing Things: Religion, Illusion, and the American Enlightenment*. Cambridge, MA: Harvard University Press, 2000.

Schoch, Rainer, Matthais Mende, and Anna Scherbaum, eds. *Albrecht Dürer: Das druckgraphische Werk*. 2 vols. Munich: Prestel, 2002.

Serraller, Francisco Calvo. *El Greco: The Burial of the Count of Orgaz*. London: Thames and Hudson, 1995.

Seydl, Jon L. "Contesting the Sacred Heart of Jesus in Late Eighteenth-Century Rome," In *Roman Bodies: Antiquity to the Eighteenth Century*, ed. Andrew Hopkins and Maria Wyke, 215–27. London: The British School at Rome, 2005.

Sinha, Vineeta. *Religion and Commodification: 'Merchandizing' Diasporic Hinduism*. New York: Routledge, 2011.

Smith, Adam. *The Theory of Moral Sentiments*. Amherst, NY: Prometheus Books, 2000.

Smith, Jonathan Z. *To Take Place: Toward Theory in Ritual*. Chicago: University of Chicago Press, 1987.

———. *Relating Religion: Essays in the Study of Religion*. Chicago: University of Chicago Press, 2004.

Smith, Mark M., ed. *Hearing History: A Reader*. Athens: University of Georgia Press, 2004.

Snyder, Joel, and Neil Walsh Allen, "Photography, Vision, and Representation," *Critical Inquiry* 2 (1975): 143–69.

Sophocles, *King Oedipus*. In *The Theban Plays*. Trans. E. F. Watling. London: Penguin, 1974.

Stange, Maren. *Symbols of Ideal Life: Social Documentary Photography in America 1890–1950*. Cambridge: Cambridge University Press, 1989.

Staudenraus, P. J. *The African Colonization Movement 1816–1865*. New York: Columbia University Press, 1961.

Stein, Sally. "Making Connections with the Camera: Photography and Social Mobility in the Career of Jacob Riis." *Afterimage* 10 (May 1983):, 9–16.

Stolow, Jeremy. "Religion and/as Media." *Theory, Culture & Society* 22, no. 2, 2005, 137–63.

———. *Orthodox by Design: Judaism, Print Politics, and the ArtScroll Revolution*. Berkeley: University of California Press, 2010.

Strayer, Brian E. *Suffering Saints: Jansenists and Convulsionnaires in France, 1640–1799*. Brighton and Portland, U.K.: Sussex Academic Press, 2008.

Strong, Josiah. *Our Country*. Ed. Jurgen Herbst. Cambridge, MA: Belknap Press of Harvard University Press, 1963.

Sturken, Marita, and Lisa Cartwright. *Practices of Looking: An Introduction to Visual Culture*. Oxford: Oxford University Press, 2001.

Tripp, David. "The Image of the Body in the Formative Phases of the Protestant Reformation." In *Religion and the Body*, ed. Sarah Coakley, 131–52. Cambridge: Cambridge University Press, 1997.

Turner, Victor, and Edith L. B Turner. *Image and Pilgrimage in Christian Culture: Anthropological Perspectives*. New York: Columbia University Press, 1978.

Valeri, Mark R. *Heavenly Merchandize: How Religion Shaped Commerce in Puritan America*. Princeton: Princeton University Press, 2010.

Van Kley, Dale K. *The Jansenists and the Expulsion of the Jesuits from France, 1757–1765*. New Haven: Yale University Press, 1975.

Vries, Hent de, ed. *Religion: Beyond a Concept*. New York: Fordham University Press, 2008.

Wackenroder, Wilhelm Heinrich. *Herzensergiessungen eines kunstliebenden Klosterbruders*. In *Sämmtliche Schriften*, ed. Curt Grützmacher and Sybille Claus. Berlin: Rowohlt, 1968.

———. *Confessions and Fantasies*. Trans. Mary Hurst Schubert. University Park: Pennsylvania State University Press, 1971.

Walsh, Michael J. *Sacred Economies: Buddhist Monasticism and Territoriality in Medieval China*. New York: Columbia University Press, 2010.

Washington, George. *Rules of Civility*. Ed. Richard Brookhiser. New York: Free Press, 1997.

Weber, Max. *The Protestant Ethic and the Spirit of Capitalism*. Trans. Talcott Parsons. London: Routledge, 2001.

Weiner, Isaac A. "Displacement and Replacement: The International Friendship Bell as a Translocative Technology of Memory." *Material Religion* 5, no. 2 (July 2009): 180–204.

Weiss, Daniel H. *Art and the Crusade in the Age of Saint Louis*. Cambridge: Cambridge University Press, 1998.

Weiss, Gail, and Honi Fern Haber, eds. *Perspectives on Embodiment: The Intersections of Nature and Culture*. New York: Routledge, 1999.

Westerhoff, John H. III. *McGuffey and His Readers: Piety, Morality, and Education in Nineteenth-Century America*. Nashville: Abingdon, 1978.

Wojcik, Daniel. "'Polaroids from Heaven': Photography, Folk Religion, and the Miraculous Image Tradition at a Marian Apparition Site." *Journal of American Folklore* 109, no. 432 (Spring 1996): 129–48.

Yoder, Don. *The Pennsylvania German Broadside: A History and Guide*. Philadelphia: Pennsylvania State University Press, 2005.

Zimdars-Swartz, Sandra L. *Encountering Mary: Visions of Mary from La Salette to Medjugorje*. New York: Avon, 1992.

INDEX

TEXT
10.5/14 Jenson

DISPLAY
Jenson Pro

COMPOSITOR
BookComp, Inc.

PRINTER AND BINDER
Maple-Vail Book Manufacturing Group